Odd Man Out

Odd Man Out

Readings of the Work
and Reputation of
EDGAR DEGAS

Carol Armstrong

The Getty Research Institute

Texts & Documents

THE GETTY RESEARCH INSTITUTE PUBLICATIONS PROGRAM
Thomas Crow, *Director, Getty Research Institute*
Gail Feigenbaum, *Associate Director, Programs*
Julia Bloomfield, *Head, Publications Program*

TEXTS & DOCUMENTS
Jeffrey M. Hurwit, Jacqueline Lichtenstein, Alex Potts, and Mimi Hall Yiengpruksawan,
Publications Committee

Getty Publications
1200 Getty Center Drive, Suite 500
Los Angeles, California 90049-1682
www.getty.edu

Christopher Hudson, *Publisher*
Mark Greenberg, *Editor in Chief*
Pamela Heath, *Production Coordinator*
Mollie Holtman, *Project Manager*

Cover redesign by Hillary Sunenshine

Set in Monotype Fournier type
Printed by Edwards Brothers, Inc., Ann Arbor
Cover printed in Canada by Transcontinental Printing

COVER: Edgar Degas (French, 1834–1917), *The Tub*, 1886. Pastel on paper,
70 x 70 cm (27½ x 27½ in.). Courtesy the Hill-Stead Museum, Farmington,
Connecticut.

Library of Congress Control Number: 2003108453

ISBN 0-89236-728-8

Please see page 300 for updated photographic credit lines for the 2003 edition.

Contents

Acknowledgments

These acknowledgments are long overdue, for they were mistakenly left out of the original edition of *Odd Man Out*. Above all, I am happy to finally have the opportunity to express my heartfelt gratitude to Tom Crow, who, by a windfall, became my adviser in 1982, when I returned to Princeton from two research years in Europe to begin writing my dissertation, the first incarnation of *Odd Man Out*. He continued in that capacity until I completed and defended the dissertation in 1986, and then was crucial to my revising of the manuscript for publication by the University of Chicago Press in 1991. All along I benefited not only from the inspiration of his teaching and writing but also from his combination of acute intelligence, discretion, hands-off supervision and succinct intervention, rigor, and openness to approaches not his own. And I am grateful to him again now, in his capacity as director of the Getty Research Institute, for proposing the republication of *Odd Man Out* as a Getty Center title.

There are many others to whom I have long owed thanks as well: Lee Hendrix, for her continuing friendship; John Plummer, for his wisdom and good conversation; Svetlana Alpers, for her practical advice, professional support, and good companionship during and since my first teaching job at the University of California at Berkeley, as well as for providing the original inspiration to enter the field of art history; Carl Schorske for his interdisciplinary teaching and writing, which initially led me to my dissertation project; Debby Silverman, for introducing me to Princeton and to Paris; Emily Apter for her companionship during our mutual year in Paris; Louis Marin, for the fascinating seminar at the Ecole des Hautes Etudes en Sciences Sociales in Paris in 1980–81, which allowed me to open up my view of art history, and move from an archival, monographic approach to Degas's work to a discursive and critical attitude that was much more congenial to my way of thinking; Jim Rubin, Bob Clark, Marilyn McCully, Peter Bunnell, and Suzanne Nash, for their teaching and advising at Princeton; Tim Clark and Anne Wagner, for the ideas they shared and generated as teaching colleagues at Berkeley; Jacqueline Lichtenstein for opening up new lines of interdisciplinary thought in the graduate seminar we taught together on nineteenth-century French writing on art; the University of California for its support of my teaching, research, and writing; the various collections and institutions that agreed to have works reproduced; and, of course, Karen Wilson at the University of Chicago Press and Mollie Holtman at Getty Publications for their work on the text of this book.

CAROL ARMSTRONG

Illustrations

(Those works which are listed without an artist's name are by Edgar Degas.)

Illustrations

Illustrations

Introduction

In 1874, a critic reviewing the first impressionist show described one of
Edgar Degas's submissions:

> This year Terpsichore brings luck to the painters. It's a fine thing
> when reality and charm are not mutually exclusive in a canvas, as
> they are not in the *Opera Stage during a Ballet,* seen from the wings
> and painted by M. DEGAS. The gilded red edge of the first pit is
> barely seen; behind the sets, a bystander is muffled in a red shawl;
> the dancers on the other side, some green and some pink, pass near
> the hats of some male spectators and await the moment of their en-
> trance, while the prima ballerina, already on stage, poised on the
> point of her toe, lifts one of her legs and stretches her long thin arms
> before curving them in the final bow. This little dancer in particular
> is marvelously drawn, painted by the hand of an artist. The whole
> thing, seen in the evening—because M. Degas's picture is singularly
> enhanced when seen in artificial light—is incontestably true, and the
> old habitués of the Opera's foyer, passing before this picture, will
> smile and heave a sigh.

> *Terpsichore, cette année, porte bonheur aux peintres. C'est une toile
> heureuse d'où la réalité n'exclut pas le charme, que la* Scène d'Opéra pen-
> dant un ballet, *vue d'une coulisse, et peinte par* M. DEGAS. *On aperçoit à
> peine le rebord rouge et doré de la première baignoire; derrière le manteau
> d'Arlequin, une marcheuse s'emmitouflé d'un châle rouge; des figurantes, de
> l'autre coté, les unes vertes, les autres roses, dépassent des chapeaux d'hommes,
> attendant le moment de leur entrée, tandis que la première danseuse, en scène,
> droite sur la pointe d'un pied, élève une de ses jambes, et détend ses bras maig-
> res et longs avant de les arrondir dans la révérence de l'accord final. Cette
> petite figurante, surtout, est dessinée à merveille, et peinte de main d'artiste.
> L'ensemble, vu le soir—car le tableau de M. Degas gagne singulièrement à
> être éclairé d'un jour factice—est d'une vérité incontestable, les anciens hab-
> itués du foyer de l'Opéra, en passant devant cette toile, souriront, avec un
> soupir.* (Prouvaire, *Le Rappel,* 1874)[1]

This is a familiar-sounding description of a familiar subject of Degas's:
the dance. It is full of references to those qualities which we have come to
think of as characteristic of Degas's work: the "charm," the "reality," the
strange light and the gauzy pastels of the ballet world; the slice-of-life
perspective, the sidelong view and the glimpses of pieces of people and
their accoutrements; the skinny creature teetering center-stage, the dan-
cers waiting in the wings, the backstage hangers-on; and the suggestion

that you, the viewer, are there—at the edge, in that artificially illumi-
nated twilight. Not to mention Degas's famous "drawing." In short, the
nineteenth-century world of the *coulisses* which Degas repeatedly brought
into the gallery spaces overlooking Haussmann's boulevards, and which
twentieth-century audiences have since then found so attractive, so al-
most-*too*-pretty. Jean Prouvaire's is a description with all the right
ingredients.

In 1877, a critic writing about the third impressionist show described
Degas's dance pictures in much the same way:

> For those partial to the mysteries of the theater, who would
> willingly slip behind the sidelights in order to enjoy a spectacle de-
> nied to the uninitiated, I recommend the sketches of M. Degas. Let
> no one gaze upon his interiors, whose doors are inscribed with these
> words: "Private entrance. The public may not enter here." For ex-
> ample, his *Dance School,* where, under the ballet master's eye, four or
> five pupils give themselves over to their steps with such conviction,
> is disquietingly real. The prima ballerina, who, all out of breath,
> takes a bow after one of her numbers, throws herself at the ramp
> with such passion that I almost feel myself compelled to catch her.
> The dancers, poised to rush onstage, one leg in the air, watching for
> their cue, are picturesque and real. The troop straightens out its line;
> their mouths are open, one brandishes a sword, the other a plumed
> toque, but they are all unconsciously, but very conscientiously lined
> up, and their foreshortening is strangely exact—they too are true
> to life.
>
> *A ceux qui sont friands des mystères du théâtre, qui se faufileraient volon-
> tiers derrière les portants, pour y jouir du spectacle défendu aux profanes, je
> recommande les aquarelles de M. Degas. Nul ne scrute, à ce point, les inté-
> rieurs sur la porte desquels il est écrit: 'Le public n'entre pas ici!' Son* Ecole de
> danse, *où quatre ou cinq élèves, sous l'oeil du maître, se livrent à des jetés
> battus pleins de conviction, est d'une sincérité inquiétante. La prima ballerina,
> qui salue après un pas, qui l'a tout essoufflée, se précipite avec une telle fougue
> vers la rampe que, si j'étais au pupitre, je songerais à la soutenir. Les dan-
> seuses, au moment de s'élancer en scène, attentives à leur entrée, une jambe
> en l'air, guettant le motif qui les convient, ont un aspect pittoresquement réel.
> Le bataillon de choristes, la bouche ouverte, brandissant, qui son épée en fer
> blanc, qui sa toque à plumes, tous alignés en un raccourci étrangement exact,
> allongeant leur profil inconscient, mais consciencieux, sont pris sur le vif.*
> ("Jacques," *L'Homme libre,* 1877)[2]

"Jacques"'s evocation of the *Dance School* has most of the same right
ingredients as Prouvaire's earlier account of the *Opera Stage:* the descrip-
tion of the backstage world of the dance, the prima ballerina, and the
dance corps; the concentration on a private domain and an exclusive class
of viewers; the suggestion that the writer and, along with him, the read-
ers of this piece are there as witnesses, even voyeurs, at once included
and excluded; the sense of spectacle, the roving eye, and fragments

of perception; the comment about draughtsmanly skill—the praise of Degas's "exact" foreshortening; and finally, the invoking of the "real," the "true-to-life." When Degas's submissions to the impressionist shows were subject to any lengthy commentary at all, this was the kind of criticism which they most often received—we shall have occasion to look at many other such examples. The apparently exact, unproblematic match for Degas's most typical works, this is the kind of criticism we might expect of writers and journalists of the period: with their naturalist taste for the spectacle of the "real," Prouvaire's and "Jacques"'s descriptions of the dance world recall Zola's writing, the newspaper *feuilleton,* and guidebook evocations of Paris nightlife spots.

Though Degas dealt in other subjects besides the dance, today it is the ballet that is most closely associated with his name. And though his critics attended to his other favored subjects as well—his laundresses and his *café-concerts* in particular, sometimes his portraits, once in a while his racecourse scenes, and occasionally some of his odd, uncategorized pictures—in the 1870s and early 1880s they tended to associate Degas with the ballet. And by the time of the last impressionist show they began to identify him with another genre, the nude. This is how a famous critic, Felix Fénéon, described Degas's nudes in the exhibition of 1886:

> From M. Degas we have women spread out in squatting positions, like gourds filling out the hulls of their tubs; one, with her chin against her chest, scrapes the nape of her neck; another, caught in a twisting motion, veering to one side, her arm glued to her back by means of a sudsy sponge, works at her coccygeal regions. An angular spine is stretched, forearms, framing pear-shaped breasts, plunge vertically between legs in order to wet a washcloth in the water of a tub in which a pair of feet are mired. A head of hair drags down upon a pair of shoulders, a bust upon a pair of haunches, a stomach upon a pair of thighs, limbs upon their joints, and this slattern, seen from the ceiling, standing upon her bed, hands planted on her buttocks, resembles an interlocked series of slightly swelling cylinders. Seen from the front, kneeling, her thighs disjointed, her head inclined upon her flaccid torso, a young girl wipes herself down. And it's in obscure little furnished rooms, in cramped spaces, that these bodies with their rich patinas, these bodies bruised by bedding, birthing, and sickness, shed their skins and stretch themselves.
>
> In the oeuvre of M. Degas—and who else?—human flesh breathes with expressive life. The lines of this cruel and sagacious observer elucidate, via the difficulties of crazily elliptic curves, the mechanics of all the movements of a being who stirs; they register not only the essential gesture, but its most minute and its most distant myological repercussions . . . This is an art of realism, which nevertheless does not derive from direct vision . . . That is, M. Degas does not copy after life: he accumulates a multitude of sketches on the same subject, out of which he mines work of unquestionable truth.
>
> *Des femmes emplissent de leur accroupissement cucurbitant la coque des*

tubs: l'une, le menton à la poitrine, se rape la nuque; l'autre, en une torsion qui la fait virante, le bras collé au dos, d'une éponge qui mousse, se travaille les régions coccygiènnes. Une anguleuse échine se tend; des avant-bras, dégageant des seins en virgouleuses, plongent verticalement entre les jambes pour mouiller une débarbouilloire dans l'eau d'un tub où des pieds trempent. S'abattent une chevelure sur des épaules, un buste sur des hanches, un ventre sur des cuisses, des membres sur leurs jointures, et cette maritorne, vue du plafond, debout sur son lit, mains plaquées aux fesses, semble une série de cylindres, renflés un peu, qui s'emboîtent. De front, agenouillée, les cuisses disjointes, la tête inclinée sur la flaccidité du torse, une fille s'essuie. Et c'est dans d'obscures chambres d'hôtel meublé, dans d'étroits réduits que ces corps aux riches patines, ces corps talés par les noces, les couches et les maladies, se décortiquent ou s'étirent.

Dans l'oeuvre de M. Degas—et de quel autre?—les peaux humaines vivent d'une vie expressive. Les lignes de ce cruel et sagace observateur élucident, à travers les difficultés de raccourcis follement elliptiques, la mécanique de tous les mouvements d'un être qui bouge, elles n'enregistrent pas seulement le geste essentiel, mais ses plus minimes et lointaines répercussions myologiques . . . Art de réalisme et qui cependant ne procède pas d'une vision directe . . . M. Degas ne copie donc pas d'après nature: il accumule sur un même sujet une multitude de croquis où son oeuvre puisera une véracité irréfragable. (Fénéon, "Les Impressionnistes en 1886")[3]

If Degas's subjects had changed by 1886, so had the terms of his critical reception. So, indeed, had the affiliation of his critics—Fénéon, for one, was a member of the symbolist generation. Fénéon's language is a little more abstractionist than that of the earlier critics, a little more that of decoration and design: "an interlocked series of slightly swelling cylinders"; "crazily elliptic curves." His orientation is a little less toward the "real": "an art . . . which . . . does not derive from direct vision"; "Degas does not copy after life." In no sense are you *there*, as in Prouvaire's and "Jacques"'s accounts; rather, Fénéon takes Degas's pictures as visual arrangements. His attention to Degas's depiction of the human scene is at once more concentrated and more fragmented: "a head of hair . . . upon a pair of shoulders, a bust upon a pair of haunches, a stomach upon a pair of thighs"; his vocabulary is also more interiorized and phenomenological: "not only the essential gesture, but its most minute and its most distant myological repercussions." Fénéon also employs the language of the series in a way that Prouvaire and "Jacques" had not: "he accumulates a multitude of sketches on the same subject"; he even connects Degas's work to another, preeminently modern medium based on the photographic series, film: "Infallible cinema . . . the modern expressed" (*"Cinématique infaillible . . . Le moderne exprimé"*—Fénéon, "Un Bottin des lettres et des arts").[4] In almost all ways, Fénéon's description of Degas's nudes seems more modernist than the earlier accounts of his dancers—more Greenbergian, Benjaminian, and even MacLuhanish, than Zola-esque: "A ditto, ditto device/" " "/A ditto, ditto device" " "/A ditto, ditto, de-

vice/" " "/ . . . abrupt zooms, elliptical editing, no story lines, flash cuts
. . . /Light, camera, no action."[5]

There are, however, many continuities between the earlier and later
examples of the critical reception of Degas's work. Prouvaire, "Jacques,"
and Fénéon all subscribe to a private world of interiorized viewing ("ob-
scure little furnished rooms," "cramped spaces"), and to an emphasis
upon point of view ("seen from the ceiling"; "from the front"). As I will
show, all of them describe groups of pictures, rather than naming individ-
ual images—Fénéon is merely more overt about this than Prouvaire or
"Jacques" is. All of them stress Degas's draughtsmanly skill: "the lines of
this cruel and sagacious observer." Finally, even Fénéon, apparently con-
tradicting himself, writes about Degas as a kind of realist: an "observer,"
an "art of realism," work of "unquestionable truth." In spite of its design
orientation, his language has a naturalist ring to it, with all the naturalist's
love of physiognomic observation and descriptive attention to the milieu:
"And it's in obscure little furnished rooms, in cramped spaces that these
bodies . . . bruised by bedding, birthing and sickness. . . ." Fénéon's vo-
cabulary of aesthetic design is strongly underwritten by the language of
"realism."[6]

This is perhaps the most important continuity between the criticism of
the 1870s and that of 1886. In 1874, Prouvaire had evoked the physiog-
nomies, witnesses, and milieu of the Opera in a highly descriptive man-
ner, suggesting things which both could and couldn't be seen in Degas's
work: the backstage drafts, the half-light, the dark and opulent audito-
rium, as well as the stage, the movement of the dancers, and the coloristic
spectacle which they presented. In 1877, "Jacques" had also embellished
and expanded on Degas's imagery, enlarging on the life at the edges sug-
gested in it. He discussed Degas's work as a slice of real life, and spoke of
it as if he were on the sidelines of real spaces, rather than in front of pic-
tures of those spaces. He was fascinated with what lay just the other side
of the frame, with what he could evoke, but couldn't quite see; he was
intrigued with the *thresholds* of "real life." In his hands, imagery and "real
life" were seamed together, and verbal description collected around the
edges of visual surfaces, seeming to begin where the pictures themselves
stopped short. For both of these critics, the work of criticism became an
excuse for expansive naturalist writing and for the deployment of all the
devices of realist description. Though Fénéon would articulate the mix of
picture and world differently, evoking the "real" through the language of
design, rather more than the other way around, he was also heir to the
kind of criticism practiced by Prouvaire and "Jacques."

One way or another, "impressionism" seemed to be of little interest to
any of these critics. As writers for left-wing journals,[7] both Prouvaire and
"Jacques" were concerned largely with the legacy of Courbet, Daumier,
et al.—the generations of 1830 and 1848. Their own writing meant to
keep step with that. This was true of almost all the critics who wrote of

Degas's submissions to the impressionist shows. "But overall, these works constitute an incomparable page from a book of contemporary anecdotes." These were "Jacques'" words in 1877. Other critics said pretty much the same. To Marc de Montifaud,[8] writing in *L'Artiste* in 1874, Degas's pictures of that year were physiognomic images of the various classes and professions of modern Paris, i.e., they were realist. Moreover, to her, it was as if they were *written* realist texts, as if their subjects were heroines, and as if they were tales *authored* by Balzac: "[N]o one can better inscribe the professional rank of his heroines. From the ballet corps, we turn to another social order, still with the same author. The *Laundress* . . . this vigorous work of character painting" (*"[N]ul ne saura mieux écrire le rang professionel de ses héroïnes. Du corps du ballet, nous abordons une autre forme de l'ordre social, toujours avec le même auteur. La Blanchisseuse . . . ce vigoureux essai de peinture à caractère"*—Montifaud, *L'Artiste*, 1874).[9] In 1877, critics wrote about Degas's *café-concert* singers and ballerinas in the same vein: "He is an observer, perhaps even a historian" (*"C'est un observateur, un historien peut-être"*—Mantz, *Le Temps*);[10] "these fine studies which in literature correspond to a short and incisive novelette" (*"ces fines études qui correspondent en littérature à une nouvelle incisive et courte"*—Burty, *La République française*);[11] "How can we speak adequately of this essentially Parisian artist whose every work contains as much literary and philosophical talent as it does linear art and color science? With one feature, he says more than anything one can say of him, and he says it faster . . . He is an observer . . . That's what makes him the most valuable historian of the scenes which he shows us . . . That too is a truly extraordinary page out of a story." (*"Comment parler bien de cet artiste essentiellement parisien dont chaque oeuvre contient autant de talent littéraire et philosophique que d'art linéaire et de science de coloration? Avec un trait, il dit mieux et plus vite tout ce qu'on peut dire de lui . . . Il est observateur . . . C'est qui fait de lui l'historien le plus précieux des scènes qu'il nous montre . . . C'est encore une page d'histoire bien extraordinaire."*—Rivière, *L'Impressionniste*).[12] And in 1879, a critic called Degas a "causeur," likening his dancers to his phrases.[13]

To each of these critics, Degas was an observer, a physiognomist, a historian; his pictures were novelettes in paint. It is no wonder that they used his realist images as the point of departure for their own little bits of realist writing. The defining characteristic of Degas's realism, to these critics, was its textuality—the ability of his images to be read and recounted, to be turned into telling. In spite of the fact that they, like Fénéon, always acknowledged the qualities of visual design, the *making* that went into these images, they also treated the images as if they were readable in a textual way, like pieces of literature. Little could be further from the rhetoric of the impression and the landscape sketch that fed so easily, with its unconflicted emphasis upon color, paint, and surface, into the synthetist language of design. Little could be further, in fact, from Clement Greenberg's account of nineteenth- and twentieth-century art in

terms of the "newer Laocoön." This writing about pictures, with all its residual literary criteria, was closer to the *old* Laocoön—but with a realist twist, a Laocoön in line with Balzac's *Comédie humaine* or Zola's *Rougon-Macquarts*. Yet this was the dominant mode of criticism of the period, and it still informed the abstractionist criticism of a writer like Fénéon, who belonged to the generation which described painting in this Greenbergian way: "Before being anything else, a battle-horse, a nude or a landscape, a painting is an arrangement of lines and colors on a flat plane."[14] Text to be read or flat visual surface to be seen and admired for its qualities of technical and physical construction? Readable as literature, or legible as painting and pattern? The old or the new Laocoön? From the seventies to the end of the eighties, Degas's imagery was always both, with something of an emphasis on the former. Criticism as a descriptive reading of "modern life" or as a direct description of "audacious arrangements of lines"? (*"l'arrangement audacieux des lignes"*—Fouquier, *Le Dix-Neuvième Siècle*, 1886).[15] In Degas's case it was both, and one was always mixed with a liberal dose of the other.

Such criticism might lead us to question Degas's placement in the history of modernism, not to mention his position within his own generation of "avant-garde" painters. It might lead us to suspect that, as conservative as he was, he really belonged to an earlier generation. The concerns of his work might lead us to class him with Courbet and Manet, with their engagement in the human scene and the social world, and their critics' involvement in the "text" of the "real"—the physiognomics of "modern life."

But unlike Degas, Courbet and Manet are established figures in the modernist trajectory, with clear avant-garde credentials. Their myths and the nature of their address to their audiences are in line with the main account of the history of modern art: the personas of the one engaging bohemian and the other equally engaging dandy were bold, public, and confrontational; they painted memorable single pictures with big ambitions and big reputations; they were generous and forward-looking in their troublemaking; and their private lives were more or less open books—with sustaining narratives. Their commitments to critique of the social scene and of the tradition and institutions of painting are properly avant-garde; and their placement on the trajectory of abstraction is secure—thanks to famous critics like Castagnary and Zola, and the painterly trademarks they publicized: the palette knife, the *Epinal* print, and signboard paint work.

Not so with Degas. The insecurity of his membership in this club is evident in Prouvaire's and "Jacques"'s readings of his work. There is Prouvaire's mention of artificial illumination and evening light, to begin with. Indirectly descriptive of Degas's favorite kind of light, it suggests his difference from the impressionists and their broad-daylight painting. It calls up a different, more secretive and edgy kind of viewing, even a

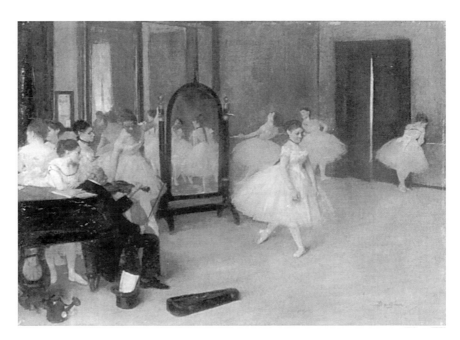

FIG. 1 Degas, *The Dancing Class,* 1872

different public—those old men, *haute monde* haunters of the Opera mentioned by Prouvaire and implicated by "Jacques": surely that is not the proper audience for avant-garde painting. Prouvaire's evening light also indicates that Degas's pictures are somehow elusive—difficult to see, eluding the gaze a bit, occupying some kind of twilight zone within the larger context of *plein air* painting, sketch aesthetics, and lower- and middle-bourgeois idylls provided by the first impressionist show. Corner-hugging in its look, safely small in statement, and often located in back rooms,[16] Degas's imagery was conceived and presented serially—much more so than was the case of the work of the other impressionists at the time, even of Monet's work, which later would become known for its conception and presentation in series. In 1874 and later, other critics besides Prouvaire indicated this about Degas's work, especially about his dancers: "If M. Renoir has painted only one dancer, M. Degas has introduced a whole seraglio of them" (*"Si M. Renoir n'a peint qu'une danseuse, M. Degas en a introduit tout un sérail"*—Montifaud, *L'Artiste,* 1874); "I'll note, in the series (of canvases by M. Degas)" (*"Je signalerai, dans la série (de toiles de M. Degas)"*—Banville, *Le National,* 1876);[17] "the remarkable series of dancers by M. Degas" (*la remarquable série de danseuses de M. Degas"*—*Le Moniteur universel,* 1877);[18] "Degas has sent a suite of interesting studies of dancers and *café-concert* singers" (*"Degas a envoyé une suite d'études interessantes sur les danseuses et les chanteuses des café-concerts"*—Schop, *Le National,* 1877);[19] "Degas's compositions repeat the same

subjects that already have often inspired him" (Mantz, *Le Temps*, 1880);[20] and so on.

The seriality of Degas's work resulted in a curious kind of criticism—rather than individually directed, most of his critics took on his submissions *en masse*. The seriality of his work aided and abetted his critics' tendency toward embellished description, and their elision of picture and real place—if in retrospective remembering and writing Degas's individual images of the Opera wings could not be singled out, the Opera itself could. And the seriality of his pictures often led to a confusion about which ones had been shown, and which were being described. It is not quite clear, for example, which single picture Prouvaire was describing in 1874. Most of the critics who wrote about Degas's individual submissions of 1874 focused on *The Dancing Class* (fig. 1), and called attention (perhaps) to the *Ballet Rehearsal on Stage* (fig. 2).[21] It is difficult to tell which of these, if either, Prouvaire meant to indicate. In its detailed enumeration of hats, gilt edges, red shawls, pink and green dancers, and precariously balanced prima ballerina, his paragraph does not seem to correspond to any one image as inventoried by others. His *Opera Stage* refers now to one picture, now to another, without signaling that it does so—to the behatted habitués, stage edge, poised prima ballerina, and waiting dancers of the *Ballet Rehearsal* perhaps, perhaps also to the colors of *The Dancing*

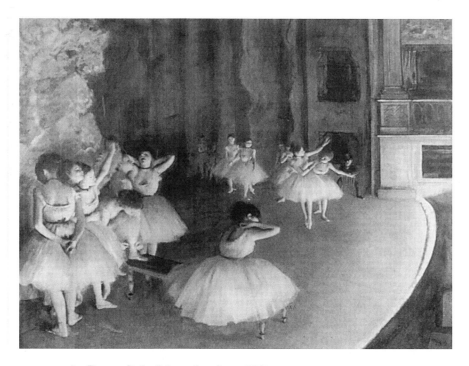

FIG. 2 Degas, *Ballet Rehearsal on Stage,* 1874

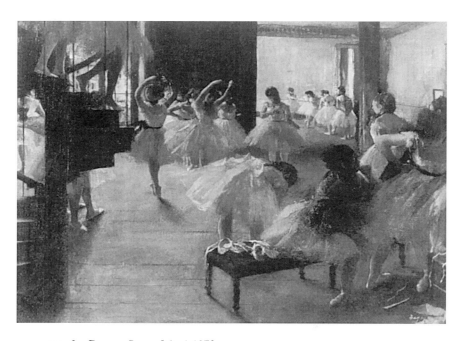

FIG. 3 Degas, *Dance School,* 1873

Class. So Prouvaire's is evidently a composite description, seaming to-
gether the various images of the Opera *coulisses* that Degas showed that
year, the population and paraphernalia implied at their edges, and the
critic's own experience of the world depicted in them.

This was also true of "Jacques" in 1877. Like Prouvaire, "Jacques"
mentioned only one picture by name—the *Dance School* (fig. 3) shown
that year. But much like Prouvaire's account of the elusive *Opera Stage* in
1874, "Jacques"'s inventory of the *Dance School* is a composite description
put together out of bits and pieces of all of the Opera pictures on view in
the exhibition of 1877: the troop of dancers of the *Dance School;* the
dancer balanced on one foot of the *End of the Arabesque* (fig. 4); the stage,
the waiting dancers, and the dancing master of another *Ballet Rehearsal on
Stage* (perhaps a variation on the picture shown in 1874—figs. 5 and 6);
and the open mouths, aligned figures, brandished sword, and plumed
toque of *The Chorus* (fig. 7). These were all pictures which were listed in
the catalogue of that year and which were, rather inconsistently, indicated
by other critics.[22]

Perhaps it comes as no surprise that critics such as Prouvaire and
"Jacques" should confuse and collate their notes from several pictures
shown together in the exhibitions they were reviewing—theirs, like
much of the art criticism of the period, is not much more than a species of
hack journalism. And perhaps it is to be expected that pictures appearing
in these group exhibitions, with their many participants and their assort-

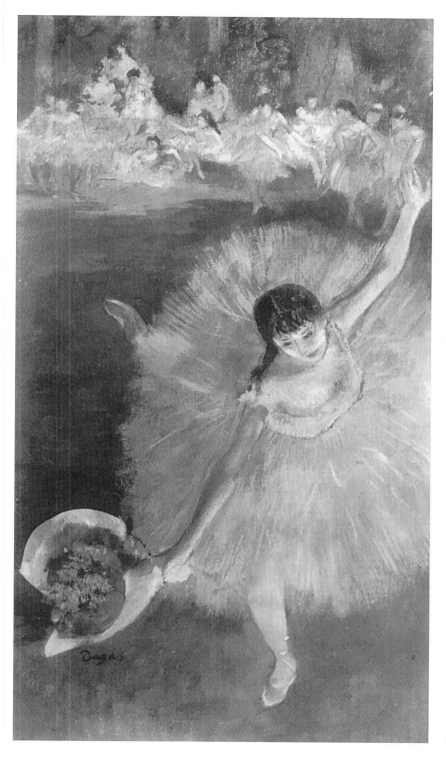

FIG. 4 Degas, *End of the Arabesque*, 1877

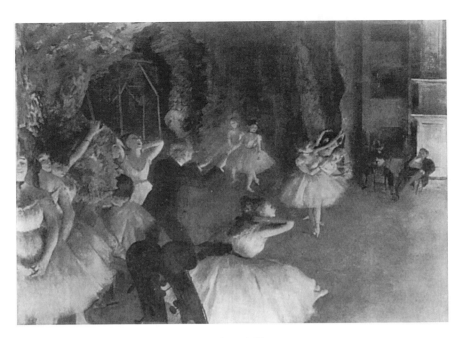

FIG. 5 Degas, *Ballet Rehearsal on Stage,* 1876

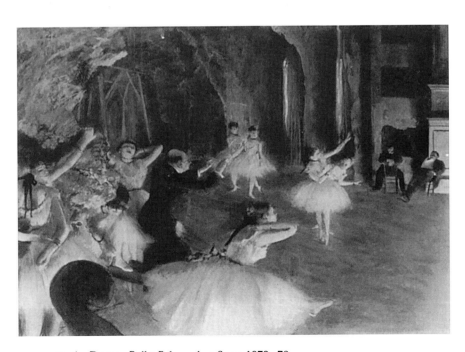

FIG. 6 Degas, *Ballet Rehearsal on Stage,* 1878–79

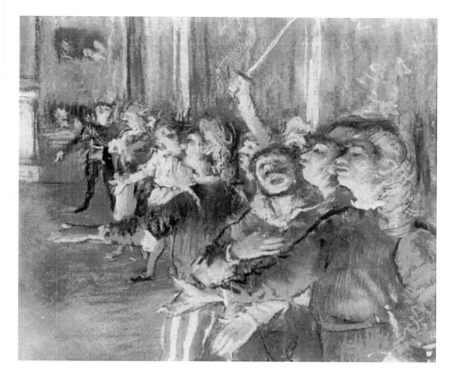

FIG. 7 Degas, *The Chorus*, 1877

ments of like and unlike images—many considered by critics to be un-
finished and unworthy of individual attention—should be the objects of
such incorrect remembering. We might look upon this tendency to run
together as a caution against taking these reviews too seriously *as docu-
ments*—against reading them too closely in that way. Yet they do suggest
something rather particular about Degas's pictures, something about the
way his work was taken in general and about the kind of language that
reiterated around his reputation within the group of which he was a
member. For while he was easy to single out as different, his individual
pictures were not. Critics good and bad, hack and otherwise, those who
approved of his work and those who didn't, all of them harped on his
repetitions more than on those of his cohorts. The following is a list of
some of the many complaints found in reviews of the exhibition of 1880
(which was not, in fact, one of Degas's most serial displays):[23]

> M. Degas is still obsessed with movement—he pursues it to the
> point of violent, disgraceful contortion. This obstinacy in one kind of
> idea had to lead to this. . . . M. Degas has made some charming pic-
> tures with his dancers. Why not stop when the subject is exhausted?
> *M. Degas reste toujours épris du mouvement, il le poursuit jusqu'à la contor-
> tion violente et disgracieuse. Cette obstination dans un même ordre d'idées de-
> vait aboutir à cela. . . . M. Degas a fait avec ses danseuses des tableaux*

charmants. Pourquoi ne pas s'arrêter quand le sujet est épuisé? (Véron, *L'Art:* 94).[24]

His talent in delineating dancers—his specialty . . .
Son talent à détailler des danseuses—sa spécialité . . . (*L'Artiste:* 142)[25]

One must take M. Degas as one finds him—he will never change; we will never have from him anything but dancers at work, light falling bizarrely from low windows, steeply sloping floorboards without any perspective. . . . [O]ne cannot help sighing and dreaming of another Degas with the same qualities but without the same difficulties.
Il faut prendre M. Degas comme il est, on ne le changera point; on n'aura jamais de lui que des danseuses au travail, des éclairages bizarres partant des fenêtres basses, des parquets sans perspective en pente bien dure . . . on ne peut s'empêcher de soupirer et de rêver à un autre Degas avec les mêmes qualités et sans les meme travers. (Baignères, *La Chronique des arts et de la curiosité*)[26]

[T]he artist excels in the silhouettes of little dancers with angular elbows.
[L]'artiste excelle dans les silhouettes des petites danseuses aux coudes anguleux. (Mantz, *Le Temps*)

His ironic wit will diminish him, if he insists on hanging around those dance classes at the Opera.
Son esprit ironique le diminuera, s'il s'attarde à ces cours de danse à l'Opéra. (Burty, *La République française*)[27]

So repetition was the catchword that went with Degas's work, particularly with his dancers. So much so that in 1886, in the last impressionist show, Degas himself dispensed with any pretensions that it was otherwise and called the ten nudes that he announced in that year's catalogue a series. It is no wonder, then, that seriality was such a pronounced feature of Fénéon's review of them, nor that he, like so many others, should run the description of one nude together with a description of the next. This had been happening all along in the domain of the dance pictures. From the beginning of his career to the end of it, Degas courted a very particular reputation for repetition, himself stressing this aspect of his practice: "[O]ne should redo the same subject ten times, a hundred times" (*"[I]l faut refaire dix fois, cent fois le même sujet"*—*Lettres de Degas,* no. 90, 17 January 1886—to Bartholomé, p. 118).[28] As George Moore would say later, "He has done so many dancers and so often repeated himself that it is difficult to specify any particular one" (Moore, *Impressions and Opinions:* 229).[29]

Degas's habit of repetition was connected in critics' minds to the twilit elusiveness of his imagery, to his special subject matter and his particular audience, and to the mode of viewing demanded by his pictures. It was standard rhetoric to talk of unfinished, incomplete works, to accuse the impressionists of producing mere sketches and fragments, of not following through and not working their pictures enough. But in the case of

Degas, the inability to follow through was connected to an inability to branch out. His irresolution was said to stem from the redundant strangeness of his preoccupations, and the fragmentary nature of his work from the distortions resulting from his insistence on a single world and a single phenomenon.[30] The problem with Degas's imagery, as critics saw it, was not the same as the problem with the impressionists' production—it did not really have to do with not-enough-work. For the consensus of opinion was that Degas had all the traditional skills. The critics could not usually explain away his repetitions as evidence of technical insufficiency. They spoke repeatedly of his ability with the pencil, and not even the hostile critics were able to include him in their complaints of sloppy brushwork, coloristic cacophony and neglected pictorial structure.[31] Where technical failure and structural disintegration were thought to be characteristic of impressionism, Degas's work was full of the signs of traditional technical control: this marked him as different from the impressionists during his own day; in our time, it also marks his work as differing from modernist principles of the picture—for his design skills are associated, not with the flatness of the medium, but with representation, and particularly with the representation of the human body.

The problem with Degas was an obsessiveness that could not quite be placed—then or now—noted by critics who suspected that his concerns were trivial. Indeed, more famous critics and writers than those whom we have looked at so far—namely, the Goncourt brothers and Manet's critic Zola—overtly described Degas's elusiveness as a function of artistic impotence, in a few notorious statements: "Now, will he ever realize something complete? I doubt it." (*Maintenant, réalisera-t-il jamais quelque chose de complet? J'en doute.*"—Edmond and Jules de Goncourt, *Journal*: 164);[32] "There are those, like M. Degas, who are imprisoned in their specialties" (*Il en est, comme M. Degas, qui se sont enfermés dans des spécialités*"—Zola, *Le Messager de l'Europe*, 1879);[33] and: "I cannot accept a man who shuts himself up all his life to draw a ballet-girl as ranking co-equal in dignity and power with Flaubert, Daudet and Goncourt" (Zola, quoted in Moore, *Impressions and Opinions*: 219).

We have seen how critics thought Degas a kind of latter-day realist, an artist whose images told the story of "modern life." Yet writers whom we might expect to praise him as such did not. For them the qualities which defined Degas's elusiveness—the private mode of viewing and the different public demanded by his work, his subjects and preoccupations, his habit of fragmentation and repetition—disqualified him from the running as either an important "realist" or a significant "modernist." By then Zola, for one, was impatient with Manet as well, but at least Manet, like Courbet before him, was a public man, broad and open and "sincere," big and singular in his picture-making rather than small, narrow, and plural. His paintings could be met head-on and challenged, singly. And if Manet wasn't quite what Zola wanted in the way of a "painter of modern life," at

least his ambitions in that direction were big enough to be laudable. At least his work was potent.[34] Not so with Degas, whose imagery was, however, arguably closer to both Zola's and the Goncourt brothers' writerly concerns than Manet's was. (The majority of the critics argued it this way, and sometimes they even compared Degas explicitly to the Goncourts.) Certainly Degas's work was closer to the naturalist writers' engagement in the gestures and features, stories and lives of modern people at home, at work, or in the street, than were Manet's quotations from the tradition and his involvement in the world of the museum.

We have arrived at the heart of the contradictions that arise in confrontation with Degas's imagery: he was a "realist" but he didn't satisfy the realists; he was a storyteller, but he wasn't up to snuff in the storytellers' eyes; he was a painter of "modern life" and his subjects were taken from modernity, but he was no "modernist"; he was a member of the impressionist group, but no impressionist; he put pictures up in the impressionist exhibitions but he seemed to demand a different public—a *private* public; his pictures were read and described and yet confused and unremembered—and it was never quite clear whether it was the place or the picture of the place that was so vividly evoked; his subjects were odd and unimportant and yet he did them over and over again; he had traditional skills in abundance and yet he didn't put them properly to use; he didn't meet the traditional requirements for completed pictures and yet he also didn't concur with the modern aesthetics of sincerity, nature, and the sketch, nor did he satisfy modern criteria for important, realized production—you couldn't say that he didn't work at it, yet you *could* say, and say quite directly, that he was impotent, not just meaning that his pictures weren't finished but also that he was *not* virile, as well as *not* important and *not* modern.

The central contradiction of his work could be characterized by the following pair of terms: realism and repetition—or, otherwise described, storytelling and seriality, a "history" of modern life, and what Fénéon called "infallible cinema, the modern expressed." In short, an older Laocoön yet one both older and even newer than Greenberg suggested, bypassing both the medium of painting and the aura-surrounded notion of the sincere, original, virile painter-author that goes with it, namely the newer Laocoön of the age of modern mechanical reproduction. By the end of the impressionist shows, in 1866, Fénéon would establish realism and repetition as the two poles of his account of Degas's nudes, but from 1874 on, in the criticism of the artist's work by critics such as Prouvaire and "Jacques," those had been the terms of critical confusion surrounding Degas's work and reputation all along.

This book is about the readings given Degas's work. It is, as well, about Degas's work and reputation: about his special subjects, such as the dance and the nude; his relation to his audience, his viewers and the busi-

ness of viewing; and his position regarding the phenomenon known as modernism—his difference from the group to which he belonged between 1874 and 1886, and from the history of modernism as it has been constructed by critics and other writers.

This book is also about the distance, both short and long, between early criticism like that of Prouvaire and "Jacques" and later criticism like that of Fénéon: it is about the space which separates and is shared by the critical poles of realism and repetition, as I have termed them. I have dealt closely with a large sampling of the critics who wrote about Degas's submissions to the impressionist shows between 1874 and 1886, beginning with the reviews concentrating on his dance pictures and ending with those written about his series of nudes. But I have also chosen to focus on the most programmatic texts written about Degas's art: first, the response of the realist writer Edmond Duranty to Degas's work; and second, that of the naturalist-symbolist writer Joris Karl Huysmans. These constitute two radically different interpretations of Degas's works—and two very different modes of paying critical attention to an artist and his oeuvre. Two different manners of reading, they have the advantage of being written by novel writers with developed literary as well as artistic programs and with fairly important places in the history of realist and antirealist literature: so they help to establish relationships between the literary and pictorial aesthetics of the period, and between the procedures of reading texts and reading images. Duranty attempts to fit unnamed works by Degas to a Third Republic version of the older Realist program; while Huysmans labors to fit Degas's series of nudes to a negation, inversion, and introversion of that program—it is my view that the oeuvre itself, with the fine-tuned powers of observation and description displayed in it, and the equally subtle struggle against those skills which it manifests, may be understood as traversing the spectrum between the two poles represented by the texts of these two writers. In short, I believe Degas's work may be understood as addressing in pictorial terms the very issues which these writers address in critical, writerly terms: the pictorial process of reading and interpreting the *histoire* of the modern human world in a non-narrative way.

In many ways, then, this book is about the rightness (and the wrongness) of the ingredients of the opening quotation from Prouvaire's review of 1874. But rather than taking their rightness (or their wrongness) for granted, I want to insist on finding strange the terms of his and others' criticism. So while it is, in this book, in my own interests to be interested in critical language and modes of reading, it is definitely not my intention to write a *rezeptionsaesthetik* history of the reception of Degas's work. This book is not *only* about the above texts (though it is also not *only* about Degas's work). I do not wish to assert a simple equivalence between the texts that I have chosen and the pictures, and I certainly do not intend to swamp the pictures with the texts, or, worse, to leave the pictures behind.

Quite the contrary. In my treatment of the texts, I wish to address myself to pictorial issues, by engaging in an exploration of how the language of visibility worked, how pictures were turned into words, how the relationship between image and world was established through language, how attention and inattention were verbalized, and what were the larger debates and litanies that surrounded particular critical vocabularies. In all cases those debates which were carried on at the time of the pictures' production are precisely those which concern me now: how to read images—in particular, ones with a new understanding of human gestures and spaces—and how to fit them to the social world around them. In that regard, I have chosen to concentrate on those groups of pictures, Degas's dancers and nudes, as well as a series of singular and exceptional works, which seem to me (and seemed to the critics of the artist's time) to be the most characteristic and the most idiosyncratic, interesting examples of Degas's work.

If this is not a history of Degas's reception, it is also not meant solely as a historical placing of his work—not *only* as an in-context reading of it, though I want it to be that too. Rather, or in addition, it is an attempt to problematize the concept of "context" and its relevance for pictorial interpretation. This was itself an important question for critics contemporary to Degas, so it is, paradoxically, historically relevant to question the concept of historical context. To this end, I have placed Degas's works between the critics of the school of "realism" and those of the school of "repetition," or antirealism: between a series of reviews, and one text in particular (Duranty's), which were based on what we might call the new art history of that time—criticism which saw a version of "social context" as the basis for interpretation—and another text (Huysmans's) belonging to another critical generation, that which closed the impressionist shows and explicitly rejected that older "new art history."

The problem of context is also an important critical question for this particular artist, who, as we shall see, was so out of context, so determinedly without a proper generation, so stubbornly an outsider within his group, and so obstinately the odd man out. Seen this way during his career, he has been seen that way since then, so much so that his out-of-context status is heard as a refrain in all of the twentieth-century monographs written about Degas. He is seen that way to this day, for he remains an odd man out, even in the diachronic context of the written history of modernism.

Perhaps what follows will read simply as a monograph detailing the life and career, or as the title of this book has it, the work and reputation of an artist who has already had many, many monographs and biographies written about him, and who has recently been the subject of renewed attention.[35] Perhaps, in questioning the notion of context, and Degas's fit with his, I will appear to be romanticizing and mythifying him, and removing him from the marketplace of which he was a part.

Introduction

Perhaps I will appear to be replacing historical context with personal story—with a myth of an individual. This book ends with an account of precisely that—a look at the way Degas has been presented in earlier biographies and monographs, and at the way he presented himself in his self-portraits. It also ends with an account that relies rather more on techniques of interpretation derived from modern literary criticism and psychoanalysis than on those derived from social history. But if this *is* a monograph, a personal history, I hope it is one which also questions those modes. While I want this account of this artist's work and reputation to be as vivid as possible, I also want it to have some distance from itself—I want it to be, in a way, a kind of *meta*-monograph. I have called it "readings" of the work and reputation of Degas—with that phrase I mean not only textual construals, but, more particularly, textual *constructions,* the critics' as well as mine, of Degas's life and work. If our history of art, and in this case our history of modern art, has been made in writing, it is a written history constructed around written lives as much as written aesthetics, written accounts of personality and personhood even more than written accounts of the look of images. For better or worse, our sense of what is or isn't important work or an important career is shaped by our sense of what constitutes an important personal history, a significant narrative of motives and intentions. Particularly true of the modern era with its devotion to manifestoes, movements, and men of daring, this aspect of our written history of modern art is worth examining—both for a closer sense of what "modernism" is and for a clearer sense of why certain individuals, such as Degas, do or do not fit within its history.

Why Degas particularly? One answer is: precisely because his is an oeuvre and a reputation which fit neither the modern history of movements and manifestoes nor the dominant narrative of personality that goes with it, nor even the dominant conception of what constitutes an important, unified oeuvre. Precisely because his work and reputation fall outside of the history of abstraction as it so far goes. Precisely because one of the things that is interesting about this artist is the way the construction of his persona as a representation appears to match his attitude toward representation—both are representations which fall *outside* the dominant modern narratives of reception, social context, artistic grouping, and selfhood. That is his interest—the answer that the readings of his work and reputation might provide to the question of what do we do, these days, with artists and images who fall outside of groups, aesthetic categories, and markets, and whose personal histories are different, *other* than those which we hold to be new and significant. What do we do with works and reputations with *another* sense of history and a different kind of narrative? That is the continuing curiosity of "Degas"—one of the reasons for another book about him and his work.

There is a simpler reason, too. Degas's art is an art which repays attention—as Prouvaire and others said—but which has rarely received the

kind of close attention it does repay. The plain answer to the question of "why Degas" is the interest of the imagery, the fact that it repays attention rather more than it solicits it. I suppose I want to have my cake and eat it too—I want to be both ambivalently newfangled *and* hopelessly old-fashioned. I want to answer, in my own way, to some of the concerns and strategies considered important today, *and* just do what has always been and still is about the most pedestrian, the most basic, and yet the rarest, the most difficult thing to do in an art-history text: look at some selected pictures hard, and write my looking at them. I have framed a lot of questions about them, and in so doing I've framed them with those questions, but I also want to keep my sights trained on and returning repeatedly to what lies within and between all those frames that now surround the pictures. Besides its other ambitions, then, the simple task of this complicated book is to try to come to grips, tortuously and plainly, deconstructively and positivistically, distantly and closely, with this one artist's work in all its idiosyncratic facets. I want, by hook or by crook, to try to be an audience for this most audience-shy of artists. And I want to do that by focusing on the period in his production in which he had the greatest audience: the period of the impressionist shows, between 1874 and 1886.

Degas, the Odd Man Out: The Impressionist Exhibitions

In 1874, Degas charged himself with administering and advertising the first impressionist exhibition. He even considered himself the leader of the impressionist group—as did others.[1] But he did not think of the exhibition as an "impressionist" one. To him it was a new "realist" Salon: "The realist movement no longer needs to fight with the others—it already is, it exists, it must show itself as something distinct, there must be a salon of realists" (*Degas Letters,* no. 12 of 1874—to Tissot, pp. 38–39).[2] Those were his words in 1874. This was the same man for whom the question of public exhibition became a real problem. About Degas Joris Karl Huysmans would later write:

> This painter, the most personal, the most piercing of all those that this godforsaken country possesses, without even suspecting it, has voluntarily exiled himself from private exhibitions and public places. At a time when all painters prostitute themselves to the crowd, he, far from it, has achieved unequaled works in silence.
>
> Some of these were shown, as an insulting adieu, in 1886, in a house on rue Laffitte.
>
> *Ce peintre, le plus personnel, le plus térébrant de tous ceux que possède, sans même le soupçonner, ce malheureux pays, s'est volontairement exilé des exhibitions particulières et des lieux publics. Dans un temps où tous les peintres se ventrouillent dans l'auge de foules, il a, loin d'elle, parachevé en silence d'inégalables oeuvres.*
>
> *Quelques unes furent, comme un insultant adieu, exposées, en 1886, dans une maison de la rue Laffitte.* (Huysmans, *Certains:* 22–23)[3]

What Huysmans said was true: between 1874 and 1886, during the years of his participation in the impressionist shows, Degas was already enigmatic and withdrawn—his fiercely guarded privacy was even then almost a legend; after 1886, he withdrew almost completely from the public eye, and critics like Huysmans constructed a kind of legend out of his reclusive personality.

How could Degas ever have considered himself a realist? What kind of realist painting was his that seemed to shun the critic's gaze? What kind of realism haunted the edges of "real life" and hung around the limits of vision, called for a kind of description that started where it stopped? What kind of realist *histoire* spun its tale out of hats, noses, lifted legs, isolated gestures, and rooms marked "do not enter"? What kind of realist

statement was it that was so small, recessive, and repetitive, so much a broken record, never saying anything just once, loud and clear? And what kind of realist artist was Degas to affect such aristocratic reserve, such disdain for his market, his public, and his profession, and for the very act of exhibiting? For Realism (with a capital R) was very much a matter of publicity, public reputation, and public confrontation. Manet and Courbet, the two painters who are now most closely identified with Realism, cultivated flamboyant personae and painted large-scale, bold-faced pictures. They maneuvered for Salon recognition and popular success and they exhibited their works in big one-man shows that made much of their reputations. None of this was true of Degas, who sometimes sneered at those two Realists.

If it is hard to understand how Degas could have described himself as a realist, it is harder still to understand his involvement in the impressionist shows. It is difficult to know what led to his early enthusiasm for the concept of the independent exhibitions, hard to explain why he behaved not only as a fervent partisan of the group, but as its leader as well—at first. For it was not characteristic of him at all. Manet was more his contemporary and cohort than the impressionists were, and Manet remained aloof from the group. And yet, compared to Manet, Degas came late to modern-life subject matter and impressionist technique. Degas was no success at the official Salons, but neither was he a failure.[4] His training, his early education, his family, his social position, his travel experience, and his personal predilections all inclined him toward the Italianate and the classical.

Degas was clearer about the distance which separated him from Monet and the others than Manet was: he was not a landscapist or a *plein air* painter; he often worked from memory rather than on the spot or in front of his *motif*, and he did not think of painting as a spontaneous activity—quite the contrary: "No art was ever less spontaneous than mine. What I do is the result of reflection and of the study of the great masters; of inspiration, spontaneity, temperament, I know nothing. Nothing in art should resemble an accident, even movement" ("*Aucun art n'est aussi peu spontané que le mien. Ce que je fais est le résultat de la réflexion et de l'étude des grands maîtres; de l'inspiration, la spontanéité, le tempérament, je ne sais rien . . . Rien en art ne doit ressembler à un accident, même le mouvement*"—Lemoisne, *Degas et son oeuvre,* I: 104). Degas was insistent about his disdain for the "natural" and his obsession with the "artificial": "the presence of nature is insipid" (*"la présence de la nature est insipide"*—*Lettres de Degas,* no. 125: 157); "to you natural life is necessary, to me artificial life" (Moore, *Impressions and Opinions:* 225). And unlike Manet, he was acid indeed about his own cohorts—he was often as anti-impressionist as the critics who reviewed the shows.

Degas was clear about his social difference as well. When he turned to "modern life" painting in the 1870s, he did so most consistently in the

context of upper-class worlds: those of the racecourse and the Opera wings—the haunts of the privileged. And he was certainly more obsessive about those worlds than Manet was. His society was other than the impressionists as well. A conservative man, his close friends were family acquaintances, classically trained artist friends from his travels in Italy, and old school companions from the Lycée Louis le Grand, the most *haut bourgeois,* traditional *lycée* in Paris in those days.[5] The Rouarts, the Halévys, the Valpinçons—collectors, *boulevardiers,* salon hosts and frequenters, wealthy, privileged people who moved at the center of conservative Parisian culture—these were the people who formed Degas's social circle.[6] His attitudes were all patrician ones: his famous love of aphorism, his devotion to a code of family honor and a cult of male friendship, his habit of double-edged *badinage* with women of wit, even his closely guarded privacy: these were the attitudes of the old *honnête homme,* very far indeed from the *populaire* image cultivated by Courbet, the bourgeois identities of most of the impressionists, or even that of the Baudelairean dandy affected by Manet. Degas was, as one critic put it, a "Parisien pur sang" (*La Petite République française,* 1879).

It is not surprising, then, that Degas never conceived of the group with which he exhibited as "the impressionists." But a new Salon of realists? Clearly Degas must have had in mind a conservative realism, one that was more socially and artistically "normal" than that of Courbet and Manet: this seems to have been the bite of his early involvement in the impressionist group—his claim that "realism need no longer fight," and his continual bids for a neutral group title and for the inclusion of traditional artists.[7] He appears to have thought of himself as the promoter of a style of realism rather in the manner of its more genteel literary practitioners, the Goncourt brothers.

Degas's membership in the impressionist group was also a reaction—*à la* Ingres, on whose persona he modeled his own—to the commerciality of one market, that of the official Salons. His biting criticism of Manet's hankering after Salon acceptance is clear testimony to that. In the first shows Degas demanded, against the wishes of the other members of the group, that Salon exhibitors be allowed to participate—this was while he thought that the group shows could be promoted as a neutral realist Salon. Then Degas changed his mind and went against the current in the opposite direction, becoming typically, contradictorily adamant in his refusal to allow members of the group to submit works to the Salon.[8] He went increasingly in the direction of exclusivity, and railed increasingly against any form of commerciality or publicity—any taint of connection with the apparent free-for-all of the market. With increasing blatancy he cultivated a reputation as the exclusive man within the ragtag group which each spring announced its rivalry with the Salons, and thus tied itself into the very market system which Degas claimed to despise.

Clearly Degas's engagement in the impressionist exhibitions was a

function of his discomfort with commerciality. The sources of this discomfort are evident in his history. He came from a reclusive family with a tendency to melancholia and mildly unhappy marriages; his parents were distant and uncommunicative with one another. More importantly than that, his family had pretensions to aristocracy—replete with mythic memories of the *ancien régime,* the first Revolution, and Degas's *émigré* grandfather.[9] And though his father, brothers, and relatives were engaged in banking, industry, the textile trade, and wine merchandising, they were evidently much more devoted to the *amateur* accomplishments and gentlemanly occupations of collecting and hosting musical soirées: to patronage rather than to profession. In that light Degas's father first agreed to and then encouraged his son's painting.[10]

In 1874, Degas's father died, leaving behind him a banking business that had been in the family for generations, and that no one knew had failed—until then. It was this business that had provided Degas with his early income. By 1875, however, his brothers both went bankrupt, largely owing to loans that they could not honor, which they had taken out from their father's bank in order to finance their wine-importing firm in Louisiana. To protect the family name Degas paid off his brothers' debts. He severed relations with one of them because of this financial crisis, and also with friends of his who conjectured about the source of his financial difficulties.[11] Already uneasy about his social position, he had felt compelled to change his name from the aristocratic "de Gas" to the more neutral "Degas" when he took up painting seriously: "In the nobility one is not used to working. Since I want to work, I should therefore have a commoner's name." (*"Dans la noblesse, on n'a pas l'habitude de travailler. Puisque je veux travailler, je porterai donc un nom roturier"*—Fevre, *Mon oncle Degas:* 23). Then more and more, he staked his endangered claim to social superiority by caricaturing the old aristocratic rules of discretion about money and disdain for trade.

The family's commercial crisis seemed to mark a watershed in Degas's career. By 1877 his own private funds were depleted—because of the family crisis, his painting had become his livelihood. Yet it was then that his enthusiasm for the impressionist shows began to wane, in spite of the fact that he needed them more than ever. In sharp contrast to letters full of plans and projects in 1874, his letters of the second half of the 1870s contain only terse remarks about picture loans and show closings.[12] In 1879, a critic wrote of Degas's well-known dislike of the press and of public display: "All the wit that he might have doesn't keep him from feeling an antipathy close to horror to any kind of publicity. He cannot imagine that the press could get hold of someone without by that very action inflicting on him something like the stigma of a street hawker." (*"Tout l'esprit qu'il a ne l'empêche pas de caresser pour toute espèce de publicité une antipathie voisine de l'horreur. Il n'imagine pas que la presse puisse s'emparer d'une monsieur quelconque, sans lui infliger, par cela même, comme un stigmate de*

cabotinage"—Montjoyeux, *Le Gaulois.*) In 1880, Degas complained bitterly about the publicity that Caillebotte, the *homme d'affaires* of the group, was actively soliciting—this after he, in 1874, had been so adamant about more notice and better advertisement: "The posters will be up tomorrow or Monday. They are in bright red letters on a green ground. There was a big fight with Caillebotte as to whether or not to put the names. I had to give in and let him put them up. When on earth will they stop the *head-lines?* . . . In view of the frenzied advertisement made by de Nittis and Monet (in the Vie Moderne) our exhibition promises to be quite in-glorious . . . I am miserable about it, humiliated." (*"Les affiches vont être posées demain ou Lundi. Elles sont en lettres rouges vif sur fond vert. Il y a eu avec Caillebotte grande lutte pour mettre ou non les noms. J'ai dût lui céder et les laisser mettre. Quand donc cessera-t-on les* vedettes? *Devant la réclame effrénée que fer-ont de Nittis et Monet (à la Vie Moderne), notre No. 5 d'Exposition devrait être votre gloire . . . J'en suis désolé, humilié"*—*Lettres de Degas,* no. 24, p. 51.) He became increasingly difficult, taking back pictures to work them over, submitting them late, not delivering them at all, or not until the exhibition of the following year,[13] splitting the group into factions with his insis-tence on the inclusion of his clique of traditional artists—until he made enemies of almost all of the group's members, withdrew from the 1882 show, and ultimately ruptured and destroyed the group. It was partly be-cause of the trouble which he caused that in 1886 the impressionist group finally disbanded.

Thus, Degas's early disenchantment with the group as a commercial endeavor is obvious; it coincided with the failure of the family businesses, with his own loss of independence, his sense of family dishonor, and the erosion of his social position. Publicity, commerce, vocation: those had become matters of anxiety to him, from which he could separate neither his engagement in picture-making nor his involvement in the impression-ist shows.

Ironically, it was the impressionist shows which provided a partial so-lution to Degas's difficulties in placing himself socially and defining him-self professionally. The group seemed to signify independence to him (as indicated by the title that he suggested for it): Independence with a capi-tal I—commercial, social, and financial. It also seemed to him to define him as an *amateur* and a fine craftsman, a member and leader of a society of the same, and it served to protect him from professional and tradesman status.[14] His closest friends were just that kind of *amateur*—and he always pushed to have them included in the group.[15] His ardent involvement in a later, failed project, *Le Jour et la nuit,* had the same ring to it: association with a group of dedicated, like-minded *amateurs* committed to a craft idea that could be discussed in letters and played out as a kind of salon game in private, informal gatherings. In fact, when Degas began to complain about the commercialization of the impressionist shows,[16] this project came to constitute a complicated kind of alternative to them.[17]

Degas also used the impressionist shows to acquire a kind of private market for himself and to define his reputation. By no means exempt from market considerations, he needed the shows. For he must have recognized that alone his pictures were not noticed enough—they did not get the recognition that Manet's and Courbet's had gotten all by themselves; his earlier experience in the Salon might have suggested that to him. Perhaps, in the group shows, his pictures would be noticed without being noticed too much.

And that was the way it went: on the one hand, the seriality and even the purported triviality of his work fit in with the tenor and composition of the impressionist shows. In the midst of the shows' mix of many diverse painters,[18] his imagery did not have the force of some kind of manifesto, and Degas was eager to avoid just that. On the other hand, the impressionist shows provided him with a context from which he could easily differentiate himself—by putting his pictures together in their own series, often in a back room apart from the others, and by surrounding himself with a coterie of middle-of-the-road painters who formed a conservative group within the larger, more controversial one. These were strategies that worked—the critics often singled out Degas, sometimes along with members of his faction, as the painter who was *not* radical, who did *not* eschew traditional skills, who could *not* quite be included in the rhetoric against the impressionists, who would have been just another skilled painter practicing his art with moderate success had he not been included in this group. This was the substance of what many critics said about Degas all the way from 1874 to 1886. Through his back-room, *à part* displays, he acquired for himself just the sort of reputation he wanted—a standoffishness that was moderately marketable. He also acquired just the market that he wanted—a following of moneyed *amateurs* and devotees.[19] Thus Degas used the impressionist shows both to identify himself as a kind of genteel *amateur* and to acquire a clientele of the same. For him the shows began and remained a realist Salon, but a realist Salon for and by the *amateur* rather than for the crowd, or for the bourgeois market.

This was the sense and purpose of Degas's curious, idiosyncratic engagement in the group shows which celebrated bourgeois life and leisure, values which were clearly other than those with which Degas wished to identify himself. The shows represented both his difficulty and his solution—in their commercial, corporate context, Degas made himself the odd man out and by these means promoted himself. Even though, in later years, he would say that "painting was private life," and that he wished to be "illustrious and unknown" (*"la peinture, c'est de la vie privée," "illustre et inconnu"*—Lemoisne, *Degas et son oeuvre*, vol. 1: 1, 9),[20] this did not mean that he was or ever had been exempt from the conditions of the marketplace and the manufacturing of reputations that necessarily accompanied it. It only meant that he had successfully acquired the public and manu-

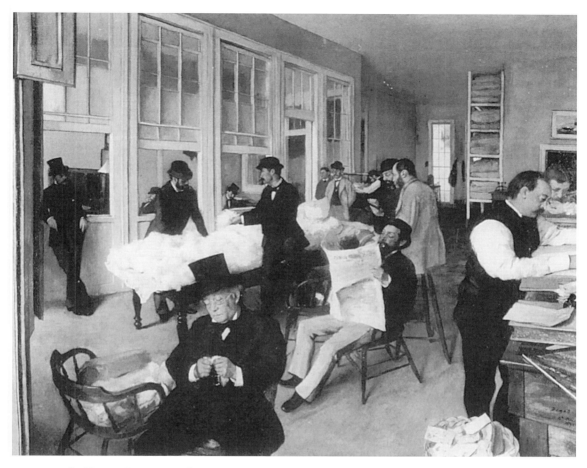

factured the reputation that he wanted—that of the private man, a kind of artisanal aristocrat. It was with this project of gentrification and privatization that he identified his career-long practice of "realism."

*

Rarely did Degas depict the arena of commerce and finance in which his family had been involved. Yet he did paint a few such images, and the few that he painted he exhibited. In 1876, he included the *Portraits in a Cotton Office, New Orleans* (fig. 8) in the second impressionist show. In 1879, he probably showed the *Portraits in the Stock Exchange* (fig. 9), and he listed it again in the exhibition catalogue of 1880. These pictures appeared at a time when Degas's anxieties about commerce, vocation, and publicity were the most acute, and while he was working out his identity as an *amateur.*

Painted three years prior to its showing, and meant for a different audience—Degas had a particular, bourgeois patron in mind, a cloth manu-

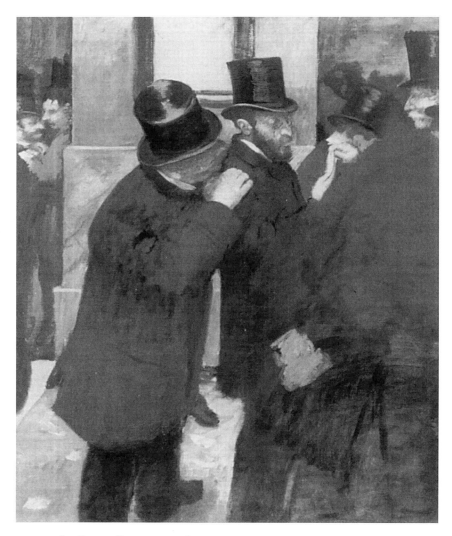

FIG. 9 Degas, *Portraits in the Stock Exchange,* 1878–79

facturer in Manchester, England (Cottrill & Co., Cotton Spinners and Manufacturers),[21] the *Portraits in a Cotton Office* was shown to its Parisian public in the midst of the financial scandal of the Degas family. (There was a slump in the cotton business at the same time, not to mention a worldwide recession, which severely affected Degas's uncle Michel Musson, portrayed in the *Cotton Office*—he was little better off than Degas's brothers.)[22]

Degas also painted the first sketch version of the *Stock Exchange* in 1876, a variation on which he was to show three years later, just prior to his disagreement with Caillebotte over the advertising of the shows, and the beginning of the group's most divided period. While the *Cotton Office*

was a family picture, the *Stock Exchange* was both a portrait of a banker-patron of Degas's—Ernest May—and a picture referring, in a general way, to his father's occupation. Evidently Degas had the world of commerce and capital on his mind during those years: both pictures must have been connected, for him, to the family bankruptcy. As such, they also provide the best pictorial match for Degas's developing market strategies—they work out in visual terms his sense of his vocation and its relationship to the marketplace.

Though the critics did not all discuss the *Cotton Office*, they did tend to mention it by name. It stood out for them; unlike his other pictures, which they reviewed *en masse*, this one had an individual title and a singular subject, and initiated Degas's habit of adding the odd, exceptional picture—usually a portrait or two—to his serial submissions. Zola wrote: "He draws pictures like the *Portraits in an Office (New Orleans)* that are halfway between a marine and an engraving in an illustrated magazine" (*"Il peint des tableaux comme ses* Portraits dans un bureau [Nouvelle-Orléans], *à mi-chemin entre une marine et le polytype d'un journal illustré"*—Zola, *Salons:* 195). Some other critics remarked on the picture's difference and described it more at length.[23]

> One of the most reasonable of all of his pictures, which represents cotton merchants of New Orleans, gives us faces well modeled and drawn with care. Its color is dark and not very agreeable. If one judged M. Degas only on the basis of this picture, one would be truly amazed to see him in such company, but in the case of his dancers and laundresses . . .
>
> *Un de ses tableaux le plus raisonnable de tous, qui représente des marchands de coton de la Nouvelle Orléans, montre des visages bien modelés et dessinés avec soin. La couleur est terne et peu agréable. Si on ne jugeait M. Degas que d'après cette toile, on s'étonnerait fort de le voir en pareille compagnie, mais avec ses tableaux de danseuses et de repasseuses . . .* (Baignères, *L'Echo universel,* 1876)
>
> Nevertheless I will make an exception for the picture bearing the following title, which is at least bizarre: *Portraits in an Office.* The picture thus designated, or disguised, is nothing more than a collection of cotton merchants examining that precious material that presently represents one of the fortunes of America. It's a cold picture, it's bourgeois, but at least it is correctly rendered.
>
> *Je fais cependant une exception pour le tableau portant ce titre au moins bizarre:* Portraits dans un bureau. *Le tableau ainsi désigné, ou déguisé, n'est autre chose qu'une collection de marchands de cotons examinant la précieuse denrée qui est aujourd'hui une des fortunes de l'Amérique. C'est froid, c'est bourgeois, mais c'est correctement rendu.* (Enault, *Le Constitutionnel,* 1876)
>
> It is difficult to explain why M. Degas, who, in this picture, seems to have wished to compete with the Dutch, has believed it necessary to make concessions to the school of spots elsewhere.
>
> *On s'explique difficilement que M. Degas, qui, dans ce tableau, semble*

avoir voulu rivaliser les Hollandais, ait cru devoir faire ailleurs des concessions à l'école des tâches. (Chaumelin, *Le Gazette [des étrangers]*, 8 April 1876)[24]

The canvases of M. Degas are of a high-quality realism. I note, in the series, the *Cotton Office in New Orleans,* and the *Laundresses.*

Les toiles de M. Degas sont d'un réalisme heureux. Je signalerai, dans la série, la Maison de coton à la Nouvelle Orléans *et les* Blanchisseuses. (Schop, *Le National,* 1876)

The ingredients of the critics' reactions to the *Cotton Office* are as follows: it was different, both from the rest of Degas's own work and from the submissions of the other members of the group; it was skilled, if not particularly attractive; both a group portrait and a kind of genre picture, it was realist, it was like Dutch painting, and it was meticulous to the point of being a sort of Biedermeyer painting; and it was businesslike, "bourgeois," and "American."

The critics' designation of the *Cotton Office* as bourgeois encapsulated everything else they noticed about the picture: its meticulousness, its genre-painting status, even its difference. And "bourgeois" was a quick way of identifying the painting with realism. Most obviously, it was a bourgeois picture because it was an image of men in the ubiquitous black bourgeois suit doing bourgeois work (and painted with a bourgeois patron in mind). The critics spoke of it as a dark picture, just as earlier critics had spoken of Courbet's *Funeral at Ornans.* In fact, this picture is strangely reminiscent of the famous painting by the notorious head of the Realist school. A provincial picture seen by a Parisian audience, apparently uncomposed, spatially strange, with none of the iridescences or accents of cake-icing color that characterize the ballet pictures to relieve it, it was an image of a group of men all wearing the funereal garb that was the Baudelairean symbol of modernity. It might even have been, in a farfetched way, a kind of response to Courbet's work of the 1850s. (In 1865, Degas had painted a self-portrait that made direct reference to Courbet's arrogant *Bonjour M. Courbet.*) It was certainly in line with Degas's ambition to re-present "realism" in conservative, neutral terms. It was a genre picture that was nothing more or less than a genre picture—as opposed to Courbet's genre painting, which made claims in scale, title, and Realist manifesto to be history painting. Degas's was a *little* picture, full of *little* social observations. It made no statement and represented no problematic social mixture. Destined for a British merchant-patron, it was a picture of tranquillity, of stable, established social position and apparently successful American commerce, rather than of the socially indeterminate, potentially volatile French provincials of 1850. It was as much an antimanifesto as Courbet's picture had been a manifesto. By painting and showing this picture in his own realist "Salon," Degas set about normalizing, neutralizing, and privatizing the concept of realism, as well as the troublesome business of commerce—this was one of his first obvious gestures in that

direction. The critics' designation of the picture as businesslike and bour-
geois can be seen as a kind of shorthand for their latent recognition of
this strategy. It was also an indication of their sense of the picture's differ-
ence—their sense that the neutralization of realism was Degas's business,
that with it he sketched out a separate territory for himself within the
impressionist shows, and that his work demanded a different audience
and a different critical vocabulary.[25]

The cool palette and skilled meticulousness of the *Cotton Office* were
central to its difference and its allegiance to bourgeois realism. (It was in
1876 that critics most often linked Degas's work to Caillebotte's equally
meticulous, equally bourgeois renderings of Paris, setting apart both
Degas and Caillebotte from the rest.) As the critics noted, the meticu-
lousness of the *Cotton Office* was of a curious kind—cold, because it was
without great social, emotional, or even material texture. The picture
possesses neither the slick brilliance of Ingres's upper-class portraits, nor
the clothing and color accents that seem to strengthen the blacks and un-
derscore the strange mannerist stares of Degas's own earlier portraits,
nor the coarse, rough thicknesses of Courbet's workman-identified can-
vases—none of the texture that seems, at least elusively, to give those
images social and psychological presence. Despite its illusionistic de-
tails—those letters and ledgers at the right and the shutters to the left—it
also has none of the descriptive richness of seventeenth-century Dutch
genre painting, with which it was identified, none of that variety of sur-
face that suggests anecdotal elaboration. It is a subtly balanced picture,
for all its typical spatial oddities and compositional disarray: its blacks
balanced against its cool, pale taupes, whites, and icy greens, and those
against the earthy tones of the floor. The picturesque notes of blue—of
the trousers of the bowler-hatted man standing center-rear and the open
letter in the right front corner—are too pale to vividly accent the picture.
It is an image constructed almost solely of silhouettes, neutral colors, de-
liberate lack of emphasis, and virtuosic absence of texture. And Degas
was deliberate about the picture's cold meticulousness; at the same time
he also painted (though he did not show) a sunny sketch version of the
Cotton Office, called the *Cotton Merchants in New Orleans* (fig. 10). Degas
himself clearly thought of the *Cotton Office* as distinct from his new,
sketchier style, different from the kind of picture he was beginning to
paint: "I am preparing another less complicated and more spontaneous,
better art, where the people are all in summer dress, white walls, a sea of
cotton on the tables" (*Degas Letters,* no. 6 pp. 29–32). So the difference
and the Biedermeyer quality of the *Cotton Office* were deliberate—and the
critics' evocation of it accurate.[26]

Evidently the *Cotton Office* was a kind of comparison picture: a finished
genre painting and group portrait to be juxtaposed to his newer, looser,
more concentrated studies. That it was a genre painting further identified
it with bourgeois realism and further separated it from the concerns of

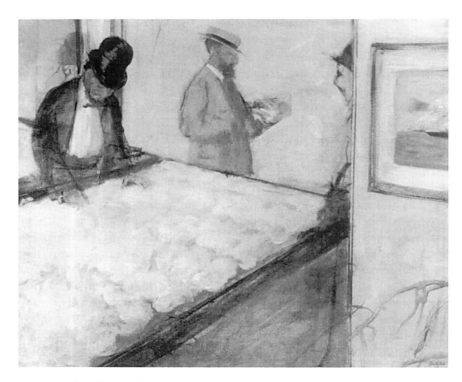

FIG. 10 Degas, *Cotton Merchants in New Orleans*, 1873

impressionism. It also fit with Degas's special desire to privatize his voca-
tion and his relation to the marketplace. The *Cotton Office* is full of genre
overtones. The most striking of these is the figure of Degas's uncle,
Michel Musson, in the foreground: he looks more like a Dutch matron or
serving girl working on her sewing than the mercantilist he was.[27] His
domestic appearance is underscored by the trompe l'oeil details of the
shuttered panel at the left edge, opening onto the space of the viewer like
the curtains and windows of Dutch pictures, and the stamped, addressed
envelopes in the wastebasket, the ledger, record books, and pieces of
paper hanging off the edge of the desk, and the artist's signature on its
wood surface, all in the lower right corner—like so many reminiscences
of still-life and trompe l'oeil images. These familiar notes serve to domes-
ticate the picture's presentation of the world of business. The domestic
tone of most of the work, and the trompe l'oeil elements at the edges, at
once too opaque and too thinly painted to really reward the connoisseur's
attention to such things, seem to quiet the activity depicted within the
picture—by framing it with the absorbing artifices of domestic painting.

Each glance and gestural incident in the image is framed and counter-
balanced by a background one which pulls it back and reverses it: such is
the case with the buyer, who forms a little Janus figure with the bowler-

hatted figure behind him, and who is repeated in the other small figure in the back, matched by the bearded figure on the stool across from him, engaged in close conversation and enigmatic figuring with Musson's partner, James Prestridge, and reversed once more by the shirt-sleeved figure of the cashier, John Lavaudais, in the front. Lavaudais, in turn, is balanced by the tan-jacketed man on the stool, and matched in reverse-and-retreat by the tiny, shirt-sleeved figure in the rear. And so on: the little game of retreat, reverse, and counterbalance is multiplied throughout the image: such that the group of men in the *Cotton Office* represents not so much a crowd of different, interacting people as it does multiple versions of a single, self-absorbed figure. Finally, even the relationship in the center of the picture between the buyer and the broker, William Bell (a cousin-in-law), is quietly undercut by the framing of their business in idleness: in the form of the two de Gas brothers, Achille lounging against the partitioning wall, and René reading the newspaper, and by the submersion of their social intercourse in a crowd of absorptive stances, glances, and gestures. And even within the relationship between buyer and broker, the emphasis is placed more on the one man's contact with cottony substance than on the exchange between the two men; that moment of material contact is echoed throughout the image, in the gesture of M. Musson and by the men in the foreground and the background, who lean heavily on their books and papers, and even by René de Gas, as he grips and crinkles his paper.

The critics, while they described the bourgeois quality, the meticulousness, the genre painting identification and the difference of the *Cotton Office* in general terms, did not, for the most part, elaborate on its anecdotal and physiognomic dimensions. The reason for this lies in the picture itself—contrapuntal design predominates over human relationships, private absorption in material is emphasized over event and transaction, and most importantly, serialization begins to replace social communication. While the *Cotton Office* is a realist picture, subtly it begins to replace realist narration with the thematics of repetition that would be worked out so obsessively in Degas's other submissions to the impressionist shows.

Thus, one way in which the *Cotton Office* privatizes the business of realism is through design strategies which emphasize repetition over narration. Another way is by separating the activity of making from that of the market. Almost alone among the impressionists (Pissarro was one other exception), Degas seemed concerned with *work* (not leisure per se), and the modern relationship of the worker to his/her work. The *Cotton Office* is an image of one kind of work, the "work" of management: with its multiplication of separately accomplished tasks, it is a powerful image of the principle of labor division which underlies the production, exchange, and management of capital.[28] It also might be seen as an image of the alienation from the process of repetitive production which is another fea-

ture of the world of capital—nowhere else is this better seen than in the idleness of Degas's own two brothers. But it is a more personal picture than that. Rather than a general image of workers' or owners' alienation from work—after all, Degas's brothers were neither workers nor owners in this concern[29] (it was their uncle's, not their, business)—it is a picture of the de Gas's disengagement from the world of work and commerce, qualified by an aloofness of a specifically genteel sort. And throughout the image, commercial work is turned into a kind of private, domestic labor: writing, reading, doing accounts, the close work of inspection and scrutinization—which, in the figure of Père Musson, becomes something like the activities of handicraft and connoisseurship. In other words, the world of family commerce is turned into the gentlemanly, even womanly work to which Degas was attracted, and with which he identified himself. Able to depict separate tasks and obsessed with repetition, Degas seems to have been *unable* to tie those tasks to the public domain of commerce and capital (or, at least, he seemed to stress that the private individual, serialization, and the relationship between men, goods, and materials—rather than between men and men—were absolutely fundamental to that domain). The contrapuntal, repetitive, and thoroughly privatized nature of each of the gestures included in the image suggests that Degas was also unwilling to depict any kind of human transaction at all without countering it and negating it, without transforming the domain of the social into that of the serial.

What the *Cotton Office* proposes is this: a separation of work from the market, repetition from transaction, and both from the apparently fluid space and the seemingly open domain of the exchange of capital. The picture engineers a close relationship, even an identity, between private production and private consumption—the simultaneous absorption in the activity of working and in that of receiving—and a curious bypassing of the intermediary of the market. Thus the domestication of realism and the substitution of repetition for narration also represent a privatization, even a gentrification, not only of realism, but of work and of the marketplace as well. The *Cotton Office* is, in short, an image of the world of the *amateur*— of the *amateur*'s private absorption in gentle work and its products. It matches Degas's identification with that world, as well as his search for, and fairly immediate acquisition of, a market within it. (There are other, earlier pictures which also link him to that identity, most notably his depictions of print collectors done after Daumier's very similar images: for example, fig. 49—the figures in the *Cotton Office* resemble these print collectors.)

So the *Cotton Office* was the pictorial embodiment of all the strategies that marked Degas's involvement in the impressionist shows: the domestication of realism, the gentrification of work, and the privatization of the marketplace. The critics indicated some of this with the catchword "bourgeois," with their identification of the *Cotton Office* as a genre picture;

their response to its coldness, meticulousness, and skill; and their curious failure to link it to Degas's reputation as a realist storyteller, their lack of interest, for the most part, in attempting to read or describe it. Most of all, they connected it to their puzzlement about Degas's participation in the impressionist group and their sense of his difference from it. With this picture he marked himself as the odd man out: the realist within the ranks of the impressionists, the strategic nonbelonger, the artist who claimed for himself an audience and an identity which were different from those of the impressionists and other than that to which the critics spoke. The *Cotton Office* also marked a difference within Degas's own career—the end of a period in his work and his embarcation on a new course: his concentration on serial motifs and new media, cheaper and faster than oil, and more suited to studies.

For as different as it is from the series in which he would specialize, neither the type of gesture, the kind of work, nor the nature of the relationships portrayed in the *Cotton Office* are completely dissimilar to those played out in Degas's pictures of female performers: repetitive, contrapuntal, and private, a world of separate tasks, of contrasted idleness and absorption, of contact with material stuff and physical self, rather than social interaction and anecdote. Degas's meticulous genre painting of male, bourgeois commerce is as curiously close to as it is distant from his more familiar pictures of demimonde women at work and rest, engaged in or disengaged from their métiers and their work of artificing, pictures in which the world of making is also defined as a secret one and disconnected from the *plein air* of the marketplace.[30]

Degas's other commerce picture provides the missing link between the meticulous *Cotton Office* and his sketchier *coulisses* series. This was the second, "finished" version of the *Portraits in the Stock Exchange* (fig. 9), which he was supposed to have shown in 1879, but which the critics never addressed. Another exceptional picture, it tells us much about the way the artist's feelings about the problems of commerce, publicity, and profession had solidified in the intervening years. This place of business is not cool and clean and open like the *Cotton Office;* rather, it is a murky, secret netherworld, as behind-the-wings and other-side-of-the-keyhole as Degas's foyers, loges, and boudoirs, peopled with marginalized physiognomies as suspect as those of his dancers, demimondaines, and criminals: witness the two figures behind the pillar to the left, very similar to Degas's *Criminal Physiognomies* (fig. 11), shown in 1881. This seems to be the same type of man as those who inhabit the sidelines of the Opera *coulisses*—Degas underlined that fact by displaying his *Portraits of Friends on Stage* (fig. 12) in the same show; another unusual, all-male picture, in which the relationship between the two men is almost identical to that between the stockbrokers in the *Stock Exchange.* Juxtaposed to his ballet pictures, to the *Friends on Stage,* painted at the same time as Degas's

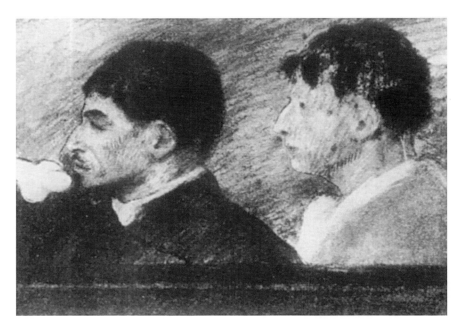

FIG. 11 Degas, *Criminal Physiognomies,* 1881

monotype series depicting dancers and prostitutes, the *Stock Exchange* is the sketch-style, *coulisses* version of what Degas had already worked out in the *Cotton Office.* Like the *Cotton Office,* it is a pictorialization of the marketplace, even, now, of capital itself. As a portrait it focuses on a man who combined in himself the functions of market representative, father figure, and patron-*amateur* of Degas's art: Ernest May. And in it, the commerce of the stockmarket is messily and somberly interpreted. Illicit and unclean—the *Stock Exchange* is a blacker, dirtier picture than any of Degas's others—this is business conducted in secret. It is a picture of clandestine commerce, depicting the exchange of market information as a species of covert operations conducted through furtive whispers and spying glances.

With its set of black frock coats it is a bourgeois picture like the *Cotton Office,* but it ups the ante, exaggerating the domesticated and gentrified world of work and commerce seen in that picture into a privacy so extreme as to constitute an image of voyeurism and paranoia. Where the *Cotton Office* neutralized the business of realism by privatizing it and delimiting its narrative possibilities, the *Stock Exchange* gives it a neurotic twist by pushing privacy to the limit and paradoxically *expanding* the possibilities of reading-in. Even the repetition and contrapuntal compositional order of the *Cotton Office* are here narrowed and focused to a single large/small, foreground/background repetition—which has us close in on the covertness of commercial conversation fore and aft the dividing pillar. And this newly covert commerce is identified with Degas's new quick

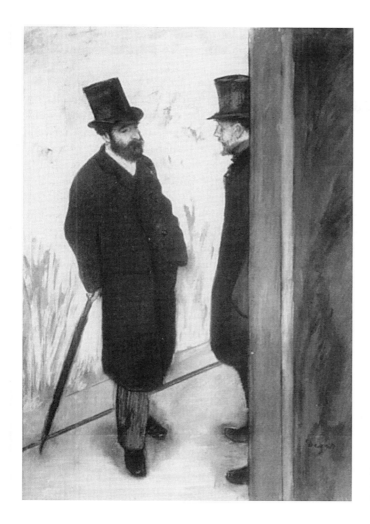

FIG. 12 Degas, *Portraits of Friends on Stage,* 1879

style—a style appropriate to things voyeuristically seen and illicitly conveyed—but not with Degas's new palette, for the covert operations of the *Stock Exchange* are linked, not to the palette of *plein air* painting or even to the colored sketches which Degas considered his commercial "articles," but to his most private, indoors, black-and-white renderings, his monotypes. Less and less the world of impressionism, this is more and more Degas's special world, tying the exaggerated secrecy of his view of business to his other pictures and series—and to the comparisons and links between pictures *within* series. Thus, the *Stock Exchange* is a picture not only of Degas's privatized marketplace but also of his exaggerated sense of the clandestine, even illicit foundation of his own style and subject matter and its manner of reception; of the spectacle of the upper-class world that he chose so often to depict; and of his identification with that world. It also may be seen as an image of Degas's increasing estrange-

ment from the impressionist shows, his growing anxiety about the issue of publicity, and his final retreat from public view.

<div align="center">*</div>

Though the critics set the *Cotton Office* apart from Degas's dance series, there are other ways besides the thematization of repetition in which they are connected. Like the *Cotton Office,* the dance series was said to mark Degas's difference from the impressionist group. Like the *Cotton Office,* it was tied to the critical discussion of realism rather than to that of the impressionist sketch. And most importantly, the dance pictures are akin to the *Cotton Office* in their engagement in the problems of work, social and professional identity, and the marketplace, as well as in their involvement in the strategies of gentrification and privatization. They are also like Degas's other picture of the business, the *Stock Exchange,* in their exaggeration of the private into the covert and the clandestine, the paranoid and the voyeuristic. Though the critics did not point out the connectedness of Degas's female series to his genre pictures of the marketplace and the male business world, they did remark on almost all of the elements which effectively bound the two together into the same enterprise.

Degas's difference was much on the mind of many of his critics: "I imagine that M. Edgar Degas is not a wholehearted impressionist," said one of them, thinking of the dance pictures (*"J'imagine que M. Degas n'est pas un impressionniste à tous crins"*—Ballu, *La Chronique des arts et de la curiosité,* 1877). "Only one of them has kept himself free of this blue tint, and that's one named Degas," said another (*"Un seul d'entre eux s'est affranchi de ce bleu, c'est un nommé Degas"*—Bertall, *Paris-Journal,* 1877). Yet another singled out Caillebotte, Renoir, and Degas: "Two or three painters—M. Caillebotte, M. Renoir, perhaps M. Degas . . . are the highlight of the group, but they are only connected to it by feeble links. Sooner or later, they will end up in the official Salon and they will submit themselves to the jury like M. Manet." (*"Deux ou trois peintres—M. Caillebotte, M. Renoir, peut-être M. Degas . . . sont l'honneur du cénacle, mais ils n'y tiennent que par des liens faibles. Tôt ou tard, ils aboutiront au Salon officiel et ils se soumettront au jury comme M. Manet"*—Schop, *Le National,* 1877.) [31] The same year Paul Mantz wrote a review for *Le Temps* in which he mentioned the singers in the *café-concert* pictures, and the dancers in the *End of the Arabesque* (fig. 4), a *Ballet Rehearsal on Stage* (fig. 5), and the *Dancers at the Bar* (fig. 13):

> We do not know exactly why M. Degas has classed himself amongst the impressionists. He has a very distinct personality, and within the group of so-called innovators, he stands apart. He is an observer, a historian perhaps. He has chosen as the subjects of his studies the singing café and its gaudy vulgarities, the floor of the theater, where the funnel of a watering can describes exact figure eights in the powder, suspect wings where beneath the reddish light of smoky lamps thin young girls puff up their skirts and repeat their steps. This is a strange world, and Baudelaire would have found in it some sickly

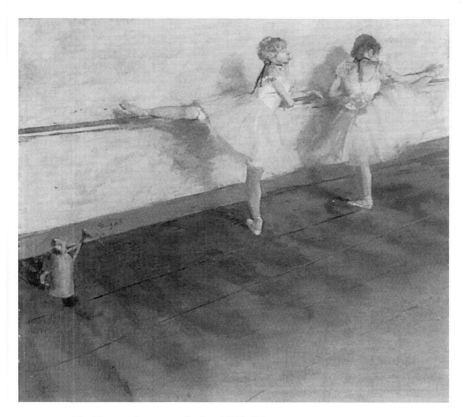

FIG. 13 Degas, *Dancers at the Bar,* 1876–77

flowers for his own garland. Moreover, M. Degas is a cruel painter. He has been visibly stirred by the pain concealed beneath the tinsel: he shows us little dancers with indigent arms, the fat old man who ambles amidst these little nymphs and who excels at "protecting" the beginners, the excessive smile of the singer who, pressing her bouquet to her chest, comes forward to thank her avid public. He knows all the scars of precocious vice; he has a feeling for disguised hideousness, and he will be, if he wants to be, a formidable caricaturist. M. Degas's compositions are sparse and disordered: his frame cuts figures in two and deliberately reduces them to the state of fragments. His talent includes some negligences which are perhaps artifice; M. Degas abounds in irritating paradoxes. The notion of disconcerting the bourgeois is one of his most constant preoccupations.

On ne sait pas exactement pourquoi M. Edgar Degas s'est classé parmi les impressionnistes. Il a une personnalité distincte, et, dans le groupe des prétendus novateurs, il fait bande à part. C'est un observateur, un historien peut-être. Il a choisi pour sujet de ses études le café-chantant et ses vulgarités voyantes, le plancher du théâtre, où l'entonnoir de l'arrosoir dessine savamment des huit dans la poussière, les coulisses suspectes où, sous la clarté rouge

des lampes fumeuses, des jeunes filles maigres font bouffer leurs jupes et répè-
tent leurs pas. C'est là un monde étrange, et Baudelaire y aurait trouvé pour
ses guirlandes quelques fleurs malsaines. M. Degas est d'ailleurs un peintre
cruel. Il a été visiblement ému de l'élément douloureux qui se cache sous ces
oripeaux: il montre les petites danseuses aux bras indigents, le gros monsieur
qui se promène au milieu de ces féeries et qui excèlle à protéger les débutantes,
le sourire excessif de la chanteuse qui vient, en serrant un bouquet sur son
coeur, remercier le public idolâtre. Il sait toutes les flétrissures du vice précoce;
il a la notion des laideurs fardées et il sera, quand il voudra, un caricaturiste
redoutable. Les compositions de M. Degas sont d'ailleurs éparses et désordon-
nées: son cadre coupe en deux les figures et les montre volontiers à l'état de
fragments. Son talent a des négligences qui sont peut-être des artifices; M.
Degas abonde en paradoxes irritants. L'idée de déconcerter le bourgeois est
une de ses préoccupations les plus constantes. (Mantz, *Le Temps,* 1877)

I have previously cited this review of Mantz's; he was one of the critics to call Degas a "historian" of modern times, including as essential to that designation the following elements: sickliness and deformity, cruelty, "precocious vice" and viciousness, the combination of hideousness and beauty, the pain and the pleasure of spectacle, the death's-head grimace beneath the cosmetic mask of female beauty, fragmentation, "disconcert-ing the bourgeois," the theme of prostitution implied in the reference to the "gros monsieur." These are Baudelairean themes and they recur throughout the critical prose surrounding Degas's depictions of women. These themes were different from those of the criticism written about the impressionists—Mantz, like others, opened his discussion of Degas's works by very clearly stating Degas's difference from his cohorts. If any-thing, Mantz's Baudelairean refrain connected Degas's dancers to the pre-vious generation: to the art of Courbet, Daumier and other caricaturists, and Manet.

Mantz placed Degas's ballet series under the sign of Baudelaire. Many of the other critics connected them to the thematics of Manet's *Olympia* (fig. 14).[32] The connection was irresistible for in 1874 Cézanne's *Modern Olympia* was shown. Taking that fact as a point of departure, Louis Leroy, for one, compared the impressionists in general to the *Olympia* (Chari-vari, 1874).[33] Rather later, in 1880, a critic writing for *La Presse* did the same: "Since the *Belle Olympia* by Manet, we have seen so many colors thrown at canvases with a kick of the foot and a blow with the fist, so many arms detached from bodies, so many figures without equilibrium, so many bold characters planted in their frames like *Epinal* figures, that we have become a little sick of it." (*"Depuis la* Belle Olympe *de Manet, nous avons vu tant de couleurs collées sur des toiles à coup de pied et à coup de poings, tant de bras non attachés aux corps, tant de figures sans équilibre, tant de braves gens campés dans leurs cadres comme des bonshommes d'Epinal, que nous en sommes un peu écoeurés"*—Delaville, *La Presse.*)[34] Evidently *Olympia* had become a code word for all the aspects of Realism which the critics dis-liked, and which they also felt to be characteristic of the work of the im-

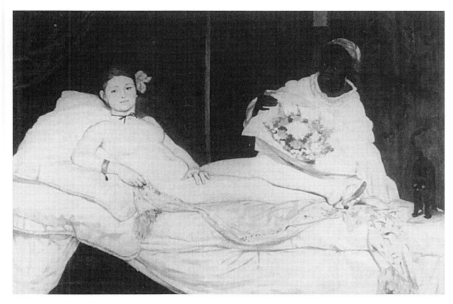

FIG. 14 Edouard Manet, *Olympia,* 1865

pressionist group as a whole. But the language surrounding *Olympia*
seemed to be particularly applicable to Degas's female series. In 1865,
Olympia had been described as dirty, "black," and deformed; in the 1870s,
the same phrases were applied to Degas's dancers, laundresses, and *café-
concert* singers. In 1874, in the context of his general comparison of the
impressionists to the *Olympia,* Leroy spoke of Degas's "laundress so
badly laundered" (*"La blanchisseuse si mal blanchie"*—Leroy, *Charivari*). In
1876, Bertall said the same of the laundress exhibited that year (fig. 15),
speaking sarcastically of her black collier's arm (*"le bras noir d'une charbon-
nière"*—Bertall, *Le Soir*).[35] Emile Porcheron said the same of that picture:
"a laundress whose head and arms are almost black. The first thought
inspired by this picture is to ask oneself if it's a collier who is also a laun-
dress, or a laundress who is also a collier" (*"une blanchisseuse dont la tête et
les bras sont presque noirs. La première pensée que vous inspire ce tableau est de
vous demander si c'est la charbonnière qui est blanchisseuse, ou si c'est la blanch-
isseuse qui est charbonnière"*—Porcheron, *Le Soleil,* 1876). And the critic for
the *Gazette des étrangers* wrote: "His *Laundresses,* otherwise drawn so cor-
rectly and firmly, would not have my business: the linen which they are
ironing is repulsively dirty." (*"Ses* Blanchisseuses, *d'un dessin d'ailleurs si
juste et si ferme, n'auront pas ma pratique; le linge qu'elles repassent est d'une
malpropreté repoussante"*—Le *Gazette des étrangers,* 1876.) Describing *At the
Seaside* (fig. 16), Georges Maillard wrote of a "yellow beach on which a
nurse, escaped from the Salpêtrière hospital, grooms the cadaver of a

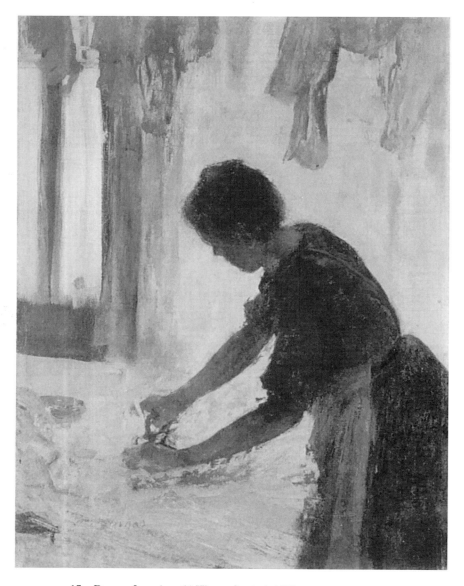

FIG. 15 Degas, *Laundress (A Woman Ironing)*, 1874

young girl from Nuremberg, a prone figure so black that even the corner collier wouldn't touch her with a ten-foot pole" (*"une plage jaune sur laquelle une bonne, échappé de la Salpêtrière, peigne le cadavre d'une petite fille de Nuremberg—une femme couchée, que la charbonnière du coin ne remuerait pas avec des pincettes tant elle est noir"—Le Pays,* 1876):[36] his words are extremely reminiscent of the descriptions of *Olympia* in 1865, several of which characterized her as a "charbonnière" as well.[37] (And *At the Seaside,* with its dishwater-complexioned, prone female figure, her flat, angled

Chapter 1

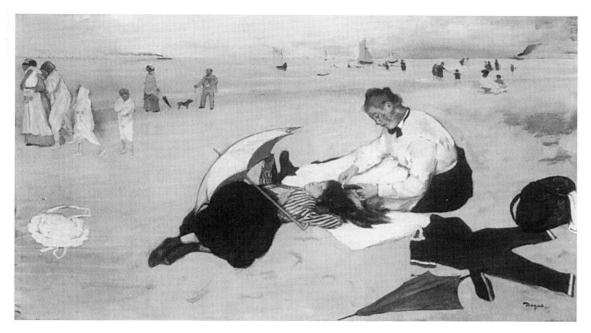

FIG. 16 Degas, *At the Seaside,* 1876

body and overlapping feet, her swarthy-skinned attendant, and the contrast of bright against off-white and stark blacks, is indeed curiously similar to the *Olympia.*)

In 1877, critics continued in this manner. The critic for *La Presse* spoke of Degas's earliest bathers thus: "They are not pretty, they are not well made, they do not have nice complexions, yet one may perhaps believe in their relative cleanliness" (*"Elles ne sont pas belles, elles ne sont pas bien faites, elles n'ont pas bon teint, mais enfin on peut croire à leur propreté relative"*—L. G., *La Presse*).[38] In 1879, Bertall spoke of Degas's images as soiled (*L'Artiste*),[39] and Henri Fouquier spoke of his dancers as bestial and cadaverous:

> I recommend to you certain green "dancers," who will give you something of an impression of what the experience of electricity on cadavers might be like. When I said that the "turkeys" of last year had no match, I perhaps missed one strange beast who descends from the cow, the hippopotamus, and the crocodile, and who would make the Geffroy St. Hilaires of the future dream.
>
> *Je vous recommande certaines "danseuses" verdâtres, que nous donnent assez l'impression de ce que peut être une expérience d'électricité sur des cadavres. En disant que les "dindons" de l'an passée n'avaient pas de pendant, j'ai fait tort peut-être à une étrange bête qui vient de la vâche, de l'hippopotame, et du caïman, et qui fera rêver les Geffroy-St. Hilaire de l'avenir.* (Fouquier, *Le Dix-Neuvième Siècle*)[40]

In 1881, Ephrussi described the *Little Fourteen-Year-Old Dancer* (fig. 17)

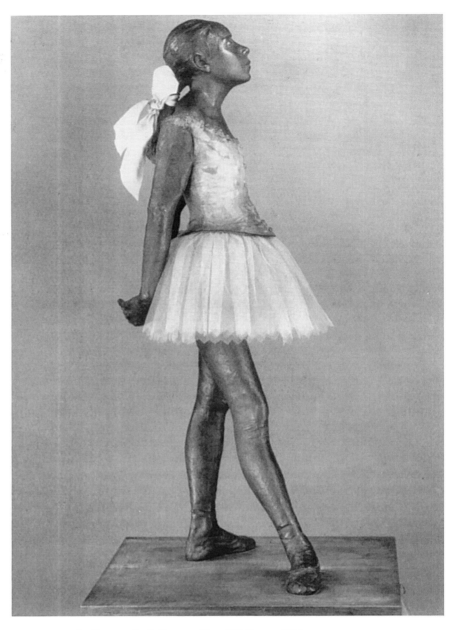

FIG. 17 Degas, *Little Fourteen-Year-Old Dancer,* 1881

in the same terms, while Wolff, the conservative critic for the *Figaro,* summed up Degas's oeuvre by speaking generally about the ugliness of his dancers, especially highlighted that year by the resemblance between the two *Criminal Physiognomies* and the profile of the *Little Fourteen-Year-Old Dancer.*

The fragmentation of Degas's dancers and other female figures was also a feature which the critics remarked upon, using the same vocabulary that had been used to compare the *Olympia* to the crude pictorial language of *Epinal* prints. In 1876 a critic wrote (regarding a *View from the Wings*: "Three or four dancers in the foreground are cut by the frame just above the knee; in the background, one sees a stage set which, not reaching entirely to the floor, reveals the legs and feet whose absence one deplores in the foreground" (*"Trois ou quatre danseuses du premier plan sont coupées par le cadre au dessus du genou; en troisième plan, on voit une toile de fond qui ne descend pas jusqu'à terre et laisse voir les jambes et les pieds dont on regrette l'absence au premier plan"*—Porcheron, *Le Soleil*). Another wrote of Degas's habit of cropping his canvases and "suppressing" feet and legs (*"Un de leurs procédés que chérit aussi M. Degas, c'est de couper la toile n'importe où, de supprimer les pieds ou les jambes"*—Baignères, *Echo universel*).

In 1877, the critics spoke of the "disjointed gestures" of the *café-concert* singers (Ballu, *La Chronique des arts et de la curiosité*). They said that the *Dancers at the Bar* (fig. 13) were "planted on one foot, throwing the other in the public's face" (*"des danseuses en travail, dressées sur un pied et jetant l'autre au nez de public"*—L. G., *La Presse*). And Mantz spoke of "figures cut in two and voluntarily shown in the state of fragments" (the *Ballet Rehearsal on Stage* and the *Dance School*—figs. 3, 5). In 1879, they wrote of the artist's penchant for contortion and dislocation: "Miss Lala [fig. 18], her crimped head violently reversed, her spine stretched in an arc, her legs hanging" (*"sa tête crépue violemment renversée, l'échine tendue en arc, les jambes pendantes"*—Silvestre, *La Vie Moderne*). They wrote of "brutal sightings" (*"visées brutales"*—*Le Temps*), of dismemberment, fragmentation, and complete bodily incoherence. These were Leroy's words that year:

> This artist excels in cutting a figure in two, in making one leg thrust out of the frame, and sometimes two hands as well, as in one rough sketch of a woman, remarkable for its extraordinary tones, truly independent of her thin chest! Not far from that is a black glove, prodigious in intensity, this too by M. Degas. Oh, what a glove, my friends! And that masculine hat, beneath which I found it impossible to discover a head after the most conscientious search: an independent hat as well!
>
> *Cet artiste excelle à couper une figure en deux, à faire sortir une jambe du cadre, les mains quelquefois comme dans une pochade de femme remarquable pour les tons extraordinaires et vraiment indépendants de sa maigre poitrine!—Non loin, toujours de M. Degas, un gant noir prodigieux d'intensité! Ah! quel gant, mes amis!—Et ce chapeau d'homme, sous lequel, après les recherches les plus consciencieuses, il m'a été impossible de trouver une tête: un chapeau vraiment indépendant aussi!* (Leroy, *Charivari*)[41]

Leroy's comments, as usual, were well laced with sarcasm, dotted with flippant puns, such as the one on the title of the group, "indépendants." But again he singled Degas's works out from the others. This is what he

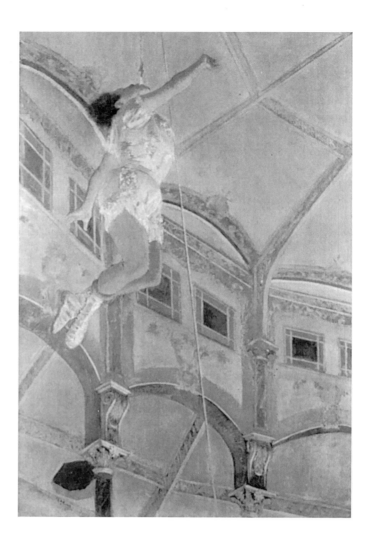

FIG. 18 Degas,
*Miss Lala at the
Cirque Fernando,*
1879

attended to: taken separately and together, Degas's submissions of that
year were particularly dislocated and dismembered, especially the *Dance
School* (fig. 19), with its leg emerging from the right edge of the picture,
the *Singer with the Glove* (fig. 21), her arm and glove "independent" from
her chest, the *Portraits in the Stock Exchange* (possibly Leroy meant the
black hat to refer to the *Stock Exchange*), and *Miss Lala at the Cirque Fer-
nando* (fig. 18)—there is no more dislocated figure than she. Another
critic concurred with this view of Degas's submissions of 1879, focusing
on the two *Dance School* pictures of that year (figs. 19, 20), as well as on
the *Dancer's Loge* (fig. 22):

> To the right, half of a dancer: an ear, a shoulder, left arm and leg.
> To the left, the other half of another dancer: ear, shoulder, right
> arm and leg.

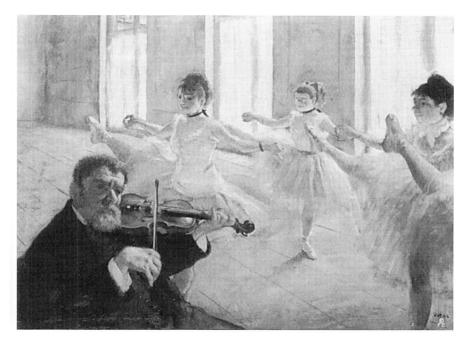

FIG. 19 Degas, *Dance School (The Rehearsal)*, 1879

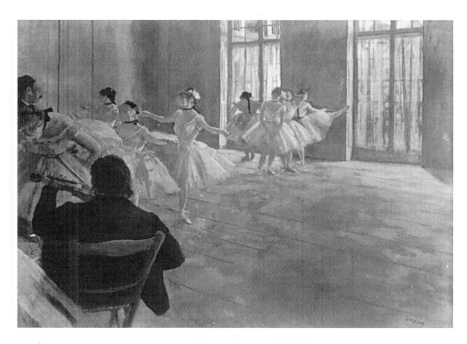

FIG. 20 Degas, *Dance School*, 1876

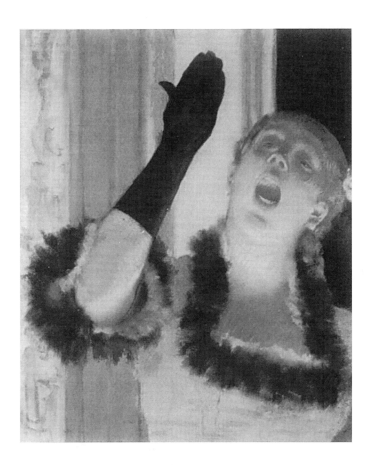

FIG. 21 Degas,
*Singer with the
Glove,* 1878

In the middle, a man whose beard serves as the hair for one of the dancers.

Next, a loge—still of a dancer—one perceives a dress, an arm, a leg, a nose, and a moustache!

. . . It's the subject that one fails to find!

A droite, une moitié de danseuse: oreille, épaule, bras et jambe gauche.

A gauche, autre moitié d'autre danseuse: oreille, épaule, bras et jambe droite.

Au milieu, un monsieur dont la barbe sert de cheveux à une des danseuses.

Ensuite, une loge—toujours de danseuse—on aperçoit une robe, une jambe, un nez et des moustaches!

. . . *c'est le sujet qu'il faut chercher!* (*La Vie Parisienne*) [42]

The critic for *La Vie Parisienne* put the two *Dance School* pictures together, as if they were pendants on the themes of spatial disorientation and corporeal fragmentation, each containing the missing parts of the other, the left half that went with the right, the leg that went with the body, and the front part that went with the back.

FIG. 22 Degas,
Dancer's Loge,
1879

Though the reference to the *Olympia* was a sign of the unacceptable in all of the impressionists' work—a way of linking this group to Manet, and before him to Courbet—it was found to be particularly appropriate to Degas's subjects. The rhetoric of filth and fragmentation was most consistently applied to his Baudelairean themes, so unlike the landscape world of his cohorts. To these critics, this rhetoric signaled a deliberately illegible world of corporeality, a physiognomics of lower-class ugliness, and a desire to "épater le bourgeois" that reminded them strongly of the confrontational techniques of Realism.[43]

There was another very important way in which Degas's images of dancers and other women were linked, by supportive and sarcastic critics alike, to the thematics of Realism: they were thought to be images of

work. Degas's dancers, as well as his laundresses and singers, were frequently described as professional women, whose gestures were those of work, and whose bodies were deformed by labor. The following are a few examples of this: "In a precise, exact way he draws all the contortions of legs and dislocations of hips and feet required by the difficult exercise of dancing" (*"Il dessine d'une façon précise, exacte tous les contournements de jambes et les dislocations de la hanche et du pied qu'exige le dur exercice de la danse"*—Chesneau, *Paris Journal*, 1874); "a beauty completely professional" (*cette beauté toute professionelle"*—Burty, *La République française*, 1874);[44] "His ironic wit will diminish him, if he insists on hanging around those dance classes at the Opera, which furnish him with baroque silhouettes, but also with types singularly deformed by their work" (*Son esprit ironique le diminuera, s'il s'attarde à ces cours de danse à l'Opéra qui lui fournissent des silhouettes baroques, mais des types singulièrement déformés par le travail"*—Burty, *La République française*, 1880). Degas's skill as a draughtsman, his "cruelty," and his emphasis on corporeal deformation were all connected to the Realist theme of *work*.

Yet the critics who were disposed to see Degas's female figures as Realist images of work were puzzled by his dancers. Indeed they are hardly Courbet's laborers or Millet's peasants. Most of the time they are not working at all. More often they are waiting and idling, more absorbed in themselves than in their tasks, and in occupations tangential to their work. (In this they are like Degas's brothers in the *Cotton Office*.) In the *Ballet Rehearsal on Stage* pictures, the *Dance Classes,* and the *Dance Schools*—in almost all of the dance pictures exhibited between 1874 and 1886—there are only small groups of dancers actually dancing, and they are invariably surrounded, like the two men at the cotton table in the *Cotton Office,* by a crowd of very different occupations: stretching, yawning, scratching, looking distractedly around.

The critics were very much preoccupied with what Degas's dancers and other professional women were *not*. In their reviews, classical themes are matched to realist subjects, classical conceptions to realist perceptions. In 1874 Burty wrote about Degas's laundresses of that year this way:

> Will not M. Degas, in his hour, be a classic? No one could translate with a surer pencil the feeling of modern elegance. . . . If he painted Nausicaa, instead of pale, nervous laundresses of fine linen, one would recognize in him a great sense of harmony. In reality, no one has yet painted, as he has, the portrait of the dancer, of the coryphée, . . . of this completely professional beauty whose many faces make up the general beauty of a society.
>
> *M. Degas ne serait-il, à son heure, une classique? On ne saurait traduire d'un crayon plus sûr le sentiment des élégances modernes . . . S'il peignait Nausicaa, au lieu de ses nerveuses et pâles blanchisseuses de fin, on lui reconnaîtrait un grand sens de l'harmonie. Personne, en réalité, n'a encore fait, comme lui, le portrait de la danseuse, de la coryphée. . . . de cette beauté*

toute professionelle dont les faces multiples composent la beauté générale d'une société. (Burty, *La République française*)

More positively than others, Burty claimed that Degas's "professional beauties" were *classic*. In 1879 Silvestre wrote about Degas's late submissions in a second installment devoted largely to the official art of the Salon of that year and, not surprisingly in this context, he used the conceit of contrasting Degas's figures to classical characters:

It is hardly Menalchus or Tityrus that one should use as a guide in this case. Those naive shepherds knew nothing of the Fernando Circus and miss Lala (fig. 18). NON OMNIA POSSUMUS OMNES. Lycoris and Galatea seem to me to be ample consolation for their ignorance. Miss Lala is in no way reminiscent of those virgins espied through the willows.

Ce n'est point Ménalque ou Tityre qu'il faut prendre ici pour guide. Il a manqué à ces bergers naïfs de connaître le Cirque Fernando et Miss Lala. NON OMNIA POSSUMUS OMNES. Lycoris et Galatée me semblent des consolations forts suffisantes à leur ignorance. Miss Lala ne rappelle pas non plus ces vierges entrevues à travers les saules. (Silvestre, *La Vie Moderne*)

Another example of this is to be found in the description of the *Little Fourteen-Year-Old Dancer* (fig. 17) written by one of Degas's patrons, Charles Ephrussi, in 1881.

She is shown half-undressed, standing in her working clothes, tired and worn out, stretching her exhausted limbs, pulling her arms behind her back; her head is fine and well felt, despite her frightful ugliness, with a vulgar snub nose, a protuberant mouth, and a forehead hidden behind hair falling almost all the way over small, half-closed eyes. See the nervous curvature of her legs beneath her pleated silk maillot, the solidly planted feet enclosed in second hand shoes, the bony torso, as supple as steel. That, certainly, is not the Terpsichore of classical lines—it is, rather, the Opera *rat* in her modern expression, learning her métier, with all her low nature and her stock of base instincts and vicious inclinations.

Elle se présente en demi-nature, debout dans son vêtement de travail, lasse et fatiguée, détendant ses membres harassés, étirant les bras sur le dos; la tête fine et sentée, malgré son épouvantable laideur, avec un nez vulgairement retroussé, une bouche saillante et un front caché par des cheveux qui tombent presque sur des petits yeux à demi-fermés. Voyez, sous un maillot de soie à plis menus, la courbure nerveuse des jambes, les solides attaches des pieds enfermés dans des souliers usés, le torse osseux et souple comme l'acier. Ce n'est point là, certes, la Terpsichore aux lignes classiques, c'est le rat d'Opéra dans son expression moderne, apprenant son métier, avec toute sa nature et son stock de mauvais instincts et de penchants vicieux. (Ephrussi, *Chronique des arts et de la curiosité*) [45]

Silvestre and Ephrussi were not content with classifying Degas's working women under the rubric of Realism—they insisted on writing about them as negative versions of classical muses, deities, and mythical fig-

ures. Though it was fairly common critical practice to juxtapose modern-life subjects to traditional ones, there is something particularly pointed about that practice in the case of Degas criticism. Degas's images seemed to remind critics of classical themes and figures, in a way that Manet's direct art-historical quotes of the tradition never had. It was as if his pictures carried that with them, as their other half. (The artist himself had a penchant for combining the vocabularies of realism and classicism in his frequent complaints about the state of his vocation.)

But the most extended variation on the realism-cum-classicism theme is to be found back in Marc de Montifaud's review of 1874, where she calls Degas's ballerinas "Déesses," before going on to describe them as *rats:*

> If M. Renoir only painted one dancer, M. Degas has introduced a whole seraglio into the Exhibition, and once more the Goddesses of the Opera surpass the great ladies of fashion. The art of choreography, which serves to display an array of rounded contours, offers an attractive revelation to him who lovingly studies the undulations of hips and the serpentine curves of movement. The *Dance Class* (fig. 1) is a fine, profound study, from which emerges that which one would never encounter in the works of certain genre painters who would blush to put undraped figures in a canvas of only a few inches' size: the study of woman in all her opulent nudity, of her elegant or thin anatomical lines. M. Degas shows us, with equally witty verve, piercing, carved-out shoulder blades, and rebounding hamstrings beneath which are attached stockings so tightly pulled and "stretched like a drum" that the leg enclosed in that mesh of rose silk recalls a typically Gallic quote. It concerns that genre of seduction which, it appears, certain women used often to practice: "If it is good to contemplate their lovely legs and calves, and their charming slippers so tight and well-fitted, which they know so well how to display, and also when they have their dresses made shorter—*à la nymphale*—in order to tread more lightly, all of which tempts and warms even the most cold and austere." M. Degas practices this costume *à la nymphale* with a mastery that Worth himself would not disdain.

> *Si M. Renoir n'a peint qu'une danseuse, M. Degas en a introduit tout un sérail à l'Exposition, cette fois encore les Déesses de l'Opéra primeront les grandes dames. La chorégraphie, qui met en dehors toutes les rondeurs plastiques, offre une attrayante révélation à celui qui étudie avec amour les ondulations des hanches, et les courbes serpentines des mouvements. Aussi la* Classe de danse *est-elle une fine et profonde étude, où ressort ce qu'on ne rencontrera jamais chez certains peintres de genre qui rougiraient de mettre dans une toile de quelques pouces des figures non drapées: l'étude de la femme dans ses nudités opulentes, dans ses lignes anatomiques élégantes ou grêles. M. Degas montre avec une même verve spirituelle des omoplates perçantes et decoupées, et des jarrets rebondissants sous lesquels s'attache un bas si bien tiré "et tendu comme un tambourin," que la jambe enfermée entre ses mailles de soie rose rappelle une citation toute gauloise. Il s'agit de ce genre de séduction*

dont, parait-il, certaines dames usaient fort largement. "S'il faisoit beau voir et contempler leures belles jambes et grèves, par leurs gentilles chaussures tant bien tirées et accomodées, comme elles scavent très bien faire et aussi qu'elles n'estoient fait faire leurs robbes plus courtes à la nymphale, afin de plus légèrement marcher, ce qui tentoit et eschauffoit les plus refroidis et mortifiés." M. Degas pratique ce costume à la nymphale avec une supériorité que ne désavouerait Worth. (Montifaud, *L'Artiste*)

Montifaud's review was an extreme case of seeing Degas's dancers as their mythical opposites. She described the dancers in *The Dancing Class* (fig. 1) both as genre figures and as classical nudes. Though her review includes one reference to the more commonly perceived deformity of the dancers, it is remarkable for the way in which the sharp detail of a jutting shoulder blade is immediately couched and submerged in a rhetoric of curvature and abundance. It is also remarkable for the way in which her description of the dancers' dress becomes an essay on the theme of undress and nudity. Montifaud did not appear to think of the dancers as women at work. Instead, she wrote about them as a series of erotica.

In this, Montifaud's appeared to be the opposite of the more typical critical response. The other critics spoke of "dancers with angular elbows" (this was Mantz, in 1880), of their dirty, unattractive, incoherent bodies, of the cruelties and brutalities of the artist's vision, of the violence of his perspectives, of the dancers' physical assault on the viewer. Montifaud described them otherwise. Instead of bodies deformed by work and fragmented by vision, she spoke of bodies present for erotic inspection. Instead of legs thrown in the face, she wrote of half-glimpsed, nicely turned limbs, half-disclosed by, half-enclosed in slippers, silk stockings, and short skirts. Where the other critics seemed to deny the erotic interest of the skinny/stocky figures of the dancers with their talk of visual violence and bodily assault, their discussion of empty, detached articles of clothing and disconnected, dispossessed, thrust-out limbs, Montifaud asserted it by speaking of limbs emerging and retreating, bodies caught up in clothing (which to her suggested nudity), inflated and stretched by corporeal content. Only in a negative sense is this a good description of Degas's dance pictures, for his "costume à la nymphale" usually reveals what the other critics said it did: fragmented bodies, angular joints, akimbo arms, short, stocky legs and planted feet, unlovely faces, features not clearly female and off-colored skin. Despite the delicacy of the little Biedermeyer *Dancing Class* of 1874, the submissions of that first year were no exceptions to this.

The value of Montifaud's discussion of Degas's dancers lies in her foregrounding of the issue of eroticism. She explicitly stated what other critics alluded to only negatively, that nudity, impropriety, sexual innuendo, states of dress and undress were all part of the content of the dance pictures. As Ephrussi later suggested about the *Little Fourteen-Year-Old Dancer* with her stiff corset, limp skirt, incongruous hair ribbon, and

her sagging tights (the opposite of the sexy silk stockings evoked by Montifaud), these dancers were read as half-dressed women ("She is *half-undressed,* standing in her work clothes"), and their ballet dress, that "costume à la nymphale," was perceived as a state of undress.

The dancers' state of *déshabillé* is a fairly evident feature of most of the dance pictures. It is seen in the bare backs, chests, arms and legs, expanses of calf, glimpses of cleavage, and exposed shoulder blades (serving as the reverse image of breasts, for example, in the *Dance Examination* [fig. 23], a variation on the Orsay *Dance Class* of 1874 [fig. 24], where the dancer with her back to us in one is turned around to display cleavage and bodice in the other). It is also seen in the pink and flesh-colored tights glimpsed through short white tutus whose tones are barely distinguishable from the tones of the dancers' skin—the tonal play of flesh against white had long been associated with the nude, from draped, classical figures like those of Ingres, to Manet's *Olympia* (fig. 14). Nudity is also suggested, as Montifaud indicated, in the ubiquitous satin ballet slippers and ballet *maillots* of the dancers—reminiscent of corsets and petticoats and other boudoir apparel. Black neck bands and cake-icing sashes emphasize the whiteness—the "nakedness"—of the dancers, as *Olympia*'s neck band had done for her. (Witness, for example, *The Star* of 1878—fig. 25.)

It is clear from Degas's preoccupation with laundering and millinery, the nude and the boudoir, that dressing and undressing, clothing and nudity were important themes of his. His dancers are likewise preoccupied, consistently involved with shoe ties and shoulder straps. Constantly correcting articles of dress that have come undone, perpetually irritated with their clothing, they repeatedly call attention to a thematics of dressing and undressing. It is clear that the critics, whether positively and explicitly, as in Montifaud's case, or negatively and implicitly, as in the case of most other critics, thought that these indications of the dancers' *déshabillé* also constituted a thematics of impropriety.[46] Less clearly, but equally persistently, they tended to think that it had something to do with the dancers' sexual status. And this brings us back to the thematics of work—the real profession of these working-class *déesses,* as critics like Mantz and Montifaud suggested in their different ways, was that of the *fille.* Indeed, *all* of the female professionals depicted by Degas—from his laundresses and milliners to his *café-concert* singers and ballet dancers—were associated with clandestine prostitution.[47]

Mantz, for one, was explicit about the connection in his Baudelairean way. So was Montifaud, in her *galante* way. Others were less explicit—they made their connections through innuendo. There was one instance when Degas himself connected the gestures of the *coulisses* to the sex market of the street in his own typically clandestine manner. In 1877 he showed the *Dance School* (fig. 3) together with the *Women in Front of the Café during the Evening* (fig. 26), slyly inserting the same *canaille* gesture into the margins of both, linking Opera dancer to Montmartre prostitute,

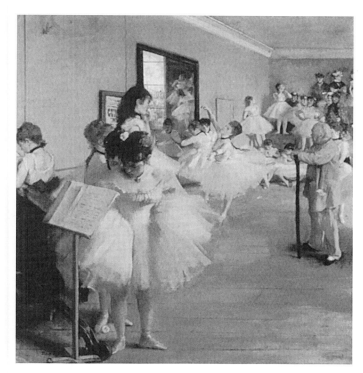

FIG. 23 Degas,
*Dance Examination
(The Dance Class)*,
1874

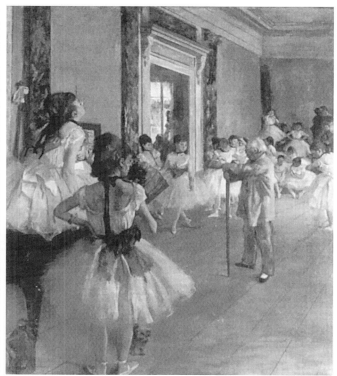

FIG. 24 Degas,
Dance Class,
1874

FIG. 25 Degas,
The Star, 1878

each with her thumbnail against her teeth. In different ways, the critics
noticed this sort of gesture, and made the connection they were invited to
make. The lifted, thrust-out leg characteristic of the balletic movements
depicted by Degas, and zeroed in on by critics, like those of the *Dancers at
the Bar* of 1877 and the *Dance School* paintings of 1879 (figs. 13, 19, 20)—
along with the glimpses of underclothing that sometimes accompany
those movements, as in the *Dancers at the Bar* and in a *Prima Ballerina* of
1878 (fig. 27)—seemed to be read as roughly equivalent to the lewd ges-
tures made by the *café-concert* singers in others of Degas's pictures, defin-
ing the dancer as a figure of the street and as an image of working-class
licentiousness. When the *Dancers at the Bar* appeared together with the
café-concerts in 1877, the critics motioned to the "foot thrown in the pub-
lic's face," and then they pointed to the "geste canaille" of the *Women in
Front of the Café.* The thrust-out leg of the *Dance School* (fig. 19) and the
thrust-up arm of the *Singer with the Glove* (fig. 21) of 1879 were selected
and connected in the mind of at least one critic—the one who wrote for

Chapter 1

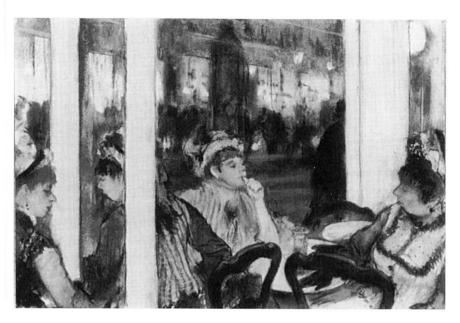

FIG. 26 Degas, *Women in Front of the Cafe during the Evening,* 1877

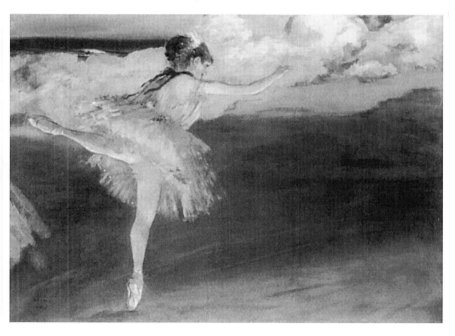

FIG. 27 Degas, *Prima Ballerina (The Star: Dancer on Point),* 1878

La Vie parisienne, that journal which so often combined ladies' fashions with gentlemen's erotica.

Degas, the Odd Man Out

In general, the fragmentation and incoherence of the dancers' bodies were taken as a language of licentiousness which worked through innuendo and furtively suggested connections between pictures. The imagery of anatomical dishevelment and bodies that wouldn't stay put together received implicitly sexual readings—the accuracy of which Degas himself would indicate in private, in his more explicitly bordello monotypes. The imagery of disjointed parts touching other disjointed parts with which they should not be in contact (emphasized in the submissions of 1879) was seen this way, as was the inclusion of male parts, isolated mustachios, tall phallic hats, and violin bows, amidst the melée of female limbs, picked up and focused on by men like Leroy and the critic for *La Vie parisienne* in 1879. The important difference between their reviews and Montifaud's was that she made this innuendo into her principal theme, subtly underlining the impropriety of Degas's imagery of the body by her mismatching of pictorial, social, and critical categories—genre painting with the nude, Opera *rats* with ladies of high fashion, realism with classicism—and by her admission of that piercing shoulder blade into the midst of her discussion of classical curvature and rococo games of titillation.

So far I have taken the language of Montifaud's review at face value, as if she saw it the way she said it. But the tone of her article is ironic, as if written in male drag, from the point of view of Mantz's "gros monsieur," and more than half tongue-in-cheek. She must have been aware of affecting a rococo style at variance with the imagery—her reference to "a typically Gallic quote" would seem to indicate that.

Montifaud's style was compatible with a certain soft-porn literary genre associated with the Opera *coulisses* which thrived at the end of the nineteenth century. It consisted of insiders' intimate accounts of the backstage world and coy anecdotes about the private lives of dancers, told by old aristocratic and *haut bourgeois* roués: marked, as Montifaud's review was, by caricatured gallantries, evocations of the *ancien régime*— particularly of the eighteenth century—and the transformation of those "suspect wings," as Mantz termed them, into mythical regions full of "déesses" and "féeries."[48] Accompanying this literature was a multitude of illustrative imagery depicting delicate-featured, black-suited *galants* dallying elegantly amidst bevies of gauzy-winged, tiny-footed, and voluptuously proportioned dancers (fig. 28). Together the literature and the imagery provided the *coulisses* with a mythology of aristocratic dalliance, classical femininity, and etherealized, rococo eroticism.

The literature of the *coulisses* was, not by accident, a covert version of another literary genre which combined soft porn with soft sociology— the literature on prostitution.[49] For it is fairly well known that the *coulisses* provided male Opera subscribers with a highly exclusive bordello. Admission to the backstage spaces of the Opera (the wings, the foyer, and the rehearsal rooms) was granted only to a select few: moneyed, high-

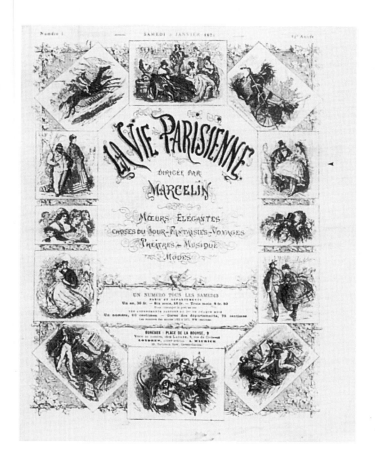

FIG. 28
A. Marcelin,
La Vie Parisienne,
3 January 1874

society men of either *haut bourgeois* or aristocratic backgound, who held
annual *abonnements* to the Opera, and who regularly sat in the high-
priced stalls and seats close to the orchestra or in the controversial *loges-
de-scène.* Access to the *coulisses* and *loges-de-scène,* the dressing rooms of
the dancers, to the viewing of rehearsals, dance examinations, and actual
performances from behind the wings, and to the dancers themselves, was
the privilege of these men.[50] In literature and in reality, the *coulisses* stood
for privilege of access, something like the eighteenth-century privilege of
presence at a woman's *toilette:* the word was a sign for a particular kind of
privileged inside information, and for the right to infiltrate, particularly
into the secrets, artifices, and métiers of the female sex.[51] It was also a sign
for the clandestine: for the acquisition of clandestine knowledge and the
enjoyment of clandestine pleasures. It usually indicated the demimonde,
and implied that the demimonde was a bordello for the privileged. With-
out a doubt it indicated titillation and covert sexuality. The word sig-
naled both all that the literature of the *coulisses* covered and masked—its
overt and its covert *subject matter*—and the *style* of the masquerade. So
Montifaud's particular combination of realism and classicism and her

ironic rococo style were both true to the usage of the *coulisses* as a word and proper to its world, as well as to Degas's images.

The mythology of the *coulisses* is implicated in many of Degas's pictures. Not only did he take his subject matter directly from the *coulisses,* stressing the theme of dress and undress, developing a subtle corporeal language of impropriety and licentiousness to go with it, and combining the gestures of profession with those of sexual innuendo, he also seemed to derive his style of seeing and composing from the literature of the *coulisses.* His behind-the-scenes vantage points, his keyhole visual mode; his attraction to edges, blocked, fragmented spaces, and cornered relationships; and his obsession with the covert and the clandestine all point to the social and sexual meanings of the *coulisses* as promoted in the literature and suggested in the language of Montifaud's review. The secrecy and the privilege that attached to the *coulisses* were indicated in his images in the self-effacing figures of those black-suited men proliferating throughout them, little more than formless shadows, hovering at the edges of untraversable spaces (as in *The Star* and the *Ballet Rehearsal*); in the headless hats and bodiless mustaches referred to by critics when they wrote of the *café-concert* pictures and the *Dancer's Loge* of 1879 (fig. 22). Secrecy and privilege were indicated also in the cornered *female* viewers of the contemporary *Woman with the Fan* series, as in *The Ballet* (fig. 29); the voyeuristic viewing stressed in the *Woman with the Opera Glass* series (fig. 30);

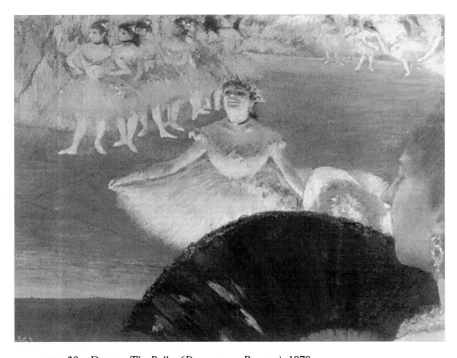

FIG. 29 Degas, *The Ballet (Danseuse au Bouquet),* 1878

Chapter 1

FIG. 30 Degas, *Woman with the Opera Glass,* 1869–72

and the wings themselves, looming up like profiles and door edges in many of the *coulisses* pictures, at once blocking and emphasizing their margins, at once marking the presence of the viewer, and declaring the clandestine quality of his viewing. The neo-rococo *galanterie* that marked the literature of the *coulisses* also found its equivalent in the factural style of Degas's dance pictures—most obviously in the pretty surfaces of his preferred medium, pastel, associated by the Goncourt brothers with the Baudelairean discourse on cosmetics and face paint, and in general with

Degas, the Odd Man Out

the eighteenth century and the rococo: "The impasto of pastel gives . . . the whole head the transparency of flesh . . . a dazzling tint . . . of red hatchings, cheeks brought to life in their soft vermilion with two or three grains of carmine, flickering flecks of crumbly crayon against the blended pastel, some light touches of crayon of another color, which turn and play in the direction of the muscles, interrupting and diversifying the general tone, giving it the uneven and nuanced color of flesh" (*"La pâte du pastel . . . donne à toute la tête la transparence de la chair . . . un teint éblouissant . . . de petites hachures rouges, la pommette des joues avivée dans leur doux vermillon avec deux ou trois égrenures de carmin, des tremblotements de crayon friable sur le fondu du pastel, des jeux de crayon d'un autre couleur qui tournent et jouent dans le sens des muscles, brisant, diversifiant la teinte générale, lui donnant la coloration rompue et nuancée de la chair"*—Edmond and Jules de Goncourt on Maurice Quentin de la Tour, *L'Art du dix-huitième siècle et autres textes sur l'art:* 106–7.[52] Degas himself collected eighteenth-century pastels, among which de la Tour's appeared to be his favorites.[53] Thus the references made by Montifaud and others to the figures and themes of classicism are based in the rococo-cum-realist resonances of the images themselves. So the *coulisses*-literature inflection of the critics' identification of Degas's work with an imagery of labor and profession, of their perception of him as a realist oddity, and of their constant mixing of the vocabularies of realism and classicism were all quite accurate to the images. Rather more than the Realism and labor imagery of that figure of 1848, Courbet, they meant the secret, aristocratizing realism of the *coulisses* and the professional physiognomics of undercover prostitution. This was the meaning, for them, of Degas's realist attachment to "work": Montifaud's review, with all its seeming inappropriateness, helps to bring this meaning to the surface.

Degas was familiar with the world of the *coulisses* in reality as well as in his imagery. He frequented the Opera, held an *abonnement,* and sometimes gained access to rehersals and examinations. Occasionally he used his own influence to further the careers of individual dancers.[54] There is no evidence that the dancers were anything more to him than painting subjects—his sexual life was a well-guarded secret—but in every other way, he himself was one of Mantz's "gros messieurs." He was intimate with the men, one of whom was his close friend Ludovic Halévy, who moved at the center of that world. (Halévy was a librettist, author of popular farces, well-known socialite, salon host, and man of influence in the world of the Opera—he and his collaborator, Henri Meilhac, are mentioned repeatedly by one of the most important aristophile society-page writers of the Third Republic, Arthur Meyer.[55]) Degas's *Portraits of Friends on Stage* of 1879 (fig. 12) bears witness not only to his friendship with other "gros messieurs" like Halévy, Ernest May, and Boulanger-Cavé, but also to his own position within the world of the *coulissses.*

Degas's famous *plaisanteries* were also very much in line with the language of the *coulisses*. His ironic mannerisms and exaggerated *ancien régime politesses* possessed what he himself called "an odor of old-time gallantry" (*"une odeur de galanterie vieux-jeu qui m'a toujours, vous le savez, été personnelle"*—*Lettres de Degas,* no. 16 of 23 October 1884; to Bartholomé, p. 92).[56] Such is the tone of one of his most famous *mots:* "Even my heart is rather artificial. The dancers have sewn it in a bag of pink satin, a somewhat faded pink satin, like their ballet slippers" (*"Et même ce coeur a de l'artificiel. Les danseuses l'ont cousu dans un sac de satin rose, du satin rose un peu fané, comme leurs chaussons de danse"*—*Lettres de Degas,* no. 90 of 17 January 1886; to Bartholomé, pp. 117–19). It is also characteristic of many of his sonnets. The following is one of the best examples of this exaggerated rococo gallantry:

> She dances while dying as if around a reed,
> From a flute where the sad wind of Weber plays,
> The ribbon of her steps winds, joins and binds,
> Her body sinks and falls in the gesture of a bird.
>
> Sigh the violins. Fresh from the blue of the water
> Silvana comes, and there, curious, gasps;
> The joy of reviving, and love in her cheek,
> In her eyes, in her breasts, in all of her being renewed . . .
>
> And her feet of satin embroider like the needle
> Patterns of pleasure. The capering girl
> Tries my poor eyes as they try to pursue her.
>
> Because of a trifle, as always, the lovely mystery ceases.
> In jumping she draws up her legs overmuch,
> It's the jump of a frog in the ponds of Cythera.

> *Elle danse en mourant comme autour d'un roseau,*
> *D'une flute ou le vent triste de Weber joue,*
> *Le ruban de ses pas s'entortille et se noue,*
> *Son corps s'affaise et tombe en un geste d'oiseau.*
>
> *Sifflent les violons. Fraîche, des bleu de l'eau*
> *Silvana vient, et là, curieuse, s'ébroue;*
> *Le bonheur de revivre, et l'amour sur sa joue,*
> *Sur ses yeux, sur ses seins, sur tout l'être nouveau . . .*
>
> *Et ces pieds de satin brodent comme l'aiguille*
> *Des dessins de plaisir. La capricante fille*
> *Use mes pauvres yeux à la suivre peinant.*
>
> *D'un rien, comme toujours, cesse le beau mystère.*
> *Elle retire trop les jambes en sautant,*
> *C'est un saut de grenouille aux mares de Cythère.*
> (*Huit Sonnets d'Edgar Degas:* 43)[57]

Degas must have been familiar as well with the literature and imagery of the *coulisses.* Certainly he was aware of the *genre* pictures by painters such as Jean Béraud (fig. 31), and the caricatural work of people such as

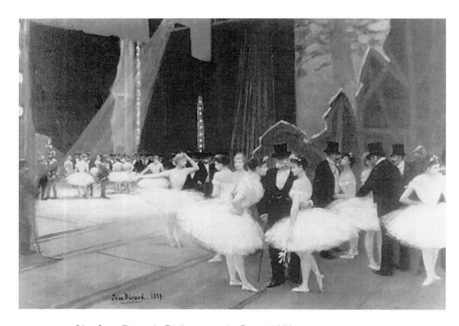

FIG. 31 Jean Béraud, *Backstage at the Opera,* 1889

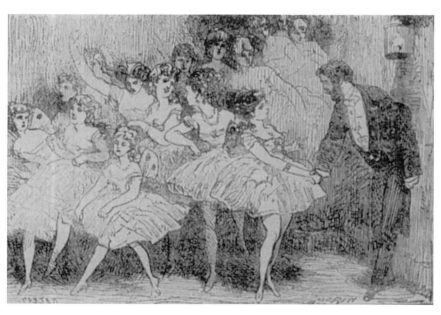

FIG. 32 Edmond Morin, frontispiece to Ludovic Halévy, *M. Cardinal,* 1871

LES PETITES CARDINAL

FIG. 33
Henri Maigrot
(alias Henriot),
frontispiece to
Ludovic Halévy,
*Les Petites
Cardinal,* 1880

his own principal follower, Forain. Moreover, the set of stories by his friend Halévy, grouped together under the title *La Famille Cardinal,* was a good example of the literature, and the sets of illustrations by Edmond Morin and Henriot that were published with the stories were exemplary of the illustrative imagery associated with the *coulisses* (figs. 32, 33).

Like the greater part of the *coulisses* literature, Halévy's Cardinal stories, *M. Cardinal, Mme Cardinal,* and *Les Petites Cardinal,* were about the love lives of a couple of dancers at the Paris Opera, Pauline and Virginie Cardinal. A series of tacky, kitsch anecdotes that took as their point of departure the lightly veiled pimping, prostitution, and social-climbing that was supposed to go on in the *coulisses,* the Cardinal stories belong both to the neo-rococo tradition of *coulisses* stories and to a genre of pseudo-realist tale written from the *haut bourgeois* vantage point. In the Cardinal stories, the upper-class *raconteur* appears throughout; they are told entirely from his man-of-the-world point of view. The stories affirm Halévy's privileged position: they take the form of inarticulate bits of news about the Cardinal girls told to Halévy by Mme Cardinal, and parts

of badly written letters from Mme Cardinal to one of her backstage friends, passed on to Halévy, who reads them to us, presumably his upper class confidantes, all the while mocking the letters and correcting their grammar. Thus, as with the literature of the *coulisses* in general, the Cardinal stories confirm the author's position in Parisian society—by affirming his access to the language, sexual secrets, and private life of the demimonde, his right to infiltrate it, and his ability to read it. They are also preoccupied with the act of storytelling itself. Written in a highly fragmentary style, anecdotal and inconsequential in the extreme, employing a deliberately sparse, inarticulate vocabulary, they are realist texts constructed in antinarrative, even antidescriptive terms. This peculiar mode served as an index of *haut bourgeois* position, and of the physiognomic skill and *raconteur*'s style attaching to that position. Effectively, Ludovic Halévy's stories combined the neo-rococo *coulisses* genre with the style of realist tales about the demimonde, joining the affectation of *galanterie* to the semidocumentary tone of the sociological literature on prostitution of the period. They made more direct reference to the prostitutional literature than was normally the case in the *coulisses* accounts, more firmly tying that discourse to the *coulisses* and to the privileges of the *gros monsieur.*

Degas knew of Halévy's work—in the early 1880s he himself undertook to do a series of illustrations for the stories.[58] Though Halévy rejected these images out of hand, they are worth considering, for they provide the most direct visual evidence of Degas's involvement in the literature and imagery of the *coulisses*. Whereas the *Famille Cardinal* illustrations by Morin and Henriot kept Halévy's more realist stories attached to the neo-rococo mode, providing the *galant* counterpart to Halévy's slumming verbal sketches of the demimonde by stressing the easy sexual and social access of the *haut bourgeois* male to the world of the *coulisses,* and remaining well within the bounds of the finicky, neo-rococo illustration conventions of the genre, this was not the nature of Degas's illustrations. Instead, his monotypes focus on the least significant, least narrational incidents in Halévy's stories. The most important themes of the Cardinal stories hinge on Virginie Cardinal's affairs, and her liaison with an Italian nobleman, the Marquis Cavalcanti; Pauline Cardinal's relationship with an official in MacMahon's government; and Papa Cardinal's involvement in Parisian and provincial politics. Degas illustrated, albeit somewhat elliptically, some of the incidents related to these events— such as *M. Cardinal Writing a Letter* to one of Virginie's lovers; an argument between M. Cardinal and the Marquis Cavalcanti, in the *Famous Good Friday Dinner;* and *Mme Cardinal Standing in the Street,* M. Cardinal having gone off to join a Communard parade.[59] But for the most part, Degas concentrated on a repetitive sequence of generalized images of dancers and their backstage admirers (figs. 34, 35), and he replicated the text's emphasis on the *raconteur* in at least twelve images of Halévy back-

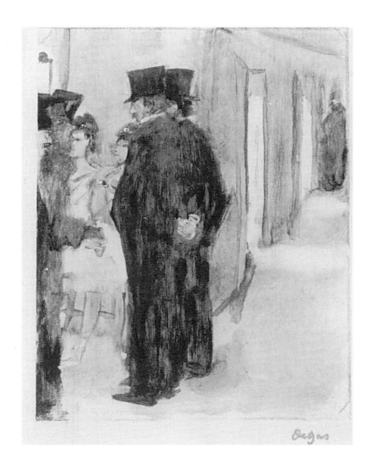

FIG. 34 Degas,
*Pauline and Virginie
Conversing with
Admirers,* 1880–83

FIG. 35 Degas,
Talking to Admirers,
1880–83

FIG. 36 Degas, *Ludovic Halévy Finds Mme Cardinal in the Dressing Room,*
1880–83

stage, talking or listening to Mme Cardinal (figs. 36–38). His images
keep step with the text in a nonspecific way—through sheer number, and
through the antinarrational device of repetition. Unlike Morin's and
Henriot's imagery, Degas's illustrations are messy *barbouillages,* more in
line with his own private brothel monotypes, executed a year or two be-
fore, than with the more common journalistic type of *coulisses* imagery.
They are explicit and caricatural, yet also so heavyhanded and slapdash

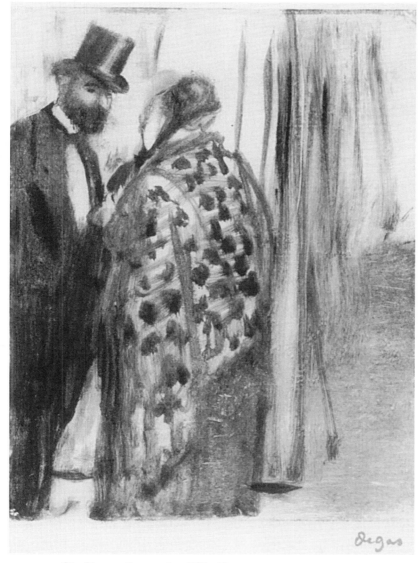

FIG. 37 Degas, *Conversation,* 1880–83

as to frequently make any descriptive information almost unreadable—witness, for example, the scribbled, smudged, sexually explicit rendering of the dancer in *Mme Cardinal Scolding an Admirer* (fig. 39).

Degas's *Famille Cardinal* monotypes also emphasize, as their pastel counterparts rarely do, the transactions carried out between *abonnés* and dancers, as well as the ugliness and vulgarity of the dancers' physiognomies—these are not "féeries," but stocky girls of the street, the little, ugly "prolétariat de l'amour" engaged in the work of producing the sex-

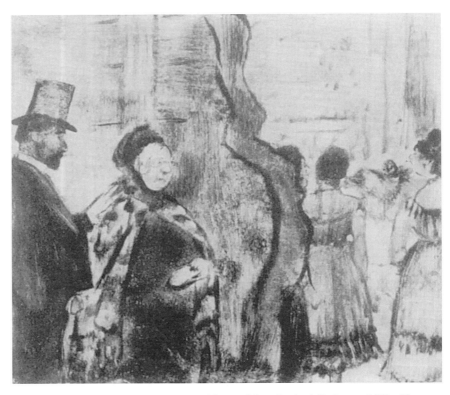

FIG. 38 Degas, *Ludovic Halévy Meeting Mme Cardinal Backstage,* 1880–83

ual myth of the *coulisses*—there is no *galante* pastel surface to mitigate that fact. The connection, in these images, to prostitutional imagery is made in a particularly blunt way—it is even more overt than the connection to the world of the prostitute established in Halévy's stories, and more overt by far than Degas's dancer pastels. Indeed, following immediately on the heels of, and visually resembling his deliberately crude brothel monotypes—and done in the medium of the print, which for Degas was the prime medium of modern life and the demimonde ("black-and-white" was the medium of what his friends called his "social chiaroscuro")[60]—the Cardinal series constitute an important link between the explicitness of the prostitute prints and the innuendo of the dance pictures. The *Famille Cardinal* monotypes constitute a kind of private interface between the world of the *rat/féerie* and that of the *fille,* the missing link between the *galanterie* of the *coulisses* genre and the realism of the demimonde mode. They also firmly establish Degas's ties to the domain of the *coulisses* and its contemporary meanings.

*

As I have said, Degas's *Stock Exchange* bears a striking stylistic resemblance to his monotypes. It is also a picture which establishes a link

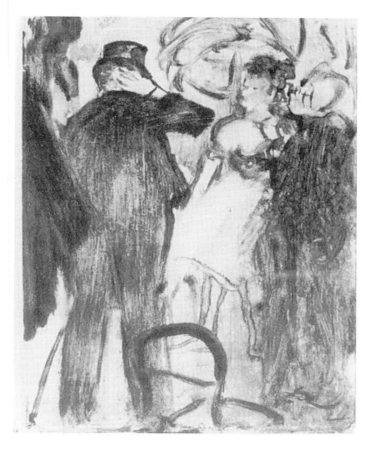

FIG. 39 Degas, *Mme Cardinal Scolding an Admirer,* 1880–83

between the domain of the *coulisses* and that of the marketplace. And this brings us back to the themes of the *Cotton Office* and the questions raised around Degas's involvement in the impressionist shows—his pastels *and* his monotypes are as much about a kind of marketplace as they are about work and professional identity, realism, and Degas's difference from the impressionist group. For as the *coulisses* genre makes clear, with its covert references to the literature on prostitution, the *coulisses,* like the brothel, was a sex market, and the work of the dancers was the selling of sex according to certain codes. (Just as the *gros messieurs* who appear in both the pastels and the monotypes were the clients, the mothers of the the the dancers who figure largely in the Cardinal monotypes and who make their appearance in many of the pastels were standard and well-understood images of the entrepreneurs of sex—the equivalent of the brothel madams who are found in Degas's prostitute monotypes.) And since the *coulisses,* like clandestine prostitution, were supposed to represent a black market for sex, Degas's *coulisses* images tie the theme of the marketplace to that of criminality just as much as his *Stock Exchange* does. (The rhetoric of vice and viciousness found in Mantz's and others' reviews exhibits

Degas, the Odd Man Out

an awareness of this, as does Degas's own engagement in overtly criminal physiognomies.) And like the *Cotton Office* and the *Stock Exchange*, they identify the project of realism and the theme of work with a program of privatization and gentrification. But now the gentleman *amateur* (the season-ticket holder watching rehearsals and performances from the sidelines is nothing other than an *amateur* of dance and dancers) is represented as the *gros monsieur*, disreputable as well as privileged and private. And the private practice of work, trade, and reception becomes a kind of criminal practice, so private that it is now defined as sexual more than social. It is in this way that Degas's odd, singular pictures and the series in which he specialized work together.

The equation seems to be this: professionalism defined by commerciality is a kind of prostitution; aestheticism, like the *galanterie* of the *coulisses* literature and the *coulisses* themselves, is merely a cover for that fact. Through a series of connections between exhibited and private pictures, Degas linked the business of making, selling, and buying art to the artificing and marketing of sex, idiosyncratically illustrating the modern sense that to make for and sell to a public is to "prostitute" one's art and one's self, and representing the equally modern notions that art is private practice, that its basis is sexuality more than it is sociability, and that sexuality and sociability must be considered separate domains of the self—and any connection between the two must be illicit.[61] The definition of the commercial-cum-professional as the prostitutional and the criminal, and the deeply negative equation between art and sexuality lies at the very heart of Degas's practice, of his difference from his group and even from earlier and other Realists like Courbet and Manet.

Duranty on Degas: A Theory of Modern Painting

The best-known and most extensive of the discussions of Degas's work of the 1870s was Edmond Duranty's *La Nouvelle Peinture,* which was supposed to have served as the introduction to the catalogue for the impressionist exhibition of 1876 (when the *Cotton Office* was shown).[1] Like many other critics, Duranty seems to have thought of Degas's pictures of that year as a group of undifferentiated images—he did not refer to them individually. In Duranty's case, the explanation for this lies in the fact that his was more a theory meant to match a body of work than a review of the pictures in a show—"Therefore it's more the cause and the idea than the present show that I mean to consider" (*"J'ai donc moins en vue l'exposition actuelle que la cause et l'idée"*—*La Nouvelle Peinture:* 38).[2] Indeed, it is because of this that Duranty's essay is important to us: because his was an attempt to articulate a theory about the works; and because it was a piece of engaged critical discourse in a way that the reviews of the other critics were not; and also because in it Duranty addresses issues of realism and realist legibility more directly and in greater detail than any of the other critics. His is the most sustained example of the realist interpretation of Degas's oeuvre, matching Degas's attempt to neutralize and privatize the realist project more thoroughly and programmatically than the other critics' short remarks on the artist's works. In spite of the fact that Duranty did not name Degas directly or address individual pictures by Degas, his essay was also alone among the reviews of the impressionist shows in its stress upon Degas's oeuvre.

So Duranty's essay provides us with a theory of realism against which Degas's realist practice can be measured. That his essay about the impressionists was primarily about Degas was a fact well known to Duranty's contemporaries. It is equally well known to any present-day student of impressionism.[3] Alike in personality, Duranty and Degas were friends and cohorts. Together they played active roles in the discussions that went on at the Café Guerbois and the Nouvelle Athènes—Duranty was known as the "docteur du cénacle." They were both more articulate and theoretical than the others; in fact, they shared a sense of their difference from the impressionist group, and were equally unimpressed with the aesthetics of the impressionist sketch. They were both confirmed Parisians[4] with equal commitments to the human, social scene. As such they both disparaged the predominant concern for landscape painting and

shared a preoccupation with an art of physiognomic perception and social observation.

The fact that *La Nouvelle Peinture* is about Degas's oeuvre is obvious from the text itself. It is true that superficially Duranty's essay was designed to elucidate the aims of the impressionist group in its entirety— "these artists exhibiting in Durand-Ruel's gallery" (*ces artistes qui exposent dans les galeries Durand-Ruel*"—*La Nouvelle Peinture*: 38): in the broadest of terms, "La nouvelle peinture" equals "impressionism." Like other critics of impressionism, Duranty opens with a lengthy disparagement of academic painting, and traces the history of the nineteenth-century avant-garde from Courbet and the Barbizon school through Jongkind, Boudin, and Manet. He does pay repeated homage to the notion of *plein air* painting. And he does include a lengthy discussion of color, light, and prismatic decomposition, as well as of Japanese influence. All of these are familiar issues of impressionist criticism.

Yet Duranty never once calls the "new" painters "impressionists," nor does he use the word "impression"—he is careful not to do so. Like many other critics disposed to be friendly to the impressionist group and the exhibiting option which it provided, he was critical of the impressionist preoccupation with landscape, and of the rendering of the retinal impression rather than the material qualities of the land.[5] He goes so far as to distinguish drawing from color and to come out on the side of the former. Degas was the "dessinateur" in this group of colorists, according to Duranty.

Duranty launches his discussion of the "new" painting with an oblique reference to Degas himself, "your guide, the honorable and able painter-writer, so courteous, so ironic and so disenchanted in his sayings" (*"votre guide, l'honorable et habile peintre-écrivain, si courtois, si ironique et si désenchanté dans ses dires*"—*La Nouvelle Peinture*: 28). He mentions, as other critics had, the wit and erudition, the visual and verbal acuity—the *esprit*—for which Degas was famed. He even quotes one of Degas's letters, in which the image of a snub-nosed demimonde woman is used as a symbol for modern art, a passage typical of Degas's *dires* in its ambiguous inversion of traditional symbols, its deliberate mixing of realist and classical imagery:

> A sculptor, a painter have for a wife or mistress a woman with a pug nose and little eyes, who is thin, light, and lively. They love this woman in all her faults. Perhaps they risked everything to have her. Now, this woman who is the ideal of their heart and mind, who awoke and brought alive the truth of their taste, their sensibility, and their *invention*, because they discovered and chose her, is absolutely the contrary of the *feminine* which they so stubbornly articulate in their canvases and statues. There they return to Greece, to dark, severe women with the strength of horses. The pug nose which delights them during the evening, they betray in the morning by straightening it out; they die of boredom or else they bring to their work the gaiety and effort of *thought* of a box maker who knows his

job very well, and who thinks about where he will be going to find his *pleasure* after the day is done.

Un sculpteur, un peintre ont pour femme, pour maîtresse, une femme qui a un nez retroussé, de petits yeux, qui est mince, légère, vive. Ils aiment dans cette femme jusqu'à ses défauts. Ils se sont peut-être jetés en plein drame pour qu'elle fût à eux! Or, cette femme qui est l'idéal de leur coeur, et de leur esprit, qui a éveillé et fait jouer la vérité de leur goût, de leur sensibilité et de leur invention, puisqu'ils l'ont trouvée et élue, est absolument le contraire du féminin qu'ils s'obstinent à mettre dans leurs tableux et leurs statues. Ils s'en retournent en Grèce, aux femmes sombres, sévères, fortes comme des chevaux. Le nez retroussé qui les délecte le soir, ils le trahissent le matin et le font droit; ils s'en meurent d'ennui ou bien ils apportent à leur ouvrage la gaieté et l'effort de pensée d'un cartonnier qui sait bien coller, et qui se demande où il ira rigoler, après sa journée faite. (*La Nouvelle Peinture:* 29. Also cited in Rivière, *M. Degas, bourgeois de Paris:* 323)

This modern, urban physiognomy becomes the symbol for the "new painting," and from here on it seems clear that Duranty could be talking of no one else but Degas. Only Degas did the kind of modern-life painting that went with that epigram. And only Degas painted subjects like the following: "He will be at his piano, or he will examine his cotton sample in his business office, or he will await the moment of stage entrance behind the wings, or he will apply the iron to the trestle table, or he will avoid vehicles while traversing the street, or he will look at his watch for the time while hurrying through the public square" (*"Il sera à son piano, ou il examinera son échantillon de coton dans son bureau commercial, ou il attendra derrière le décor le moment d'entrée en scène, ou il appliquera le fer à repasser sur le table à trétaux ou il évitera des voitures en traversant la rue, ou il regardera l'heure à sa montre en pressant le pas sur la place publique"—La Nouvelle Peinture:* 45). This is the only time that Duranty makes reference to specific subjects, indicating some of the pictures by Degas that the other critics had mentioned: the laundresses, the dancers, and the *Cotton Office,* as well as other images not shown or mentioned, such as what sounds like the lost *Place de la Concorde.*[6]

Having introduced Degas as a "dessinateur," "peintre-écrivain," and man of *esprit*—he makes Degas over into a mixture of Diderotian observer and Balzacian Virgil, a kind of street guide to the *comédie humaine* of the 1870s—Duranty turns to the kind of imagery that would best fit his theory. His general remarks about impressionism sharpen into a discussion of an acute, radically framed and fragmented, physiognomic mode of vision:

Farewell to the human body, treated as a vase, from the point of view of the decorative curve . . . what we need is the *special detail* of the modern individual, in his clothes, in the midst of his social habits, at home or in the street. *The datum becomes singularly acute . . .* it is . . . the observation . . . of *the special feature* which inscribes in him his profession, gestures which it leads him to make, *partial aspects . . .*

Duranty on Degas

With *one back,* we desire that a temperament should be revealed, the age, the social class; with *a pair of hands,* we must *express* a magistrate or a merchant; with *one gesture, a whole series of sentiments . . . Hands sunk in pockets could be eloquent . . .*

If one takes a person either in a room or in the street, he is not always at an equal distance from two parallel objects, . . . *he is never at the center of the canvas or at the center of his setting. He does not constantly appear complete—so that sometimes he appears cut off at mid-leg, at mid-body, or sliced longitudinally.* The details of all these cuts would be infinite, just as the indication of all the settings would be. [Italics are mine.]

Adieu le corps humain, traité comme un vase, au point de vue du galbe décoratif . . . ce qu'il nous faut, c'est la note spéciale de l'individu moderne, dans son vêtement, au milieu de ses habitudes sociales, chez lui ou dans la rue. La donnée devient singulièrement aiguë . . . c'est l'observation . . . du trait spécial que lui imprime sa profession, des gestes qu'elle entraîne à faire, des coupes d'aspect . . . Avec un dos, nous voulons que se révèle un tempérament, un âge, un état social; par une paire de mains, nous devons exprimer un magistrat ou un commerçant; par un geste, toute une suite de sentiments . . . Des mains qu'on tient dans les poches pourront être éloquentes . . .

Si l'on prend à son tour le personnage soit dans la chambre soit dans la rue, il n'est pas toujours à l'égale distance de deux objets parallèles, en ligne droite . . . il n'est jamais au centre de la toile, au centre du décor. Il ne se montre pas constamment entier, tantôt il apparaît coupé à mi-jambe, à mi-corps, tranché longitudinalement . . . Le détail de toutes ces coupes serait infini, comme serait infinie l'indication de tous les décors. (La Nouvelle Peinture, 42–43, 45–47)

These are the passages most clearly about Degas's art. They do not exactly fit the rhetoric surrounding impressionism, with its emphasis upon landscape, optical and surface effects, "violetomania" and slapdash execution, light, color, and diffuse vision. Rather than diffuse, the world which Duranty describes in these passages is sharp, focused, and exclusive: the field of vision is narrowed to isolated, singular details, a back and a pair of hands. Rather than surface, it is all edge, a pictorial world without a center, in which both bodies and spaces are radically partialized. And finally, it is a world made up not so much of paint, color, and optical sensation, but of human gestures, bodies, and spaces. No matter how rebelliously fragmented and out of kilter, it still has the traditional arts of drawing, physiognomic expression, and perspective as its fundamental concerns.

Duranty's vocabulary, then, is like the language that many other critics would use when they wrote about Degas's pictures, that of dislocation and dismemberment. Duranty pays attention to a vision which slices through the world, uproots and unbalances it, and dismantles the human bodies which people it. It was this world of corporeal incoherence that

Degas's hostile critics would equate with pictorial illegibility—while his friendly critics would match it with a discussion of realist textuality.

Duranty's essay was the most striking example of the latter type of criticism. For, more insistently than the others, he defines Degas's pictorial world as a profoundly legible one. In writing about Degas's fragmented pictures, he sets out, point by point, the different readable elements, movements, and accoutrements of the human body: faces, hands, backs, a way of leaning against a door, a manner of wearing a suit. He alludes to the information that those details should provide: age, profession, class, sex, personal character, and life history. And he implies that Degas's realist images are ones that narrate as they describe: "with one gesture, a whole series of sentiments." In short, the "coupes d'aspect" and "mi-corps," the fragments and details so characteristic of Degas's art, are, according to Duranty, quite literally eloquent: they *speak* of contexts and histories.

Duranty had opened his essay by citing Eugène Fromentin's "Les Maîtres d'autrefois," which had appeared earlier that year in several installments of the *Revue des deux mondes:* "[Y]ou will remark that the goal of the most recent painting is to confront the eyes of the crowd with striking, *textuelle*[7] images, easily recognized for their truth, stripped of artifice" (*"[V]ous remarquez que la peinture la plus récente a pour but de frapper les yeux des foules par des images saillantes, textuelles, aisément reconnaissables en leur vérité, dénuées d'artifices"*—La Nouvelle Peinture: 22; Fromentin, "*Les Maîtres d'autrefois*": 796).[8] Duranty took issue with this passage, objecting to Fromentin's bias against the "new" school. Yet the passage also provided him with an appropriate introduction to "la nouvelle peinture." For Fromentin's phrase "images textuelles" served as a kind of motto for Duranty, condensing the realist criteria that he applied to Degas's painting: those of striking accuracy, readability, and textuality. The "image textuelle," the image as a literal text of modern life, this in a nutshell was Duranty's theory of the "new" realist painting—i.e., of Degas's physiognomic drawing-painting.

*

Duranty's theory of the "image textuelle" was simply a more extended version of the assertions of critics like Burty who were concerned more with realism than with impressionism. (The rhetoric of impressionism with which we are now familiar was by and large a creation of the flippant, negative critics—the dominant mode of the serious critics was that of realism and had very little to do with what we now think of as the dominant aesthetics of the period.) But Duranty's theory of realist legibility is of particular importance because of his direct connection to the Realism of the 1850s and 1860s, and because of the way his essay engages certain critical traditions. His essay is the best exemplar of the Third Republic theory of realism—the best theoretical counterpart to Degas's own neutralization of the earlier Realist project. For Duranty's is

an opinion about Degas's work which more or less reconstitutes it in terms of mid-century Realism, of which Duranty had been one of the foremost champions in the early years of the Second Empire. We will come back to the "textuality" of the "new painting"—let us first explore its relation to the older Realism.

In 1856, Duranty, Jules Assézat, and Henri Thulié began a short-lived journal called *Réalisme;* only six issues were published, between July of 1856 and May of 1857. After its demise there were a few vague plans to revive it in a new form—in the end, *La Nouvelle Peinture,* itself a kind of resuscitation of the 1850s pamphlet, was all that remained of those plans.[9] *Réalisme* had been devoted to the defense and propagation of the ideas born of the 1840s and 1850s—those of Courbet, Proudhon, Baudelaire, and Champfleury—and to the program of the encyclopedic representation of the "social spectacle." Indeed, the series of articles contained in the pages of *Réalisme* constituted the main theoretical writing about Realism in the 1850s, much more extensive than the more famous pamphlet by the same name by Champfleury.

In 1857 Duranty undertook to devote himself to the writing of Realist fiction—at the instigation of Champfleury. Champfleury helped him enter into and make his way in the world of Realist writing—it was Champfleury who pushed to get Duranty's stories published, and who, as a critic, stood up for him in the face of a critical press that was largely hostile. According to his biographer, Crouzet, Duranty was a confirmed Champfleuryste—Champfleury's style, subjects, and concerns were consistently at the root of his own.[10]

In the 1870s, Duranty was still following in Champfleury's footsteps, still echoing his concerns and taking up his genres of criticism. In 1872, he wrote about caricature, taking up a genre of criticism that Champfleury had initiated. Just as Champfleury before him had done, and would continue to do, Duranty tied his discussion of the caricatural medium to a particular context and specific historical moment, in this case to the Franco-Prussian War.[11] In 1878, at the time of Daumier's first retrospective, both he and Champfleury wrote about that artist.[12] Duranty's late 1870s series of articles on the collections of the Louvre, called "Promenades au Louvre," also echoes Champfleury's criticism.[13]

At the same time Duranty began to take up the critical themes of the new generation, specifically those of his more recent supporter, Emile Zola; in the late sixties and early seventies, he began writing about Manet and the impressionists in a manner that recalls Zola's criticism.[14] And he became an intimate of the circle of naturalist writers that surrounded Zola. But Duranty continued to call himself a Realist. In 1867 he said, "Oh! the new philosophy, the positivist, materialist philosophy . . . Go on, do not count only on your adversaries to keep you on the proper road: that of Realism!" (*Eh! la nouvelle philosophie, la philosophie positiviste et matérialiste . . . Allez donc, et qu'on ne compte pas seulement sur vos adversaires*

pour vous maintenir dans la voie du salut: le Réalisme!"—Duranty, "Ceux qui seront les peintres.") This was a motto for 1876 as well.

But if Duranty's attachment seemed to be the avant-garde ideologies of the Second Republic and Second Empire, nevertheless, he, like Champfleury and other "Courbetistes," attempted to disassociate himself from the 1848 beginnings of those ideologies, to sever Realism from its particular political moment and rid it of the resonances that identified it with 1848 and made it a radical matter.[15] He made the realism of the Second Republic, Realism with a capital R, over into the realism of the Third, realism with a little r. In this, Duranty's theory was like the strange little Biedermeyer picture by Degas which critics noticed in the 1876 exhibition, the *Cotton Office*. It was also a bit like Degas's own claim that "realism need no longer fight."

One way that Duranty depoliticized the concept of realism was by citing Courbet's painting as the *prehistory* of the new realism (*La Nouvelle Peinture*: 30).[16] Another way was by quoting Diderot's "Essai sur la peinture":

> I have never heard a figure accused of being badly drawn as long as its exterior organization clearly manifested its age and its habits and its ability to fulfill daily tasks. These tasks determine both the overall size of a figure and the true proportions of each of his limbs—and of the relationship between them: it is out of that that I see the child, the adult, and the old man emerge; as well as the wild and the civilized man, the magistrate, the soldier, and the porter alike. If there is a figure difficult to find, it is that of a twenty-five-year-old man who has suddenly been born out of the clay of the earth and who has so far done nothing—but that man is a chimera.
>
> *Je n'ai jamais entendu accuser une figure d'être mal dessiné lorsqu'elle montrait bien dans son organisation extérieure l'âge et l'habitude ou la faculté de remplir ses fonctions journalières. Ce sont ces fonctions que déterminent et la grandeur entière de la figure, et la vraie proportion de chaque membre et leur ensemble: c'est de là que je vois sortir et l'enfant et l'homme adulte, et le vieillard, et l'homme sauvage, et l'homme policé, et le magistrat, et le militaire, et le porte-faix. S'il y a une figure difficile à trouver, ce serait celle d'un homme de vingt-cinq ans, qui serait né subitement du limon de la terre, et qui n'aurait encore rien fait; mais cet homme est une chimère.* (*La Nouvelle Peinture*: 41; Diderot, "Essai sur la peinture": 463)[17]

This quote helped to substantiate Duranty's contrast between the realist physiognomy, "the modern individual, in his clothes, in the midst of his social habits, at home or in the street," and the academic "corps," "the human body, treated like a vase, from the point of view of the decorative curve." (Diderot had done the same, opposing "the figure [whose] exterior organization clearly manifests its age and its habits and its ability to fulfill daily tasks" to "a twenty-five-year-old man who has suddenly been born out of the clay of the earth and who has so far done nothing.") Duranty also echoed Diderot's contrast between "l'école" and "mon car-

refour" ("Essai sur la peinture": 464) and emphasis on direct, modern-life observation ("Essai sur la peinture": 466), when he demanded that the studio be opened up to the light of day and that the painter descend into the street to observe the contemporary human scene (*La Nouvelle Peinture*: 32). In short, Duranty claimed Diderot as an eighteenth-century progenitor of nineteenth-century realism. He says, "This extraordinary man is at the back of all that the art of the nineteenth century shall have realized" (*"Cet homme extraordinaire est au seuil de tout ce que l'art du dix-neuvième siècle aura réalisé"*—*La Nouvelle Peinture*: 41).

Duranty claimed Diderot's text as a model for his own anti-academic stance. Earlier in *La Nouvelle Peinture* he had echoed Diderot's language in another way, mocking the poses and masquerades of academic models, characterizing them as cosmetics and fancy-dress costume rather than "habits" and "habitudes," as masks rather than physiognomies: "They have done better than the teacher, demanding that actors teach them theatrical grimaces to put on the face, always the same face, of their little *marquis* and *incroyables* . . . They have dressed up, made up, and trussed up nature, they have covered it in curl papers. They have dressed its hair, and prepared it for an operetta" (*"Ils ont renchéri sur le maître, demandé aux comédiens de leur enseigner quelques grimaces de théâtre à mettre sur la face, invariablement la même, de leurs petits marquis, de leurs incroyables . . . Ils ont chiffonné, maquillé, troussé la nature, l'ont couverte de papillotes. Ils la traitent en coiffeurs, et la préparent pour une opérette"*—*La Nouvelle Peinture*: 31).[18]

Duranty ends his essay with a passage that reads as if there too he were harking back to Diderot's "Essai sur la peinture." Diderot had finished his essay on painting with a discussion of the genre of history painting: "Oh! if only a sacrifice, a battle, a triumph, a public scene could be rendered with the same truth in all its details as a domestic scene by Greuze or Chardin" (*"Ah! si un sacrifice, une bataille, un triomphe, une scène publique pouvoit être rendue avec la même verité dans tous les détails qu'une scène domestique de Greuze ou Chardin!"*—"Essai sur la peinture": 505ff.). (That passage was the beginning of Diderot's famous lament about the state of eighteenth-century history painting, and his commentary on the relationship between genre pictures and history paintings.) The terms are not the same, but in his summation Duranty addresses the issue of genre painting raised to the level of history painting just as Diderot had done:

> I envisioned a painting that would undertake vast series of men of the world, priests, soldiers, peasants, workers, merchants, series in which the characters would be varied in their own tasks, and related in scenes common to all: marriages, baptisms, births, successions, parties, familial interiors—above all scenes which take place frequently and which, consequently, express the general life of a country . . . a generosity of views which perhaps does not obtain in any of the present painters.
>
> *J'entrevoyais la peinture abordant de vastes séries sur les gens du monde, les prêtres, les soldats, les paysans, les ouvriers, les marchands, séries où les*

personnages se varieraient dans leurs fonctions propres et se rapprocherait dans
des scènes communes à tous: les mariages, les baptêmes, les naissances, les
successions, les fêtes, les intérieurs de familles; surtout des scènes se passant
souvent et exprimant bien, par conséquent, la vie générale d'un pays . . . une
largeur de vues qui n'appartient peut-être à aucun des hommes d'à présent.
(Duranty, *La Nouvelle Peinture:* 49)[19]

The comments that follow this passage expand on the vision of large-scale, significant modern painting, with some remarks about the uncertainty of the future of the "new painting." Like Diderot, Duranty complains that good modern, properly ambitious painting done on a properly gradiose scale, in other words, serious modern history painting, was lacking. It is possible that Duranty was thinking of Diderot's summation when he wrote his own. Certainly he established an equivalence between the pre- and post-1789 programs of physiognomic expression, modern-life observation, and pictorial legibility. Certainly his new realism, a renewed, renamed, and reapplied version of the old, paralleled Diderot's antirococo argumentation of the 1760s. Perhaps, by recalling the summation to Diderot's essay, he also equated his own nineteenth-century demands for seriousness, significance, and renewed vigor in painting with the demands of the eighteenth century. Since the "big paintings" which he desired can also be taken as a reference to Courbet's large Second Republic works, perhaps he even meant to rid them of their attachment to 1848 by attaching them instead to the older demands of the eighteenth century. In any event, Duranty matched *La Nouvelle Peinture* to a diachronic rather than a synchronic history of realism, and attempted to give it something of a pre-1789 sound—by connecting it up to a piece of prerevolutionary art theory, and identifying it with the observations and argumentation of a *philosophe.*

Other Realist writers and critics, among them Balzac, Champfleury, Baudelaire, and Proudhon, had discovered in Diderot's writing a precedent for their own attitudes; Diderot makes his appearance in the writing of nineteenth-century Realists as a kind of eighteenth-century *eminence grise.* Like Duranty, other Realists seem to have thought of him as a progenitor of nineteenth-century avant-gardism in many of its aspects: in his stance of opposition, criticism, and skepticism; his apparently unstructured style; his language of sarcasm; even his themes and subjects. Certainly it is true that Diderot's works gained public recognition as realism gained acceptance.[20] His complete works were published between 1875 and 1877 (contemporaneous to *La Nouvelle Peinture*) by Duranty's old friend and realist cohort Jules Assézat, who planned to write a study of Diderot and the Enlightenment as a follow-up on his publication of the *Oeuvres complètes.* (Assézat died before this project came to fruition. Duranty, who had apparently read the proofs for volumes fourteen and fifteen of the *Oeuvres complètes* for Assézat, was to have written one of a series of essays that was supposed to take the place of Assézat's general

study on Diderot. Duranty's essay, which never saw the light of day, was to have been about Diderot and the fine arts.)[21]

Assézat's interest in Diderot fits with the concerns of the circle of people to which he, Duranty, and Thulié were connected. To these men, a group of anticlericals, educational reformers, positivists, and republicans—they were known as "freethinkers"—[22] the eighteenth century was extremely important; they quoted it, wrote about it, published its works, and based their ideas upon it.[23] Theirs was a different eighteenth century from that of the rococo revivalists, like the Goncourts, for example—theirs was the antirococo eighteenth century, the "siècle des lumières." Diderot, Voltaire, and Rousseau were, for them, the first anticlericals, the first educational and social reformers, the first modern natural and social scientists: the first encyclopedists and the first positivists, in other words. Duranty's cohorts thought of the *philosophes* as the original exemplars of their own *libre-penseur* philosophies.

And so did Duranty. This is the context of friends and associates, persuasions and preoccupations into which his use of Diderot's "Essai sur la peinture" properly fits. His claiming of Diderot as the progenitor of his own theory of realism defined Duranty as a man of the Third Republic, rather than of the Second, aligned his realist aesthetics with those of bourgeois positivism rather than those of radicalism, and defined his "avant-garde" criticism as a piece of liberal discourse with a prerevolutionary tradition to back it up. The reference to Diderot served, ultimately, to disconnect Duranty's "new" realism from the resonances of 1848.

Duranty depoliticized and neutralized realism in other ways as well. As Crouzet has pointed out, *La Nouvelle Peinture* was written only shortly after Quinet's *L'Esprit nouveau* was published (in 1874); Crouzet suggests that Duranty was aware of that late text by the follower of Michelet and the historian of the Restoration and the Second Empire when he wrote *La Nouvelle Peinture*.[24] *La Nouvelle Peinture* undoubtedly echoes Quinet's concerns in its preoccupation with the liberalization of French institutions (i.e., the Ecole des Beaux Arts), its proclamation of contemporaneity and its critique of academicism, its interest in physiognomics as a semiotics of human history and society, and in its task of discovering and defining a new, vital French art form to match the new French age.[25] Certainly it is true that *La Nouvelle Peinture* is predicated on newness: it posits a new beginning—an "esprit nouveau"—and identifies itself with a new era. It compares the new school to the old one, explicitly in its contrast between "la nouvelle peinture" and academic painting; implicitly, in its reference to Fromentin's "Les Maîtres d'autrefois" as a kind of companion text.

Duranty's reference to Fromentin's article also helps to detach the new realism from 1848—by attaching it to a growing genre of criticism which emphasized national culture as the basis for style. The writings of Fromentin,[26] along with those of Thoré-Burger, Taine, and Charles Blanc, constitute an early social art history defined by nationalism and racialism.[27]

They posited the encyclopedic, contextual, proto-anthropological approach as a model for art criticism, establishing historical description and narration, rather than aesthetic judgment, as the proper critical model. Most obviously, they also attached realism to nationalism and national culture—one of their principal preoccupations was the contrast between realism and classicism, the Northern and Italianate schools;[28] another was the issue of where the French school fit.

In *La Nouvelle Peinture,* Duranty engages every one of these aspects of the new art history of realism. First, there is a narrative strain to his tracing of the history of impressionism. It is his stated task to consider the "new painting" as French, contemporary, and socially representative. His essay is entirely given over to the contrast between a bastard classicism and a new realism—his quote of Fromentin's "Les Maîtres d'autrefois" serves to highlight that contrast. Finally, Duranty was very much concerned with what to do with the French school, where to locate it, how to define the Frenchness of the new French painting—it was the passages on French painting in Fromentin's articles on Dutch art that he cited. Put these aspects of *La Nouvelle Peinture* together with Duranty's later "Promenades au Louvre," in which Dutch and Italian, classical and realist paintings are explicitly compared, and it is clear that Duranty was thoroughly engaged in the new nationalist art history.

By citing Fromentin, Duranty attempted to lend some measure of respectability to his own argument. By citing Diderot, he tried to give a history—a French history—to the French practice of and discourse on realism. That Duranty conflated Fromentin's and Diderot's, as well as Champfleury's, genres of criticism underscores the fact that *La Nouvelle Peinture* was about realism as subsumed within a larger, less charged debate—made over into a part of national "art history," and thereby separated from recent period-specific sociopolitical history. *La Nouvelle Peinture* is a good example of the degree to which the old 1848 Realism had been transformed into the "new" French realism, and of the degree to which the social issues engaged in the painting of Courbet had been neutralized,[29] converted into questions about how French art was French, how it represented the French social scene, and how it was to be read. So, though written by a man with rather different political opinions from those of Degas, *La Nouvelle Peinture* was consistent with Degas's own attempt to deradicalize the business of realism.

*

Duranty's *libre-penseur,* positivist affiliations were also the basis for his notion of the "image textuelle." Let us take a look, now, at his account of realist readability. Though Duranty uses the language of optical sensation belonging to impressionism, his is always a language of language as well. For even the luminous, prismatic instants of impressionism are also flashes of instantaneous textuality, according to him: the impressionist's "laws of light" are also laws of "expression." For Duranty, the impres-

sionist "hour of the day" is a human and social hour, rather than merely an optical one—it is identical to a "moment of public life":

> [O]ur existence takes place in rooms or in the street, and . . . the rooms, the street have their *special laws of light and expression* [my italics]. . . . With us, the tonal values of our interiors change with infinite variety, depending whether one is on the first floor or the fourth, whether the lodging is extremely furnished, papered, and carpeted, or meagerly embellished; thus an atmosphere is created in every interior as well as a sense of family between all the furnishings and objects which fill them . . .
>
> . . we will no longer separate the individual from the background of his apartment or the street. Never in our existence does he appear to us against a neutral, empty, vague background. Instead there are furnishings, chimneys, wall hangings around him, *an interior which expresses his fortune, his class, his métier* [my italics] . . . [30]
>
> *The language of the empty apartment will be precise enough so that one may deduce from it the character and the habits of him who inhabits it, and the street, by its passersby, will tell us what hour of the day it is; what moment of public life is represented.* [My italics.]
>
> *Notre existence se passe dans des chambres ou dans la rue, et . . . les chambres, la rue, ont leurs lois spéciales de lumière et d'expression. . . . Chez nous, les valeurs des tons dans les intérieurs jouent avec d'infinies variétés, selon qu'on est au premier étage ou au quatrième, que le logis est très meublé et très tapissé, ou qu'il est maigrement garni; une atmosphère se crée ainsi dans chaque intérieur de même qu'un air de famille entre tous les meubles et les objets qui les remplissent . . .*
>
> *. . . nous ne séparerons plus le personnage du fond d'appartement ni du fond de rue. Il ne nous apparaît jamais dans l'existence sur des fonds neutres, vides et vagues. Mais autour de lui sont des meubles, des cheminées, des tentures de murailles, une paroi qui exprime sa fortune, sa classe, son métier . . .*
>
> *Le langage de l'appartement vide devra être assez net pour qu'on puisse en déduire le caractère et les habitudes de celui qui l'habite et la rue dira par ses passants quelle heure de la journée il est, quel moment de la vie publique est figuré.* (*La Nouvelle Peinture:* 44–46)

Duranty joins the "impression" to "expression," thoroughly conflating visibility and textuality, insisting on the legibility of every visual aspect of the world, reading the discursive imperatives of the French tradition,[31] its privileging of language and literature, rhetoric and exegesis right into his discussion of impressionism, and thus refusing to recognize any essential difference between impressionism and a realism strongly inflected by literary expectations. Impressionism was simply a new realism—and Duranty's combination of the visual and the discursive was absolutely central to his "new painting."

This is not altogether surprising. Duranty was a story writer first and foremost, trained in the literary practice as well as the criticism of the 1850s.[32] His new realism was based not only on an older pictorial realism but also on an older literary school of realism. His "image textuelle," in-

cluding not only human features, gestures, and accoutrements but also human spaces and settings, was derived from the descriptive practices of realist writers such as Balzac. In a series of pieces in *Réalisme* about the different aspects of a literary work—plot, characterization, description, and so on—Duranty's cohort, Henri Thulié, had cited Balzac, criticizing him for the surfeit of description in his writing, yet implicitly referring to him as the grand old man of the realist tradition in literature.[33] Although Duranty was also critical of Balzac's novels,[34] it is obvious as well that Balzac was his model—he says as much when, in *La Nouvelle Peinture,* he cites Courbet and Balzac as the twin fathers of realism. By the 1850s most critics concurred with the view of Balzac as the *paterfamilias* of realism; by the 1870s, Balzac was considered a realist classic, and his notions of description, observation, and encyclopedic social classification formed a standard, popularly accessible part of the French literary tradition.[35] In a general way, Duranty too thought of Balzac as the exemplar of realist observation. He thought that paintings should be readable in the same way that the verbal pictures in Balzac's novels were. In any event, it is clear that Duranty's theory of the readability of the visual data of realist depictions, in particular his codification of the expressiveness of inhabited places and owned inanimate objects, was founded on the example set by Balzac's fiction.

Duranty's emphasis on the narratability of the striking descriptive image, and his sense of the textuality of immediate visibility, owe more to Thulié's essays on literature in *Réalisme* than to his own earlier writing on painting in that journal. In his article on novelistic description, which was obviously indebted to Balzac's writing, Thulié had written explicitly about the way that description should do the work of narration:

> The interior is the intimate part of life; there one deposits all one's hypocrisies; like clothing, little by little it takes on the inflections of the body, it betrays all its habits, one can guess at a man by seeing his rooms. The choice of furniture, colors, of a thousand little nothings spread all about are traitors which recount tendencies, meannesses, and secret vices. Frequently, in describing an interior, one recounts the private life of an individual or of a family.
>
> *L'intérieur c'est l'intimité de la vie; on dépose chez soi toutes ses hypocrisies; comme le costume il prend peu à peu toutes les inflexions de corps, trahit toutes ses habitudes, on peut deviner un homme en voyant sa chambre. Le choix des meubles, des couleurs, des mille petits riens qui traînent partout sont des traîtres qui racontent les tendances, les mesquineries, les vices secrets. En décrivant un intérieur, on raconte souvent la vie privée d'un individu ou d'une famille.* (Thulié, "Du roman: La Description": 38)

In *Réalisme,* Duranty had been careful to keep painting and literature distinct, farming the latter out to Thulié, while he focused on the former. He was aware that painting and writing operated on different principles. But he and Thulié shared the feeling that literature functioned best through

descriptive imagery—through verbal pictorializations (even plot and action were nothing more than a succession of images: Duranty's own novels were composed that way)—and that painting should be a kind of pictorial literature. Indeed they shared the belief that painting was a more powerful kind of literature than literature itself. Thulié's remarks about Balzac's tendency to drown his stories in detail indicated that the advantage of a picture was its directness, its obviation of the need to explicate and interpret a description (the way Balzac had to explain the import of his descriptions), its immediate readability and self-exegesis.

In *Réalisme,* Thulié had used the word "impression" in a physiognomic way: "To understand a physiognomy well, one must render the *impression* that one has when one sees it. There are always *conspicuous features* in a face or a costume that are immediately *striking* [my italics]" (*"Pour bien comprendre une physionomie, il faut rendre l'impression qu'on a éprouvé en la voyant. Il y a toujours des traits saillants dans le visage et dans le costume qui frappent de primes abords"*—"Du roman: La Description," 38). In *Réalisme* and elsewhere, Duranty spoke of the "trait saillant" as Thulié had done, referring to the *impressive,* immediately significant visual detail, the one that made an image more immediately readable than an equivalent descriptive passage in a novel by Balzac ("Le Spectacle social," *Réalisme,* no. 2 of 15 November 1856: 4). In *La Nouvelle Peinture,* Duranty uses similar terms—not "impression" or the "trait saillant," but the "trait spécial" and the "images saillantes, textuelles" in the quote from Fromentin. Terms like these betray the older, novelistic basis of Duranty's theory of the "new painting"—appropriately, they also refer to the "science" of physiognomics. For that is the positivist semiotics which lies at the back of Duranty's conception of the readable realist image, his joining of the concept of modern life to the concern with legibility, and his union of "impression" and "expression," visibility and textuality. The science of physiognomics permeates both *Réalisme* and *La Nouvelle Peinture,* as well as all the rest of Duranty's writings, both fictional and critical. It had informed Thulié's interest in Realism, providing the link between his brief venture as a critic and theorist of Realist literature and his vocation as doctor and anthropologist.[36] It was central to the Realist movement in both painting and literature, the subject of Balzac's *Comédie humaine,* and the basis on which Courbet's paintings were received. Most in vogue at the beginning of the nineteenth century, it remained popular until the end of the century—Duranty's 1867 essay on it in *La Revue libérale,*[37] and Degas's own interest in it in the late 1860s, 1870s, and early 1880s,[38] were not exceptional.[39] It had also become a matter of scientific and pseudoscientific debate, informing the work of physicians, criminologists, sociologists (like those concerned with prostitution), and social reformers. It was very much a part of the encyclopedic-positivist concerns of Duranty's circle—Duranty himself wrote it into *La Nouvelle Peinture* in many ways: not only in his Balzacian discussion of readable figures, features, and interior set-

tings, but also in his citation from Diderot and his quote of Fromentin.

Physiognomics meant many things in the later nineteenth century. Essentially, it was an eclectic semiotics, founded on the theory of expressions and based on a reading of the human form, but applied to all the objects and spaces of the world, cultural, natural, animate, and inanimate. A mixture of contradictory discourses and epistemologies, it was a system on the basis of which everything visible could be a text, every surface and exterior could be read.[40] The particular brand of physiognomic "science" that informed Duranty's and Thulié's theory of realism was a semiotics of costume and setting, accoutrement and context familiar from the writing of Balzac and the days of Courbet, a system of social signs which placed special emphasis on those of profession: "It is that conspicuous physiognomy produced by the costume and the way of life that each profession demands which strikes the public more readily" (*C'est cette physionomie saillante produite par la costume et le genre de vie qu'exige chaque profession qui frappe plus vivement le public*"—Duranty, "Le Spectacle social": 4).

Above all, Duranty's was a physiognomics of exteriority—"the science of exterior observation" (*la science de l'observation extérieur*"—"Notes sur l'art": 2)[41]—rather than one of interiority; of social signs and unambiguous visibility rather than elusive personality and private psychological quirks:

> [T]he investigation of little interior movements, infinitely finicky sensations, troubles, and aspirations, which are not directed toward a clear, definite end, straightforward in a word, are imperceptible and consequently not very interesting for the large majority of readers, in whom they awake no important idea. . . . It is for that reason that the public prefers a badly written book which paints the life of a soldier or a bourgeois—i.e., a social man—to the well-written book full of elusive, irritating psychological details . . . [which] paint a being who is too individual for the public.
> *[L]es recherches sur les petits mouvements intérieurs, sur les finesses infinies des sensations, sur les troubles et les aspirations qui ne sont pas dirigés vers un but clair, défini, carré, en un mot, sont imperceptibles et par conséquent peu intéressantes pour la presque totalité des lecteurs chez qui elles ne réveillent aucune idée importante. . . . Voilà pourquoi le public préférera le livre mal fait qui lui peint la vie du soldat, ou du bourgeois, homme social, au livre bien fait . . . plein de détails psychologiques insaisissables et ennuyeux . . . ils lui peignent un être trop individuel. (Duranty, "Le Spectacle social," 4)*

This notion of physiognomics was the basis of Duranty's concept of pictorial legiblity—it lay at the root of his conception of the "new painting" and of its basis in earlier, novelistic versions of realism. It also lay at the root of the other critics' readings of Degas's works, and of their perception of him as a realist painter concerned with the gestures of profession and the textuality of modern urban life.

*

Though Degas's works were supposed to exemplify Duranty's theory of the "trait saillant" and the "image textuelle," Duranty did not attempt to test his theory against Degas's images by reading them—he simply listed a series of such "traits": a back and a pair of hands, etc., and left it at that. A year later, however, in an article about gesture in painting that showed how much Duranty was engaged in the new realist-nationalist art history of his period, he did attempt to apply his theory of realist physiognomics. In his first "Promenades au Louvre," he addressed a series of seventeenth-century Dutch pictures and tried to read them, with a thoroughness that is remarkable and a fascination for subtle, conflicted gestures and enigmatic expressions, for physiognomies hovering at the very edge of illegibility, that are worth our extended attention:

But sometimes, because of their subtlety, sometimes because [these pictures] localise the truth too much, they become veritable enigmas. But these enigmas are amusing to decipher . . .

M. Villot is mistaken, I think, vis-à-vis an enigma by the adorable Metsu, which, in his catalogue, he entitles: *A Soldier Receiving a Young Woman* (no. 293 [fig. 40]). Metsu wanted to present us with a scene that was a little more difficult to interpret. One thing is sure, the soldier does not receive—he is received; his attitude is that of a man who is on the point of bowing and taking his leave. The expression of the exchanged glances, the glass that is just about to be offered to

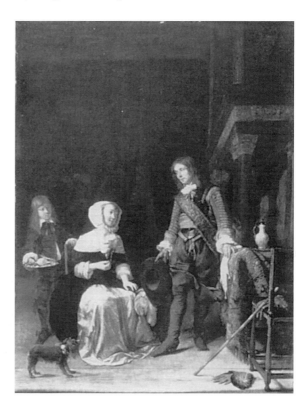

FIG. 40 Gabriel Metsu, *A Soldier and a Young Woman*, 1660s

Chapter 2

him, indicate that he is being detained and that he will stay. This picture is prodigious in spirit—in it, Metsu has succeeded in rendering intentions, contained sentiments, and movements which are about to take place. But is a very knowledgeable and very intelligent catalogue-writer condemned to remain in front of this composition for ten minutes, in order to read it as one reads a book?

I stand charmed in front of his ravishing *Music Lesson* (no. 294 [fig. 41]), which is truly a moving, speaking picture—in the serious sense of those two words. "I don't see how this can be played otherwise," says the woman with some resentment, letting her hand fall open—protesting the impossibility of playing the clavichord in another manner besides her own. "But yes, yes, it goes like this!" responds the teacher, and he gives her the bar, he gives her the pitch, and the accent—and we are within the scene, we follow it, we hear it! That is the height of expressiveness and all because of the simplicity of his means. But whereas here the natural gesture gives clarity to the incident, an equally natural expression leads to a kind of uncertainty in another picture by Metsu. That is, in this other picture, the *Vegetable Market* [fig. 42], reality has been too localized, as I said before. I'm referring to the man dressed in red who laughingly addresses the townswoman with her white iron bucket. This man has positioned his right arm on his left in such a way that its meaning is not easy to analyze—even though there is nothing unexpected or

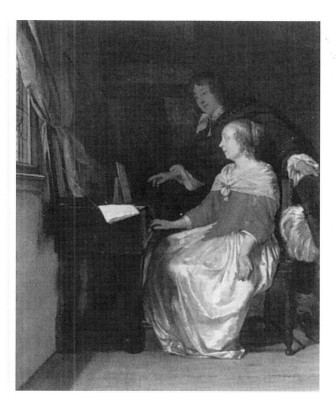

FIG. 41 Gabriel Metsu, *The Music Lesson (Lesson at the Virginal)*, 1660s

forced about it. Is he hamming it up and pretending to beg? Is he pretending to salute her with good manners? Is he proposing to carry the bucket, which must, he says, tire her arm? Is he prodding at his arm with a kind of lust—as if he were groping that of the woman? Is he feeling somewhat embarrassed because he risked some familiarity or some pleasantry that might be poorly received?—his gesture approximating that of scratching one's ear? The woman evidently wears a surprised look: "That," she thinks, "is an impudent, gay rascal"—but it is clear that she is about to smile. Nevertheless, she could become angry, one senses that. Might she have already slapped him? In contrast, one cannot mistake the argumentative marketwoman with her hands planted on her hips. What a singular gesture that popular gesture is—and how complex! It indicates many things at once: that she restrains her hands temporarily, with great disdain, itching to lash out and hit; that she wishes to give herself a majestic air appropriate to assuring and affirming her superiority over her opponent, and finally, that she dreads the other so little that she walks toward him, leaving her weapons sheathed, that's to say with her fists reposing and hanging from her belt. Two fists on the hips: low gesture, or at least vulgar—one fist alone on the hip: noble, royal gesture. It is interesting to compare Charles I by Van Dyck to Metsu's fishwife.

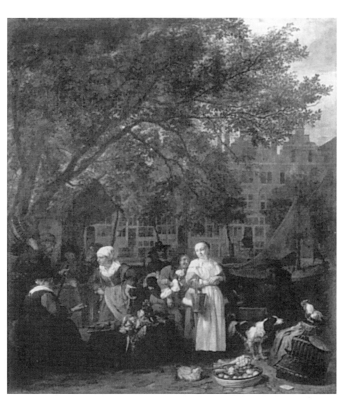

FIG. 42 Gabriel Metsu, *Vegetable Market in Amsterdam,* 1661–62

Chapter 2

Mais parfois à force de subtilité, et quelquefois en localisant trop la vérité, ils en arrivent à des véritables énigmes. Ces énigmes sont d'ailleurs amusantes à déchiffrer . . .

M. Villot s'est donc trompé, je crois, en face d'une énigme de l'adorable Metsu, que, dans son catalogue, il intitule: Un Militaire recevant une jeune dame *(no. 293)*. Metsu a voulu donner à deviner une scène un peu plus compliquée. A coup sûr, le militaire ne reçoit pas, mais il est reçu; son attitude marque un homme qui s'apprête à saluer pour prendre congé; l'expression des regards échangés, le verre qu'on est près de lui tendre, indiquent qu'on le tient et qu'il va rester. Ce tableau est d'un esprit prodigieux; Metsu est parvenu à y rendre des intentions, des sentiments contenus, des mouvements qui vont avoir lieu. Mais un très savant et très intelligent redacteur de catalogue était-il condamné à rester dix minutes devant cette composition, pour la lire comme on lit un livre?

Je reste donc charmé devant cette ravissante Leçon de musique *(no. 294)* qui est un véritable tableau mouvant et parlant, dans le sens sérieux de ces deux mots. "Je ne vois pas que cela puisse se jouer autrement que je ne fais," dit avec quelque dépit la dame, en laissant tomber sa main ouverte qui proteste de son impuissance à attaquer le clavecin d'une autre manière qu'elle n'en a l'habitude. "Mais si, mais si, c'est comme ceci!" répond le maître, et il bat la mésure, et il donne le ton, et il scande; on est dans la scène, on la suit, on l'entend! C'est le maximum de l'expressif, à cause de la simplicité des moyens. Mais tandis que le naturel du geste donne ici une parfaite clarté à l'incident, un naturel égal laissera une espèce d'incertitude dans un autre tableau du même Metsu. C'est que, dans cet autre tableau, le Marché aux herbes, la vérité a été trop localisée, comme je l'ai dit plus haut. Je veux parler de l'homme vêtu de rouge qui s'adresse en riant à la bourgeoise au seau de fer blanc. Cet homme a une façon de poser son bras droit sur son bras gauche dont le sens n'est pas facile à analyser, quoiqu'elle n'ait rien d'inattendu ni de forcé. Feint-il de mendier avec bouffonnerie? feint-il de faire un salut à belles manières? propose-t-il de porter le seau qui doit fatiguer, dit-il, le bras de la personne? tâte-t-il le bras avec une sorte de convoitise comme s'il tâtait celui de cette bourgeoise? éprouve-t-il un certain embarras parce qu'il a risqué quelque amabilité ou quelque plaisanterie qui peut être mal accueillie, son geste équivalent alors presque à celui de se gratter l'oreille? La dame a évidemment l'air surpris: "Voilà, pense-t-elle, un hardi et gai polisson," mais il est clair qu'elle va sourire. Cependant elle pourrait se fâcher, on le sent. Lui aurait-elle déjà donné une tape? En revanche, il n'y a pas à se méprendre sur la marchande en dispute, les mains campées sur les hanches. Singulier geste que ce geste populaire, et très complexe! Il indique beaucoup de choses à la fois: que l'on retient dédaigneusement et provisoirement ses mains désireuses de frapper, qu'on veut se donner une contenance majestueuse propre à assurer et affirmer la supériorité qu'on se croit sur l'adversaire, qu'enfin on redoute si peu celui-ci qu'on marche sur lui en laissant les armes au fourreau, c'est-à-dire les poings au repos et comme accrochés à la ceinture. Les deux poings aux hanches, geste "canaille" ou au moins vulgaire; un seul poing sur la hanche, geste noble et royal: Il est intéressant de comparer le Charles Ier de Van Dyck à cette harengère de Metsu. (Promenades au Louvre": 20–22)

And Duranty goes on in the same vein, musing about the thin line between popular and aristocratic gestures, debating Darwinian notions of the evolution of gestures and expressions, wondering, but unable to decide, whether or not certain gestures were particularly Dutch, or seventeeth century, or whether they could be traced back to Spain or Sicily, and so on.

Duranty's "Promenades au Louvre" brings together the new art history of the Dutch school with the realist engagement in physiognomics. It shows what he might have done had he chosen to read Degas's pictures. But it also bears witness to a curious contradiction in Duranty's sense of what picture-reading and physiognomic perception were about. For one thing, the "Promenades" betrays its involvement in a paradox that informed all of Duranty's writing about physiognomics. This was the paradox of positivist "objectivity": the presumption of the possibility of objectivity without subjectivity, empirical induction without deduction from a system, together with the reliance upon, indeed the celebration of, subjective sensation. According to Duranty's system, physiognomic information was to be arrived at through direct sensation. A physiognomic feature was readable because it was literally *striking,* because it *struck* and *impressed* itself upon the viewer: "a *striking* individuality, the contemplation of which was brimming with ideas and *sensations* [my italics]" (*"une individualité saisissante, dont la contemplation était grosse d'idées et de sensations"* "Notes sur l'art": 2). That was what Thulié had meant by "impression" and the "trait saillant," and what Duranty meant by the "trait spécial"— that was how he could conflate the vocabularies of "impression" and "expression," arriving at a "science" of sensation which symbiotically joined "objectivity" to the subjective responses of the viewer, the exteriority of the physiognomic object to the interiority of the physiognomist. The "Promenades," with its first-person account of Duranty's interpretations, and his disagreements with other critics' readings, demonstrates just how subjective this supposedly objective physiognomic system was, and always had been.[42]

The "Promenades" also conflicts with Duranty's stated theory to an extent, succumbing to a certain slippage between the system and its application. For as much as Duranty may have wished for a physiognomics of exteriority, contextuality, and plain social fact, of clarity, classifiability, and immediate readability, that is not what he finds when he starts looking for it; it is not what fascinates him most. When he sets out to read, he writes about *not being able* to read, about an *inability* to classify or deduce historic moment from the physiognomic image, or context from the gestural text before him.

It was not the clearly readable that caught Duranty's attention at all. In "Promenades au Louvre," his readings are uncertain ones; more often about the ins and outs and indeterminacies of pictured psychologies than about plain social facts, they all involve multiple choices and many possi-

bilities. Almost every time Duranty begins to interpret a physiognomy as a straightforward social sign, he ends by asserting the impossibility of doing so. Instead, he constantly attempts to hunt down the subtlest, minutest, most individual physiognomic twitches to their source. Indeed, rather than simply exposing manifest social meaning, Duranty seems to have desired to plumb the psychological depths of social surfaces, *to make them surface:* to make the most private pantomime a matter of public meaning, and the most public gesture a matter of private convolution. In short, in "Promenades au Louvre," the social and the psychological, the clear and the convoluted, the readable and the unreadable, are all confounded.

Nevertheless, though Duranty's actual picture-reading is somewhat at odds with his theory, in its first-person subjectivity the "Promenades au Louvre" underscores his obsession with the activity of physiognomic reading. His sense of the impossibility of clear social readings, his uncertainty, his listing of many possible interpretations, his insistence on tracking and pinning down the most inconsequential, fleeting, and ambiguous of gestures, all bear witness to this obsession. His insistence on *difficult* readings demonstrates that he was fascinated with the act of reading itself, more than with what it turned up: Duranty plays with several different manners of reading, ranging from debate with another critic and explication of artists' intentions to mesmerization before and entrance into pictures, animation of pictorial characters, eavesdropping on conversations between them, queries about them, and so on.[43] The activity of paying attention to pictures was his concern; physiognomic acuity and the process by which a physiognomy *impressed* itself on the consciousness of the viewer were what preoccupied him. Indeed, his reduction of the grand program of the representation of the "Spectacle social" in *Réalisme* to that of the "trait saillant" in *La Nouvelle Peinture,* to the narrowest, the most "aigu," the sharpest, most striking of details—in short, to Degas's imagery as opposed to Courbet's—shows that there too Duranty was more interested in the act of physiognomic observation itself than in the social significance of realist physiognomics or the realist program per se. In this respect as well, *La Nouvelle Peinture* matches Degas's concerns: not only the partial, fragmentary look of his images, and his obsession with repetition, but also his privatization of realism and modern-life imagery, his engagement in innuendo and his interest in the process, rather than the products, of physiognomic readability.

There is one picture by Degas which provides a modern, French counterpart to Duranty's reading of private relationships in Dutch pictures in "Promenades au Louvre." This is *The Interior* of 1868 (fig. 43), the most obviously relatable of Degas's images to the discourse on realism, the "new" art history and the engagement in seventeenth-century Dutch genre-painting. Duranty might even have indicated this picture specifi-

FIG. 43 Degas, *The Interior*, 1868

cally in *La Nouvelle Peinture,* with his mention of those speaking "hands sunk in pockets," possibly referring to the man standing by the doorway at the right-hand side of *The Interior.*

Even more than the *Cotton Office,* and unlike Degas's other, serial images of the seventies, *The Interior* is full of the kind of genre detail found in Dutch seventeenth-century pictures. It includes, as few of Degas's other works do, a world of information such as would meet Duranty's requirements for the readable realist image. It is an interior that can be described in detail: an inventory of its contents reveals a carpet, wallpaper, a bed, lamp and table, a door and a mirror, and dim lamp lighting which bespeaks a particular time of day—if not Duranty's "moment of public life," at least a moment of private life. It contains a man and a woman, the one in street clothes, the other in her chemise, with her corset cast off on the floor. The two figures are manifestly young, it is clear that the male at least belongs to the middle class—his clothes and the accoutrements of the room connote a certain comfortable economic position in life. The stances of the two figures, aggressive and vulnerable, as

Chapter 2

well as their coloring and costume, dark as opposed to light, dressed versus undressed, clearly speak of a gender opposition between the two. As well as the "hands sunk in pockets," *The Interior* contains another one of Duranty's speaking elements, the back of the woman. Seen together with that vulnerable female back and the man's feral gaze, the gesture of "hands sunk in pockets" seems to solicit from the viewer an interpretive response much like those that the gestures in Metsu's pictures in the Louvre received—a wish to know what emotion it betrays, what event lies behind it.

Indeed, *The Interior* has acquired exaggerated narrative significance in the eyes of later critics. It has been taken to be an illustration of an event in one of Duranty's novels, *Les Combats du François Duquesnoy*.[44] It has also, variously, been seen as an illustration of very specific events in two of Zola's novels, *Madeleine Férat* and *Thérèse Raquin,* published serially as newspaper *feuilletons* in the 1860s.[45] Moreover, it has been used, in a rather extreme way, as a piece of pseudopsychoanalytic evidence for an interpretation of the personality of the artist.[46] The narrational, or at least anecdotal, dimension of the image was one which Degas himself seemed to suggest—though he reportedly did *not* give the painting the title *The Rape* that it has since acquired, he did call it "my genre painting,"[47] as if to stress the anecdotal content and possible readability of *The Interior,* as well as its connection to the tradition deriving from Dutch seventeenth-century imagery.

Yet, as fully descriptive as *The Interior* is, its "meaning" is at least as ambiguous, if not more so, as the "meanings" that Duranty discovered in Metsu's genre pictures. While denotation is plentiful, the most straightforward kinds of physiognomic connotation yield themselves up with some difficulty. The profession of the male figure is not clear. Neither, because she is unclothed, is the class or status of the young woman—she could be a servant, a mistress, or a wife; it is not evident whether she is working class, demimonde, or bourgeois. And it is not clear what the relationship between the two characters is. The setting in which they find themselves could be the interior of a house, a hotel chamber, or a furnished apartment room. The stances of the figures are as connotatively multivalent as the Dutch pictures interpreted by Duranty seemed to be: on the one hand, aggression, anger, lust, seen in the brooding gaze, the dark, vaguely rodent-like facial features, and the splayed legs of the male figure; on the other hand, vulnerability, victimization, dejection, rejection, seen in the turned back, the nape of the neck, and the listless, drooping arms of the female figure. Has the youngish man just come in, or is he about to leave? (That was Duranty's question in front of Metsu's picture.) Is the youngish woman undressing, has the man raped her, has the couple failed to consummate their marriage or their liaison? Is it before or after such an event? Is the nature of the violence and distance between the

two of them pre- or post-coital, that of frustration, general unhappiness, or specific violation? What kind of couple are they—if they *are* a couple? The questions multiply, as did Duranty's questions in front of Dutch genre paintings—indeed, these are the kinds of questions that have been asked of *The Interior* in trying to ascertain the moment that is depicted in it and to pin down the narrative that it illustrates.[48] Ultimately, however, all that one may be sure of is the latent violence and the probably sexual nature of the relationship between the two figures; beyond that, it is a picture which requires a caption in order to be read. The stances and poses of the two figures resonate with questions, but not with answers—like the pictorial equivalent of a detective novel without a solution, yet replete with its repertoire of clues: the corset on the floor, the valise on the table, for example. Theirs is a body language and a set of accoutrements full of resonances but possessing no clearly pictorialized text. *The Interior* speaks of the difference between the textuality of genre painting and that of history painting: for its language of gestures and accoutrements is of a reserved rather than a rhetorical nature, which is to say that here those gestures and accoutrements work by holding information back and in reserve, rather than by displaying conventional, and thus clearly and publicly readable body language. It is also to say that the prior text, whatever speculations there are about it, is not known—and is not clearly recognizable in the picture. While Henri Thulié may have suggested, in contrast to the literary example of Balzac, that descriptive pictures contain their own exegesis, and, following the example of Balzac, that settings betray their owners' characters and stories—their "vices"—and while Duranty echoed him on both counts with his discussion of "traits saillants," informative interiors, and expressive luminous instants and impressions, this picture provides evidence that contradicts those claims: all by itself, pictorial description does *not* yield narration, unless it is supported by a known text and a familiarity with characters and actions shared by painter and viewers.

Interpreters of this picture have looked upon it as an unprecedented image. Quentin Bell, in particular, implied that its polarization of male and female was one of the original elements of the picture. This is not precisely true. Degas was drawing on an established tradition of internally bifurcated, sexually split imagery, i.e., the neoclassical history paintings of David, and in so doing, he was subtly Frenchifying, as well as both updating and backdating, his Dutch-inspired, modern genre picture, and at the same time privatizing narrative painting. Organized around the Davidian lacuna, *The Interior* seems to draw directly on David's *Oath of the Horatii,* and even more on his *Lictors Returning the Bodies of His Sons to Brutus* (figs. 44, 45), replacing the seated stance of Brutus with a female back and maintaining his brooding Roman glare in the face of the modern male figure. Those "sources" are both split between male and female poles, and both are based on texts similar to those

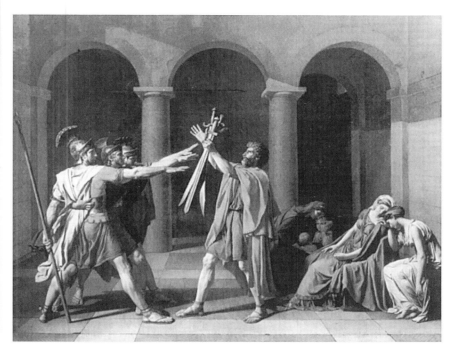

FIG. 44 J. L. David, *Oath of the Horatii,* 1785

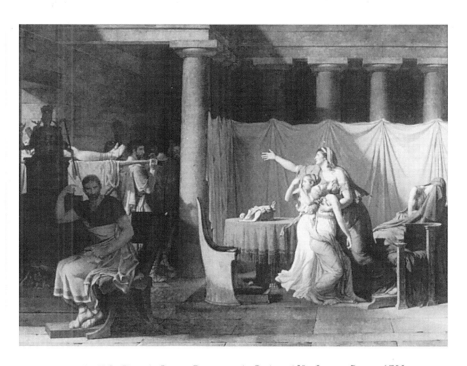

FIG. 45 J. L. David, *Lictors Returning the Bodies of His Sons to Brutus,* 1789

suggested for *The Interior* (in the cases of the neoclassical pictures, those texts are known and given in their titles)—narratives of conflict and desire, dramatized through radical, black-and-white oppositions between passive and active figures. In *The Interior*—illustrating as it does an unknown text, given a neutral, uninformative title that critics have attempted to replace with a luridly expressive one, and marked by a resonating, twilit space rather than by an event or an action—those oppositions have been undercut. The expressive, rhetorical gestures of neoclassical history painting (whose connotations are fully denoted) have been deleted, and the left-to-right, passive-to-active, empty-to-full, dark-to-light reading interrupted by the weirdly lit and furnished orthogonals of the room: the bodily rhetoric of traditional history painting has been interrupted and quite literally replaced by the mutely descriptive surfaces and spaces of genre painting.

One of the key elements of the *Brutus* that Degas may be said to maintain in *The Interior* is the still life in the center of the image. In the *Brutus* the still life serves as the displacement of the violence of the narrative: the decapitation of the sons of Brutus onto the domestic image of shears and pins stuck into balls of thread and yarn.[49] In *The Interior,* such displacement may also be said to occur, but in a more generalized fashion. The latent violence and sexuality of the relationship between the two figures also seem to be displaced onto a still life—the exposed, luridly pink interior of the valise open on the little table between the figures in the center of the room, which might be read as an instance of discreetly erotic display, as an image of an inside opened out and offered up, as one of secret contents exposed and divulged, which the rest of the clue-laden room, as long as it remains without caption, utterly refuses. (Unlike the still life in the *Brutus,* however, this is not a narrative displacement; it does not, as far as we know, implicate any part of a narrative which occurs off-stage.)

In calling *The Interior* a genre painting, Degas surely meant to distinguish it from the history painting with which he was still somewhat preoccupied. In drawing on history painting as a compositional source for his own image of male-female conflict and desire (one of the mainstays of the tradition of history painting), and in transforming the rhetorical devices of history painting into his own antirhetorical structure of pictorial reserve, Degas seems to have underlined the essential antitextuality of the modern-life genre image—its *difference* from the tradition of textual painting. He seems to have pointed to the fact that the requirements of history paintings could *not* be applied to modern-life imagery, nor could the same demands of readability and textuality be met by it, or the physiognomics of modernity and modern painting ever really be a physiognomics of direct, single-meaning readability. *The Interior* continues, even now, to ask to be read, but it fails to provide its own reading. Thus, rather than illustrating a story by Duranty, it illustrates the problems inherent in

reading genre imagery that Duranty would expose and explore in "Promenades au Louvre."

The Interior is a good counterpart to both *La Nouvelle Peinture* and the "Promenades au Louvre." In look and theme it is a "new painting" variation on the art history of the "maîtres d'autrefois": a modern realist response, not only to the French tradition of history painting, but also to seventeenth-century Dutch genre painting (its ambiguous subject is even rather similar to the frequent ambivalence found in Dutch pictures combining domesticity with allusions to sexual transactions and prostitution).[50] The ambiguity of its social signs, the tense muteness of its interpretation-soliciting collection of clues, its transformation of the public into the private *histoire* and of narrative forms into descriptive ones, its separation of the connotational and the denotational, and the association of its descriptive contents with sexual resonances rather than social meanings: all of these aspects of *The Interior* make it a good counterpart to Duranty's peculiar, subjective/objective positivism, his new-realist physiognomics. It is also the counterpart to Duranty's updating (and backdating) of realism: his detachment of it from 1848 through his attachment of it to the eighteenth century and the "maîtres d'autrefois," his modernization and depoliticization of the old republican Realism by Frenchifying, and even, however reluctantly, by privatizing it.

Certainly known to friends of his, a source of curiosity and puzzlement to them, *The Interior* was just as certainly important to Degas. Though he executed it early in his career it continued to preoccupy him—he worked it over later in the 1890s.[51] It sat in the back of his mind and his studio through much of his working life—possibly as an illustration of how the "trait saillant" of realist physiognomics actually worked and didn't work. Meanwhile Degas isolated the "trait saillant" as his peculiar specialty—rehearsing it repeatedly throughout his series, studying its condensation and materialization of positivist physiognomics over and over again, obsessed with the process by which it collapsed the objective into the subjective and rolled the public text over into the private.

Indeed, all the elements of readability that Duranty listed in *La Nouvelle Peinture*—physiognomies and gestures, glances and stances, pieces of costume and context—are present in Degas's other, later images, as the critics noticed. Body parts, bits of accoutrement, human features and spaces are so obviously and exclusively concerns in Degas's 1870s imagery, yet so radically fragmented and juxtaposed, scattered and shuffled, lined up feature to isolated feature, that they do at least seem to thematize Duranty's preoccupations. Certainly Degas's are images in which acuity is the issue; attention and inattention, sharpness and diffusion, precision of detail, absence and elision, are played out throughout them. Individually and as a body of work, they come together as a collection of physiognomic *sensations*. Many of their viewers seemed to understand them

this way: as a series of "traits saillants," strangely repetitive, marginal and self-interrupting, insistently physiognomic, insistent in their demand to be read for some critics and in their refusal to be read for others. Across his various specialties, before and after *La Nouvelle Peinture,* Degas began to remove the "trait saillant" from the context of *The Interior's* genre-picture space and its narrative pretensions, to give it over to caricature, and to further introvert and invert the nature of its readability, always, however, making physiognomic picture-reading the problem, just as Duranty did both in *La Nouvelle Peinture* and in "Promenades au Louvre."

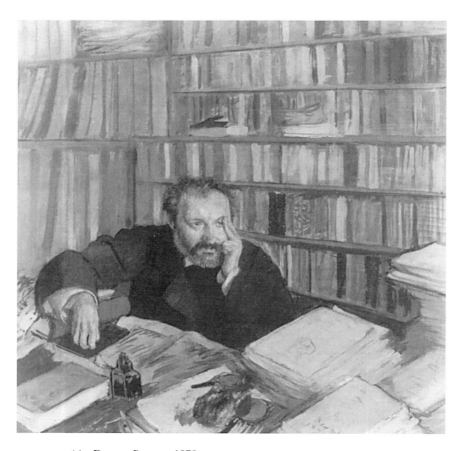

FIG. 46 Degas, *Duranty,* 1879

Chapter 2

Reading the Work of Degas T H R E E

In 1880, Degas exhibited his portrait of Duranty (fig. 46). "Looking at a head that alive, that well-drawn," the critic Arthur Baignères was struck by its likeness, its *aliveness,* its character drawing, and by what an "extraordinary portrait" it was (*La Chronique des arts et de la curiosité,* 1880).

Another critic, whose criticism I shall address at length in the following chapter, described the portrait rather more extensively. This was Joris Karl Huysmans:

> I shall stop for a few minutes in front of the portrait of our regretted Duranty.
>
> It goes without saying that M. Degas has avoided the imbecilic backgrounds so dear to portrait painters, with their scarlet, olive-green, and pale-blue drapes, their speckled planes of old wine, brownish green and ashen gray, which are monstrous untruths, because instead, when all is said and done, one should paint the person who is sitting for one in his home, or in the street—within a setting that is in all ways real, but not in the context of a slick stratum of vacant colors.
>
> M. Duranty is seated there, in the midst of his prints and books, before his table, and his slender, nervous fingers, his keen, humorous gaze, sharp, searching mien, comic English grimace, his little dry laugh behind the stem of his pipe, all come before me again upon sight of this canvas in which the character of that curious analyst has been so well rendered.
>
> With the pen it is difficult to give even a vague idea of the painting by M. Degas; it finds its equivalent only in literature; if a comparison between the two arts were possible, I would say that M. Degas's style of execution reminds me in many ways of the literary style of the Goncourt brothers.
>
> . .
>
> Just as Jules and Edmond Goncourt, in order to render visible, practically palpable, the exterior of the human beast, in the milieu in which he functions, in order to disassemble the mechanism of his passions, to explicate the movements of his thoughts, the aberrations of his devotions, the natural eclosion of his vices, in order to express the most fugitive of his sensations, just as they have had to forge a new, incisive, more powerful tool, to create a new palette of tones, an original vocabulary, a new language, so Degas, in order to render the vision of beings and things in the atmosphere that is proper

101

to them, in order to show the movements, the postures, the gestures, the plays of physiognomy, the different aspects of features and clothes, changing according to the increase or decrease of light, in order to render effects that so far have not been understood—or have been judged impossible to paint—so he has had to fabricate an instrument that is at once more tenuous and more generous, more flexible and more firm.

He also has had to borrow from all the vocabularies of painting, to combine the diverse media of *peinture à l'essence*, oil, watercolor and pastel, distemper and gouache, to forge neologisms of color . . .

.

Here, in the portrait of Duranty, there are patches of rose that is almost alive on the brow, green in the beard, blue in the velvet collar of the suit; the fingers are made with a yellow bordered by a bishopric violet. Up close, it's a slashing and hatching of colors at war with one another—colors which hammer at, shatter and encroach upon each other; a few steps away, it all harmonizes and melts into the precise tint of flesh, of flesh which palpitates, which lives, as no one else in France knows how to paint anymore.

Je vais m'arrêter, pendant quelques minutes, devant le portrait du regretté Duranty.

Il va sans dire que M. Degas a évité les fonds imbéciles chers aux peintres, les rideaux écarlates, vert olive, bleu aimable, ou les taches lie-de-vin, vert brun et gris de cendre, qui sont de monstrueux accrocs à la vérité, car enfin il faudrait pourtant peindre la personne qu'on portraiture chez elle, dans la rue, dans un cadre réel, partout, excepté au milieu d'une couche polie de couleurs vides.

M. Duranty est là, au milieu de ses estampes et de ses livres, assis devant sa table, et ses doigts effilés et nerveux, son oeil acéré et railleur, sa mine fouilleuse et aiguë, son pince de comique anglais, son petit rire sec dans le tuyau de sa pipe, repassent devant moi à la vue de cette toile où le caractère de ce curieux analyste est si bien rendu.

Il est difficile avec une plume de donner même une très vague idée de la peinture de M. Degas; elle ne peut avoir son équivalent qu'en littérature; si une comparaison entre ces deux arts était possible, je dirais que l'exécution de M. Degas me rappelle, à bien des points de vue, l'exécution littéraire des frères de Goncourt.

.

De même que pour rendre visible, presque palpable, l'extérieur de la bête humaine, dans le milieu où elle s'agite, pour démontrer le mécanisme de ses passions, expliquer les marches et les relais de ses pensées, l'aberration de ses dévouements, la naturelle éclosion de ses vices, pour exprimer la plus fugitive de ses sensations, Jules et Edmond Goncourt ont du forger un incisif et puissant outil, créer une palette neuve des tons, un vocabulaire original, une nouvelle langue; de même, pour exprimer la vision des êtres et des choses dans l'atmosphère qui leur est propre, pour montrer les mouvements, les postures, les gestes, les jeux de la physionomie, les différents aspects des traits et des toilettes selon les affaiblissements ou les exaltations des lumières, pour traduire des effects incompris ou jugés impossibles à peindre jusqu'alors,

M. Degas a du se fabriquer un instrument tout à la fois tenu et large, flexible et ferme.

Lui aussi a du emprunter à tous les vocabulaires de la peinture, combiner les divers éléments de l'essence et de l'huile, de l'aquarelle et du pastel, de la détrempe et de la gouache, forger des néologismes de couleurs . . .

. .

Ici, dans le portrait de Duranty, des plaques de rose presque vif sur le front, du vert dans la barbe, du bleu sur le velours du collet d'habit; les doigts sont faits avec du jaune bordé de violet d'évêque. De près, c'est un sabrage, une hachure de couleurs que se martèlent, se brisent, semblent s'empiéter; à quelques pas, tout cela s'harmonise et se fond en un ton précis de chair, de chair qui palpite, qui vit, comme personne, en France, maintenant ne sait plus en faire. (L'Art moderne: 117–19)[1]

Huysmans, as I shall show, based much of this review of the 1880 show on Duranty's *La Nouvelle Peinture*. This was how he described the portrait of Duranty, pausing longer before it than in front of Degas's other submissions of that year, which, like other critics, he referred to more generally—as series, rather than as single pictures. Echoing Duranty's criticism of traditional portraiture, with its nondescript backgrounds, and Duranty's prescription that people be painted "at home, or in the street," in the midst of their milieus, he went on to characterize Duranty's physiognomy as rendered in the portrait, comparing Degas's oeuvre to realist writing. Duranty, the man, was the best exponent of the readerly, realist approach—for Huysmans, Duranty the portrait was the icon to go with this approach. So it is with this picture that we begin our reading of Degas's oeuvre.

The portrait of Duranty was representative of one of Degas's preoccupations: portraiture. Except for the first show, he exhibited, or planned to exhibit, several portraits each year; the previous year, when he had first meant to show the portrait of Duranty, he had planned a kind of overview of his portrait work.[2] Yet as Baignères suggested, the portrait of Duranty was one of Degas's exceptional pictures. It stood out as a prime example of what Degas could but usually didn't do in the physiognomic line. It illustrated the realist program more straightforwardly than the innuendo about profession and prostitution found in Degas's major speciality, the dance series.

The portrait of Duranty was a commemorative picture, meant to be shown the year of Duranty's death. It was testimony to the fact that Degas saw Duranty as his critic. At the same time Degas painted—and meant to exhibit—the portrait of another of his critics, Diego Martelli (fig. 47):[3] the two portraits, of approximately the same size and same format, and the same kind of striking palette and abstracted formal arrangement, were evidently meant to go together. Both of them appear to have been based on Manet's 1868 portrait of his critic of the sixties, Emile Zola (which must have been based, in turn, on Degas's portraits in the late 1860s of *amateurs* and fellow artists, most notably that of Tissot—figs.

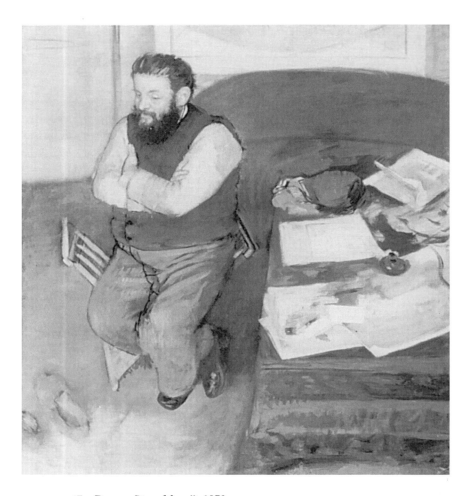

FIG. 47 Degas, *Diego Martelli,* 1879

48–50). Manet shows Zola seated "at home," in his study, at his desk, with *his* array of pamphlets before him and the imagery that concerned him around him, instead of setting his figure against a blank, deliberately nondescript background, such as is found in the small Duret portrait (the kind of portrait background that Duranty and Huysmans both derided—fig. 51). This portrait of Zola may well have been Degas's source for his two portraits, underlining the fact that where Zola was Manet's champion, Duranty and Martelli were Degas's partisans.

According to Huysmans, the portrait of Duranty was an accurate rendering of the physiognomy of the man and a striking evocation of his personality. Certainly most of Huysmans's remarks are accurate to the portrait: the "slender, nervous fingers" placed against Duranty's eyes and on the desk before him (pl. 1), emphasizing the critic's work and his "keen humorous gaze"; his rumpled, suited-up intensity—his "sharp, searching

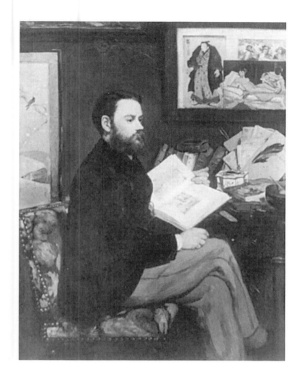

FIG. 48 Edouard Manet,
Emile Zola, 1868

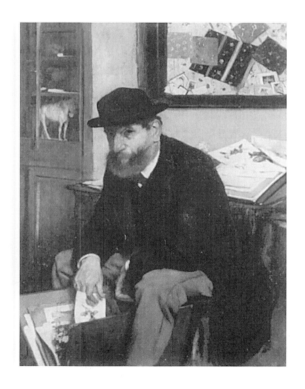

FIG. 49 Degas,
The Print-Collector, 1866

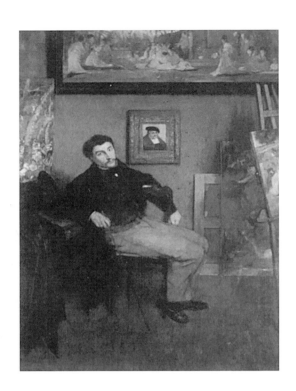

FIG. 50 Degas, *James Tissot in the Artist's Studio*, 1868

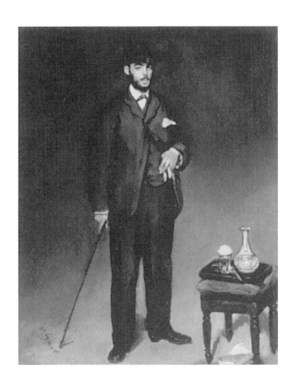

FIG. 51 Edouard Manet, *Théodore Duret*, 1868

mien"; his fierce, pursed features—"his comic English grimace" and "his little dry laugh"; the mixture of mild straining-forward aggression and vague, hemmed-in discomfort. Especially when compared to the plump, generous figure of Martelli, in vest and shirt sleeves, with his fez and slippers nearby, his mess of papers and comfy couch in the back, and the generally rounded, opened-out space of that portrait, Duranty is emphatically presented as small, cornered, and slightly embattled, not at all comfortably *chez soi*. He is encroached upon by, and sandwiched between, his work in the form of bookshelves which completely take up the background and high piles of pamphlets which completely take up the foreground—with none of the easy breathing and living space of the Martelli portrait. The picture captures the "character of that curious analyst."

In Degas's portrait of him, Duranty is represented as the very image of the analytical personality—the portrait is a picture of the physiognomist's gaze. Duranty's eyes, framed and marked by the two fingers placed at the side of his face, superseding his squashed torso, are the focus of the image's physiognomic power. In fact, the portrait is one of Degas's few images of a compelling, engaging gaze, very different from that of Martelli, and from his other portraits, with their distant stares. The portrait of Duranty seems to punctuate Degas's sense of the writer as a sharp-sighted observer.

The portrait of Duranty is even a kind of self-portrait of Degas, alluding to the many similarities between the personae and pursuits of the two men: the smallness, the corneredness, the keen, aggressive acidity, the rumple-suited presence (Degas almost always presented himself suited-up in that manner), the bristling, sharp little face, the intense engagement in work, and the refinement of the perceiving mechanism. Perhaps it was because they were so much alike that Degas could depict Duranty's physiognomy so powerfully: the comparison with the opened-out image of Martelli highlights this, for the latter is a sloppier, easier, more generous, but less resolved image, without the peculiar resonances of sympathy that one feels in the portrait of Duranty. If Duranty is represented as Degas's critic, he is also a stand-in for Degas himself, and for Degas's own physiognomic gaze.

So the portrait of Duranty is *readable* in a physiognomic sense. Its handling is physiognomic as well, marked by the quick caricaturist's line: seen most notably in the loose, bumpy edge of Duranty's jacket, similar to the obviously caricatural line in another of Degas's portraits—that of the cartoonist Carlo Pellegrini (fig. 52).

But there are problems in trying to give a physiognomic reading of the portrait of Duranty. First, that caricatural line is neither sure nor consistent, nor it is evident what essence of character is captured in it. Completely lost in the left sleeve of the jacket, so that Duranty's arm blends into his torso; hesitant at the right shoulder, rimmed with a white ghost of a contour—as opposed to the emphatic black which marks the edges

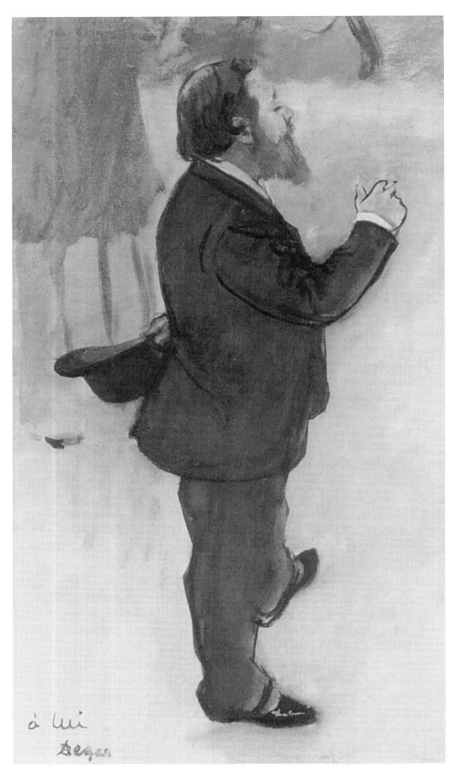

FIG. 52 Degas,
Carlo Pellegrini, 1876–77

of inanimate objects, such as Duranty's piles of pamphlets on the right-hand side of the picture—it maps out the loose terrain of Duranty's distended right sleeve. The sleeve seems disembodied and empty, and it loses contact with the body beneath it more than it captures and reflects it. Though this record of physiognomic sensation seems to capture the "trait saillant"—the striking feature and the telling gesture—it is really the *marginal* sensation that is emphasized. Unlike Duranty's "hands sunk in pockets," this is not a sensation that can be turned into any kind of biographical narration about the man. Ultimately, the graphic quality of the Duranty portrait is very different from that of Pellegrini, which is *all* caricature, capturing the jaunty stance of the little man, his characteristic gesture, as well as his manner of wearing his clothes—the way his clothes and his person interact characteristically with one another. The portrait of Duranty, by contrast, is full of elisions where clothes, body, and defining contours are concerned.

To a certain extent, the piecemeal, hesitant quality of the graphic work in the portrait of Duranty makes it a record of the *process* of physiognomic perception as much as it is an account of a particular physiognomy. Consistent with Degas's focus on the physiognomist's gaze, such a concentration on process is also consistent with Duranty's own theory and practice of realism.

Even coloristically the portrait is a record of sensory process. The swatches of pastel and distemper describing the local colors of the array of book covers behind Duranty are blurred into one another, resulting in an almost musical sensation of syncopated color planes. These abstract color sensations, reminiscent of the proto-naturalist mode of description employed by Duranty himself in his stories,[4] account for the vividness of the portrait—even more than its physiognomic accuracy: indeed, the figure of Duranty is almost overwhelmed by them. Closer inspection of the lineaments of the man also yields a concentration on vivid coloristic sensation. Duranty's face is made up of passages of hatching and colored drawing recording the layers of color in his flesh and the planes of his face. Instead of relying solely on the physiognomic contours and outlines of Duranty's features, Degas elides drawing and color, deploying color sensations in a draughtsmanly manner, weaving together the process of forming and perceiving: emphasizing the way face and flesh are put together by the hand and in the eye. Almost as much as Cézanne's portraits, landscapes and still lifes, Degas's portrait of Duranty is a record of the process of perceiving and recording physiognomic, coloristic, and volumetric data: a record of the process of taking in and taking down the features and surfaces and the milieu of the man.

But the portrait of Duranty is not entirely a happy marriage of processes and sensations. In fact, it is something of an illustration of the old war between color and line. Was Degas a colorist or a draughtsman?—the critics were divided on that score. In the portrait, coloristic and

graphic sensation work against and apart from, above and below, and often replace one another. The graphically rendered, colored surface of living flesh "wars" with the hesitant contours beneath it, and covers them over. This "war" between two kinds of sensation, surface and physiognomic, coloristic and graphic, is highlighted by the mixture of media employed in the image—distemper and pastel on linen.

Huysmans's language suggests this "war of sensations": "patches of rose . . . on the brow, green in the beard, blue [on the jacket]. . . , a slashing and hatching of colors at war with one another, colors which hammer at, shatter and encroach upon one another." It also suggests that a kind of effacement is built into the sensory work of the portrait. Those strokes of color which cover the figure of Duranty, rendering the tones of flesh, hair, and cloth, also screen his features, "encroaching" upon the repeated and slightly obliterated contours that describe his face and form. At the same time, Huysmans suggests, the portrait's war of sensations resolves itself into a compelling illusion of living human flesh: it is as if we can watch the portrait alternately resolve into visual illusion and disintegrate into *touches* and colored marks before our eyes, as if we see both the conflict of sensations and their resolution, the double processes of resolution and disintegration. The "war" between color and line speaks both to the portrait's emphasis on *process* and to its curious combination of the processes of image-emergence and image-effacement.

The process of effacement is found in all of Degas's portraits of the late seventies and early eighties: the most extreme example in pastel is the portrait of Mme Dietz-Monnin (fig. 53). Degas's later portraits in oil, many of them conspicuously messy images, also feature the work of obliteration. This aspect of the later portraits is especially striking in contrast to the careful delineation and finished, fully descriptive surfaces of Degas's early portraits, such as those of his brothers, his grandfather René-Hilaire de Gas, and the famous portrait of the Bellelli family (fig. 54).

The body of Degas's early portrait work was conceived in the spirit of recuperation: of the minutely descriptive, fully costumed and accoutremented likeness, and its various traditions, northern, Italian and French, royal, aristocratic, and bourgeois. The recuperative spirit of the Bellelli portrait is especially striking; it is based on the precedents of Ingres's portraiture and the Florentine Renaissance—Bronzino's portrait work, among others (fig. 55). The Bellelli portrait contains a veiled quote from the northern Renaissance as well, in the form of the portrait of René-Hilaire de Gas on the back wall.[5]

The Bellelli portrait contains detailed likenesses, meticulously rendered costumes clearly signifying station and sexual difference, and a closely depicted setting whose furniture serves both as an index of the social rank of the Bellellis and as a mark of their psychological separation from one another—witness the barriers created by the frame of the picture on the

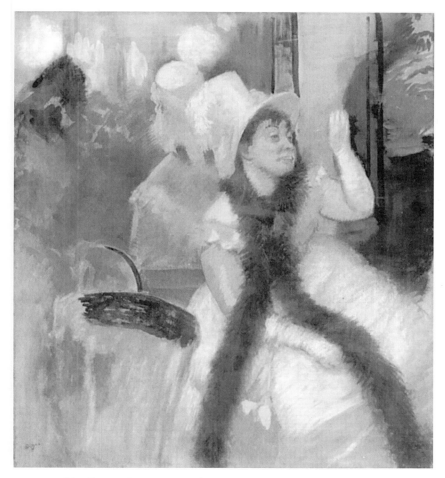

FIG. 53 Degas, *Portrait after a Costume Ball (Portrait of Mme Dietz-Monnin),* 1877–79

wall and the legs of the desk. Careful attention is paid to the figures' gazes and stances: we see, and understand as such, the cold, distant gaze of the mother, her stiff-backed posture, her carefully studied hands (note the oil sketch after the portrait—fig. 56), one relaxed and encircling, the other bent limply, uncomfortably back. We see the outward gaze, folded hands, and decorously placed feet of the one child—she is the figure of obedience—and we observe the turned-away gaze of the other, just missing that of her father. We notice that child's akimbo arms and dangling leg, her separateness from the black bell shape of her mother, and also from the crowded, worried form of her father. She is evidently the more unruly child—even her hair is less slickly banded and pulled back, and her pinafore less neatly symmetrical. In short, there is a world of things to be

Reading the Work of Degas

111

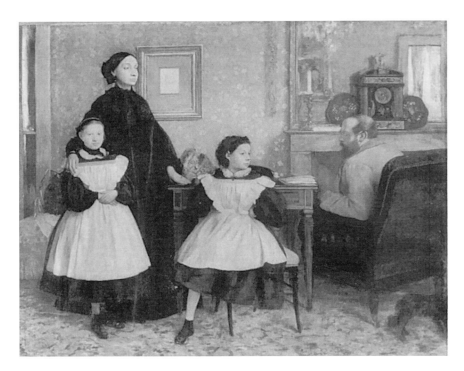

FIG. 54 Degas, *The Bellelli Family*, 1860–62

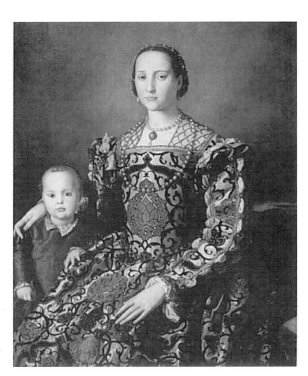

FIG. 55 Agnolo Bronzino,
Eleanora di Toledo, 1545

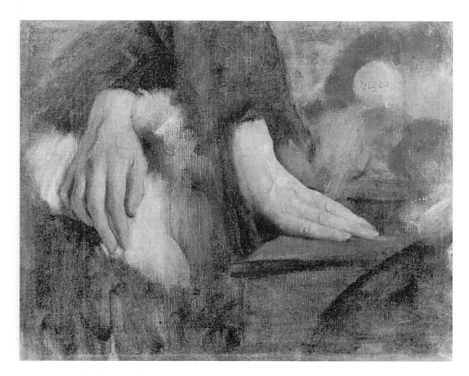

FIG. 56 Degas, *Study of Hands*, 1868

read and described in the Bellelli family. It is a highly successful physiognomic image demonstrating Degas's rich powers of description and observation, complete in its recuperation of the tradition of the portrait likeness, answering in every way to Duranty's recipe for the readable realist description. This is where Degas began—the Bellelli portrait demonstrates a rigorous representational formation and a powerful descriptive capacity which would continue to be evident in Degas's portraits; it is the foundation of most of his later oeuvre. It is, paradoxically, this foundation that he worked against in his later, obliterative portraits. (The work of obliteration had already begun in the sixties; curiously, Degas's other portraits of his Italian relatives of those years, though marked by the beginnings of the descriptive fullness that characterize the Bellelli portrait, are often left deliberately unfinished—see fig. 57.)

The portrait of Duranty falls between the early and later likenesses—it is a middle term between the two poles of skilled tradition recuperation and its subtle obliteration, physiognomic readability and sensory process—and between the public and the private, the objective and the subjective terms of Duranty's account of physiognomic perception. The portrait of Duranty manages a balance between the described realist likeness and its effacement. It is between those two poles that the whole of Degas's enterprise lies, answering both to the straightforward claims of

Reading the Work of Degas

FIG. 57 Degas, *Edmondo and Therese Morbilli,* 1865–66

Duranty's program and to its ambivalences. As we have with portraiture, we shall work backward to the examples of tradition retrieval in other genres, and forward to the process of effacement.

*

If Degas's first portraits represented an attempt to retrieve the tradition of the readable likeness, his first and most important picture in the genre of history painting, his other principal preoccupation in the early sixties, represented another kind of recuperation. This was *Young Spartan Girls*

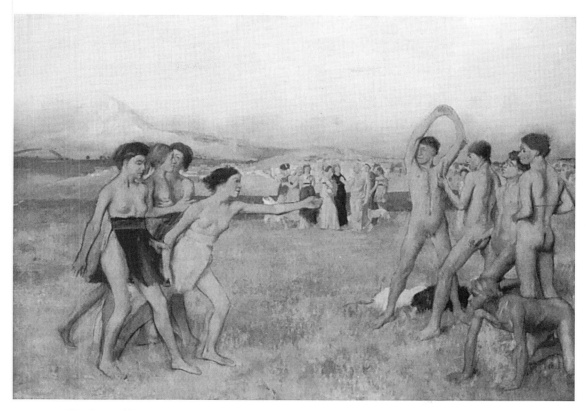

FIG. 58 Degas, *Young Spartan Girls Practicing for Battle*, 1859–60

Practicing for Battle (fig. 58), undertaken upon Degas's return to France, after the inception of the *Bellelli Family*.

In the early 1860s, Degas made copies first of Renaissance pictures encountered during his stay in Italy, and then of classic examples of seventeenth-century history painting, notably Poussin's *Rape of the Sabines* (fig. 59). He also turned to Delacroix's history painting, either directly copying pictures like *Mirabeau Protesting to Dreux-Brézé* (fig. 60) or aping Delacroix's compositional structure, as in *The Daughter of Jephtha* (fig. 61). In a kind of personal sequel to his academic training carried out during and immediately after his sojourn in Florence, Degas attempted to recuperate for himself the tradition of history painting in the modes of both *disegno* and *colore*, both in its operative sixteenth- and seventeenth-century forms and in its running aground in the early nineteenth century. The *Young Spartan Girls* was the prime example of Degas's foray into history painting, and of the problems of narrative space and corporeality that go with it.

Degas began his dissolution of the readable history painting almost as soon as he began his retrieval of it: The *Young Spartan Girls* is an illustra-

FIG. 59 Degas, copy after Poussin, *Rape of the Sabines,* 1861–63

FIG. 60 Degas, copy after Delacroix, *Mirabeau Protesting to Dreux-Brézé,* 1860

FIG. 61 Degas, *The Daughter of Jephtha*, 1859–60

tion of both enterprises. Its subject is a curiously non-narrative, anti-epic one. Based on two texts, Plutarch's *Life of Lycurgus* and Abbé Berthélemy's *Voyage du jeune Anarchises en Grèce*,[6] its subject is a wrestling challenge made by a group of Spartan girl athletes to a group of boys. The moment it represents is both protomilitary and pseudosexual. It is a rehearsal for games of different kinds—of war as well as of courtship. But it is not a narrative event; dressed up, or undressed, to look like a classical *histoire*, it replaces the epic moment with the unsingular movements characteristic of genre pictures, the movements of *répétition*. The feint and parry of fencing have been characterized as the opposite of the significant, readable actions of the legible body engaged in the great military events of history painting.[7] According to this discussion, the gestures of the *répétition* are fundamentally different from those of the epic—inherently uncertain and ambiguous, they are based on repetition and incompletion, mistakes, starts and stops, fragmented moves and attempts to mislead. The gestures and movements of practice, rather than those of narrative, are the ones selected by Degas for the *Young Spartan Girls*. With its representation of adolescent bodies flexing undeveloped muscles and rehearsing as yet unrefined moves, Degas's first "history painting" is already more of a precursor to his later series of dance rehearsals than it is depicted enactment of a classical narrative; with hindsight, it may be seen as a kind of rehearsal for the later theme of *répétition*.

A notion of the illegible body (as opposed to the legible body) is also borne out by the peculiar sexuality of the *Young Spartan Girls*. Like much history painting the picture is about sexuality: note its polarization of

male and female figures, its emphasis on the barely formed sexual signs of male and female adolescent bodies, its engagement in the actions of crouching, lunging, and embracing, and its focus on a single gesture, half-appealing, half-challenging, made across an empty space—the projectile formed by the arm of the girl. But it is also an image of sexuality of some ambivalence—witness, for instance, the embrace inserted in the background so discreetly that one almost does not see it, sandwiched as it is between the movements of advancing and retreating: the forward lunge and the action of pulling back. The lunge itself is interrupted and obstructed by the abyss of incompletely rendered space and by the block of gesturing adult spectators sketched in the background, with no middle ground to separate them. Because of their age, the sexual signs of the Spartan boys and girls are inherently ambiguous, the rendering of their bodies ambivalent, half-polished and half-patchy, half-transparent and half-opaque, and without a sense of the underlying armature and musculature of the male body in action or of the malleable, transparent look of female flesh. The style of their rendering (most comparable to Puvis de Chavannes's work) belongs neither to *colore* nor to *disegno,* and their corporeality is that of the androgyne—pubescent and protosexual, but neither clearly male nor positively female. (It is no accident that Degas was attracted to the Italian primitives, with their cult of youth and their celebration of the androgynous body of adolescence.) The *Young Spartan Girls* stands in a curious relationship to the frequent themes of violence and gender conflict and the subject of eroticism found in history painting. With its thematization of the repressed sexuality of history painting, and its presentation of unformed, androgynous corporeality, it is, in this way as well, a precursor to the sexual innuendo and adolescent world of the dance pictures.

The *Young Spartan Girls* is based on classical frieze sculpture.[8] Its compositional format is neoclassical. In the finished version, however, that frieze format is fragmented and pulled apart. (The same may be said of the *Misfortunes of War*—fig. 62,[9] an image of the aftermath of battle, rather than a rehearsal for it, which consist of a series of fragmented, isolated pieces of what looks like classical sculpture.) The resulting spatiality of the *Young Spartan Girls* is odd—it is made up of gaps and lacunae, awkwardly flattening the figures and framing gestures such as the lunging arm in the center of the picture. Again, this spatial style seems to have been learned from David's oeuvre on view in the Louvre.[10] As in David's *Oath of the Horatii* (fig. 44) and his *Lictors Returning the Bodies of His Sons to Brutus* (fig. 45), it underlines the dissolution of traditional compositional structure. But though David's emphasis on the lacuna, along with his thinly painted, sometimes patchy surfaces, his opaque, uninflected bodies, and his polarization of left and right, male and female, was a fairly radical transformation of the pictorial structure of the epic, it was still a narrative technique, reducing the historical image to the "declarative" mode[11] by

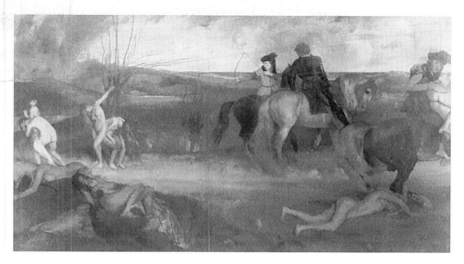

FIG. 62 Degas, *Misfortunes of War (Scène de guerre au Moyen Age)*, 1865

diagramming the meaning of the most important conflicts and unions, oppositions and equations of the text on which it was based. Degas stretched that technique to the breaking point, turning it into a strategy of blockage and interruption. While the lacuna framing the lunging arm in the *Young Spartan Girls* gives it a certain dramatic resonance, it tells us nothing and means nothing. Like a blank or a meaningless pause in a sentence, it simply interrupts the frieze-space horizontal reading of the picture. And while it may help to signify the opposition between the male and female halves of the image, it does not help to make that opposition signify anything else but itself. So just as the *Young Spartan Girls* problematizes the repressed sexuality of history painting, so it thematizes history painting's conflictive modes and its forms of punctuation without ever giving us the text of the conflict to be punctuated. Like the gaps and groupings in the later dance pictures, the central lacuna in the *Young Spartan Girls* is a form of meaningless punctuation: an example of signifying devices without significance, grammar without words, sentence-less sentence structure.

Like neoclassical and *juste milieu* history painting, the *Young Spartan Girls* included archaeologically correct props in its original conception (fig. 63). Yet those props are all but eradicated in the final image: observe the architecture of the sketch, gone in the "finished" picture, and the patchy rendering of the landscape setting. The classical dress and classical look of the figures themselves are obscured: witness the transformations in headdress from sketch to picture, and the changes made in the profiles of both girls and boys: here is the beginning of the blunted caricatural physiognomy characteristic of Degas's later work, the prototype of the squashed, pug-nosed mug of the modern-life *rat* of his ballet pic-

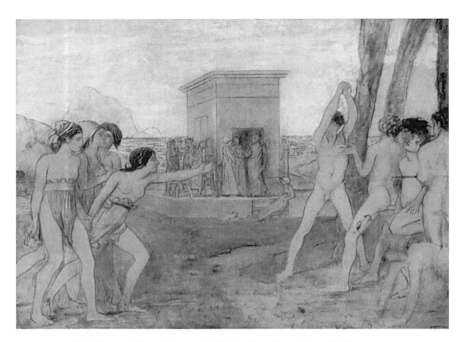

FIG. 63 Degas, *Young Spartan Girls Provoking Some Boys,* 1860

tures. Here also is the beginning of the graphic hesitations of his later imagery: the contour of the stretching boy, the transparent overlapping of his leg with that of the boy next to him, the repeated outlines of the girls' legs—it is difficult to tell whose limbs are whose, which were left in and which left out. Like the emphasis on *répétition* and obstructed erotic signification, the techniques of obliterated props, blunted caricature, and graphic hesitation also serve to undermine the readability of this already antinarrative *histoire.* In the *Young Spartan Girls,* the sensation of mug and movement that proliferates through the later performance pictures begins to replace the readability of form and action—the picture is an image of that replacement.

Degas's engagement in history painting gradually turned into a preoccupation with its theatrical equivalent: operatic fiction and operatic *intermèdes,* such as *Mlle Fiocre in the Ballet "La Source"* and *The Ballet of "Robert le Diable"* pictures (figs. 64, 65). From there into the ballet pictures Degas simply withdrew from depicting the fiction to study the making and watching of it—and from history painting to genre painting and modern-life typology. But like *The Interior,* the *Young Spartan Girls* remained an important picture for Degas, even after he turned away from history painting. It occupied a place of honor in his atelier[12] and served to bridge the gap between his early involvement in history painting and his later performance series, between the classical and the realist subject, as well as between his early Salon work and his involvement in the impres-

Chapter 3

FIG. 64 Degas,
*Mlle Fiocre in the
Ballet "La Source,"*
1866–68

FIG. 65 Degas,
*The Ballet of
"Robert le Diable,"*
1876

sionist exhibitions: shown in the Salon of 1856, it was also meant to appear in the impressionist exhibition of 1880. (It was listed in the catalogue for the show, but appears to have been one of those many promised works which Degas subsequently held back—no critic mentioned it.)[13] Had it appeared, it would certainly have marked Degas's difference from the others in his group once again, not to mention his difference from himself—for it was another of those exceptional pictures that he was wont to include, in order to upset the balance of the perception of his work, and to disturb the critical categories surrounding it. Certainly it would have served to underline the link between the *histoire* and the theme of *répétition,* as well as the participation of Degas's modern-life series in the business of dismantling pictorial, narrative, and corporeal readability, of privatizing the text of the body and transforming pictorial textuality into the work of sensory process. The *Young Spartan Girls* was the flip side of his later specializations: particularly the dance pictures.

The portrait of Duranty suggests the double project of recuperating the readable likeness and of undoing it, as well as the objective and subjective sides of the physiognomist's coin. Likewise, the *Young Spartan Girls* is involved in both retrieving and dismantling the readable space and corporeality of history painting while at the same time effacing the old gestural text of the classical subject and eliding it with the subtext of sexuality. Degas's later performance series would stress the dismantling, subjective, and subtextual sides of this double project. Another related aspect of Degas's work in both portraiture and history painting would be explored more thoroughly in the performance series. This is the tendency to combine and confuse the old classical categories of critical judgment: color, line, and chiaroscuro; background, middle ground, and foreground; space and corporeal form; the part and the whole; compositional simplicity, complexity, and variety; the "coup d'oeil," the single dramatic moment, sequentiality, and simultaneity; expression and the impresssion; and finally, the hierarchy of genres. Both the *Young Spartan Girls* and the portrait of Duranty exhibited the recombination of at least some of these categories: the dance pictures, in particular, with their more overt connection to classical subjects and the classical treatment of the body, repeatedly insisted on this confusion of critical criteria.

The categories of critical judgment were also featured in Duranty's writing on Degas. As I have shown, Duranty used Diderot's "Essai sur la peinture" to give theoretical weight and discursive precedence to his own writing on realism. And in *La Nouvelle Peinture* there are traces of the larger critical order of judgment that Diderot himself had flippantly and parodically upheld in the "Essai."[14] Duranty makes some very traditional critical distinctions, such as the very basic one between color and drawing: "I turn now to drawing. It is easily conceded that among these painters as among painters of old the perpetual opposition of the colorists to

the draughtsmen remains. Therefore, when I speak of coloration, one should think only of those to whom it applies; and when I speak of drawing, one must look only at those for whom that is their particular temperament." (*Je passe au dessin. On conçoit bien que parmi ceux-ci comme ailleurs, subsiste la perpétuelle dualité des coloristes et des dessinateurs. Donc, quand je parle de la coloration, on doit ne penser qu'à ceux qu'elle entraine; et quand je parle du dessin, il ne faut voir que ceux dont il est le tempérament particulier"—La Nouvelle Peinture:* 41.) His essay is by and large devoted to the promotion of "dessin"—it is central both to his distinction between Degas's work and the landscape school and to his theory of modern painting: "Little by little he has come out into the open air and the real sun . . . he has brought with him a penetrating *drawing* [my italics], wedded to the character of modern beings and things, following them at need with infinite perspicacity, down to their attractions, their professional intimacy, the gestures and sentiments interior to their class and their rank." (*C'est peu à peu qu'il est venu au plein air, au vrai soleil . . . qu'il a apporté un dessin pénétrant, épousant le caractère des êtres et des choses modernes, les suivant au besoin avec une sagacité infinie dans leurs allures, dans leur intimité professionnelle, dans le geste et le sentiment intérieur de leur classe et leur rang"—La Nouvelle Peinture:* 32.) In introducing his quote from Diderot's "Essai" (taken from the essay on drawing), Duranty writes, "In his *Essai sur la peinture,* at the end of the Salon of 1765, the great Diderot established the *ideal* of modern drawing, the drawing of observation, drawing after nature." (*Dans son* Essai sur la peinture, *à la suite du Salon de 1765, le grand Diderot fixait* l'idéal *du dessin moderne, l'idéal du dessin d'observation, du dessin selon la nature"—La Nouvelle Peinture:* 41.)

Duranty made piecemeal remarks about the other categories of critical judgment as well. He quoted Fromentin on chiaroscuro "[F]rom dark it became light, . . . from deep space to the surface, . . . from chiaroscuro to Japanese paper" (*[D]e sombre, elle devient claire, . . . de noire elle devient blanche, . . . de profonde elle remonte aux surfaces, . . . du clair-obscur au papier japonais"—La Nouvelle Peinture:* 2; Fromentin, "Les Maîtres d'autrefois": 7). He seemed to agree with Fromentin's criticism of modern compositional incoherence: "meager lines, detonating colors . . . formal confusion" (*lignes maigres, colorations détonnantes . . . confusion de formes"—La Nouvelle Peinture:* 24). His "image textuelle" passage was taken from Fromentin's larger discussion of the comparative success of old and new, Dutch and French drawing, color and chiaroscuro. Duranty also writes about perspective; it is worthy of note that he discusses the off-center, out-of-kilter spaces that characterize Degas's images as variants of the old centralized, single-point perspective. Obliquely, at least, Duranty employed the categories of traditional critical judgment in his pamphlet on the "new painting."

It might also be claimed that Duranty organized his essay on modern drawing and expression in vaguely ascending order, ending with what is

essentially a discussion of composition. His remarks progress from the part to the whole, from single, isolated gestures to the settings for those gestures, and from partialized bodies to the perspectives that partialize them. His discussion unfolds from the smaller issue of the bodily part and the single figure to the larger, inherently compositional issue of context and space, and of the interrelationships between figures and spaces. In an even broader way, the essay progresses from the fragment to the "big picture" or the "sujet": the end of Duranty's essay is as much a discussion of the "sujets d'art," in his own words, as the end of Diderot's essay had been.

Duranty's remarks at the end of his essay show that to his notion of the "big picture" he applied some of the same criteria that Diderot had applied to history painting. Rather than the partial and the marginal, the repetitive and the unfinished, Duranty wanted a kind of painting that would more broadly and significantly represent its time and its society. He wanted a *series,* not in the sense of odd, half-idle, private gestures serialized ad infinitum, like those in Degas's pictures, but in the sense of a public program. Duranty wanted the depiction of events important to the society, like baptisms and funerals, with actors acting on a big stage. He required breadth as well as variety, the same requirements as the traditional ones of history painting. In other words, he required what the tradition had taught him to require: completeness, complexity, synthesis, and significance. His attitudes all seem to be informed by the traditional privileging of that kind of painting—in *La Nouvelle Peinture,* remarks about modern history painting seem to bracket the discussion of realism: the essay opens with a critique of academic art and history painting, and closes with a call for the regeneration of the latter, in modern terms.

Yet Duranty never explicitly defined the subject of his closing remarks as "composition," nor did he announce that his essay was organized according to categories of critical judgment, the way that Diderot did. Instead, Duranty's critical categories take the form of allusions to other people's writings. Moreover, if the traditional categories of judgment, as derived from the theoretical writing of critics like Roger de Piles, were predicated on the classical notions of unity, synthesis, and composition, this was not true of Duranty's text. The mediating, unifying, globalizing terms of theoretical and critical discourse are absent from his discussion. For example, the category of chiaroscuro—traditionally the interface between "color" and "drawing," surface and space—appears only negatively (and in secondhand form), as a category undergoing fission and negation, and pertaining to the kind of painting that Duranty was seeking to negate. And, though his discussion does seem to progress from figure to setting, from the fragment to the "big picture," those issues remain separate and contrary ones, rather than closely linked steps in a progression toward completeness and wholeness. Color remains a disconnected matter of diffusion; drawing is confined to bits of drawing, expression to

"traits saillants," and perspective to edges, the frame, and the cut—as a category of judgment, perspective, for Duranty, is involved in the partialization and *de*construction of pictorial unity, rather than in the construction, unification, and totalization of the picture.

Finally, Duranty discusses the "big picture," the *sujet,* as negatively as academic painting—as something unrealized, appearing at the end of the essay as a contradiction rather than a culmination, and as a final failure to unify, terminate, or arrive at a resolution. This negativity is ultimately an acknowledgment of the uncomposability of the fragment and the modern impossibility of pictorial completion. In sum, if *La Nouvelle Peinture* is in any way about composition and critical categories, it adds up to a discussion of their deconstruction: it seems to define realist composition as a form of *de*composition. If Duranty's theory is a theory at all, it is one which inadvertently defines realism in terms of dissolution, fragmentation, and negation, sundering body, space, and vision, and severing the critic's viewing from the painter's making. (One of the points about the old categories of critical judgment is that they took the order of seeing from the organization of making.)[15]

In his passage on tilted, asymmetrical perspectives, Duranty summed up his notion of physiognomic perception, realist observation, and modern composition, as well as the character of Degas's pictures, with the phrases "coup d'oeil" and "coupe d'aspect." The notion of the "coup d'oeil" was traditional critical parlance. Diderot had distilled in it the range of his ideas about expression and composition, including the principle of accurate observation; the maintenance of the unities through the representation of a single time and place; the concentration of the significance of an event within a single pregnant moment; the exclusion of anything that could not be taken in at a single glance; the elimination of baroque complexities; the promotion of simple, uncluttered, clear compositions, just "various" enough to reward closer inspection; the notion that a painting's protagonists should appear natural, unstaged, and unselfconscious to the eye of the viewer, and unaware of his glance: "If the scene is one, clear, simple and joined, I will seize the whole in one glance" (*Si la scène est une, claire, simple et liée, j'en saisirai l'ensemble d'un coup d'oeil*"—"Essai sur la peinture": 497–99).[16] (This was the beginning of Diderot's extended dissertation on the subject of composition.) In any event, for Diderot, as for his forebears, that phrase, the "coup d'oeil," referred to a glance that was constructive and compositional, and to a kind of critical looking which embodied requirements of unity and cohesion, uninterrupted singleness and a wholeness, plausibility, decipherability, and signification.

Duranty's use of the phrase retained and exaggerated some of those meanings. His "coup d'oeil" referred to a sidelong, keyhole kind of viewing, in which sights were seen and caught unawares, and to the act of keen, readerly seeing itself, by which the immediate significance of partial

sights was discovered in a kind of telegraphic, intuitive flash. It was all about decipherability: the "trait saillant" was the feature which distilled the essence of a character—the feature which was the most subjectively striking and therefore the most significant and readable. The "coupe d'aspect" was, according to Duranty, fundamentally a readable image; the "trait saillant" and the "coup d'aspect" were that which was seen in a "coup d'oeil." But the "coup d'oeil" to which Duranty referred was clearly a fragmenting kind of glance. If we put together Duranty's vocabulary, that of the cut and the bodily fragment (the "mi-corps," "mi-jambe," etc.), with the cropped, disjointed, dismembering pictures that he meant to indicate, we will find that when he used the term "coup d'oeil," he inadvertently meant by it just what the phrase literally means: a *blow* with the eye.

In classical theory, the principle of pictorial unity, with all the requirements and categories that it engaged, was fundamental to the intelligibility of an image—it joined the criteria of critical judgment to the methods of pictorial construction and composition, to the rules of pictorial rhetoric. When Duranty spoke of the "coup d'oeil" and the "coupe d'aspect," along with the "trait saillant" and the "image textuelle," he spoke, as no one before him had, to a visual culture in which cohesiveness and decipherability, painterly construction and interpretation, had come undone—and in which pictorial composition and pictorial text had been radically severed from one another.

So Duranty's theory of modern painting was ordered according to, and yet it also disordered, the traditional categories of judgment. Degas's performance pictures did the same. For Degas's series of the seventies are the embodiment of the order-cum-disorder implied in Duranty's "coup d'oeil" and "coupe d'aspect." If Duranty's theory is a theory fragmented and negated, so one might characterize Degas's pictures by saying that they represent the deliberate dissolution not only of pictorial readability but also of completeness, cohesion, and variation, and of the unity of critical categories within an image. If the classical notion of composition was based on the successful synthesis of analytical parts, and on the ideas that drawing was the foundation of painting and that drawing, color, and chiaroscuro were to be seamlessly joined, Degas's images are ones in which drawing is an issue, but where drawing, color, and chiaroscuro are found sundered and jumbled, hovering around, above, and beneath one another. If, in the classical conception of painting, expression was of the essence, if it was based on the representation of the actions of human bodies within perspectivally constructed spaces, and if body and space were necessary companions of one another, the positive and negative of the same totalizing system, then Degas's images are ones whose perspectives are constructed of obviously dislocated orthogonals and patently excluded vanishing points, in which expression is based on half-bodies

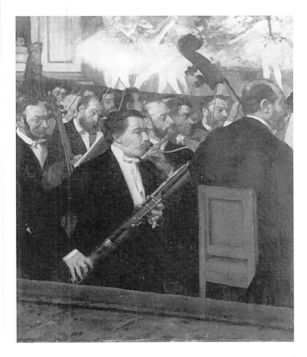

FIG. 66 Degas, *The Orchestra of the Opera*, 1868–69

performing pseudo-actions, and on corporeal absence as often as not. His are images in which bodies and spaces cut up and slice through one another, in which corporeality and spatiality are separated, jumbled up, and set in almost violent opposition to one another. If the traditional composition was founded on the principles of contrast, gradation, connectedness, and "ordonnance," and variety-within-unity, Degas's pictures are distinctly out-of-order ones, based on the principles of interruption, random collection, and polarization, in which the unities of time, place, and action are caricatured; in which variation, repetition, and replication begin to equal one another, and in which gestural "variety" begins to be equated with a principle of systematic incoherence. Finally, if in the old form of criticial discourse, picture-viewing had been based on picture-making, in Degas's images, the viewer is simply uprooted, displaced, and ultimately dismissed. Just as Degas's pictures make reading a problem, so they make composition a controversy and critical judgment a difficulty.

Fragmentation is the most obvious device of Degas's series—the aspect which most obviously confuses principles of *ordonnance*. Let us begin with the performance pictures, which devolved most immediately from his history painting and opera *intermèdes*. Fragmentation is an obvious quality of the 1860s' and early 1870s' orchestra suite. In the 1868 *Orchestra of the Opera* (fig. 66) one effect of fragmentation is this: the shuffling of the order of the human body, in this case the collective human body in performance—the orchestra and the ballet corps. Here the legs of the body are at the apex of the picture, heads at its center, and torsos at its base.

Such disassembling and disorganizing of the human body is emphasized almost obsessively in the dance pictures, when from the orchestra suite Degas turned to his new and most long-lasting, most repetitive preoccupation. It was also selected by many critics as the principal feature of the dance pictures, to which we return now, with the order of critical judgment in mind.

To nineteenth-century critics, Degas's fragmentation and disordering of the human body were not functions of natural, "photographic" vision, but deliberately disruptive of coherent pictorial structure. Let us take a moment to denaturalize the phenomena of the "coupe d'aspect," the "coup d'oeil," and the "mi-jambe," and try to see the dance pictures, which specialize in these phenomena, the way the critics saw them. Besides the *Orchestra,* the shuffling of body parts is most consistently seen in the dance-class and rehearsal pictures, particularly in the Corcoran *Dance School* and the Glasgow *Dance Rehearsal* (figs. 3, 67), with their sliced-off figures at the right-hand margins, and their disembodied legs and feet descending the spiral stairs on the left-hand side. It is also seen in the *Ballet Rehearsal on Stage* series (figs. 2, 5, 6), with those collections of legs, arms, torsos, and dresses interrupting one another in each of the groups of figures repeated throughout them: witness the performing dancers, their bodies increasingly indistinguishable from the 1873 to 1878 version; the yawning dancer, cropped at the legs at first, without legs at last, framed by the increasingly disembodied profile of the other dancer emerging from the sets to the left; the dancer fixing her shoe, also on the left, more and more reduced to a barely seen head, a hand and foot; the dancer on the bench at the left, with one arm and no feet (the legs of the bench stand in for hers at first); finally, the group of backs, faces, and arms at that same left margin, cropped in the last colored versions, to emphasize their fragmentation. From first monochrome version to last, the coherence of those bodies is increasingly disrupted, while the focus on isolated gestures and features is stepped up: those chicken-wing elbows, that stretched, dispossessed arm, those series of replicated profiles on the left-hand side. These are collections of physiognomic sensations and "traits saillants"—rendered increasingly difficult to read by the facts of isolation and collection, multiplication, interruption, and repetition. Like the *Young Spartan Girls,* these are *répétitions* in both senses of the word: in the sense of rehearsal and in the sense of replication. Intensely physiognomic, obsessively corporeal, they are nevertheless images of the illegible and disordered, rather than the legible, hierarchical, and symmetrical, body.

Degas's exploration of different media and different combinations of color, line, and chiaroscuro accompanies his increasing stress on the fragmented and disordered body. This too is seen most obviously in the *Ballet Rehearsal on Stage* series, which begins as a monochromatic oil painting focusing on the function of chiaroscuro isolated from colored surface, and ends in pastel and distemper variations in which the layers of colored me-

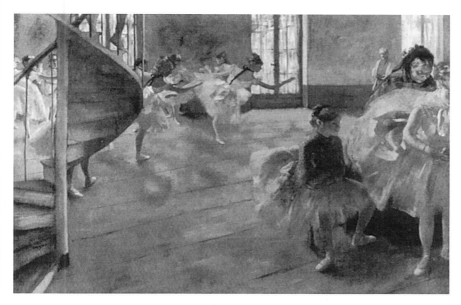

FIG. 67 Degas, *Dance Rehearsal,* 1874

dia do not entirely cohere and from which passages of colored drawing emerge. The combination of media is also seen in Degas's other dance series, traversing the spectrum from finished oil painting to more concentrated gestural studies in pastel and other materials. Like Duranty's *La Nouvelle Peinture,* Degas's dance pictures combine the dismantling of the order and totality of the gesturing human body with the disordering of the classical compositional process and the criteria of judgment. As the order of the parts of the human body is systematically confused, so is the relationship between making and seeing.

Besides the categories of color, line, and chiaroscuro, there remains that traditionally totalizing, contextualizing element: perspectivally ordered space as the stage for human action. Attached to the Italian tradition, which writers like Fromentin opposed to the Dutch realist school, perspectival construction was neither a principle of realist design nor of artists' training in the period. Yet it still figured largely in some theoretical writing of the time. And it was an important, if oblique, feature of Degas's dance pictures, another element which distinguished them from the look of impressionist painting. Spatial construction is always at issue in the dance pictures—they are never reduced to the bright, color-pure, white-laden flatness of the optical-datum patchwork of the impressionists. Most of the images in Degas's dance series refer rather dramatically to the single-point perspective—through the orthogonal lines created by floorboards, and devices like the spiral stair in the Corcoran *Dance School* and Glasgow *Dance Rehearsal:* the spiral stair was one of the more complicated exercises in much-published perspectival treatises like the ones by

Fig. 115.

FIG. 68 Armand Cassagne,
Eléments de Perspective, 1881,
fig. 115: "L'escalier tournant"

Armand Cassagne (fig. 68).[17] But in the dance pictures, the dramatization of perspectival order is also a dislocation of it. Both vantage and vanishing points are implied—yet because they are off to the side, beyond the frame, they are disconnected from one another. Because they are off frame, they help to exclude from the viewer's comprehensive purview the very principles of connectedness, measurability, and totality upon which perspectival construction was based. Perspective is torn apart from its main functions: the rationalization of sight, the unification of legible action, and the controlled framing of the human *histoire.*

The function of the perspectival construction had once been to locate and connect the body and space of the viewer to that of the picture. Its effect was to make the picture a reflection and a disembodied extension of the viewer's measured body, to depict his gaze at the back of the image, marking with the vanishing point the place where his gaze and the reflection of his body, where appearance and disappearance met, catching invisibility and incorporeality within a controlling grid of visibility deriving from the rationalized corporeality of the dominating subject of pictorial vision. The uprooting of that perspective and the exclusion of that vanishing point in Degas's dance pictures constitute the negation of the legible connection between body, gaze, and space, the elision and reversal of containing world and contained bodies, the problematization of the bodily basis of seeing and picturing, and a fundamental disturbance of the space of the viewer-subject, of the power to dominate arrogated to vision, and of the viewer's claim that to see was to be able to know, to measure,

distinguish, and judge, and to read. The orthogonal had been the means by which near and far were related and made legible, and by which bodies were measurably, legibly related to one another: the uprooting and warping of the orthogonal in Degas's dance pictures result in the collapse and disconnection of the near and the far, and in the disorientation of the body. Even the spiral stair at the edges of Degas's *Dance School* and *Dance Rehearsal,* a traditional means of measuring and comparing the scale of one figure to another (for Cassagne, who also wrote treatises for artists on anatomy and the body, the spiral stair was an ultimate demonstration of perspectival transparency and measurability), when cropped becomes an emblem of the disruption of measurability and transparency, for it emphasizes spaces and bodies which cannot be seen or measured against one another. Those spiral stairs help to stress the viewer's uprootedness and *in*ability to see and know, connecting that dislocation and disability to the disordering of the body within the viewer's partial purview. The stairs also signal the substitution of opacity for transparency, interruption and obstruction for the *Durchsehung,* and the anamorphic, unmeasurable ellipsis for the graphable, intersectable curve. Perhaps the best image of such space is seen in the original monochromatic *Ballet Rehearsal on Stage* (fig. 2)—the ellipse of its stage edge, connecting one margin and one black void to another, embodies the facts of collapse, elision, and disconnection, unreadable void and illegible, anamorphic space, implicating, yet avoiding and excluding the body and the gaze.

There is one last element of the dance pictures' dismantling of the terms of pictorial legibility and critical judgment to consider—and that is the element of time and temporal sequence. The old notion of the *coup d'oeil* referred not only to a single place and space, but also to a single moment in time. In addition, it embodied the precept of gestural *variety* within the larger construct of the single moment and the simple, clear composition. Degas's dance pictures refer to the old criteria of the unity of time, place, and action—they also provide for gestural variety within those unities. Indeed, they seem to caricature both the single moment of the *coup d'oeil* and to extend the possibility of gestural variety to its limit. Yet from picture to picture gestures are so often repeated as to become exaggeratedly uniform—the critics responded to this in their irritation at the obsessive quality of Degas's repetitions. And even within individual pictures, gestures repeat and echo one another so often that their variety begins to look like uniformity, variation like repetition, differentiation like replication. The most obvious examples of this are the three *Ballet Rehearsal on Stage* paintings (figs. 2, 5, 6), each with the same figure groupings, and the front-back variations of the cropped figure to the left. Related variations on themes appear in such images as the *Two Dancers on Stage* and the *Ballet Rehearsal* (figs. 69, 79), and in the *Dance Class* (fig. 24) and the *Dance Examination* pair (fig. 23), one of which was shown in 1876: again with the front-back variations of the dancer on the left, the repeti-

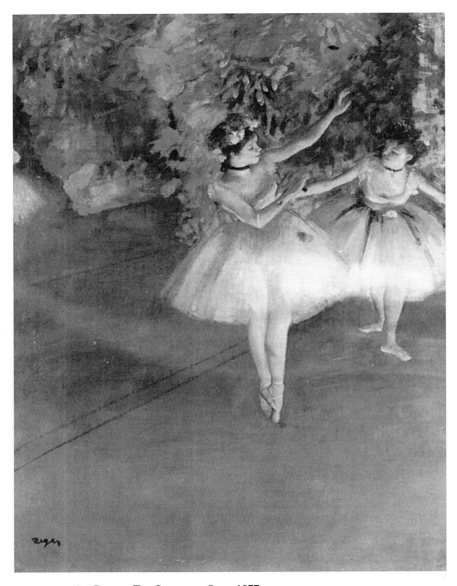

FIG. 69 Degas, *Two Dancers on Stage*, 1877

tions of the background dancers, and the displacement of figures like the dancer with her elbow stuck out on the far right of the *Dance Class* who is moved to the other side of the dance master in the *Dance Examination*. Similar repetitions and variations appear as well in the *Rehearsals* of 1876 and 1877 and the *Dance Schools* of 1876 and 1879 (figs. 19, 20). These are merely the most evidently paired and tripled images. The principle of repetition appears throughout the dance pictures and all of Degas's other preoccupations. Along with fragmentation, repetition is a signature of his

work. Ultimately, the effect of this exaggeration of the *coup d'oeil* and the *coupe d'aspect,* and of their caricaturing of the principle of the single moment, is the fracturing of all forms of singularity, the confusion of all the categories of sameness and difference, and the transmutation of temporal sequence into simultaneity and, vice versa, simultaneity into sequentiality. Both the single moment and the continuous temporal sequence are divided and multiplied into series of separate gestures and moments which are at once endlessly different and endlessly the same.

Degas referred to the old dramatic universe of body language and narrative painting through his focus on performative worlds like that of the ballet—in doing so, however, he collapsed, confused, and dismantled all of its criteria of construction and analysis, and all of the elements of the old readable, significant picture: the totality and hierarchy of the body; the technical order of the finished picture, with its careful, ordered combination of drawing, chiaroscuro, and painting, and its address to a critical eye informed in that technical order; the perspectival construction, its principles of continuity, transparency, and unity, its linking of vision, corporeality and incorporeality, intra- and extra-pictorial spaces, and its dependence on a dominant and controlling viewing-subject; and finally the principles of the single moment and the sequence, uniformity and variation, sameness and difference. The *Young Spartan Girls* was an early, partial example of the dissolution of the pictorial grammar of the *histoire,* and Degas's dance pictures, with their classical subject resonances, took up all of the elements of that pictorial grammar and worked them over, carrying them into the realms of confusion and repetition. And if the *Young Spartan Girls* linked this disruption of pictorial grammar to a sexual subtext, so the dance pictures used their deliberate compositional and categorical disarray to translate the text of the social body into the subtext of the sexual body. As we turn now to Degas's modern-life types less closely connected to the classical subject, we will begin to see how the processes of dismantling, repetition, and privatization were tied together. The dance pictures' involvement in undoing the grammar of making and judgment was at the same time a foregrounding of the viewer's and painter's *processes:* we will also see, in Degas's laundresses, *café-concerts,* and brothel pictures, how the interest in process per se grew out of an engagement in another tradition of readable, physiognomic imagery, that of caricature.

*

History painting was one major genre from which Degas derived many of his pictorial interests. Another area from which he derived his work was not a high-art genre at all, but a field of practice connected to the popular press, caricature—particularly that of Daumier. Degas copied and owned a large number of Daumier's lithographs.[18] The critics frequently pointed out the connection between his work and Daumier's: "powerful and true like a Daumier" (*"puissant et vrai comme un Daumier"*—Pothey, *La Presse,* 1876);[19] "It's a pity that M. Degas ruins his originality with a

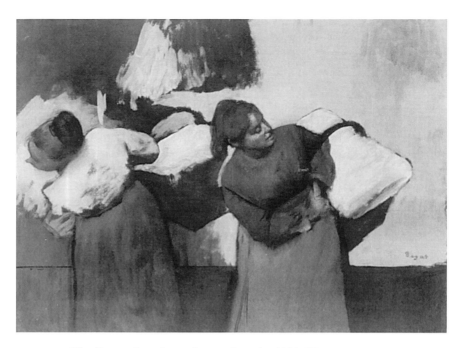

FIG. 70 Degas, *Laundresses Carrying Laundry*, 1876–78

burlesque facetiousness which becomes monotonous with repetition, be-
cause sometimes he encounters *characteristic features* [my italics] which
make one think of Daumier" (*"Il est dommage que M. Degas gâche son origi-
nalité dans des facéties burlesques que l'assemblage rend monotones, car il recontre
quelquefois des traits caractéristiques qui font songer à Daumier"*—Bergerat, *Le
Journal Officiel de la république française,* 1877);[20] "I ask myself if he wanted
to do caricature or painting . . . his dancer posing at the photographer's
could be a bad Daumier" (*"Je me demande s'il a voulu faire de la caricature ou
de la peinture . . . sa danseuse posant chez un photographe pourrait être de
mauvais Daumier"*—Besson, *L'Evénement,* 1879);[21] "Look at these *Laun-
dresses* (fig. 70) bending under the load of their baskets. From afar one
would say it was a Daumier, but up close it's much more than a Daumier"
(*"Regardez ces* Blanchisseuses *pliant sous le faix de leurs paniers. On dirait un
Daumier de loin, mais, de près, c'est bien plus qu'un Daumier"*—Silvestre, *La
Vie moderne,* 1879); "Mr. Degas is a rigorous draughtsman, of the family
of Daumier, though less sincere in his search for the caricatural side of
things which Daumier has already discovered" (*"M. Degas est un des-
sinateur rigoureux, de la famille de Daumier, moins sincère en ce qu'il cherche de
côté caricatural que Daumier rencontrait déjà "*—Burty, *La République française,*
1880).[22] Sometimes he was compared to other caricaturists as well: "M.
Degas is certainly the most original artist of the *pléiade.* No one, including
Gavarni and Grevin, has seen the world of the wings and the *café-concert*
in as humorous a fashion: *Women in Front of the Café during the Evening,* the

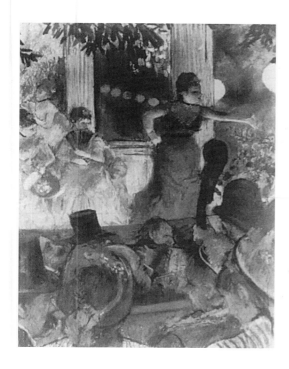

FIG. 71 Degas, *The Café-concert at the Ambassadeurs,* 1876–77

Dancer with the Bouquet [End of the Arabesque], The Chorus, At the Seaside, Dancers at the Bar, and the *Café-concert* (figs. 26, 4, 7, 16, 13, 71) represent a collection of little masterpieces of true and witty satire" (*M. Degas est certainement le plus original de la pléiade. Personne, y compris Gavarni et Grevin, n'a vu d'une façon aussi humoristique le monde des coulisses et des café-concerts:* Les Femmes devant la café, le soir, *la* Danseuse au bouquet, *les* Choristes, *les* Bains de mer, *les* Danseuses à la barre, *le* Café-concert *sont autant de petits chefs-d'oeuvres de satire spirituelle"—La Petite République française,* 1877).[23]

The link established between Degas's art and caricature served a variety of purposes. For one thing, it helped to define the artist as a certain kind of technician—a draughtsman. And like his history painting, his engagement in caricature belonged to his interest in the question of pictorial legibility. For caricature, like history painting, functions as a kind of pictorial text. But what kind? We have already seen how Degas manipulated the criteria of legibility and judgment attaching to history painting; in order to understand his engagement in the practice of caricature, we need to sort out some of the inherent differences between caricatural gesture and the body language of traditional narrative painting—the distinction will be fundamental to our understanding of Degas's borrowing of Daumier's motifs and gestures in his modern-life work of the seventies.

Caricature is an imagery constructed entirely of graphic gesture. Unlike that of history painting, however, its language is summarily descriptive rather than strictly narrative: a phenomenological, experiential structure

of expression rather than a discursive one. It is based on the descriptive and expressive verity of the graphic gesture rather than on pictorial phrases and sentences built out of interrelated limbs and movements. It is, in other words, a language of sensation constituted in the bodily movement of the artist himself rather than in a vocabulary of depicted gesture and pictured body language. Caricature operates by *concentrating* the expressive gesture, by minimizing, rather than maximizing, the complexities and intricacies of composition.[24] In a sense, then, though its concerns for textuality and illustration are similar, it lies at the far end of the spectrum from history painting. It is also allied to the concept of the "trait saillant."

Degas worked with the concentrated, phenomenological side of caricature, sometimes pushing the sensational nature of the caricatural gesture to the point of self-obliteration. This work in and on caricatural graphics is redoubled in the modern-life pictures of the seventies and eighties—in the work identified with the concerns of caricature: the laundresses, the *Orchestra,* the *café-concerts,* the ballet images, and finally, the two monotype series.

As the trajectory is commonly traced, Degas turned from a strict involvement in portraiture and history painting in the sixties to modern-life subjects in the seventies, most of which derived from Daumier's repertoire of Parisian physiognomies. The modern-life subjects treated earliest were those of the laundress and the racecourse, to which Degas had turned his attention already at the beginning of the sixties. The racecourse scenes (figs. 72, 73), only occasionally mentioned and even then hardly described at all by the critics when Degas showed them,[25] belong most obviously with the dance pictures: linked in Degas's mind,[26] they are often connected in the monographs on the artist. They share with the dance pictures both an engagement in physical performance and a claim to social position, for, like the dance pictures, they clearly belong to an upper-class world of entertainment.[27] The laundresses, on the other hand, repeated throughout Degas's oeuvre, belong to his preoccupation with female professional types—like the work of the dancers, singers, and milliners, theirs is a métier of confection connected to clothing and underclothing, and hence associated, in the literature on prostitution, with the clandestine practice of that métier as well. The laundresses are the earliest and clearest examples of Degas's dependence on Daumier. So it is with a brief study of them that we will commence our address to Degas's engagement in caricature.

The transformation wrought by Degas on Daumier's caricatural graphics is evident in early images like the Münich *Laundress* (fig. 74)—in the stressed, doubled drawing of the laundress's arms. Already, the drawing in this picture has become largely inexpressive, emphasizing the corporeal fragment and the sensation of movement per se more than anything else. It is drawing put to the service of dissolution: partly because of it,

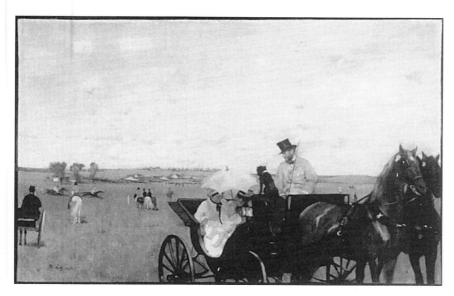

FIG. 72 Degas, *At the Racecourse (Carriage at the Races)*, 1870–73

FIG. 73 Degas, *In Front of the Stalls*, 1869–72

surface and contour come apart quite radically—as they never do in Daumier's paintings, such as his *Laundress* (fig. 75), in which painting is an extension of drawn contour. Yet in other ways the Münich *Laundress* is

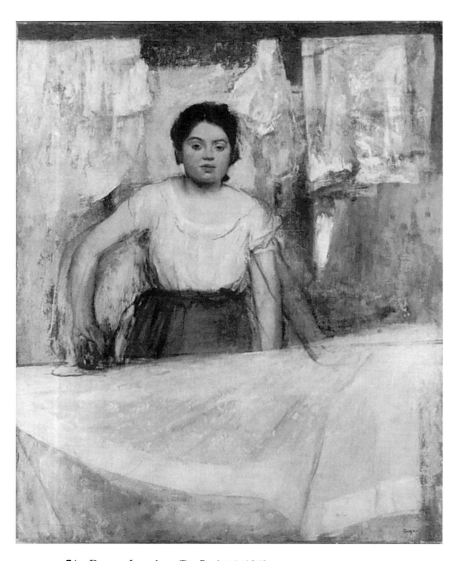

FIG. 74 Degas, *Laundress (Die Büglerin)*, 1869

a satisfying, fully described physiognomic image, replete with traditional chiaroscural modeling. In 1876, Baignères, writing about the *Laundress* shown that year (fig. 15), put it this way: "Look at that arm—look how well it is drawn! . . . How can a man, who in effect has delineated nothing, modeled nothing, who mixes everything in a vague layer of white, how did he manage to make such an arm, with its indications of bones and muscles?" (*"Voyez ce bras, comme il est dessiné! Comment, en effet, un homme qui n'a rien écrit, rien modélé, qui mêle tout dans une vague blancheur, a-t-il pu faire un bras avec des indications d'os et de muscles?"—L'Echo universel*). In later images, such as the two figures in the *Laundresses Carrying*

FIG. 75 Honoré Daumier, *The Laundress,* 1863

Laundry (fig. 70) shown in 1877, mentioned and connected to Daumier by the critics, Degas refers more obviously to Daumier's image as a source. It is in this picture that Degas's transformation of the caricatural medium comes most to the fore. The dark, burdened, exhausted forms of mother and child trudging up from the Seine in Daumier's image are brightened

in Degas's work into red and orange forms, removed from their defining urban context, reduced to the single form of the woman, and then doubled, front to back, to become, not a study of a particular urban physiognomy, but a pseudoclassical, frieze-like *étude* of the act of carrying—justifying the references to Nausicaa made by some of the critics. With Daumier as his source, Degas did the same thing as he did with his references to David's works: he obliterated the props, depleted the space, and blunted the tools of description and expression, and focused exclusively on movements, directions, and lacunae, on color and graphic sensations, in all ways minimizing the "text" of what started as a caricatural subject.

From the laundresses and racecourse scenes, Degas's modern-life imagery branched directly into his studies of urban performance. The earliest of these were his orchestra pictures (fig. 66) and the *Ballet of "Robert la Diable"* paintings mentioned in connection with the artist's history painting (fig. 65). As I have indicated, the pictures take their place, together with *Sermiramis* and *Mlle Fiocre in the Ballet "La Source,"* in a fairly straightforward evolution from narrative fictions to the theme of the *répétition.* They also belong to Degas's portrait oeuvre—for in addition to being genre pictures, they are group portraits.[28] The orchestra series leads in two directions: toward the *café-concert* pictures, with their wedges of audience in the foreground, and the ballet pictures, with their emphasis on fragmentation.

The orchestra series also derived from Daumier's imagery: from his pictures of singers, musicians, and spectators (figs. 76, 77). In the *Orchestra* of 1868 (fig. 66), Degas used Daumier's device of physiognomic and gestural repetition. The series of highly finished, detailed likenesses that make up the orchestra in the foreground are multiplied and overlapped to such a degree that each portrait likeness is interrupted by the other, each feature by the individual features of other likenesses. Because of its insistent interruption of continuous aperception, Degas's use of directional discord is disruptive: so sparingly and eloquently used in the Bellelli portrait, so stripped down and emphasized later, in pictures like the *Place de la Concorde,* in the *Orchestra* it is multiplied ad infinitum. The simple facts of gaze, physiognomy, and performing gesture are isolated for themselves—in place of the emotionally readable acts of yawning and stretching found in Daumier's imagery. That is true of the series of isolated eyes in the *Orchestra,* underlined by the presence of the onlooker to the left, echoing the foreground figure of the concertmaster on the right, and resembling those framed images in the background of some of Degas's other portraits, such as *James Tissot in the Artist's Studio* (fig. 50) and *The Bellelli Family* (fig. 54). It is also true of the series of partial physiognomies and isolated hands, like the hand of the flute player framing the profile of the bassoon player, whose hands, in turn, are separated from his person by his distended arm, and the great, undifferentiated patch of

black that describes his suit. Physiognomic fragments are isolated from gestural units, and from action, function, and profession—which, according to Duranty, were supposed to be all of a piece.

FIG. 76 Honoré Daumier,
*The Orchestra during the
Performance of a Tragedy*, 1852

FIG. 77 Honoré Daumier,
At the Champs-Elysées, 1852

Reading the Work of Degas

In the several series deriving from the *Orchestra,* the fragmentation of the physiognomic body would be emphasized, as would the transformation of the job of physiognomic and caricatural signification into that of simple physiognomic sensation. The *Ballet Rehearsal on Stage* series, like others of Degas's dance imagery—such as the 1879 *Dance School* duo referred to by Leroy and the critic for *La Vie parisienne*—was directly drawn from the *Orchestra* series: witness the violin and bass players, and the conductor-cum-dance master. The shuffling and multiplying of physiognomies and body parts found in the *Orchestra* series are to be found in these images as well. In addition to this, there are other, explicitly caricatural effects derived from the *Orchestra* series, such as the shortening or lengthening of certain body parts. One noticeable example of this is the distended arm of the dance master, especially in the final version of the *Ballet Rehearsal on Stage.* First seen in the *Orchestra,* this effect of caricatural distortion appears in many of Degas's dance pictures—the distended arms of the background dancers in the Glasgow *Dance Rehearsal,* the arm of *The Star* and the arm of the violin player in the Vermont *Dance School* (figs. 67, 25, 20). Its opposite, the cramping and stunting of parts, is also to be found; a good example of that is another *Orchestra*-based image, *The Dance Lesson* (fig. 78)—note the shortened leg of the dancer and the hunched figure of the violin player. These distortions result from the warping of isolated caricatural gestures, disconnected from a caricatural whole, as well as from the separate, concentrated study of individual body parts, gestures, movements, and individual physiognomic sensations. These are neither images of bodies studied as a whole, as in the legible body of narrative painting, nor as one large, single gesture, as in caricature. Rather, they involve the concentrated sensation of *parts.* As such, they are images of the dismantling of the physiognomic body, accomplished by distorting partialization. They are also images in which certain aspects of the language of caricature—distortion, for one—are isolated and studied for themselves, and in the process removed from their expressive, signifying contexts. From the Daumier-based *Orchestra* through all the series that derive from it, the language of caricature is used to destroy itself.

But perhaps the most obvious descendants of the Daumier-derived orchestra pictures were Degas's *café-concerts.* Undertaken between 1875 and 1880, they were briefly a major part of Degas's exhibited oeuvre—principally in 1877. (By 1880, he had largely dropped them as a subject.) For that brief moment they were read more thoroughly by critics than were any of his other subjects—perhaps because they fit the type of the modern-life physiognomic image better than Degas's other preoccupations. The following are two such readings from 1877—the first by the critic "Jacques" and the second by Georges Rivière:

> Nothing, however, touches the two *café-concerts.* In the first, the

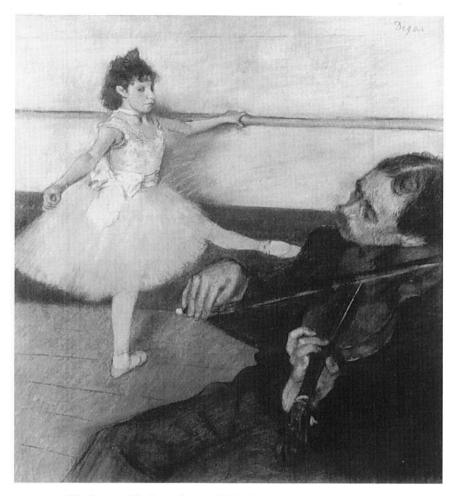

FIG. 78 Degas, *The Dance Lesson,* 1877–78

women forming a semicircle on the platform in their new toilettes, imposed uniforms whose play of contrary colors blend in the gaslight, listen enviously to their companion belting out a comical song, interspersing it with smiles and kisses, her mouth contorted, her shoulders hunched, her skirt half-raised, while the admiring musicians lean on their instruments and wipe off their sweaty foreheads.

Every type has been studied, every stance has been researched, every gesture is true. The whole thing practically smells of rice powder. And there, at the ghostly edge of the stage, one can sense the audience applauding, swooning in the heat, making themselves hoarse with cries of "encore!"

The studies of the boulevard cafés are no less interesting, no less complete . . . Indeed, there is perhaps a little too much focus on detail. But overall, these works constitute an incomparable page from a book of contemporary anecdotes.

Rien pourtant n'atteint les deux cafés-concerts. Les femmes, en rond sur l'estrade, en leurs toilettes neuves, uniformes imposés, dont les chatoiements contraires se fondent à la lumière vague du gaz, écoutent dans le premier, la compagne enviée, qui hurle une chanson comique, la bouche contournée, les épaules haussées, la jupe à demi-relevée, mêlée de sourires, et soulignée de baisers, tandis que les musiciens admiratifs s'appuient sur leurs instruments ou s'épongent le front en sueur.

Chaque type est étudié, chaque posture fouillée, chaque geste vrai. Des senteurs de poudre de riz s'épandent alentours; et, dans la bordure blanche du passe-partout on devine le public qui se pâme, applaudit, et s'époumonne à bisser.

Les études des cafés du boulevard ne sont pas moins finies ni moins curieuses . . . Il est permis de critiquer une certaine accentuation des détails. Mais l'ensemble constitue une page incomparable du livre anecdotique contemporain. ("Jacques," *L'Homme Libre*)

His studies of the *café-concerts* will make more of an impression on you than the place itself . . . There is one *café-concert* with a woman in a red dress [*The Café-concert at the Ambassadeurs*—fig. 71] accompanied by vulgar gestures!

This woman, can't you guess, is a liquor-drenched contralto. The ideal of the public! How carefully that gesture and that voice must be studied by some pretty *marquise* in the silence of her boudoir—for she will earn the bravos of her friends when she sings: *Am I a woman of cardboard?*

The gesture of the singer who leans toward the public is extraordinary; it is necessarily the result of a success. This woman does not have what actors call a *trac;* no, she harasses and interrogates her public, knowing that it will respond according to her desires, to her who is mistress of the despot whose vices she flatters.

And then there are those women at the door of the café in the evening. One of them clicks her nail against her teeth, as if to say, "and not only that"—which is a poem in itself. The other splays her huge, gloved hand on the table. In the background, the noise of the boulevard diminishes little by little. That too is a truly extraordinary page out of a story!

Ses études sur les cafés concerts vous font bien plus d'effet que l'endroit lui-même . . . Il y a un de ces cafés concerts avec une femme en robe rouge accompagnée de gestes canailles!

Cette femme, n'est ce pas? vous le devinez, est un contralto trempé dans le rogomme. L'idéal du public! Comme ce geste et cette voix doivent être soigneusement étudiés dans le silence du boudoir par une jolie marquise qui briquera les bravos de ses amies lorsqu'elle chantera: Suis je une femme de carton?

Le geste de cette chanteuse qui pend vers le public est extraordinaire; il est nécessairement le résultat d'un succès. Cette femme n'a pas ce que les acteurs appellent le trac; non, elle interpelle le public, elle l'interroge, sachant qu'il repondra selon ses désirs, à elle, maîtresse du despote dont elle flatte les vices.

Puis voici des femmes à la porte d'un café, le soir. Il y en a une qui fait

claquer son ongle contre sa dent, en disant, "pas seulement ça" qui est tout un poème. Un autre étale sur la table sa grande main gantée. Dans le fond, le boulevard dont le grouillement diminue peu à peu—C'est encore une page d'histoire bien extraordinaire. (Rivière, *L'Impressionniste*)

"Jacques" picked out the boulevard types in Degas's *Café-concert at the Ambassadeurs* (fig. 71) and his smaller Corcoran *Café-concert* (fig. 81) and described them in naturalist fashion, befitting a "page from a book of contemporary anecdotes." For his part, Georges Rivière picked out several telling gestures from the exhibition of that year—the "geste canaille" of the *café-concert* singer, and the gestures of the *Women in Front of the Café during the Evening*—and tried to make them the basis of his own short and incisive "page d'histoire."

So it was Degas's *café-concerts* which elicited the largest, firmest claims about realist readability. Yet there is something peculiar about these readings and their fit with the images they indicate. On the one hand, "Jacques" evokes a minor flirtation and a general enthusiasm as the anecdotal ingredients of the Corcoran *Café-concert*. In fact, however, his reading misses the essential vulgarity of the singer's relationship to her unseen public. On the other hand, Rivière evokes a mood of harassment, confrontation, and interrogation that is a little too strong for the gesture of the singer in *The Café-concert at the Ambassadeurs*. Where exactly is that responsive, vice-ridden public whose passions she rules? And these are the incidents of the *Women in Front of the Café during the Evening* (fig. 26), as described by Rivière: a thumbnail against the teeth, a hand flat on a table, the city defined as diminution, disappearance, and undefined distance, the comment: "pas seulement ça," referring perhaps to a stingy client.[29] Whereas Rivière's description of the *café-concert* is a bit too lurid, his account of the two prostitutes in a Montmartre café is indeterminate and understated.

These images become the spaces of a free play of decipherment and detective work, of gestures and physiognomies which can be underread, or overread, in any way you like. This is so partly because of the nature of the gestural and physiognomic information given in them. The Corcoran *Café-concert* and the *Singer with the Glove* (fig. 21) both contain explicit, "canaille" gestures, yet what are they but so many studies of jabbing hands, bent wrists, open mouths, so many abstractions of the vulgar in general: the specific vulgarity, the particular obscenity is hard to locate. The same may be said of the *Women in Front of the Café*, where the explicitly vulgar gesture of the prostitute is carefully framed, yet rendered simply as a motion, a gesture *quelconque*, signifying little else but the *feeling* of the gestural life of the street. Like the set of laundress images and the orchestra pictures, the *café-concert* series represents a transformation of Daumier's gestural studies and compositional formats—this is true of *The Café-concert at the Ambassadeurs* in particular: in which the bits of profile and accoutrement constituting the audience are obviously caricatural

in derivation, as clearly related to the formats of Daumier's images as are the *Orchestra* and the *Ballet of "Robert le Diable"* suite. Also like the laundress series, however, *The Café-concert at the Ambassadeurs* deploys the language of caricature almost in order to destroy it, exaggerating, isolating, partializing, and disordering its constitutive elements. For when compared to the exhausted back of the worker and the dejected, dissipated profile of the bourgeois in Daumier's *At the Champs-Elysées* (fig. 77), the profiles and backs in Degas's *Café-concert at the Ambassadeurs* are blunted and fragmented: again we derive nothing from them but the general sensation of a lowlife experience. Witness the transformation of the black projecting top hat in Daumier's image into an ownerless object on the left and a positionless projectile on the right, and the clear division of foreground, middle ground, and background in Daumier's image into a sea of fragments: pieces of costume, instruments, and facial features. In 1877 one other critic went so far as to indicate the paradoxical destruction of the *trait saillant* in the face of Degas's concentration on the process of physiognomic sensation: "Attitudes, contours enveloping his figures, clothing, he cares only about that and nothing but that. Do you wish to see their features? M. Degas will absolutely forbid you to do so. Are there by chance no features in nature?" (*L'attitude, le contour enveloppant ses personnages, le vêtement, il se soucie de cela et rien que de cela. Avez-vous envie de regarder leurs traits? M.Degas vous le défend bien. Est-ce que par hasard des traits ne seraient pas dans la nature?*—de Lora, *Le Gaulois*).

Another element of the *café-concert* pictures which contributed to the readings they received—and to their transformation of Daumier's language of caricature—was the presence of a monotype base. Many, in fact about one-fourth of Degas's work in pastel, gouache, *peinture à l'essence*, and so on, have that monotype foundation, including, most consistently, the *café-concert* pictures: the *Café-concert at the Ambassadeurs*, the Corcoran *Café-concert*, the *Singer with the Glove*, and the *Women in Front of the Café during the Evening*.[30] In each case, the monotype base is the source of Degas's play of gestures and mugs. It is also the level where elisions and absences are established and where gestures begin to be effaced, where dissolution begins.

Monotypes are created by drawing directly on a plate in greasy ink (the "light ground" method), or by covering a plate with ink and then rubbing it away to make a negative image (the "dark ground" method). They are then transferred to paper in a printing press, reversed and effaced in the process, for the image on the monotype plate is impermanent—as each successive impression is made and the ink is removed, the image disappears; only two to three pulls can be taken. Based on quick, large gestures, the monotype lends itself to caricatural treatment, but it is also a medium into which effacement is built. Certainly that is the way Degas used it, in the second, half-disappeared impressions which he favored as the foundations for his colored modern-life images (see figs. 79,

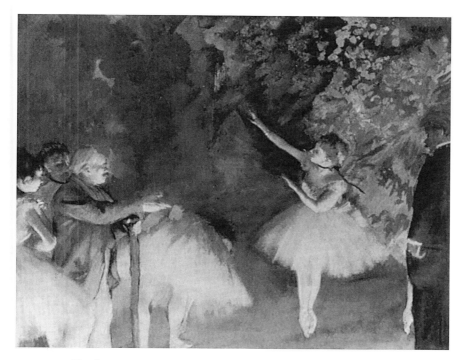

FIG. 79 Degas, *Ballet Rehearsal,* 1875

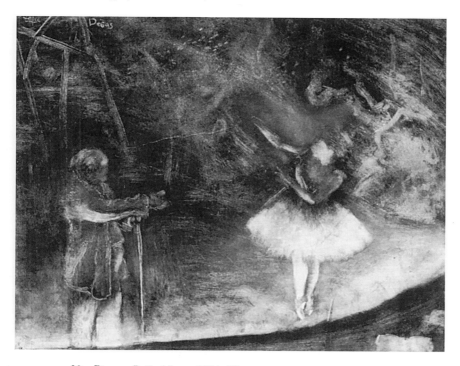

FIG. 80 Degas, *Ballet Master,* 1874–75

80 for Degas's first monotype and the pastel variant that derived from it)—as in the second impression of the dark-ground monotype image which lies beneath the pastel surface of *The Café-concert at the Ambassadeurs*. In this work, the monotype base helps to establish a vulgarized version of Daumier's caricatural image, heavier, thicker, and messier than its caricatural derivation, both exaggerating its caricatural dimension and obliterating it, by erasing observational nuances and the information they provide and by dissolving the distinction between gesture and ground, depicted movement and material support—as is the case with the singer's blurred arm.

The monotype base also appears to have been a kind of anticompositional ground for Degas—a chiaroscural foundation which reverses the traditional role of chiaroscuro. (He was interested in the traditional chiaroscural ground across his work. It is clearly seen, for example, in the first, monochrome version of the *Ballet Rehearsal on Stage*—fig. 2.)[31] In the monotype ground of *The Café-concert at the Ambassadeurs,* the lights and darks of the composition are polarized, rather than graded and fused as in traditional chiaroscuro. The chiaroscural foundation is laid down *beneath* the drawn details of facial features and clothing folds, rather than on top of them. It severs the monochrome ground from the colored surface, rather than joining them—for the pastel seems to float above the monotype base. It shows through the pastel—in the obscure void of the boulevard, the gesture and face of the singer, and the physiognomies of the audience. Thus it undermines pictorial surface, rather than cooperating with it. Finally, and most importantly, it denies substance and volume to the descriptive details of the image—fundamentally negating the traditional role of chiaroscuro. For the monotype foundation of *The Café-concert at the Ambassadeurs* is literally a negative—it describes empty, murky space into which bodies disappear, rather than positive object-volumes or anatomical structure. The exposure of the monotype ground in the colored version tells us that where there is not pastel surface there is nothing, only shadows defining emptiness and absence, hollow faces and disappearing limbs.

The undermining use of the monotype base is not peculiar to the *café-concerts,* however—it is also found in the dance pictures, many of which also have monotype foundations. As for the pastel surface, it is hardly descriptive or cohesive itself: extremely partial in its work of localization and particularization, it tends toward the further obliteration of detail, gestural specificity, and the boundaries between spaces and figures. Deliberately anticohesive, the *café-concerts* are predicated on a fundamental ground of dissolution, and covered over in a brilliant *couche* of obliterative color. So the monotype foundation supports both the caricatural dimension of the *café-concerts* and the dissolution of the language of caricature. Tied to a technique of physiognomic rendering, it also disrupts it, mirroring the destructuring of critical criteria found in Duranty's writing, as well

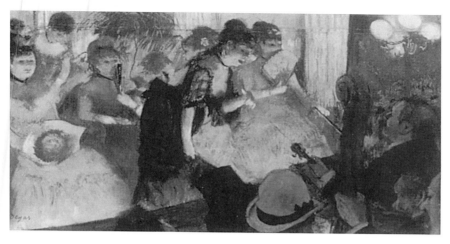

FIG. 81 Degas, *Café-concert (Cabaret)*, 1876–77

as his conflicted program of realist legibility. In short, the monotype base forms an important groundwork for both the effects of descriptive, caricatural sensation and those of semiotic indeterminacy found in the readings of specific *café-concert* pictures, and in the general claims about the realist legibility of Degas's work.

The series of images deriving from Daumier's work—the laundresses, the orchestra series, and the dance pictures which devolved from them, and the *café-concerts*—all filtered Degas's larger dismantling of pictorial legibility through the medium of caricature. Caricature was *the* form of nineteenth-century pictorial physiognomics and as such an important concern in the domain of realism. But from the seventies to the turn of the century, the art of caricature was increasingly aestheticized and neutralized. Daumier's own earlier turn—partly in response to censorship of the press—to generalized typologies of class and profession rather than specific political satire, and to the medium of painting, was part of that tendency. So was the interest in caricature and other kinds of popular imagery shared by realist writers like Champfleury, who elevated an industrial/artisanal, mass-media practice into the domain of high art, if only by treating it canonically. Indeed, around the same time that Degas produced his caricature-based series, Daumier's reputation was also being canonized and depoliticized, while his imagery was being given the stamp of aesthetics, which effaced the stigma of politics—his retrospective of 1878 was more or less contemporary to Degas's most insistently caricatural works.[32] So Degas's transformation of caricatural significance into caricatural sensation, and his articulation and dissolution of the elements of caricature, were also part of the larger drive toward the depoliticization and privatization of realism. Just as Duranty's writing was a bourgeois

revalorization of *Réalisme*, so Degas's dealings in the types and tools of the urban picture press were a post-1848 revision of the practice of caricature and of its prime subject, the city.

*

Degas's dissolution of the language of caricature, and with it the language of physiognomic depiction, had something to do with the city in which he worked and the new urban typology that went with it. The free but indeterminate play of physiognomic interpretation which his images seemed to solicit was also encouraged by the new spaces and classes of the Haussmannized city.[33] Foremost among the spaces of the new city were the boulevard cafés, with their celebrated lowlife entertainers, their mixed clientele, and their guidebook promotion.

Another important representative of the new city was the prostitute, fast becoming a popular literary type and, throughout the seventies and eighties, the disguised dominant subject of Degas's modern-life imagery. Between 1879 and 1880, just prior to the *Famille Cardinal* illustrations, Degas turned to the direct representation of prostitutes in their brothels, in a private series of monotypes never meant to be seen by any sort of public. In these all of the caricatural and physiognomic concerns of his more "public" pastels and paintings were worked out much more explicitly.

Because of their privacy, Degas assigned these monotypes pride of place. Connected to the monotype foundations of his pastels, and in particular to the repetitiousness and the privacy-preoccupied aspects of his dance pictures, they are linked as well to his illustrative ventures, for the brothel monotypes also came to be thought of as illustrating texts, namely, the tales about prostitutes told by the Goncourts, de Maupassant, et al.[34] They are even less specifically illustrative of any of these tales than the *Famille Cardinal* series would be of Halévy's stories, but I think it is fair to say that they were taken up in a general spirit of illustration, and that, since they were executed at the time of the greatest spate of prostitute fiction, they may be linked in an equally general way to the literature on prostitution.

Though it was unambiguously designed as a set of illustrations, the slightly later *Cardinal* series was a deliberate failure as such, as we have seen. But as a series it also demonstrates very clearly that Degas used the monotype medium to transform the caricatural language of Daumier's modern-life imagery. For example, the image of *Ludovic Halévy Meeting Mme Cardinal Backstage* (fig. 38), based on Daumier's *Mother of the Singer* (fig. 82), is a clear pastiche of Daumier's caricatural techniques. Caricatural in its emphasis on exaggerated profiles and summarized features—and in its replication of the profile of Mme Cardinal in the fat, double contours of the *coulisses*—this image is *anti*caricatural in its physiognomic elisions, literally scribbling and rubbing out the descriptive efficacy of Daumier's caricatural graphics.

pl. 1 Degas, *Duranty* (detail), 1879

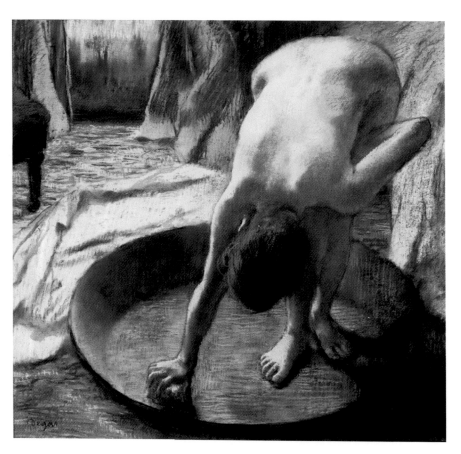

pl. 2 Degas, *The Tub,* 1886

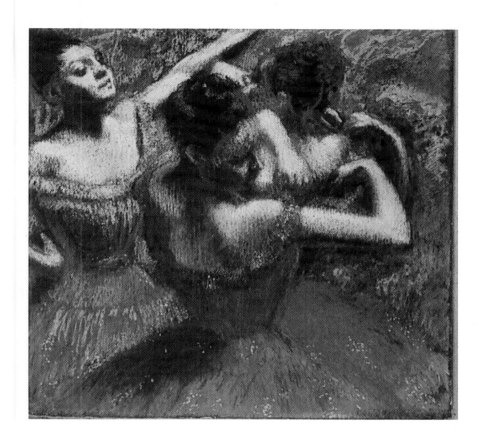

pl. 3 Degas, *The Dancers*, 1899

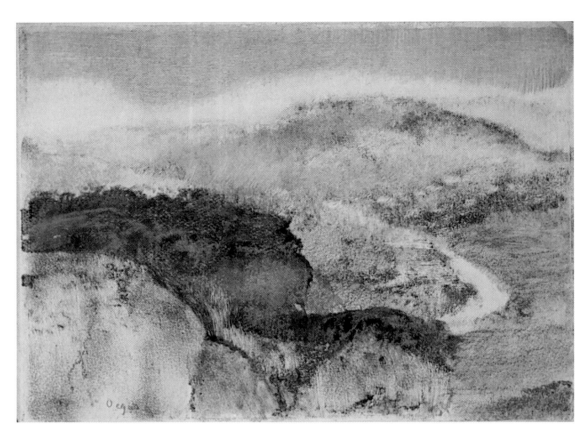

pl. 4 Degas, *Landscape,* 1890–93

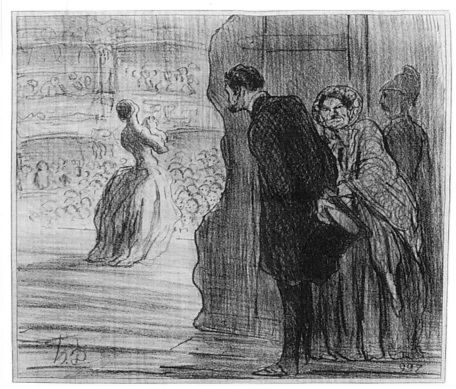

FIG. 82 Honoré Daumier, *Mother of the Singer,* 1856

The *Cardinal* monotypes also tell us something of Degas's actual attitude toward the illustration of a realist text and toward pictorial narration. Moreover, they help to demonstrate the degree to which Degas's art was pulling away from the type of reading that Duranty's writing provided for. In fact, they make a better fit with the language of the ironic critics— if the litany of the critics was a caricature of the exhibited pictures, these monotypes in their turn are a kind of caricature of the critics' language. All *barbouillage,* more genuinely messy and dirty, and more illegible than the exhibited pictures are, in the end the *Cardinal* monotypes so effectively efface physiognomic sensation and realist information that they cannot even be included in the same field as Duranty's difficulties. (Effacement is one of the dynamics of the succession of black smudges rendering the *raconteur,* Halévy himself, from image to image; it occurs in the scribbled, scrubbed-out forms of dancers and *abonnés,* and in the artist's emphasis on faded, virtually disappeared second and third impressions— fig. 36.) Their work of erasure is too complete. The same may be said, much more emphatically, of the earlier set of brothel monotypes as well.

In depicting the illicit underworld of the Haussmannized city, the brothel series also makes the subtext of Degas's colored pictures of urban

spectacle and artifice quite obvious. For one thing, the brothel monotypes make it even clearer, though they do so privately, that the female métiers chosen by Degas were associated with the literature on prostitution and its clandestine practice.[35] They also have something to say about the gestural life of the pastels, particularly of the ballet pictures.

In the brothel series, the women of Degas's "public" pictures are stripped naked of their spectacular costumes and their choreography, and reduced to displayed parts, ugly mugs, and masturbatory, scatological, and ablutionary gestures (figs. 83–86).[36] The corporeal dishevelment that characterizes them is defined as a function of their profession and their consumption, but also of an extremely private level of bodily life, indeed of homo- and autoeroticism—theirs is a self-absorption of an explicitly genital nature. The brothel monotypes constitute an imagery of human gestural life completely stripped of its public, representational functions—the body and the face explicitly *not* doing their job of rendering themselves coherent or significant in Duranty's physiognomic terms: as signs of sex, age, class, profession, personal history, and temperament. Or perhaps it would be better to say that they reduce the signs of profession so crucial to Duranty to those of sex. What is insidiously true of the "public" ballet pictures is blatantly stated in the private brothel series.

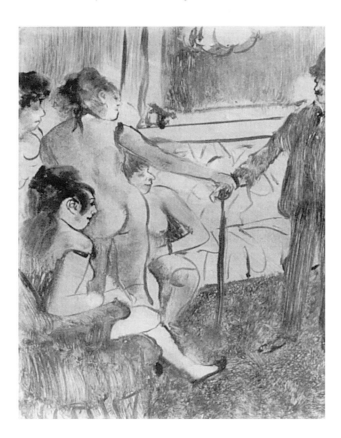

FIG. 83 Degas, *The Serious Client*, 1879

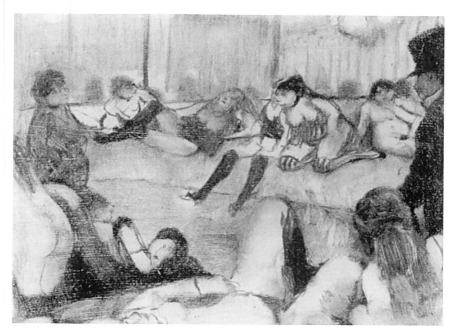

FIG. 84 Degas, *In the Salon,* 1879

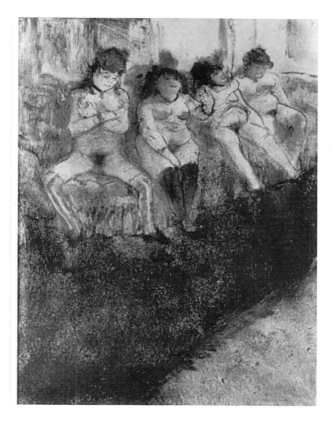

FIG. 85 Degas, *Waiting,*
1879

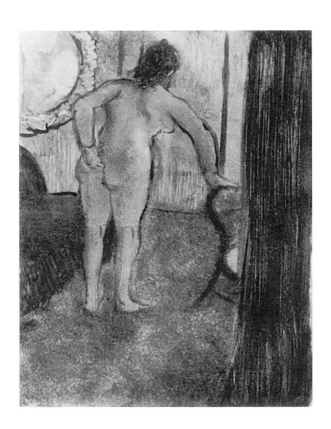

FIG. 86 Degas,
*In the Salon
of a Brothel,* 1879

In the brothel monotypes, sexual signs are clearly and coarsely repre-
sented—breasts with nipples, hairy pubises, buttocks, thighs, stomachs,
black stockings, and manes of hair. Yet those signs are jumbled, strewn
about the monotype page in disowned, dismembered fashion: the brothel
becomes a realm where the most basic bodily signs are disconnected and
left at the absolutely base level of bodily parts and sensations. Moreover,
the brothel monotypes are full of the effacement seen in the *Cardinal* se-
ries. Like the dancers in the *Cardinal* series, the figures of the prostitutes
in all of the monotypes are bodied forth in crude caricatural lines, their
features and gestures brutally elided, barely readable as eyes and mouths
capable of physiognomic movement, or as limbs capable of the significant
motions of flexing and relaxing. Their bodies, like the spaces which sur-
round them and the clients who stand before them, are rendered as
thumbprints, erasure marks, and hit-or-miss smudges, as patches of clean
and dirty paper. So the brothel becomes a very particular field of oblitera-
tion and almost scatological waste—*ordure,* in French [37]—of effacement
and *def*acement as well. Delineating graphics are redefined as scribble
pure and simple, caricature is transformed into *barbouillage* more bluntly
even than would be the case with the *Cardinal* monotypes. The facts of

Chapter 3

gesture and corporeality are described as little more than the residue of a touch which effaces as it creates—witness the smudged body of the principal prostitute in *The Serious Client,* and the gestures, as elided and smudged as they are explicit, of the prostitutes in *In the Salon* (fig. 83, 84). On the level of subject matter, these are images of body parts caught up in the sensation of themselves. On the level of facture, they are simply smudged, obliterated traces of Degas's own gestural life, of his physical contact with ink and paper. The thumbprint, eliding the mark of his own body—the blunt trace of his hand on paper—with the indications of the bodies of others, the prostitutes, is a kind of emblem for the peculiar gestural life of these pictures. The trace of the artist's own gesture and the depicted gestures of the prostitutes are one and the same: private, both constitutive and obliterative, returning the gesture back to its ground on both levels—back to the *tabula rasa* of white paper and blackening marks on the one hand; back to the brute physicality, the *phenomenon,* of the body on the other.

The brothel monotypes tell us much about the dissolution of physiognomy and caricature, of descriptive and narrative space found in the rest of Degas's work—in the *café-concert* and the ballet pictures, in the portraits, the history pictures, and the illustrative images. Not only has the expressive physiognomic world of Daumier's caricatures been taken apart, it has also been made to regress. In this private space and this private medium, both the graphics *and* the gestures of the human body are explicitly "hunted back" to the corporeal, animal ground of their genital and scatological origins.

It is perhaps no accident that this reads like a caricature of Clement Greenberg's famous trajectory: from representation and literary content to pure pictorial form—painting "hunted back to its medium."[38] The particular way in which this trajectory must be traced in Degas's works accounts in part for his marginal place in the writing of the history of modernism. For his was not so much a project of liberation from representation as a struggle within and against it, at once reconstituting and negating it. He was never free of it, not when he worked on interiorizing the physical life of the gesture, not when he insisted on exploring the boundary between physiognomic expression and effacement, between caricature and its erasure. His was a practice deeply embedded in the particular demands of physiognomic representation, pertaining both to the classical pictorial culture in which he was trained and to the realist tradition; Duranty and the other realist critics were not wrong to see this. That is another reason for Degas's marginality in the modernist trajectory: his entry into what we call abstraction was accomplished, not in terms of the free celebration of surface per se, but in the traditional terms of corporeal representation and its negation. His engagement in surface was arrived at by a different route: by replacing the old bond between corporeality and representation with a new, difficult union between ges-

ture and surface. This was a union which necessarily incorporated the activity of structural dissolution and formal obliteration into itself, and whose materiality could not be disassociated from the body. Thus Degas's work, set against Duranty's theory about it, suggests that we might see the journey toward abstraction described by Greenberg a little differently: less as a turning away from literature, and more as a turning-inward, a collapse of language into materiality; hunting back not only to the medium but also to the body, the private, primitivized body of modernity, severed from its sociability and its historicity.

Against the Grain: J. K. Huysmans and the 1886 Series of Nudes

In one of the early monographs written about Degas after his death in 1917, the German art historian Julius Meier-Graefe would write the following:

> Degas stripped off his classicism in the riot of luminous color. The substratum of bourgeois Empire was supplanted by a new conception of Gothic art, and what is Gothic in Degas is Gothic in the severest sense. Gothic line, but tenser, more jagged, more shadowy than any of the primitives of France . . . Degas rejected all softness, he seized an ankle, but not the flesh. The puppets which nestle together softly in Ingres move by taut wires in Degas, and their motion is the dance of death. Not a sound emanates from their mummified faces. Bones have expressions and human backs are bent in anguish, arms howl and legs whine . . . and the dusk resembles the depth of a mighty chord. . . . His color is determined not to stimulate the appearance of reality. The unreal elements are made visible by Degas. His structures lay claim to the term anatomy, but composed out of visionary skeletons. There is something like the wings of tropical butterflies in the depths and chasms of his work, and in their dust sunlight lies concealed, as in the spotted tongues of twisted orchids. His blues, purples, his oranges, his greens, and his pinks are like exotic plants, a decomposing process supplies the rare tones of his colors. . . . There are pastels of *danseuses* which leave us with an impression similar to fragments of enormous friezes. We can imagine the Pantheon decorated in this way. His dancers cease to be mere *balleteuses,* just as the ancient warriors in the Pantheon frieze have surrendered their objectivity and have become the servitors of divinity . . . dancers multiply and seem to grow . . . They are more akin to colored expressions than to human beings. Their flesh . . . resembles the rind of trees in a primeval forest. Their clothes are like the scales of salamanders . . . The glory of it all gives a sense of hierarchic festivity to the delight we experience. (Meier-Graefe, *Degas:* 79–81)[1]

Strikingly different in tone from the criticism which surrounded Degas's work in the 1870s and early 1880s, this passage was clearly written about the artist's later, more coloristically vivid series. The vocabulary in this passage is distinctly *not* that of realist criticism—indeed, the notion that Degas's late art was reflective of the "bourgeois Empire" is counter-

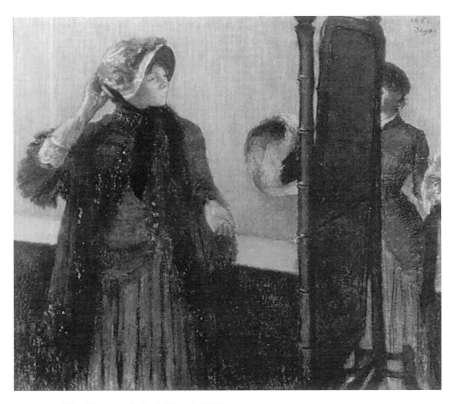

FIG. 87 Degas, *At the Milliner's,* 1882

manded at the beginning. Instead of references to writing on the art of the merchant nation of seventeenth-century Holland, there are references to the Gothic, to the primitives, and to the bodily style of medieval work: howling arms, whining legs, and the dance of death. And instead of the language of realist physiognomics, we find resonances of art-nouveau organicism, symbolist analogies to music, and synthetist color—even a kind of syphilitic palette: "a decomposing process supplies the rare tones of his colors."

Meier-Graefe's passage, then, has more to do with the writing of the symbolists than it does with that of the realist generation. It is closest to the language of the reviews and essays written in and after 1886: Fénéon's and George Moore's treatment of Degas's work, and of course, Huysmans's *Certains,* spring immediately to mind. Indeed, the language of Meier-Graefe's monograph on Degas would not be what it is without the generation of 1886, and without the final impressionist show of that year. For 1886 was the year of the emergence of a new group of literati and the beginning of the publication of a series of symbolist reviews, each promoting new theories of meaning and sensation in painting and literature.

Besides being the year in which many of the symbolist *revues* began, and with them a new brand of critical discourse, 1886 was also the year that marked the final terminus of the old association of impressionist painters, and the emergence of new names and new exhibiting concerns. Coming after the factioned exhibitions of 1880 and 1881, in which Degas and his cohorts had dominated the scene; that of 1882, when they backed out and were replaced by Monet's coterie; the following three years of silence; and then the final refusal of Monet, Renoir, and Sisley to exhibit with the group one more time, the last impressionist show was characterized both by the falling away of many of the old members of the group, and the presentation of works by painters with neo- and anti-impressionist tendencies. It contained an odd assortment of works by Cassatt, Morisot, Pissarro, and Degas, the only remaining "impressionists" in the group; by Degas's friends Forain, Rouart, Zandomeneghi, Mme Bracquemond, et al; by Gauguin, who had shown with the group before (in 1880, 1881, and 1882); and by the newcomers Redon, Schuffenecker, Seurat, Signac, and Pissarro's son Lucien. It was the group of newcomers which made its mark in 1886. At least one critic stressed this fact: "Impressionism now has two manners. It's the new one which dominates the present exhibition and gives it a particular character." (*"L'impressionnisme a maintenant deux manières. C'est la nouvelle qui domine à l'exposition actuelle et lui donne un caractère particulier"*—Paulet, *Paris.*)[2] As far as the old "impressionists" were concerned, the exhibition of 1886 underscored their dissolution.

It was against this background of dissolution that Degas presented his most consistent, his most explicitly *serial* series to date. His catalogue listings for 1886 included two pictures of milliner's shops (fig. 87—*At the Milliner's*), one or two miscellaneous portrait sketches, and a series of ten nudes. (Actually he probably exhibited only a half dozen of these.) The series of nudes was the group of pictures that Huysmans, Fénéon, and the other critics described with the difference of 1886. These were listed in the exhibition catalogue under one title, as a *"Suite de nus de femmes se baignant, se lavant, se séchant, s'essuyant, se peignant ou se faisant peigner"*—or, translated: "A series of female nudes bathing, washing and drying themselves, wiping themselves down, combing their hair, or having it combed." The nudes included in the series were the following: the Pearlman *Baker's Wife* (fig. 88), the Orsay *Tub* (fig. 89), the Tate *Woman in the Tub* (fig. 90), another *Woman in the Tub* (fig. 91), and the Metropolitan *Woman in the Tub* (fig. 92) and *The Toilette* (fig. 93), and possibly the Metropolitan *After the Bath* (fig. 94), the Orsay *Woman in a Bath Sponging Her Leg* (fig. 95), another *After the Bath* (fig. 96), and the Farmington *Tub* (fig. 97).[3]

Degas's submissions to the earlier shows had been marked by an occasional insistence on deliberately exceptional, nonimpressionist pictures— not only the *Cotton Office* and the *Stock Exchange*, but also pre-impressionist pictures, such as *Rose Adelaide Aurore de Gas, Duchesse Morbilli* (fig. 98), painted in 1867 and shown in 1877, and the *Young Spartan Girls* painted in

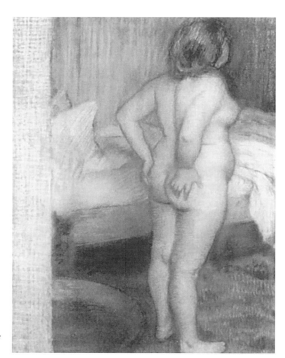

FIG. 88 Degas, *The Baker's Wife*
(The Morning Bath), 1886

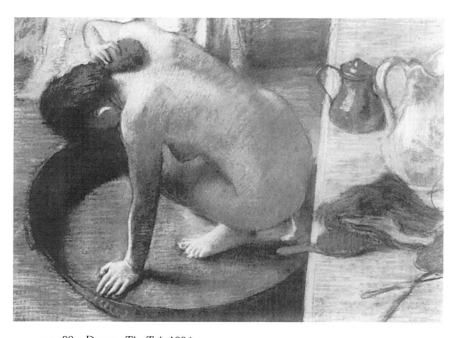

FIG. 89 Degas, *The Tub*, 1886

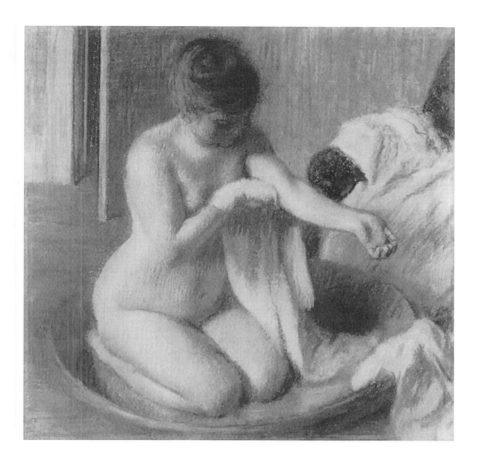

FIG. 90 Degas,
Woman in the Tub, 1885

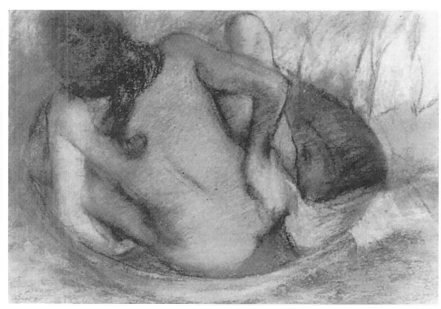

FIG. 91 Degas,
Woman in the Tub, 1884

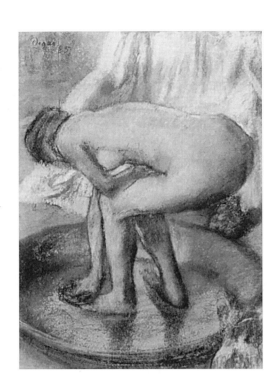

FIG. 92 Degas,
Woman in the Tub (Woman
Bathing in a Shallow Tub), 1885

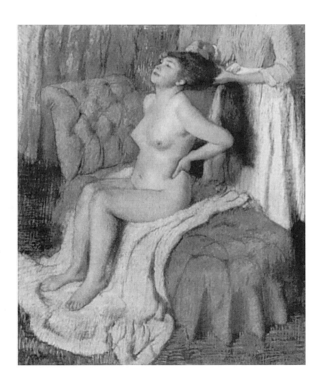

FIG. 93 Degas,
The Toilette (A Woman
Having Her Hair Combed)
1885

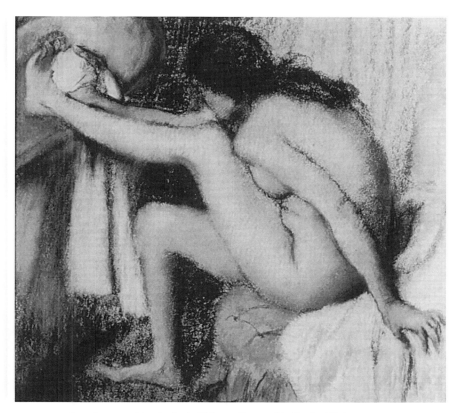

FIG. 94 Degas, *After the Bath (Woman Drying Her Foot)*, 1886

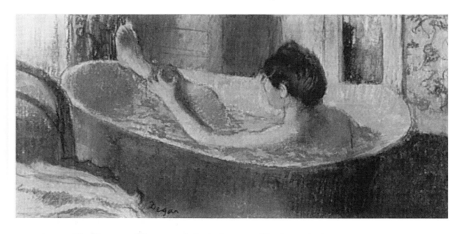

FIG. 95 Degas, *Woman in a Bath Sponging Her Leg*, 1883

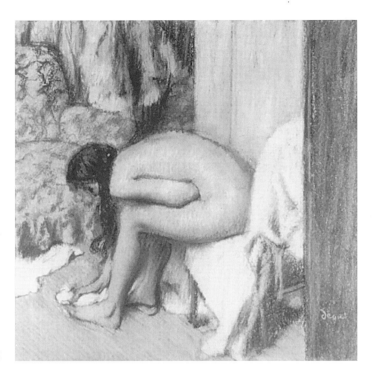

FIG. 96 Degas,
After the Bath, 1886

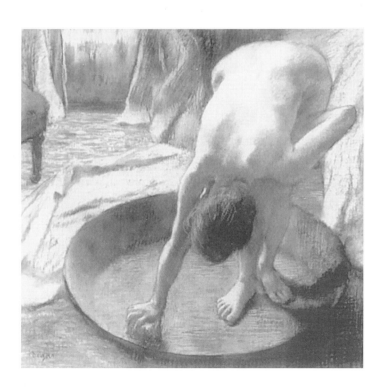

FIG. 97 Degas,
The Tub, 1886

1860 and meant to be shown in 1880. They had been characterized by a refusal to match up—not only with Degas's own contemporary work but also with that of the impressionist group as a whole—and critics had noticed this. Now, in 1886, in the context of the group's closing miscellanea of works, in the midst of pictures by newcomers, Degas's series of nudes was unwontedly consistent as a body of work. One critic picked out Degas, as well as Pissarro, not only as representative of the old impressionism, but also as the most concentrated and personal of the remaining group: "MM. Degas and Pissarro distinguish themselves, in this context, as artists of the highest worth. In this show they shine not so much by their singularity as by their talent. Both of them belong to militant impressionism through their past. But here they have merely shown themselves to be personal artists which no school can really claim." (*"MM. Degas et Pissarro s'y distinguent comme des artistes de la plus haute valeur. Ils y brillent non par la singularité, mais par le talent. Tous les deux appartiennent à l'impressionnisme militant par leur passé. Mais là ils se montrent seulement des artistes personnels qu'aucune école ne saurait réclamer"*—Paulet, *Paris.*)

In essence, then, insofar as the last impressionist show was "impressionist" at all, it was Degas's show—a kind of final grandstand. His were the only submissions which could be described as forming any sort of united front; his friends and cohorts of the old group were the ones who remained;[4] and the last show represented a kind of strange, dissolute vic-

tory over the landscape emphasis and the other impressionist faction, that of his rival Monet, the first to have deserted the group. It was also the last major exhibition of Degas's life—apart from the odd one-man show of his landscape monotypes which took place at Durand-Ruel's in 1892–93. As Huysmans would characterize it in *Certains,* this was Degas's "adieu"— not only to the impressionist group, but also to his "public."

The nudes exhibited many of the aspects of Degas's earlier works, particularly those of the dancers, which had made it difficult to categorize his pictures as realist images in the first place. Degas's repetitions had always puzzled the critics who wanted to designate him as a realist. Blatantly serial now, the nudes of 1886 isolated and concentrated on the repetitious qualities of those earlier works. Characteristics of the dancers selected for emphasis in the nudes were their movements of pulling, stretching, and doubling over, their *déshabillé,* their gestures of artifice and *maquillage,* of dressing and undressing.

With their chorus of similar gestures aimed at their own bodies, the nudes pointed to all the acts of private, physical absorption multiplied throughout the images of the seventies, highlighting what had always been one of the important subtexts of the dancers: their reflexivity. In the exhibition of 1886, Degas directly confronted his public with this subtext: repeated now ten times over, writ almost large as life, in a palette of spectacular pastel color, and spelled out in the title of the series of nudes. *All* but that subtext was now excluded, now closed off. Further, where the act of viewing had been fairly consistently addressed and problematized in the dance pictures, so was it isolated in the nudes of 1886. For the gaze of the viewer is radically confronted by, but just as radically excluded from, the series of nudes: the viewer is almost bodily ousted from most of these images by the inflated and enlarged backs of the nudes, pushed right up to the foreground. (The increased scale of the figure-to-ground relationship, and the occupation of the extreme foreground, placing the nudes in the plane of virtual sculpture, would be further heightened in Degas's post-1886 oeuvre, during the years of his increasing blindness— in both his late pictorial work and his ever-growing engagement in sculpture per se.)[5] If voyeurism was one of the issues in the dance pictures, it was now *the* issue, and, now clearly, as a mode of viewing it was predicated on absolute exclusion.[6]

Other themes related to the earlier pictures were those of *déshabillé* and feminine artifice: the *coulisses* view of dressing-room undress and make-up. But in many ways, the nudes of 1886 are the inverse of those earlier images. Rather than referring to nakedness, they are a group of images of unambiguously naked women *un*dressed, *un*made up, *un*making themselves, scrubbing and rubbing away, ridding themselves of powder and paint and workaday grime—all layers of artifice, all signs of profession and class. This too was emphasized in the title of the series, with its clear stress on verbs of cleansing (which also continue to situate the nudes in

Degas's earlier thematics of impropriety, clandestine profession, and suspect sexual status). The theme of undress and unmaking was also emphasized in the balancing of the nudes against the two images of women in milliner's shops:[7] an exhibition theme connected to Degas's earlier dancers' loges (with the nudes combing their hair or having it combed as a middle term between making and unmaking, between the images of ablutions and the pictures of *essayage*).

In short, Degas's series of nudes close in and down on the sociability of viewing. They provide a kind of commentary on the way that closure had been a long time in preparation—a potential in Degas's works from the beginning, and from the opening of the first impressionist show, with the inclusion of his first image of the closed-off *coulisses* spaces of seeing and making. The nudes are extensions of those images, and they are replete with the concerns that, even initially, set Degas apart from the others of his group: seriality and reflexivity, the viewing and reading of gestural life, and the *coulisses* world of *déshabillé*. But they also invert some of those concerns.

For as much as the overt seriality of the bathers connected them to Degas's interests of the seventies, it also spoke to a change in the artist's direction: *away* from the *coulisses* of the "bourgeois Empire," as Meier-Graefe would have it, toward the repeated removal of gestural life from the context of the described social worlds of Opera wings, boulevard cafés, and the like. And the palette of the bathers was more a premonition of the bright, acid, overtly powdered, and hatched pastels of the later eighties, the nineties, and the first decade of the twentieth century, and of the type of musical-coloristic language employed by Meier-Graefe, than it was a recollection of the more "realist" make-up tints of the seventies. Finally, their focus on the explicitly naked female body attending to itself was new too, only directly predicted in Degas's most private images, the brothel monotypes.[8] This was a series fit for an "adieu" to the impressionist decade, and for the different kind of critical language, of which Meier-Graefe's passage is exemplary, which began to prevail after 1886.

*

In 1886, the majority of critics still tied Degas's submissions to the concerns of realism. "This is an art of realism," said Fénéon of the nudes, concentrating, no matter how formalistically, on the gestural life of the series ("Les Impressionnistes en 1886").[9] Other critics also emphasized the nudes' connection to the language and vision of realism: "the sharp gaze of a surgeon . . . a taste for reality" (*"un regard aigu de chirurgien . . . un goût de réalité"*—Desclozeaux, *L'Opinion*); "The figures are thrown into relief through the scrupulous truth of their poses. One might think this a strong study by a Dutch master" (*"Les personnages se détachent vigoureusement dans une scrupuleuse vérité d'attitude. On dirait d'une forte étude d'un maître hollandais."*—Paulet, *Paris*); or:

> His school tending towards realism, having forcefully ousted the gods, it must not be demanded of him [Degas] that he make Amphitrite arise from the ocean or Venus Astarte dry her hair for us . . .
>
> No! Nana washing, sponging, and caring for herself, arming herself for combat, that is the impressionist ideal. Don't forget that the Exhibition is only two steps from the streetwalker's corner!
>
> *L'école visant au réalisme, ayant bruyamment chassé les dieux, il ne faut point lui demander de nous faire sortir de l'océan Amphitrite ou de sécher les cheveaux de Vénus Astarté . . .*
>
> *Non! Nana qui se lave, qui s'éponge, qui se soigne, qui s'arme pour le combat, voilà l'idéal impressionniste. N'oubliez pas que l'Exposition est à deux pas du coin de boulevard!"* (Michel, *La Petite Gazette de Paris*)[10]

Even Meier-Graefe connected Degas's late work to the aims of the old "new painting" by explicitly negating those aims in the comment about "bourgeois Empire." And Degas himself, albeit negatively too, was still more of an adherent to that old school of thought than he was to the tenets of the symbolist generation—he was, as usual, somewhat contemptuous of the symbolists: "I can't stand all this poetry, this sophistry, and these young men in long-tailed morning coats holding lilies in their hands while they talk to women" (Daniel Halévy's diary entry of 20 February 1897, quoted in Kendall, *Degas by Himself:* 241).[11]

It is because of Degas's continuing connection to the concerns of realism that we shall concentrate here on one critic's writing—that of Joris Karl Huysmans, who wrote about the 1886 nudes in his 1889 collection of essays, *Certains.*[12] For of all the critics, Huysmans mediated most insistently between the discourse on realism and its obverse; of all of them he insisted most on the *negation* of realism—he did so by depending on its terms. In *Certains,* Huysmans directly addressed the school of realist criticism to which Duranty belonged, and from which he himself emerged. Like Duranty, he wrote of Degas's oeuvre in terms of the notion of the readable, determining, modern-life milieu, explicitly identifying that notion with Taine's art criticism.

As we shall see, Huysmans's realist background is inscribed in *Certains,* as well as in his earlier collection of reviews, *L'Art moderne.* He had begun as a naturalist writer, and like Duranty, he was one of the intimates of Zola's circle. In 1876, at the time of the publication of his first naturalist novel, *Marthe, histoire d'une fille* (the story of a prostitute), he also wrote a series of four articles in the Belgian newspaper *L'Actualité* defending Zola's novel *L'Assommoir,* championing naturalism as a school of literature and declaring himself a fervent partisan of it: eventually, that novel and the articles that together constituted Huysmans's naturalist manifesto would appear together in the same volume.[13] Through the seventies and early eighties, Huysmans continued to write slangy, lowlife stories with subjects that betrayed Zola's, Flaubert's, and the Goncourts' influence. The heroes of these stories were Baudelairean ones: nervous, inverted dandies filled with the spleen of modern urban life.[14] One of the stories,

Sac au dos, was included in the naturalist group's famous collection of tales *Les Soirées de Medan.* During these years Huysmans also began his career as an art critic, writing "Salons" and other art criticism for *Le Voltaire, La Réforme,* and *Le Gaulois.*[15] In 1879, he began writing about the impressionist group. He focused on Degas's work—following Duranty's lead in the seventies, he became Degas's principal champion of the eighties.

Beginning in 1879, Huysmans, like Duranty, characterized the impressionists as the "painters of modernity" (*"les peintres de la modernité—*"Salon de 1879," *L'Art moderne:* 31), with a special emphasis on physiognomics: "Such as it is, and above all, such as it will become, impressionist art manifests a very curious observation, a very particular and profound analysis of temperaments put into play within their settings" (*"Tel qu'il est, et tel qu'il sera surtout, l'art impressionniste montre une observation très curieuse, une analyse très particulière et très profonde des tempéraments mis en scène"*—"Salon de 1879": 34). For Huysmans, just as for Duranty, it was Degas's art that best exemplified his notion of physiognomics: "[H]e [Degas] . . . knows . . . how to set on her feet before you a creature whose face, stance, and gesture *speak,* and tell you who she is" (*"[I]l sait vous jeter sur les pieds une créature dont le visage, la tournure et le geste parlent et disent ce qu'elle est"*—"Salon de 1879": 34). It should not come altogether as a surprise, then, that Huysmans appears to have used Duranty's *La Nouvelle Peinture* as a model for his own discussion of Degas and the impressionists at the end of the seventies and the beginning of the eighties.

Huysmans prefaced his "Salon of 1879," as Duranty had prefaced *La Nouvelle Peinture,* with a lengthy quote of Fromentin's comments about "les peintres de la modernité" (Salon de 1879": 31). This quote led directly into Huysmans's remarks about Degas's work. His article on the "Exposition des Indépendants" of 1880 betrayed Duranty's influence even more clearly. It was fitting that it should, since that was the year in which Degas exhibited Duranty's portrait in commemoration of his death the year before. From beginning to end of his 1880 article, Huysmans paid indirect tribute to his realist forbear, declaring himself Duranty's successor. This was apparent in his opening discussion of the eclecticism of modern academic painting, of the mixing up of effects derived from different schools of painting, and of the ahistorical depiction of the lighting and setting of modern scenes; and in his remarks about the impressionist rendering of light, replete with Fromentin's familiar statement about the lightening up of the modern palette which Duranty had also quoted (and which Huysmans attributed to Zola): "As Emile Zola has remarked so aptly, painting has gone from dark to light, thanks to them [the impressionists]" (*"Comme l'a excellemment remarqué Emile Zola, de sombre qu'elle était, la peinture est, grace à eux, devenue clair"*—"Salon de 1879": 90; Zola, "Deux expositions d'art au mois de mai": 193). Duranty's influence was declared also in Huysmans's claim, complete with a catalogue of Degas's subjects very similar to Duranty's in 1876, that Degas

was *the* painter of modern life, *the* inventor of a *new* art; and in his discussion of Duranty's portrait, with his remarks about the neutral backgrounds of traditional portraits, Degas's mastery of physiognomics, the descriptive setting, and the twin arts of color and drawing. Finally, Duranty's presence is felt in Huysmans's closing essay about the great, as yet unrealized, subjects of modernity:

> It is to be hoped that new talents will also arise and come to join the group. All of modern life remains still to be studied; only a few of its many faces have begun to be perceived and noted down. It all remains to be done: official galas, salons, balls, corners of family life, of artisanal and bourgeois life, department stores, markets, restaurants, cafés, bars, in sum, all of humanity, no matter what class of society it belongs to, no matter what function it fills, at home, in almshouses, in taverns, at the theater, in public squares, in wretched streets or in the vast boulevards whose American attractions are the necessary frame for the needs of our time.

> And then, if one or two of the painters who engage our interest have, here and there, reproduced several episodes of contemporary existence, which artist will now render the imposing grandeur of industrial cities, who will follow along the road opened up by the German painter Menzel, by entering into the immense forges, and the railway stations that Mr. Claude Monet has already tried to paint, it is true, but without succeeding in evoking, in his uncertain abbreviations, the colossal volumes of the locomotives and their stations; which landscapist will now render the terrifying and grandiose solemnity of tall furnaces flaming up in the night, of giant chimneys crowned at their summits with pale fires?

> All the work of man laboring in mills and factories, all this modern fever which the activity of industry presents us with, all the magnificence of machines, all of that is still to be painted, provided that the modernists truly worthy of that title will consent to no longer diminish themselves, to no longer fossilize themselves in the eternal replication of one subject.

> *Il faut bien espérer aussi [que] de nouveaux talents surgiront et viendront se joindre au groupe. Toute la vie moderne est à étudier encore; c'est à peine si quelques-unes de ses multiples faces ont été aperçues et notées. Tout est à faire: les galas officiels, les salons, les bals, les coins de la vie familière, de la vie artisane et bourgeoise, les magasins, les marchés, les restaurants, les cafés, les zincs, enfin, toute l'humanité, à quelque classe de la société qu'elle appartienne et quelque fonction qu'elle remplisse, chez elle, dans les hospices, dans des bastringues, au théâtre, dans les squares, dans les rues pauvres ou dans ces vastes boulevards dont les américaines allures sont le cadre nécessaire aux besoins de notre époque.*

> *Puis, si quelques-unes des peintres qui nous occupent ont, ça et là, reproduit plusieurs des épisodes de l'existence contemporaine, quel artiste rendra maintenant l'imposante grandeur des villes usinières, suivra la voie ouverte par l'Allemand Menzel, en entrant dans les immenses forges, dans les halles de chemin de fer que M. Claude Monet a déjà tenté, il est vrai, de peindre, mais*

sans parvenir à dégager de ses incertaines abréviations la colossale ampleur des locomotives et des gares; quel paysagiste rendra la terrifiante et grandiose solennité des hauts fourneaux flambant dans la nuit, des gigantesques cheminées, couronnées à leur sommet de feux pâles?

Tout le travail de l'homme tâchant dans les manufactures, dans les fabriques; toute cette fièvre moderne que présente l'activité de l'industrie, toute la magnificence des machines, tout cela est encore à peindre pourvu que les modernistes vraiment dignes de ce nom consentent à ne pas s'armoindrir et à ne pas se momifier dans l'éternelle reproduction d'un même sujet. (L'Art moderne: 121–23)

Though written using the more vividly scenic language of Zola's naturalism, Huysmans's *grand finale* is remarkably like Duranty's conclusion to *La Nouvelle Peinture.*

Obviously, Huysmans paid homage to Zola's criticism as well as to Duranty's, both in his remark about the transition of painting from dark to light and in his discussion of the great subjects of modernity, "naturalist" subjects each one of them. He also addressed Baudelaire's writing: in his use of the familiar phrase "painter of modern life," and in his assertion that Baudelaire (along with the Goncourts) was Degas's writer-equivalent. And in an extended discussion of the similarities between Degas's painting and the Goncourt brothers' writing, Huysmans stressed the *textuality* of Degas's work—as Duranty, Rivière, and Burty had: "It [the painting of M. Degas] can have its equivalent only in literature." And his descriptions of Degas's ballet imagery had the same ingredients as those of "Jacques," Prouvaire, Mantz, et al.: the emphasis on dislocation, the attraction to caricatural features, lowlife "charm" and negative divinity, and the vivid evocation of movement, sound, and life:

> But look at them now, resuming their clownish dislocations. Rest is finished, the music strikes up again, the torturing of limbs recommences, and in these pictures whose characters are so often cut up by the frame, as in certain Japanese images, the exercises accelerate, legs are positioned in cadence, hands are clamped to bars which run along the length of the room, while the points of shoes frenetically beat the time, and lips smile, automatically. The illusion becomes so complete when the eye fixes itself on these leaping creatures that they come alive, so complete that the cries of the mistress can almost be heard, piercing the fierce din of the little room: "Advance those heels, pull in those buttocks, hold out those wrists, break a leg! . . ."
>
> And then the metamorphosis is complete. The giraffes who couldn't break themselves in, the elephants whose hinges refused to bend, are broken in and bent . . .
>
> The observation is so precise that, with these series of girls, a physiologist could do a curious study of the organism of each of them . . . here the man-girl, roughed up and beaten into shape, there the original anemics, the deplorable lymphatics . . . and there again, the dry nervous ones . . .

And how many among them are charming, charming with a special beauty—made up of a mixture of lowlife squalor and grace! How many are ravishing, almost divine.

Mais les voici maintenant qui reprennent leurs dislocations de clowns. Le repos est fini, la musique regrince, la torture des membres recommence, et dans ces tableaux où les personnages sont souvent coupés par le cadre, comme dans certaines images japonaises, les exercices s'accélèrent, les jambes se dressent en cadence, les mains se cramponnent aux barres qui courent le long de la salle, tandis que la pointe des souliers bat frénétiquement le plancher et que les lèvres sourient, automatiques. L'illusion devient si complète quand l'oeil se fixe sur ces sauteuses, que toutes s'animent et pantillent, que les cris de la maîtresse semblent s'entendre, perçant l'aigre vacarme de la pochette: "Avancez les talons, rentrez les hanches, soutenez les poignets, cassez-vous". . . *Puis, la métamorphose s'est accomplie. Les girafes qui ne pouvaient se rompre, les éléphants dont les charnières refusaient de plier, sont maintenant assouplies et brisées*. . . *L'observation est tellement précise que, dans ces séries de filles, un physiologiste pourrait faire une curieuse étude de l'organisme de chacune d'elles. Ici, l'hommasse qui se dégrossit* . . . ; *là les anémies originelles, les déplorables lymphes des filles* . . . *là encore les filles nerveuses, séches* . . .*

Et combien sont charmantes parmi elles, charmantes d'une beauté spéciale, faite de salauderie populacière et de grace! Combien sont ravissantes, presque divines (*L'Art moderne*: 114–16)[16]

Indeed, Huysmans's review of 1880 showed him to be firmly grounded in *all* of the critical arguments of the sixties and seventies: Duranty's *La Nouvelle Peinture*, Zola's "Salons" and impressionist reviews, realist and naturalist writing, Baudelairean theories, the language of caricature and dislocation, and the rhetoric of modern life—as well as realist art history. At the beginning of the review, in the passages on lighting and setting that I have already briefly mentioned, Huysmans betrayed his beginnings as an *amateur* of seventeenth-century Dutch painting, who knew inside out the nationalist art history of the time—as practiced by Duranty, Fromentin, Thoré-Bürger, Charles Blanc, and most particularly, by Hippolyte Taine:

This painter will light a modern woman, a Parisian, seated in a salon overlooking the Avenue of Messina, with the light of Gerard Dow, without understanding that that light, particular to the countries of the North, determined by the closeness of the Ocean, and the vapors rising from water which bathes the foot of houses, as in Amsterdam, Utrecht and Haarlem, filtered, moreover, through special sash-windows sectioned into little squares, is correct in Holland, just as are certain skies of a greenish turquoise blue, dotted with russet clouds, but that it is absolutely ridiculous in Paris, in the year of our Lord 1880, in a salon overlooking a street whose "canal" is reduced to a mere stream, in a salon opened up by large French windows with clear, unbubbled, undivided white panes.

Another painter will imitate the shadowy spaces of the Spanish and of du Valentin . . . When Ribera depicted scenes in cold little

cells, barely pierced with a ray of light falling from a vent, the cave-like lighting that he adopted was correct, but when transported into the present-day world, and adapted to the depiction of contemporary scenes, it is absurd.

Yet others will assimilate the procedures of the Italian school . . .

Celui-ci éclaire une femme moderne, une Parisienne, assise dans un salon de l'avenue de Messine avec le jour de Gerard Dow, sans comprendre que ce jour particulier aux pays du Nord, déterminé par le voisinage de l'Océan et par les buées montant de l'eau qui baigne, comme à Amsterdam, à Utrecht et à Haarlem, le pied des maisons, tamisé en sus par des fenêtres spéciales à guillotines et à petits carreaux, est exact en Hollande, de même que certains ciels d'un bleu verdi de turquoise, floconnés de nuées rousses, mais qu'il est absolument ridicule à Paris, en l'an de grace 1880, dans un salon donnant sur une rue dont le canal est un simple ruisseau, dans un salon troué de larges croisées, aux vitres blanches, sans bouillons ni mailles.

Celui-là imite les ténèbres des Espagnols et du Valentin . . . Quand Ribera représentait des scènes dans de froides cellules, à peine transpercées par une flèche de lumière tombant d'un soupirail, le jour de cave qu'il adoptait pouvait être juste, transporté dans le monde actuel, adapté aux moeurs contemporaines, il est absurde.

D'autres encore s'assimilent les procédés de l'école italienne . . . (L'Art moderne: pp. 85–86)

That was 1880. In 1889, Huysmans's engagement in the positivist argumentation about past and present art would be more clearly stated than before. Taine, invoked by name, would make his appearance, along with his "theory of the milieu." Haussmann's boulevards, one of those great modern-life scenes that Huysmans had enumerated in 1880, would be evoked throughout *Certains*. An eloquent describer of urban place, Huysmans would use the boulevards as the backdrop and the connecting link for his series of analyses of the works of very disparate painters: Degas, Rops, Moreau, Redon, Cézanne, Forain, to name most of them. Baudelaire, with his "painter of modern life," would make his appearance felt.[17] Huysmans again would employ the mode of writing of his own earlier naturalist novels—and the caricatural language associated with the critical discussion of realism since the Second Empire.

But unlike *L'Art moderne, Certains* was tied to the discourse of the seventies through negation. The connection to positivist criticism is announced several times through references to Taine: "the theory of the milieu adapted by M. Taine to art," and regarding Degas, "the method inaugurated by M. Taine." But each time Tainean discourse is mentioned, it is mentioned negatively, so that the refrain that Huysmans develops is explicitly anti-Tainean. And this was not idiosyncratic to Huysmans—other critics were doing the same at that time: Sar Péladan, the guru of the Rosicrucian group, later wrote a book refuting Taine's criticism, incorporating Huysmans's remarks into a specifically symbolist argument, which claimed erotic self-display, rather than national character or so-

ciety, as the basis for art. The argument with positivist forms of criticism, as well as the substitution of the themes of eros, negation, and exception, was an important discourse of the period.[18]

The negational, anti-Taine stress of *Certains* was connected to an about-face in Huysmans's career as a writer: intervening between his "Salons" and *Certains* was his famous novel of 1884, *A Rebours,* and the creation of his most renowned Baudelairean character, Des Esseintes. This was the novel with which Huysmans denied the naturalist cause—it is most commonly thought of as his turning point,[19] and with good reason, for it constituted an extended argument with the fundamental premises of the school of naturalism,[20] an argument that would be taken up in most of Huysmans's subsequent stories, particularly in the one that followed on the heels of *A Rebours, Là-Bas.*[21] As such, *A Rebours* became a kind of bible for the symbolist generation.[22] But more than anything else, it was a manifesto of *negation*—the title itself, variously and uneasily translated as *Against the Grain* and *Against Nature,* is simply negational, signifying nothing more than "against," "opposite," "contrary," "the wrong way." It is this manifesto disguised as a novel which lies behind much of *Certains.*

To begin with, Degas and many of the other artists who concern Huysmans in *Certains* are turned into versions of the protagonist of *A Rebours:* the spleen-filled, proto-Proustian figure of Des Esseintes, *amateur* of the arts, neurasthenic pursuer of decadent pleasures, and the last of an old aristocratic line—modeled in almost every way on the symbolist aesthete Robert de Montesquiou-Fézensac. *A Rebours* revolves around Des Esseintes's flight from Paris—and the quintessential modern-life milieu that Paris clearly represents—and his retreat to the nearby town of Fontenay, where he ensconces himself in a mansion that he has purchased for himself, and which he proceeds, throughout the story, to decorate. The book is devoted to the interior life of the aristocratic figure of Des Esseintes in a double, psychological and physical sense: to his sensations and ruminations, and to the description of the eclectic surfaces, objects, and rooms inside his house. Retreat, interiority, and interiorized sensation, as well as aristocracy and antimodernism: these are also the principal qualities assigned to Degas, as well as to the other artists treated by Huysmans in *Certains.*

Huysmans's article on Degas opens in this manner:

> Be sure, moreover, that those artists whose ideas are less nomadic, whose stay-at-home imaginations fasten onto the present era, feel an execration no less lively [than that of Moreau], a hatred no less sure [for the contemporary milieu], . . . that is, if they are superior spirits rather than those subaltern souls to whom alone the method inaugurated by M. Taine is applicable.
>
> So their art evolves in a different way, they concentrate, they dig in their heels, and in malicious or ferocious works, they paint the

milieu which they abominate, the milieu which they scrutinize, whose uglinesses and shames they express.

And that is the case with M. Degas.

Soyez certains encore que les artistes dont la cervelle est peu nomade, dont l'imagination casanière se rive à l'époque actuelle, n'éprouvent pas une exécration moins vive; un mépris moins sûr, s'ils sont des esprits moins vifs; s'ils sont des esprits supérieures et non de ces âmes subalternes auxquelles s'adapte seule la méthode inaugurée par M. Taine. Alors leur art évolue d'une façon différente; ils se concentrent, se pietent sur place et, dans des oeuvres narquoises ou féroces, ils peignent ce milieu qu'ils abominent, ce milieu dont ils scrutent et expriment les laideurs et les hontes. Et c'est le cas de M. Degas. (*Certains:* pg. 22)

These comments lead into the passage on Degas's privacy and re-clusiveness, his abstention from public view, and his "insulting adieu":

> This painter, the most personal, the most piercing of all those that this godforsaken country possesses, without even suspecting it, has voluntarily exiled himself from private exhibitions and public places. At a time when all painters prostitute themselves to the crowd, he, far from it, has achieved unequaled works in silence.
>
> Some of these were shown, as an insulting adieu, in 1886, in a gallery on the rue Laffitte.
>
> *Ce peintre, le plus personnel, le plus térébrant de tous ceux que possède, sans même le soupçonner, ce malheureux pays, s'est volontairement exilé des exhibitions particulières et des lieux publics. Dans un temps où tous les peintres se ventrouillent dans l'auge des foules, il a, loin d'elle, parachevé en silence d'inégalables oeuvres.*
>
> *Quelques unes furent, comme un insultant adieu, exposées, en 1886, dans une maison de la rue Laffitte.* (*Certains:* 223)

Huysmans characterized the other artists in *Certains* in much the same way. Opening his essay on Moreau, immediately prior to that on Degas, he wrote:

> Distanced from the throng . . . M. Gustave Moreau has long ceased, for years now, to station his cnvases . . . in the glassed-in sheds of the Palace of Industry . . .
>
> He has also abstained from fashionable exhibitions. The view of his works . . . is therefore rare.
>
> *Eloigné de la cohue . . . M. Gustave Moreau n'a plus, depuis des années, immobilisé de toiles dans les hangars vitrés du palais de l'Industrie.*
>
> *Il s'est également abstenu des exhibitions mondaines. La vue de ses oeuvres . . . est donc rare.* (*Certains:* 17)

At the end of his discussion of Cézanne, Huysmans stated that "since 1877, he has ceased to exhibit" (*"Il n'a plus exposé depuis l'année 1877"*— *Certains:* 43). Speaking of Whistler, he remarked, "In 1867, M. Whistler exhibited one canvas—'At the Piano' . . . and since then, no one has spoken of him, he has ceased to exhibit in France" (*"En 1867, M. Wisthler exhibe une toile 'Au Piano', et ne fait plus parler de lui, n'expose plus en France"*—

Certains: 65). This was the essence of Whistler's greatness, according to Huysmans:

> And that will be his glory, as it will be that of others who shall have disdained public taste—to have aristocratically practiced an art which disrupted common ideas, which effaced itself before the throng, a resolutely solitary, haughtily secret art.
>
> *Et ce sera sa gloire, comme ce sera celle des quelques-uns qui auront méprisé le goût du public, que d'avoir aristocratiquement pratiqué cet art réfractaire aux idées communes, cet art s'effaçant des cohues, cet art résolument solitaire, hautainement secrêt.* (*Certains:* 73)

The principal link between the diverse artists whose work Huysmans chose to address was their reclusiveness and their refusal to be seen. This was the common condition of their very different oeuvres. Huysmans elevated the difficulties of their personalities into the defining characteristic of a new "avant-garde," or "avant-retro" persona—at the furthest remove from the Second Republic figure of Courbet. Rather than that sort of modern-life man, Degas, Moreau, Whistler, and the rest were all permutations of the aristocratic Des Esseintes, who in turn was a version of Baudelaire's "dandy"—their shared retreat from view was but one way in which this was true.

In 1876, Duranty had written of Degas's works as bourgeois art— as illustrations of post-1848 positivist physiognomics. Ten years later Huysmans replaced that bourgeois identification with an aristocratic one. He was not alone in his aristocratizing, and eventually Catholicizing tendencies: this was the Third Republic of the *Ralliement* and of the resurgence of *snobisme*.[23] Huysmans's aristocratizing characterization of his hero Des Esseintes, and of figures like Degas and Moreau, was part and parcel of the pro–*ancien régime*, anti-Empire, and anti-Republican vogue of the literary, social, and political life of the eighties and nineties. In this respect, Huysmans's characterization of Degas was quite apt— considering Degas's own aristocratizing tendencies. But it also tied Degas and the others, through the figure of Des Esseintes, to the negational aesthetics of *A Rebours.*

Writing about Moreau at the beginning of *Certains*, Huysmans established the notion of the rejection of modern life as the definition of the avant/retro art of the Third Republic:

> Upon reflection, upon promenading and regarding with a tranquil eye that shame of modern taste: the street; those boulevards . . . those roadways jolted by enormous omnibuses and ignominious vehicles; those sidewalks filled with hideous crowds in search of money, women degraded by sex, deadened by frightful transactions, men reading infamous newspapers, or dreaming of fornication, of schemes and scams along the length of all those boutiques . . . one could better understand the oeuvre of Gustave Moreau . . .
>
> The theory of the milieu, adapted by M. Taine to art, is right—but it is only right *against the grain*, when it's a question of great artists—

because the milieu acts on them through revolt, by the hate which it inspires in them; instead of modeling and fashioning their souls in its image, it creates, in the midst of immense Bostons, solitary Edgar Poes; it acts on them in *retrograde* fashion, creating, in the midst of a disgusting France, Baudelaires, Flauberts, Goncourts, Villiers de l'Isle Adams, Gustave Moreaus, Redons, and Rops—beings of exception. [My italics.]

A la réflexion, alors qu'on se promenait, que l'oeil rasséréné regardait, voyait cette honte du goût moderne, la rue; ces boulevards . . . ces chaussées secouées par d'énormes omnibus et par des voitures de réclame ignoble; ces trottoirs remplis d'une hideuse foule en quête d'argent, de femmes dégradées par les gésines, abêties par d'affreux négoces, d'hommes lisant des journaux infâmes ou songeant à des fornications et à des dols le long de boutiques l'on comprenait mieux encore cette oeuvre de Gustave Moreau . . .

*La théorie du milieu, adaptée par M. Taine à l'art, est juste—mais juste à rebours alors qu'il s'agit de grands artistes, car le milieu agit sur eux par la révolte, par la haine qu'il leur inspire; au lieu de modeler, de façonner l'âme à son image, il crée dans d'immenses Bostons, de solitaires Edgar Poe; il agit par rétro, crée dans de honteuses Frances des Baudelaire, des Flaubert, des Goncourts, des Villiers de l'Isle Adam, des Gustave Moreau, des Redon, et des Rops, des êtres d'exception. (*Certains: 20–21)

Elsewhere, Huysmans wrote of an art in opposition to its surroundings, its milieu—and again Haussmann's boulevards make their appearance as the setting for this discussion:

They [the works of M. Cheret] ruin the taciturn sadness of our streets; by this time the engineers have destroyed the few houses, the few chimney pots that could have still been pleasing; all the intimate corners have disappeared, all the vestiges of past ages have fallen, all the gardens are dead; the boulevard St. Germain, the avenue Messina impose themselves on us as the essence of modern Paris; soon we will see nothing except straight streets, cut according to the compass, bordered by icy houses, by buildings painted in lime, by flat and mournful edifices, the sight of which leads to an atrocious feeling of boredom . . .

It is always against this general tone, of a morose gray, that the posters of M. Cheret are detonated, that they destabilize, by the sudden intrusion of their joy, the immobile monotony of the penitentiary décor which has finally been imposed upon us; this dissonance compromises the ensemble realized by M. Alphand.

Elles gâtent, en effet, la taciturne tristesse de nos rues; à l'heure qu'il est, les ingénieurs ont démolis quelques maisons, les quelques sentes qui pouvaient demeurer aimables; tous les coins intimes ont disparu, tous les vestiges des anciens âges sont tombés, tous les jardins sont morts; le boulevard St. Germain, l'avenue de Messine s'imposent comme le type du Paris moderne; nous ne verrons bientôt plus que des rues rectilignes, coupées à cordeau, bordées de maisons glaciales, de bâtisses peintes au lait de chaux, d'édifices plats et mornes, dont l'aspect dégage un ennui atroce . . .

Toujours est-il que sur cette teinte générale, d'un gris morose, les affiches de

M. Cheret détonnent et qu'elles déséquilibrent, par l'intrusion subite de leur
joie, l'immobile monotonie d'un décor pénitentiaire en fin pose; cette disso-
nance compromet l'ensemble de l'oeuvre réalisée par M. Alphand." (*Certains,*
pp. 51–52)

In passages on modern architecture and modern décor, interspersed
with essays on other artists, old and new, toward the end of *Certains,*[24]
Huysmans continued his diatribe against Haussmannized Paris, decrying
the architecture of modern industry, whose great scenes he had wanted
painted nine years before, calling now for a milieu of ruins and frag-
ments,[25] writing *against the grain* of modern scene, modern architecture,
and the modern city. This was the milieu to be painted *against, à rebours:*
in terms of retreat and retrogression, or dissonance and disruption. This
was the milieu which Des Esseintes escaped, and replaced with the sensa-
tional interior life of his decadently decorated mansion. This was also the
milieu against which Degas's nudes were to be seen: *in opposition to* the
milieu of the great new city of the boulevards.

Meier-Graefe would later link Degas's painting with that of the primi-
tives. This is another ingredient of Huysmans's negation of positivist
criticism—in *Certains* he too invokes the art of the primitives as a differ-
ent sort of "realism":

> A powerful, isolated artist, without authenticated precedent, outside
> of all lineage worth considering, M. Degas's . . . oeuvre belongs to
> realism, to a brand of realism which that brute Courbet would not
> have understood: a brand of realism, rather, such as certain of the
> Primitives would have concurred with, that's to say, an art express-
> ing an expansive or abbreviated burst of feeling, in living human
> bodies in perfect harmony with their surroundings.
> *Artiste puissant et isolé, sans précédents avérés, sans lignée qui vaille, son*
> *oeuvre appartient au réalisme, tel que ne pouvait le comprendre la brute qui*
> *fût Courbet, mais tel que le conçurent certains des Primitifs, c'est-à-dire à un*
> *art exprimant une surgie expansive ou abrégée d'âme, dans des corps vivants,*
> *en parfait accord avec leurs alentours.* (*Certains:* pg. 27)

Huysmans's engagement with the primitives, which Degas shared,
was crucial to his reversal of the terms of positivist criticism. Between his
impressionist reviews and *Certains,* Huysmans had acquired an interest in
pre-Renaissance Germanic art. Specifically, he is credited with the discov-
ery of Grünewald—on a trip to Germany in 1888—which he later wrote
up in *Là-Bas* and in his work of 1903, *Trois Primitifs.*[26] The art of the
primitives was attractive to Huysmans because of its premodernism and
its marginality, and more importantly, because of the against-the-grain,
expressionistic content of its "realism." It is important to realize that
Huysmans saw the art of the primitives as essentially naturalist: "The
revelation of this Naturalism Durtal had in front of Matthias Grünewald's
Crucifixion [fig. 99]." (*"La révélation de ce Naturalisme Durtal l'avait eue de-*
vant une crucifix de Mathaeus Grünewald"—*Là-Bas:* 9.)

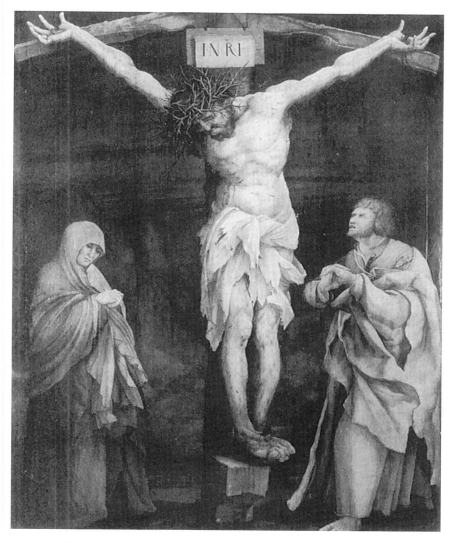

FIG. 99 Matthias Grünewald, *Crucifixion (Tauberbischofsheim)*, 1523–24

Huysmans's interest in the primitives, shared by other critics, historians, and religious personalities of the period, as well as by certain symbolist figures,[27] grew after the 1880s, but it was already evident in *Certains,* and it was not limited to his closing remarks about Degas as a modern primitive, an antimodern realist set in contrast to Courbet via the primitives. Huysmans also described Félicien Rops as a "Primitive against the grain," comparing him to Fra Angelico, Grünewald, Roger Van der Weyden, and Memling: Rops, according to Huysmans, was an *inverted* Memling (*"M. Félicien Rops, avec une âme de Primitif à rebours, a accompli l'oeuvre inverse de Memlinc"*—*Certains:* 91–92). Moreover, *Certains* is char-

acterized by a preoccupation with marginal and negational artists, both primitive and modern, like Luykens and Bianchi on the one hand and Moreau and Rops on the other, not to mention exceptional painters such as Cézanne and Degas, and minor artists such as Forain and Raffaelli. In the sense that Huysmans's engagement with the primitives amounted to an involvement in marginal, exceptional, and negational art, it permeates *Certains,* for in all these ways *Certains* is devoted to art which goes "against the grain" of Tainean art history.

A similar engagement is found in *A Rebours,* with its critique of modernity and its celebration of "decadent" authors. Loosely speaking, *A Rebours* is also the source of this aspect of *Certains*—and the source, if not directly of Huysmans's anti-Taine argument (I am referring to the explicit negation of Zola's naturalism in *A Rebours*), then certainly of the mode of criticism which *Certains* exemplified. This mode of critical apprehension is outlined in *A Rebours,* a pseudostory which is really made up of a collection of critical essays devoted to artists like Moreau and Redon, as well as a discussion of the nature of the critic and of the act of criticism. (Besides chapters devoted to Des Esseintes's peculiar interior decoration, *A Rebours* includes one prominent chapter on the works of Moreau, Bresdin, and Redon, and on that of the seventeenth-century Dutch engraver Jan Luyken (hung in Des Esseintes's house), along with remarks about Goya and Rembrandt. There are also several chapters on the reading interests of Des Esseintes and the books in his library, which really constitute extended passages of literary criticism: chapter 3 is on the history of the literature of the Roman decadence, and chapter 4 is devoted to the history of contemporary writing according to Des Esseintes—in which the issue of naturalism is again engaged, and the importance of Baudelaire repeatedly announced. Chapter 15 is partly devoted to musical criticism.) In the preface of 1903, Huysmans made it clear that "criticism," in the sense of the collection, connoisseurship, and description of works and objects, was the means and end of *A Rebours:* "Each chapter became the concentrate of a specialty, the sublimation of a different art; it condensed into an 'of meat' of gems, perfumes, flowers, religious and secular literature, profane music and plain chant" (*"Chaque chapitre devenait le coulis d'une spécialité, le sublimé d'un art différent; il se condensait en un "of meat" de pierreries, de parfums, de fleurs, de littérature religieuse et laïque, de musique profane et de plainchant."—A Rebours:* 48).[28] In *A Rebours,* Huysmans defines criticism as the eclectic connoisseurship of extreme states of sensations, whose consistency derives not from the objects admired, nor from their milieu, but from the extremity of the *amateur*'s sensibility.

Thus *A Rebours* was the basis of *Certains* in more ways than one—it seems to have functioned behind all of the essays in *Certains.* Referred to explicitly, in Huysmans's against-the-grain remarks about Moreau, the modern milieu, and Taine's positivist school of thought, as well as in his commentary on Rops and his discussion of Jan Luykens (in which he

mentioned *A Rebours—Certains:* 133), the novel's presence is also felt in the opening remarks of *Certains,* which includes a diatribe against "dilettantisme," contemporary criticism, and the "promiscuity of admiration" (*la promiscuité dans l'admiration"—Certains:* 7),[29] as Huysmans terms it, for which he substitutes Des Esseintes's consistency of passionate taste and extreme language, rather than that of neutral verbiage and "objectivity."[30]

In sum, *Certains* as a whole is predicated on *A Rebours* and its manifesto of negation, in a number of interconnected ways. The novel is felt behind Huysmans's reference to particular personalities and behind his celebration of artists in retreat and retrogression: Degas, Moreau, Whistler are each turned into versions of the repudiatory figure of Des Esseintes. The traces of *A Rebours* are felt as well in Huysmans's invocation and repudiation of the modern-life milieu and in his argument with positivist lines of reasoning. The residue of *A Rebours* is present in Huysmans's celebration of against-the-grain "realists," whether modern or primitive, and his attention to marginal, exceptional figures. Finally, *A Rebours* is the basis of the kind of attention given these figures, the kind of language used to talk about their art. *A Rebours* was a manifesto of negation—not only of realist writing, but of realist practices of criticisim and realist theories of sensation—and the same may be said of *Certains.*

*

One of the obvious themes of *Certains* is that of misogyny. Indeed, Huysmans as much as equates the theme of misogyny with his own negational aesthetics, while making Degas's "repudiation of woman" stand for the artist's iconoclasm, his repudiation of his century, and his rejection of his milieu. In short, Huysmans aligns misogyny with his own anti-Tainean discourse, and with Degas's Des Esseintes-like stance, as well as with the artist's strategies in representing the female body.[31]

The theme of misogyny is evident in Huysmans's opening comments on Degas's nudes. After listing the title of the series, "Suite de nus de femmes se baignant, se lavant, s'essuyant, se séchant, se peignant et se faisant peigner," as it appeared in the exhibition catalogue, Huysmans wrote:

> M. Degas, who seems to have been aggravated and irritated by the baseness of his world, must have wanted to take his revenge, and hurl in the face of his century the most extreme outrage—by toppling the idol so constantly kept and cared for, woman, whom he debases as he depicts her, in her tub, in the humiliating poses of her intimate activities.
>
> *Il semblait qu'excédé par la bassesse de ses voisinages, il eut voulu user de représailles et jeter à la face de son siècle le plus excessif outrage, en culbutant l'idole constamment mènagèe, la femme, qu'il avilit lorsqu'il la représente, en plein tub, dans les humiliantes poses des soins intimes. (Certains:* 23)

In this regard as well, the essay on Degas plays an important part in *Certains*'s inversion of positivist art criticism, for misogyny is the

theme which is used to bring together these ingredients: the evocation of Haussmann's city, the critique of Taine, the remarks about isolated, exceptional artists, and the account of the nudes.

This is how Huysmans described the nudes individually. Regarding the Orsay *Tub* (fig. 89), he wrote:

> Here we have a redhead, plump and stuffed, curving her spine, breaking the bone of her sacrum on the stretched roundnesses of her backside; she fractures herself in order to bring her arm behind her shoulder, so that she may press her sponge against it, which dribbles down her spinal column and falls along the length of her loins.
>
> *Ici c'est une rousse, boulotte et farcie, courbant l'échine, faisant poindre l'os du sacrum sur les rondeurs tendues des fesses; elle se rompt, à vouloir ramener le bras derrière l'épaule afin de presser l'éponge qui dégouline sur le rachis et clapote le long des reins.* (*Certains,* pg. 24)

Describing *The Baker's Wife* (fig. 88), he said:

> [T]here we have a blond, straightened up, thickset and standing, also turning her back on us—she has finished her toilette and, pressing her hands against her rump, she stretches herself in a movement that is more masculine than feminine, that of a man lifting the flaps of his jacket to warm himself before the fire.
>
> *[L]à, c'est une blonde, ramassée, trapue et debout, nous tournant également le dos, celle-là a terminé ses travaux d'entretien et, s'appuyant les mains sur la croupe, elle s'étire dans un mouvement plutôt masculin d'homme qui se chauffe devant une cheminée, en relevant les pans de sa jaquette.* (*Certains:* pg. 24)

Earlier, Huysmans had used *The Baker's Wife* as a kind of emblem for the series of nudes:

> In order to recapitulate his repudiation of her [woman], he [Degas] chose her fat, potbellied and short, her curves drowned beneath tubular rolls of flesh, losing, from the plastic point of view, all line and all bearing: no matter what class of society she belonged to, he turned her into a pork-butcher woman.
>
> *Et afin de mieux récapituler ses rebuts, il la choisit grasse, bedonnante et courte, c'est-à-dire noyant la grace des contours sous le roulis tubuleux des peaux, perdant, au point de vue plastique, toute tenue, toute ligne, devenant dans la vue, à quelque classe de la société qu'elle appartienne, une charcutière, une bouchère.* (*Certains:* 23–24)

Using the *Baker's Wife* to stand for the rest, Huysmans reduced Degas's nudes to one low class of creature, effectively denying that they catalogued a range of social types and gestures.

Referring to yet another nude (fig. 91, 92, or 97), Huysmans went on:

> [T]his other one is a crouching blimp, inclining all askew to one side, leaning on one leg, passing one arm beneath her, stretching herself into her tub of zinc.
>
> *[L]à encore, c'est un dondon accroupie; elle penche tout d'un côté, se soulève*

sur une jambe, passe en-dessous le bras, s'atteint dans le cuveau de zinc.
(*Certains:* 24)

And so on. Summing up, Huysmans wrote:

> Those are, briefly cited, the pitiless poses which this *iconoclast* assigns to the being so constantly flattered with inane gallantries. These pastels include crippled stumps, the battered chests of brawlers, tottering jug-asses—a whole series of poses inherent to woman, even when young and pretty, reclining or upright, frog- or monkey-like. [My italics.]
>
> *Telles sont, brièvement citées, les impitoyables poses que cet iconoclaste assigne à l'être que d'inanes galanteries encensent. Il y a, dans ces pastels, du moignon d'estropié, de la gorge de sabouleuse, du dandillement de cul-de-jatte, toute une série d'attitudes inhérentes à la femme même jeune et jolie, adorable couchée ou debout, grenouillarde et simiesque.* (*Certains*, pp. 24–25)

Thus Huysmans employed a language of violence, reversal, and caricature to describe the nudes of 1886; he wrote of the nude in the Orsay *Tub* in terms of breakage, as a fractured, twisted body; of the one in the Farmington *Tub* as an upside-down, radically askew figure with tangled limbs; of the *Baker's Wife* as a man rather than a woman. Each of them he turned into crippled grotesques, likening them to frog and monkey. Not only would Huysmans not allow that the nudes formed a physiognomic catalogue, he also went so far as to treat the series in terms of complete bodily incoherence: as a collection of out-of-order limbs, ruined symmetries, wrong indications of sex, leveled social signs, and nonhuman resemblances. In short, Huysmans described the nudes as corporeally out of order and physiognomically illegible.

Huysmans seems to have derived his language from his own earlier naturalist writing—the slangy, vituperative, expressly caricatural epithets used most prominently in *Marthe, histoire d'une fille:*

> [Y]ou are not vulgar enough yet. It'll come, my girl, but you haven't learned to make that juicy thrust of the hips that should punctuate the "boom" of the cash box. Look here, see, I've turned my legs into nippers, my arms into vines, I open my chops like a frog in a barrel, I do my all for my pieces of metal, ta da! the cymbals crash, I shake it, I rasp the last word of the song, I gargle a clumsy trill, and I've got 'em in the palm of my hand!
>
> *[T]u n'es pas encore assez canaille! Ca viendra, bibiche, mais tu ne donnes pas encore assez moelleusement le coup des hanches qui doit pimenter le "boum" de la grosse caisse. Tiens, vois, j'ai les jambes en branches de pincettes faussées, les bras en ceps de vigne, j'ouvre la gueule comme la grenouille d'un tonneau, je fais le mille pour les palets de plomb, v'lan! la cymbale claque, je remue le tout, je rape le dernier mot de couplet, je me gargarise d'une roulade ratée, j'empoigne le public.* (*Marthe; histoire d'une fille:* 111–12)

Huysmans's language also derived from that used by the ironic critics in the seventies and early eighties to describe Degas's dancers. Huysmans himself establishes that link:

> M. Degas who, in his admirable pictures of dancers, had already so
> implacably rendered the decadence of the mercenary dulled by her
> mechanical frolics and monotonous leaps, brought this time, to his
> studies of nudes, an attentive cruelty, a patient hatred.
> *M. Degas qui, dans d'admirables tableaux de danseuses, avait déjà si impla-*
> *cablement rendu la déchéance de la mercenaire abêtie par de mécaniques ébats*
> *et de monotones sauts, apportait, cette fois, avec ses études de nus, une atten-*
> *tive cruauté, une patiente haine.* (*Certains:* 23)

Huysmans connects the forms of the nudes to the dislocated figures
of the dancers of the seventies. He also relates the nudes to the nega-
tive, caricatural language applied to the dancers by the critics. But now
Huysmans uses that critical, oppositional litany in a celebratory manner,
so that illegibility is no longer described as the failure, but comes to con-
stitute the very principle of the "realism" and of the modernity of the
nudes.

It is, perhaps, surprising to find how closely and subtly the series cor-
responds to Huysmans's unsubtle language.[32] The series constitutes a se-
quence of *backs*. (Only two of the ten nudes in the series are turned
toward the viewer.) For a painter who had begun with portraits—with
fully seen and sharply described *fronts*—and for whom portraiture con-
tinued to be an important aspect of his exhibited work—this was a radical
gesture. For the series of backs forms the *negative* of Degas's famed
physiognomic preoccupations. As such, the sequence was also a procla-
mation of privacy—a cold shoulder farewell to the public. This is the
most obvious way in which the nudes added up to an *adieu.*

But there are others ways as well—and other ways in which the nudes
represent a break with Duranty's positivist concerns. In some way, as
I have already indicated, they are simply a concerted enlargement of
Degas's earlier focus on gestural life. There is, however, an important
difference. The suite of nudes foregrounds its series of reflexive actions
rather than including them here and there, at the edge, in the background,
within a larger context. A collection of reflexive verbs, "se baignant, se
lavant, s'essuyant, se séchant, se peignant . . . ," the title of the series
spelled out the theme of reflexivity as well. With their hands planted on
hips and backsides, tucked against stomachs, pressed against chests,
passed under and over shoulders and legs, glued to napes of necks, reach-
ing for feet and mops of hair, the nudes are a group of images of bodies
turned insistently toward and in on themselves. That is emphasized by
the way so many of the nudes are doubled and folded over, one bodily
surface sandwiched against another, so that external contours become
internal creases and gestural extremities are linked to a kind of uterine
interiority. (See in particular the U-shaped form of fig. 89.) After the un-
finished, aggressively broken-off, viewer-directed gestures of the seven-
ties, such as those of the *Dancers at the Bar* and *The Café-concert at the
Ambassadeurs* of 1877, as well as those of the *Dance School* and the *Singer*

with the Glove shown in 1879 (figs. 13, 71, 19, 21), to mention the ones that the critics had singled out, the nudes are very decisive images of reflexivity, corporeal interiority, and closure.

Certainly the gestures of the nudes can still be read in a physiognomic way—indeed, many of their critics saw them as physiognomic distillations. And that is not wrong, for theirs is a stripped-down physiognomics, a reduction, rather than an expansion, of gestural life to the bare fact of naked corporeality. The gestures of the nudes are all of a uniform kind, too. The most apparently disparate figures of the series are the Pearlman *Baker's Wife* (fig. 88) and the Metropolitan *Toilette* (fig. 93), for their settings and physiques are set in contrast to one another: on the one hand, a stuffed and buttoned chaise longue, white linen and a servant, and the somewhat more restrained, poised proportions of her naked mistress; and on the other hand, a simple, rumpled bed, a zinc tub, and the fat, uncorseted, heavily planted anatomy of a baker's wife or a "pork-butcher woman." Nevertheless, these two figures are more clearly likened, back to front, and leveled, than they are differentiated and catalogued: both of their gestures—their fingers sunk into and splayed over ample flesh— are simple, basically physical ones. The physicality of all of the nudes is emphasized in the title of the series: bathing, washing, drying, wiping down—all of these are verbs of tactile contact. As such, the gestures of the nudes are quite different from Duranty's gestures of class and profession. Though critics like Fénéon still felt that the mark of everyday modern life was stamped on the flesh of the nudes, deeply embedded in their most intimate activities and reflexive movements, their gestures are very difficult to read as differentiated social indices. Rather than the gestures of social representation, they are of a strictly phenomenological nature: simple phenomenal contact with phenomenal self, "the body . . . tries to touch itself in the act of touching" (*"le corps . . . essaye de se toucher touchant"*—Merleau-Ponty, *La Phénoménologie de la perception:* 109).[33]

In its distilled way, the reflexive physicality of the nudes closes in but also down on the modern-life physiognomic language that Duranty outlined for Degas's works in the seventies. If the gestures and corporeal forms of the nudes coincide with Huysmans's *adieu*, with his program of artistic isolation and his argument with positivist art criticism, so they also match the *à rebours* language of *Certains*. For indeed, the bodies of the nudes are inverted, upside-down and inside-out, their disorder emphasized by their tangled limbs. Even Ingres's, Courbet's, and Manet's nudes are posed and presented in proper anatomical order, from head to bust and arms to hips and legs and feet, and they tend to be readable in linear fashion, from top to bottom, or from side to side. Not so with Degas's nudes, whose feet can be found in the air, whose heads, as often as not, are aimed toward their feet, whose arms are frequently where their legs should be, and whose torsos are squeezed and sandwiched between limbs, rather than placed atop them. The symmetry of left and right is

confounded, the hierarchy of upper and lower body is skewed, and the distinctions between inside and outside, surface and edge, bodily volumes and bodily limits, are all confused. Their elbows resemble flippers, their ankles, feet, and haunches amputated stumps; their doubled-over bodies look like clenched fists; and their gestures are utterly without issue: it is not at all outlandish to see the nudes, as Huysmans did, in crippled, caricatural, grotesque terms.

Thus the nudes match the language applied to them by Huysmans. Like Huysmans's description of them, they are caricatures of the cropped, disordered bodily vocabulary noted by the critics in Degas's imagery of the seventies, and they disrupt bodily syntax to such a degree that the physiognomic readability claimed for the earlier works by critics like Duranty is controverted. Turned over and in on themselves, they also quite literally embody Huysmans's strategies of inversion, as well as his thematics of introversion. Indeed, they can easily be allied with representations of the dysfunctional, abnormal body current in the sociological, criminological, and protopsychoanalytic discourses of the period—discourses with which both Degas and Huysmans, in their somewhat different ways, were preoccupied. In the writings of Bordier and Lombroso, for example, and in the illustrated accounts of Drs. Charcot and Richer (fig. 100), bodily disorder and asymmetry were seen as signs of deviant social and psychological states, and criminal fields of perception. Their accounts of prostitutes, thieves, and murderers, as well as of hysterics, demoniacs, and syphilitics, seemed to be based on the assumption that *any* form of corporeal expressiveness denoted deviance and excess: gestures, stances, and expressions, which once had been signs of characters and passions, were now signs of the body's deviance from bourgeois norms. Now bodily expressiveness, which requires display, could only be expressive of the dysfunctional body. And because those writers and illustrators focused on the female body, and seemed to assume that the female sex was already corporeally and psychologically deviant by nature,[34] the equation between expression and the dysfunctional was most often located in the female body. Deviant expressiveness, the deviance *of* expression: the female form embodied one and was the emblem of the other. This strange semiotics of the body is the only possible one to which Degas's brothel monotypes could belong—for they strongly resemble the illustrations to Charcot's and Richer's art-history-based treatises on the abnormal female body. So does the 1886 series of nudes, with its bringing to the fore of the bodily subtext of the dancers and other images of the seventies, and its public presentation of the private world of bodily tumult seen in the monotypes. With their bold proclamation of the bodily themes of asymmetry and disorder, of inversion, introversion, and reflexivity, the 1886 nudes also belong in the same realm as the curiously tautological, negative discourse on expression that was common currency by the 1880s.

Chapter 4

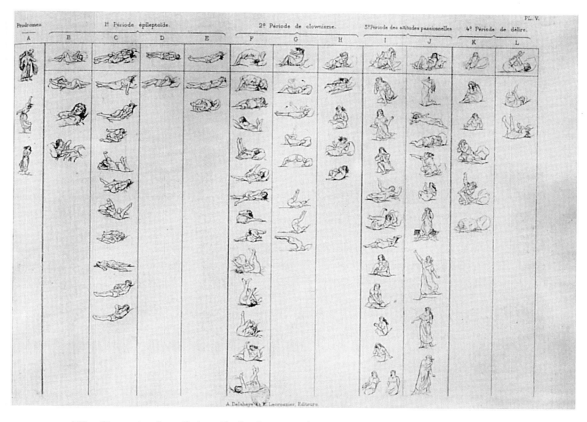

FIG. 100 Illustration from Richer, *Etudes cliniques sur la grande hystérie ou hys-
téro-épilepsie,* 1885

Huysmans, and later Meier-Graefe, asserted a connection between
Degas's disordered, inverted bodies and the "dance of death" of late me-
dieval imagery—the twisted, stretched, "whining" and "howling" limbs
of martyrdoms and crucifixions. I believe it is the discourse on the aber-
rant body which gives particular meaning to these assertions. Even if
Degas was not specifically aware of Charcot's and Richer's work (he
was aware of Bordier's and Lombroso's, and he *did* share the earlier
nineteenth-century obsession with prostitution, with which all of these
late nineteenth-century writings were continuous), Huysmans did seem
to be directly conscious of them—at least by the time he wrote *Là-Bas*
and *Trois Primitifs.* His writing on Grünewald's Karlsruhe altarpiece is full
of the resonances of their work on demonism, hysteria, and syphilis.[35]
This was what induced Huysmans to use the language of the "gro-
tesque"[36] to describe the deviant corporeal order of Degas's nudes, and to
talk of them as the works of a "modern Primitive," an against-the-grain
Taine, as exceptions and negations, rather than reflections, of the milieu
against which they are set.

Against the Grain

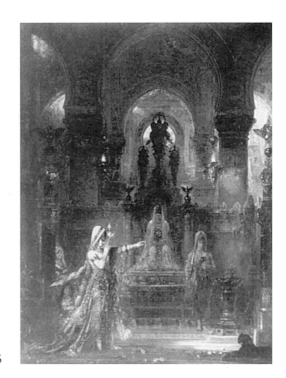

FIG. 101 Gustave Moreau,
Salomé Dancing before Herod, 1876

Degas's disordering of the syntax of the female body is also what allows Huysmans to tie them into his own misogyny, a misogyny redolent with notions of the aberrant body. Huysmans is more directly and vitriolically misogynistic in his discussion of other artists. These are his comments on Moreau's *Salomé* (fig. 101):

> An identical impression results from these different scenes (of *Salomé*), an impression of spiritual onanism, repeated in a chaste body; an impression of a virgin provided with a body of solemn grace, and a soul exhausted by solitary ideas, by secret thoughts, of a woman turned within herself, babbling sacramental formulae and obscure prayers to herself, insidious calls to sacrilege and debauchery, torture and murder.
>
> *Une impression identique surgissait de ces scènes diverses, l'impression de l'onanisme spirituel, répété, dans une chair chaste; l'impression d'une vierge, pourvue dans un corps d'une solennelle grâce, d'une âme épuisée par des idées solitaires, par des pensées secrètes, d'une femme, assise en elle-même, et se radotant dans de sacramentelles formules de prières obscures, d'insidieux appels aux sacrilèges et aux stupres, aux tortures et aux meurtres. (Certains: 18–19)*

And on Félicien Rops's prints (fig. 102):

> It's there, in effect, that one finds the character of these plates. A painter of talent might perhaps have rendered this carnal heat, this rutting ferocity, might have depicted, after nature, the ardent face of

Chapter 4

FIG. 102 Félicien Rops,
Les Sataniques: L'idole, 1882

female satyrs and nymphomaniacs, might have created, ultimately, a
materialist work confined to the aberrations of the generative faculty,
without taking it beyond reality, but I do not know anyone who has
so far been able, in the way that M. Rops has, to show you the
fulminations of the enraged soul of woman cursed, possessed, en-
flamed, in all her ideas, by the genius of Evil.

*C'est là, en effet, que réside la personnalité de ces planches. Un peintre de
talent eut peut-être rendu cette fougue charnelle, cette férocité de rut, simulé,
d'après nature, la face ardente de satyriasiques et de nymphomanes, créé enfin
une oeuvre matérielle confinée dans les aberrations de sens génésique, et sans
au delà, mais je n'en connais maintenant aucun qui eut pu, de même que
M. Rops, faire fulminer l'âme enragée de la femme maléficiée, possédée,
tisonnée, dans toutes ses idées, par le génie du Mal. (Certains: 108–9)*

Moreau's paintings and Rops's prints, with their satanic, pornographic
iconography,[37] may seem to fit Huysmans's notoriously lurid misogyny
more closely than Degas's imagery. Yet Huysmans treats Degas's nudes
misogynistically as well. He introduces his remarks on the nudes with the
theme of repudiation, rehearsing the comments about "cruelty" long
found in the criticism of Degas's works. In addition, he sums up his ad-
dress on the nudes with these words:

> Among the people visiting the exhibition, a few . . . cried out, in-
> dignant at this frankness, struck even so by the life emanating from

these pastels. In the end, they exchanged a few embarrassed, disgusted words, passing the judgment as they left that all of this was obscene!

Ah, if ever paintings were less so, if ever paintings were without generalizing strategies, without seductive ruses, if ever paintings were fully, decisively chaste, they are these.—For in fact, they proclaim a disdain for the flesh, as no artist has dared to do since the Middle Ages!

Moreover, it is not just a case of a man's wavering distaste for women, it's even more than that, it is the penetrating, sure execration that these women themselves feel for the deviated joys of their own sex, an execration which fills them with atrocious desires and leads them, *all on their own, to soil themselves* [my italics], proclaiming loud and clear the humid horror that they feel for their own bodies which no lotion, no amount of cleaning, will clean.

> *Parmi les gens qui visitaient cette exposition, d'aucuns s'écriaient, indignés par cette franchise, poignés quand même par la vie émanée de ces pastels. En fin de compte, ils échangeaient quelques réflexions honteuses ou dégoûtées, lachaient au départ le grand mot: c'est obscène!*
>
> *Ah! si jamais oeuvres le fûrent peu; si jamais oeuvres fûrent, sans précautions dilatoires et sans ruses, pleinement, décisivement chastes, ce sont bien celles-ci!—Elles glorifient même le dédain de la chair, comme jamais, depuis le moyen âge, artiste ne l'avait osé!*
>
> *Et cela va même plus loin, car ce n'est pas un dédain revisable d'homme, c'est bien plutôt l'exécration pénétrante, sûre, de quelques femmes pour les joies déviées de leur sexe, une exécration qui les fait déborder de raisons atroces et se salir, elles-mêmes, en avouant tout haut l'humide horreur d'un corps qu'aucune lotion n'épure.* (Certains: 267)

Several things are worth noting in this passage: first, Huysmans's reference to the Middle Ages—again Degas is identified with the primitives; second, his emphasis on the "chaste" nature of Degas's engagement with the nudes—Degas's refusal to make them titillating, pornographic, or possessable; third, his description of the nudes' gestures as onanistic—his sense that the nudes are acted on by themselves, loved and hated by themselves, both self-generating, in a way, and self-destroying; and fourth, his emphasis on the verbs of soiling and cleansing, activities which are equated with generation and destruction, and can be equated with representation itself. In all of these ways, the nudes are as implicated in Huysmans's themes of negative eroticism, perverse asceticism, onanism, and even woman-as-monster, as are the works of Moreau and Rops.

Degas's "misogyny" has often been and continues to be debated, very often in terms of the artist's biography. It is not my aim to further this debate or to decide whether Degas was a misogynist or not. There is plenty of material to suggest that he was —including his life as a probably celibate *célibataire* and his famed anti-woman *bons mots*. There is also plenty of material to suggest that he wasn't—his support of women artists, his friendships with salon hostesses, his sympathy for female rela-

tives, and his obsession with the depiction of women (an obsession which could be and has been read either way). The matter is too complicated to be neatly resolved. Moreover, the life of the artist is not our principal concern—rather it is the imagery. Anyway, the theme of the misogynist *célibataire* was a long-standing literary *topos* of the nineteenth-century artist, from which it is difficult to extricate "real life" attitudes.[38] So misogyny was a theme having to do with concepts of the artist, of artistry and representation—that is the way in which it is mainly interesting. The same is true of Huysmans's misogyny. In "real life," he appears to have been thoroughly unlikable, and though notorious, not particularly interesting—certainly a lot less interesting, because less conflicted, than Degas seems to have been. It is in his writing, where the misogynistic *topoi* of nineteenth-century literature are exaggerated, and where disgust begins to turn against itself, that Huysmans's misogyny becomes interesting— again as a representational matter.[39]

Huysmans's written misogyny is connected to the theme of repudiation, to his anti-Tainean discourse, his celebration of the primitives, and his vocabulary of the aberrational, "grotesque" body. This misogyny becomes the spearhead of all of Huysmans's negational weaponry. Huysmans himself says that the nudes are not to be taken as reflections of the artist's personal hatred of women. Instead, the artist's "misogyny" is related to more impersonal structures. It is tied to his "chastity"—a transformation of the *topos* of the familial unattachment of bachelorhood into the sexual detachment of celibacy. The "chastity" which Huysmans imputes to Degas is less real life than it is representational, less a matter of a life story and more a question of structural relations between representing subject and represented object. Misogyny is also tied to the negation of idolatry—"the idol so constantly kept and cared for": in this regard, the image of woman is equated with a canon of illusionistic fetishes, and she becomes the principal object of a form of iconoclasm. Thus, when misogyny is aligned with "chastity," it is set against fetishism,[40] which in turn is set against itself, and thereby converted into iconoclasm. Confronted with Degas's nudes, Huysmans takes the old figure of the artist as bachelor/misogynist/libertine and transforms him into a celibate fetish-basher, a monkish idol-toppler and -smasher: an artist-iconoclast. It is in this negative way that misogyny has to do with structures and processes of representation.

But Huysmans does more than impute an iconoclastic attitude to Degas—in fact, he states that the nudes are somehow *self*-destroying. Faced with Degas's series, Huysmans articulates his misogyny in terms of formal rather than iconographic description—given the onanistic, self-fragmenting reflexivity which he finds in Degas's nudes, misogyny becomes another name for a kind of auto-iconoclasm, whereby the act of representation turns in on and works against itself from within its own procedures. In short, Huysmans sees Degas's nudes as doubly negative

corporeal tautologies, which employ the language of corporeal expression and modern-life physiognomics, and the gestures of representation, to destroy and erase themselves. The nudes are, according to Huysmans, enactments of a process of disintegration interior to representation itself. And he is, I think, not far off.

Where Huysmans's writing is fevered and exaggerated, Degas's formal language is subtle, impersonal, almost abstract—yet in their cool way the nudes correspond to Huysmans's *à rebours* heat. The investment is different: self-mocking revulsion, apparently, on the one hand; some kind of conflicted empathy, perhaps, on the other—nevertheless, the results of their experiments in critical writing and canonical figuration do rather line up. Huysmans's strategies of negation, his inversion of the realist attitude, his language of the grotesque, his focus on the aberrational, "primitive" body, above all his misogyny: all of these ingredients of *Certains* are matched by Degas's formal maneuvers and add up to an *à rebours* aesthetic, an aesthetic set against the processes of commodification, communication, and exchange—of which the "American" city of late nineteenth-century Paris was the emblem, and the idolized image of woman the fetish. They are both implosions and inversions of the canons to which they belong: positivist criticism and realist writing in the one case, the nude and the language of the body in the other. Whereas Huysmans's misogyny is, if anything, self-caricaturing, Degas's is, if anything, self-undermining. Yet both of their very different misogynies are fairly radically iconoclastic, more truly subversive, I think, of the image as a fetish-commodity, and of the female body as idol and icon of the canon, than any other corpus of their era.

*

There is one last aspect of Huysmans's discussion of the nudes which is worth investigating—namely, the vocabulary of coloristic sensation which he employs to describe the flesh of the nudes and the surfaces of their surrounding. This is a language of sensation very close indeed to Zola's (and Duranty's) naturalist vocabulary, yet Huysmans also inverts and introverts it by caricaturing it—more subtly perhaps, but just as dramatically as he caricatures and negates the language of physiognomics on which positivist criticism is founded. By announcing the subjectivity of the naturalist vocabulary of sensation, Huysmans worked to detach it from a notion of objective representation. Further, by celebrating a "sick" optics, a world of overtly deformed optical sensation, and by taking up the body, in this case as a perceiving and consuming mechanism, and turning it inside out, making it function backward (*à rebours*), in this way as well Huysmans disintegrated the fetish, converting what he called the "idol," by its nature a hard and durable thing, into its opposite, something putridly amorphous, so *informe* as to no longer be a body, a *corps* in the sense of a corporeal thing or object. In this way as well Degas's nudes make a complicated fit with Huysmans's writing. They too con-

struct a world of deformed sensation, and, instead of putrefaction, a kind of abstraction made up out of a conflict between fragmentation and amorphousness.

In another passage on the nudes, Huysmans wrote:

> Above and beyond that particular accent of hate and contempt, the unforgettable truth of the types in these images should be remarked, thrown into relief by drawing that is both generous and incisive . . . The *ardent, insensible color,* the *mysterious, opulent tones* [my italics] of these scenes should also be regarded: the supreme beauty of flesh tinted blue or rose by the water, lit by closed windows draped in muslins, dark interiors illumined by veiled daylight filtering in from courtyards outside, and walls tapestried with textured cloth, washstands and basins, phials and combs, boxwood brushes and hotwater bottles of roseate copper!
>
> This is no longer the slick, even, always nude flesh of goddesses, . . . it is real, living, undressed flesh, flesh seized in its ablutions, goose-pimpled and deadened with cold.
>
> *Mais en sus de cet accent particulier de mépris et de haine, ce qu'il faut voir, dans ces oeuvres, c'est l'inoubliable véracité de ces types enlevés avec un dessin ample et foncier . . . ce qu'il faut voir c'est la couleur ardente et sourde, le ton mystérieux et opulent de ces scènes; c'est la suprême beauté des chairs bleuies ou rosées par l'eau, éclairées par des fenêtres closes vêtues de mousselines, dans des chambres sombres où apparaissent, en un jour voilé de cour, des murs tapissés de cretonnes de Jouy, des lavabos et des cuvettes, des flacons et des peignes, des brosses à couvertes de buis, des bouillottes de cuivre rose!*
>
> *Ce n'est plus la chair plane et glissante, toujours nue de déesses . . . c'est la chair déshabillé, réelle, vive, de la chair saisie par les ablutions et dont la froide grenaille va s'amortir.* (*Certains:* 25–26)

This is little enough to go on, all by itself. Yet Huysmans's nuanced description of the "ardent, insensible [*sourde*]" colors and the "opulent, mysterious" tones of Degas's series of nudes is not wholly unlike his more dramatic description of Moreau's jewel-like settings (fig. 101):

> In the room where they were hung there was a veritable conflagration of immense, ignited skies; crushed globes of bleeding suns, starry hemorrhages running in purple cataracts on the tumbling clusters of nudes . . . Against these backgrounds . . . women with hair of raw silk, eyes of a pale blue, flesh of icy whiteness . . . goddesses . . . radiating from the lapis of their wings . . . ; feminine idols . . . with brows mantled in green, . . . decked in long pearls, . . .
>
> . . . they disseminated in one's memory, in their indefatigable detail, in their minutiae of strange accessories . . . this whole surprising chemistry of *over-sharp colors,* they arrived at their most extreme levels, went to one's head and *dimmed one's sight.* [My italics.]
>
> *Ce fût dans la salle qui les contient un auto-dafé de ciels immenses en ignition; des globes écrasés de soleils saignants, des hémorragies d'astres coulant en des cataractes de pourpre sur des touffes culbutées de nues . . . Sur ces fonds des femmes aux cheveaux de soie floche, aux yeux d'un bleu pâle, . . . aux chairs*

*de la blancheur glacée . . .; des déesses . . . rayant du lapis de leurs ailes . . .;
des idoles féminines . . . aux fronts mantelés de vert, . . . couturés de longues
perles, . . .*

*. . . elles se disséminait, dans la mémoire, en leurs infatigables détails, en
leurs minuties d'accessoires étranges . . . toute cette surprenante chimie de
couleurs suraiguës, arrivées à leurs portées extrêmes, montaient à la tête et
grisaient la vue.* (*Certains:* 17–20)

The similarity between these descriptive passages and those on Degas's
nudes lies in Huysmans's description of flesh, and in his emphasis on a
kind of coloristic sensation so extreme as to result in the loss of sensation:
the dimming of sight.

Huysmans's evocation of the bluish tones of the naked skin of Degas's
nudes also bears a resemblance to his later fascination with the moribund,
many-hued flesh in Grünewald's *Crucifixion* (fig. 99):

> [R]osy fluids, little milky streams, liquids similar to gray Moselle
> wine, oozed from the chest . . . then the knees, brought together by
> force, collided at the kneecap, and the legs, twisted right to the feet,
> which, one brought over the other, bloomed in full putrefaction and
> became green beneath streams of blood. Those spongy, clotted feet
> were horrible; the flesh pimpled, gathered up around the head of
> the nail, the contracted toes contradicted the imploring gesture of the
> hands, cursed, almost clawed with the blue horns of their nails, at the
> ochre of the earth, shot through with lead, similar to the empurpled
> terrain of Thuringia.
>
> *[D]es sérosités rosâtres, des petits laits, des eaux semblables à des vins de
> Moselle gris, suitaient de la poitrine . . . puis les genoux rapprochés de force,
> heurtaient leurs rotules, et les jambes tordues s'évidaient jusqu'aux pieds qui,
> ramenés l'un sur l'autre, s'allongeaient, poussaient en pleine putréfaction,
> verdissaient dans des flots de sangs. Ces pieds spongieux et caillés étaient
> horribles; la chair bourgeonnait, remontait sur la tête du clou et leurs doigts
> crispés contredisaient le geste implorant des mains, maudissaient, griffaient
> presque avec la corne bleue de leurs ongles, l'ocre du sol, chargés de fer, pareil
> aux terres empourprées de la Thuringe.* (*Là-Bas:* 10–11)

Although Huysmans's description of Grünewald's *Crucifixion* is war-
rantedly more extreme than his discussion of Degas's nudes, his truly
spectacular description of the palette of the *Crucifixion* bears some resem-
blance to his evocation of color in the nudes. Moreover, the language he
uses to evoke the gestural life and twisted corporeal form of Grünewald's
Christ resonates vaguely with his caricatural descriptions of the poses and
stances of Degas's nudes. So, though subtly, does his rendering of the
textures and colors of Christ's moribund flesh resemble his coloristic evo-
cation of the nudes' "flesh tinted blue . . . goose-pimpled and deadened
with cold."

As befitted a naturalist writer, Huysmans always wrote colorful de-
scriptions—and his criticism, whether realist or antirealist, always be-
trayed the naturalist leaning: it is some of the most vividly descriptive

critical writing of the period. Huysmans's description of the interiors and surfaces of Degas's nudes is no exception—it is still essentially naturalist writing. (So is his description of Moreau's *Salomé* and Grünewald's *Crucifixion*.) Yet is also bears the trace of the discourse on the connoisseurship of sensation produced in *A Rebours,* which itself, though its argument is antinaturalist, is profoundly, vividly naturalist in its mode and its profusion of description.

A Rebours consists of chapters and chapters of description—of the opulent interiors of Des Esseintes's house, the exotic objects and the art works, the books, dreams, memories, retrogressive ruminations, perverse fantasies, and negational sensations with which the "hero" surrounds, drowns, and literally stupefies himself. In *A Rebours* Huysmans applies the naturalist mode of detailed, sensational description to an exclusive, aristocratic, anti-modern-life milieu. Rather than discarding naturalist description, he turns it inside out: using to evoke an eclectic interior world and low states of mind (rather than *low life*), severing it from the social meanings attached to description since Balzac, putting it to the service of perverse connoisseurship of extreme sensations—which leads consistently to their opposite, the deadening of all sensation. Indeed, *A Rebours* is scattered with adjectives and adverbs of stupefication and loss of sensation, *surdité* of all kinds: muffling, dimming, choking and stifling, muteness, blindness, and finally, syphilitic impotence. (Sex is included in this solitary carnival of gluttony and nausea of all kinds, and leads to a febrile celebration of its attendant sickness, syphilis—*A Rebours:* 137ff.) Everything in Des Esseintes's overly artificed interior world participates in this deadening of sensation through excess—from his taste organ to his overwrought tortoise, killed by the jeweling of its shell (*A Rebours:* 95–97, 99–100, 103), and to his collection of rare orchids, an emblem and prime example of the language of stupefication—"an effaced lilac, of an almost extinguished mauve . . . plants without odor . . . flowers of harsh, blinding tones . . . These plants are truly stupefying" (*"un lilas effacé, d'un mauve presque éteint . . . les plantes inodores . . . des fleurs aux tons aveuglants et durs . . . Ces plantes sont tout de même stupéfiantes"—A Rebours:* 136–37).

Though in *A Rebours* all the senses are addressed—sound, smell, touch, and taste as well as sight, it is the latter sense which concerns us most. In that regard, the array of blind-making colors that the orchids represent is not far off from the visual sickness, the "violetomania" and "indigomania" referred to by the critics of impressionism, but the deformed opticality criticized by those critics is now glorified and exaggerated into its opposite, the *loss* of visual sensation. Thus *A Rebours* is a kind of allegory of the senses driven insensate through orgiastic overuse and too eclectic combination (also found in Huysmans's insistence on elaborate artificiality and his caricaturing of Baudelairean *correspondances*). In the novel, the body as an organ of perception and consumption, a standard feature of Zola's naturalist criticism, in which the modernity of

Manet's and the impressionists' painting, for example, is located in the advanced individuality of their organs of sight,[41] is forced to function too concentratedly, too eclectically, too extremely, and then to reverse itself—as, for example, in Des Esseintes's substitution, after bouts of fasting, feasting, and stomachaches, of the enema for the meal (*A Rebours:* 194–204)—and to almost kill itself in the process. By announcing the built-in excess and the intense subjectivism of naturalist description, also a feature of positivist criticism and of Taine's writing, and by locating subjectivist description in an unnaturally artificed and hermetically sealed interior world which constitutes a rejection of the exterior, social world of modern-life Paris, *A Rebours* effectively becomes a treatise on naturalist perception run amuck and turned backward against itself—such that "à rebours" means not only against the grain of modern life, but also against the grain of naturalist description and sensation.

We have already established that the traces of *A Rebours* are found throughout *Certains*. The mark of the novel is also found in the mode of description employed in the little book of criticism, including the article on Degas's nudes. It haunts Huysmans's evocation of "ardent, *sourde* colors" and "opulent, mysterious" tones, his enumeration of muslin drapes, dim interior light, tapestried walls, phials, boxwood brushes, and copper bottles, and his description of flesh deadened by cold. His emphasis on a lurid palette defined at once by its obscurity and its intensity, as well as by its exoticism, in short by its *surdité,* and his technique of inventorying artificed surfaces and objects are both informed by the discourse on stupefication, artifice, and sensory excess produced in *A Rebours.*

Like most of his other remarks on Degas's nudes, Huysmans's description of their settings and surfaces undermines the possibility of a modern-life reading. In spite of Huysmans's obligatory comment about incisive drawing and true-to-life types, the milieu that he paints in words seems to signify nothing about the figures themselves—or if it does, it does so by opposition, by serving as a contrast to his descriptions of the bodies of the nudes. As we have seen, Huysmans levels the nudes to one low class of creature, the butcher woman. These "opulent," "mysterious" interiors hardly correspond to that class of woman. And Huysmans's stress on the corporeal illegibility and gestural violence of the nudes stretches even further the split between description and meaning. If Huysmans's vituperative language concerning the gestures and bodies of the nudes is a form of naturalist writing caricatured to the point of negation, so is his description of the nudes' settings—it does the work, not of designation, signification, and contextualization, but of the contrary: contrast, opposition, and negation. It announces the subjectivity rather than the objectivity of the artist's vision, and it concentrates on the artist's artifice rather than on his or his world's "nature." In *A Rebours,* the theory of the readable modern-life milieu is descriptively inverted and the perceiving body of its main character turned away from the world and backward against

itself: in *Certains* the figure of the painter as perceiver, maker, and character is made similarly hermetic, and the text of the modern-life interior is similarly obscured through the process of description, and similarly negated.

Again, the nudes fit these descriptive strategies in their look as well. Their surroundings are crowded with the textured surfaces of a variety of fabrics: towels and bedclothes, carpets and wallpaper, curtains and drapes, muslin and linen, and so on. The rainbow palette in which these textiles are rendered is a fairly spectacular feature of the series, which would be intensified in Degas's post-1886 work and indicated by critics like Meier-Graefe. (See figs. 103–7: the Norton Simon *After the Bath,* the Courtauld *After the Bath,* the London National Gallery *After the Bath,* the Orsay *After the Bath,* and the Toledo *Dancers* [pl. 3].) Neither the colors nor the textures of the 1886 or the later nudes are locally descriptive. They tend to hover between description and abstraction, constantly pulling away from the chiaroscural foundations and the prominently drawn contours of the nudes, floating away to the top of the paper to form arrays of peculiarly groping touches, strangely uniform matrices of pastel hatchings (reminiscent of the portrait of Duranty, though this particular graphic vocabulary is more obvious and consistent in the nudes). The colors and textures of the nudes have little to do with social description— in many cases, they do not seem to correspond to vision at all, to the transitions in gaze as one's eye passes from depth to volume, or from

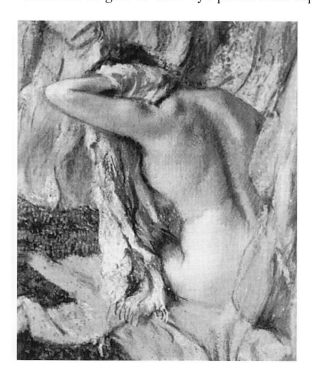

FIG. 103 Degas,
After the Bath, 1885

object to object. Indeed, the pastel marks constituting the nudes often have the effect of muffling and screening the forms beneath them, resulting in the constant awareness of the artist's touch on the surfaces of depicted bodies and on the surface of paper itself—as if these bodies were formed by blind marks made on a surface by touch, and not by sight at all.

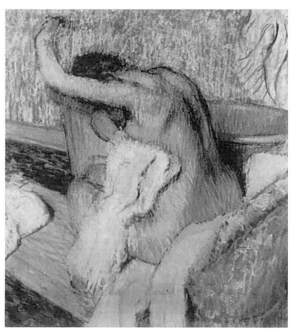

FIG. 104 Degas, *After the Bath (Woman Drying Herself)*, 1890

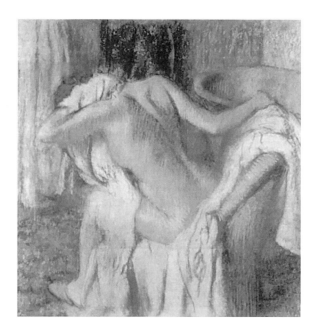

FIG. 105 Degas, *After the Bath*, 1888–92

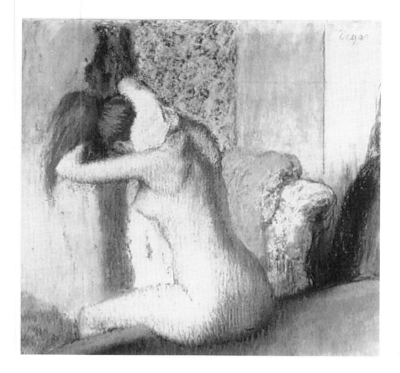

FIG. 106 Degas,
After the Bath, 1898

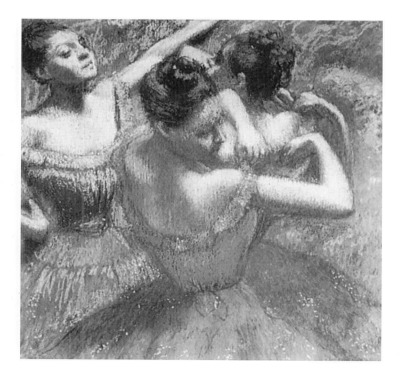

FIG. 107 Degas,
The Dancers, 1899

This muffling effect adds to the stress on the blind tactile life of the nudes. The woman in the Orsay *Tub* (fig. 89), for example, gropes at portions of her person which she herself cannot see, as if the acts of touching and seeing were not connected and the fact of touch has replaced that of the gaze. The gazes of most of the other nudes are simply excluded. This "blindness," along with the emphasis on tactility, extends to the claustrophobically textured, blinding-hued surroundings of the nudes— because of their *sourde,* peacock palette, the nudes, already defined as inward and interior through their surrounding spaces, their gestures and ablutionary activities, are more thoroughly interiorized in this sensational closeness, a *surdité* as stifling and stupefying as Des Esseintes's eclectic interior world. In other words, the introversion of sensation is just as complete in the nudes as that of gesture is. Just as their inverted bodies make a good fit with Huysmans's caricatural language in *Certains,* and with his thematics of corporeal inversion in *A Rebours,* so their surfaces and surroundings match his caricature of the subjective sensationalism of naturalist description, and the resulting *surdité* of his coloristic vocabulary in both texts.

Huysmans's language of color is as self-negating as his physiognomic vocabulary. The same is true of the nudes themselves: not only do their obsessively textured surfaces and dim-brilliant colors confound sight and produce a kind of blindness, the pastel marks which constitute them also have the effect of partially destroying them—this is particularly true of the later, post-1886 nudes, whose increasingly obvious pastel striations give them the look of skin surfaces scratched and flayed by the artist's mark-making. And the monotype grounds beneath some of the nudes produce similarly self-destructive effect. Especially striking is the relationship between the original monotype and the pastel-over-monotype version of the Orsay *Woman in a Bath, Sponging Her Leg* (figs. 95, 108). The dark-ground, second-impression monotype base for this image is literally a negative image: the bathing woman has been created by various degrees of erasure. She is black and hideous, sunk in a bath of grime, monkeylike in the clawing gesture she makes at her leg—a cleansing gesture in the pastel version which in the monotype appears somehow self-abusive. She is a particularly good illustration of Huysmans's sense that these are images of women who can't get clean (as are Degas's earlier, grimier monotypes like *The Bidet,* and other images of ablutions, self-absorption and voyeurism—figs. 109–11. It is worth relating the pastels to monotypes like these). As I indicated in my earlier discussion of the medium, the presence of the monotype image beneath the pastel, in *The Woman in a Bath Sponging Her Leg* partially revealed in the bather's smudged back and foot and murky bathwater, is an inherently undermining one. But the monotype bather is also concealed and contradicted by the pastel surface laid down on top of her—her gesture, established in monotype, is transformed in pastel. This one image is made out of a dia-

lectic of rubbing out and covering over, two mutually contradictory, self-negating levels of depiction. Thus she supports Huysmans's negative version of naturalist description and matches his characterization of ornamentation as ruination, decoration as destruction, artifice as *ordure*, the act of representation as a matter of soiling, staining, spoiling, of not really production, nor really consumption, but instead waste-making, the reverse-side permutation of both.

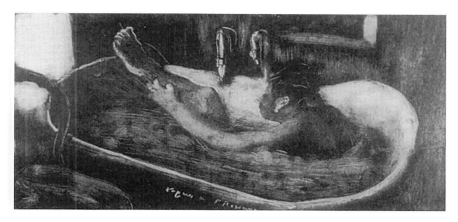

FIG. 108 Degas, *Woman in Her Bath*, 1880–85

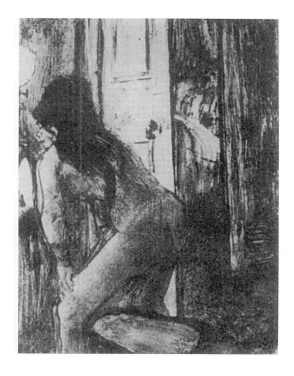

FIG. 109 Degas,
The Bidet, 1878–80

Against the Grain

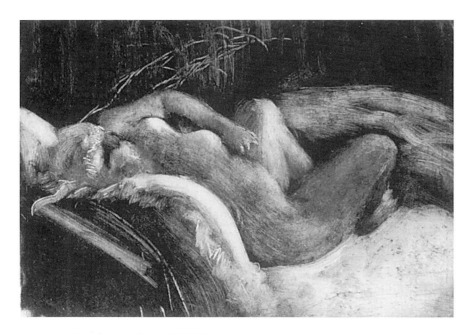

FIG. 110 Degas, *Sleep,* 1883–85

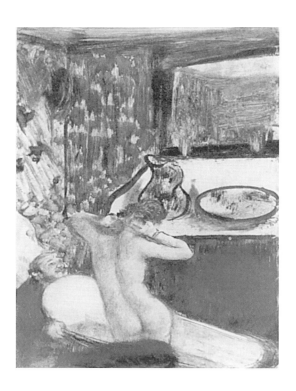

FIG. 111 Degas,
Admiration, 1877–80

There is one striking way in which Degas's nudes do not quite match Huysmans's *à rebours* language. In the novel, at least, the vocabulary of stupefaction and *surdité* is combined with an insistence on adjectives of mineral putrefaction and liquefaction.[42] The amorphousness which Huysmans celebrates in *A Rebours* is thoroughly rotten, of a kind where the solid shapes of bodies and the hard forms of objects turn, soften, melt, and deteriorate into liquid: it is not by accident that Huysmans's emphasis on the concentrates and extracts of various media is articulated in terms of the word "coulis," nor that his celebration of decadent language takes this form: "completely rotten, she [the Latin language] sagged, lost her limbs, ran into pus. In the full corruption of her body, she barely retained a few firm parts, which the Christians detached in order to marinate them in the brine of their new language" (*"complètement pourrie, elle pendait, perdant ses membres, coulant son pus, gardant à peine, dans toute la corruption de son corps, quelques parties fermes que les chrétiens détachaient afin de les mariner dans la saumure de leur nouvelle langue"*—*A Rebours*: 91). Prime examples of this, after *A Rebours*, are the passages on Moreau in *Certains* and the description of Grünewald's *Crucifixion* in *Là-Bas* and *Trois Primitifs*. In these, the adjectives of mineral liquefaction are even more pronounced: they are at the same time adjectives of color and exaggerations of the traditional alignment between color and amorphousness, as well as of that between color and femininity.[43] To give Huysmans some credit for recognizing differences between artists, his passages on Degas's nudes do not employ this vocabulary of liquefaction; instead, his language there is one of hardness, brittleness, breakage. Rather than insisting that the solid forms articulated in drawing *turn* into the soft, fluid amorphousness of color, Huysmans sets the "cruel" hardness of Degas's drawing subtly *against* the rich vagueness of his color.

And this is true to the nudes—instead of soft and fluid (this would be a better description of Bonnard's nudes), they tend to have sharp and broken shapes. Their disintegration is different: rather than melt-down their's is fragmentation and rather than a degradation of object matter, a disordering of corporeal and morphological syntax. For in a way the nudes are anything but formless—rather than solid shape liquefying into shapeless streams of color, they represent a merger between normally opposite morphologies and conventionally distinct aspects of form: between angularity and circularity, for instance, or between interiority and exteriority, contour and fold, fleshy surface and bony structure, and even between drawing and color. And instead of drawing *turned* into color, Degas's pastel striations do the opposite, they turn color into drawing, a colored drawing which clashes with itself, as Huysmans indicated earlier, in his description of the portrait of Duranty. Color-as-drawing, drawing-as-color, whichever way you have it, it is at war with itself, a battle of tinted marks. This suggests a kind of violence, as I have already shown—rather than decay, chaos: a melée of opposing forces. And so this is after

all a form of amorphousness. The manner of Degas's drawn color also suggests amorphousness, in its cloudy, tainted, veiled look, and in its lurid combination of dimness and brilliance, vagueness and vividness, suggesting changeability, translucency: almost a gaseous, definitely a particulate, but never a liquid, state of matter. Its amorphousness is dry, not wet—by the eighties. Degas's pastels, no longer so given to combination with liquid media like watercolor, distemper, and turpentine, are too insistently chalky to suggest wetness.

Moreover, if material deterioration is at work at all in Degas's nudes and other late works, it takes the shapeless shape, not of the "natural," organic degeneration of plant, thing, and body, but of the inorganic grinding down of pigment associated with the productive, cosmetic artifices of the atelier, the laboratory, and the boudoir—the pulverization of both drawing and color simultaneously (because they are the same) into powder. Both the sometimes hesitant drawn lines which define yet confuse edges and creases *and* the striations which describe object surfaces yet screen them in woven webs of canvaslike colored hatching are constituted and also half-obliterated in this pastel dust. Elsewhere I have described the nudes, *à la* Huysmans, as facturally as well as morphologically and gesturally onanistic; I have claimed that even their facture is self-reflexive, returning them to the ground of representation ("Edgar Degas and the Representation of the Female Body"). But I think it is also true that each breaking down of shapes and surfaces to their foundations is also a building up, and, vice-versa, each building up is also a breaking down. It is above all there that the peculiar amorphousness of Degas's nudes lies—not in their forms per se, but in the confounding of distinctions, even between conjunction and disjunction, construction and destruction.

So Degas's nudes are similarly but differently *sourde,* similarly but differently *informe.* Sometimes built on top of a shadowy, greasy, dissolute layer of chiaroscuro, traditionally meant as a foundation in which to establish volumes and build forms, but here doing the opposite, they are constituted out of a strange, conflictual merger between levels of form and facture and aspects of the sensory experience of painting that are conventionally opposed. At all levels, including those of color and drawing, they are both self-reflexive and self-destructive, building dissolution upon dissolution, inversion upon inversion. They too dissolve the shapely symbolic form of the fetish, the "idol," by turning it in on and setting it against itself, by making it *sourde,* both sensational and insensate, by dissolving, pulverizing, merging, disarticulating the means and the experience of the illusionism upon which the fetish is built—but without recourse to the symbolist, decadence-celebrating strategies of Huysmans, whereby metaphors of nature and culture, ornamental and organic matter, are symbiotically, synesthetically combined. Huysmans's writing proposes a world of unnatural artifacts organically *and* unorganically degen-

erating into a written version of pure coloristic sensation which suggests a kind of written facture that is half artifice and half nature. Degas's nudes, by contrast, construe a completely solipsistic, completely artifice-bound world which has nothing to do with natural or organic processes, and everything to do with its own procedures, those of image-making. His is an imagistic world completely within and against itself, within which the process of image-making *becomes* the process of image-dissolution, the means of illusionism *become* the means by which illusionism is made to disintegrate, and the elements of the sensory experience of painting *become* the elements of the *surdité* of painting. This was Degas's way of toppling the idol, by having her invert and negate herself through her own artifices. This was Degas's *à rebours* version of late nineteenth-century proto-abstraction, his negative, inverted, corporeal variant of what Greenberg would later celebrate in positive terms. And at all of its confused levels, it was a perfectly against-the-grain *adieu* to Degas's milieu, to his century, his group, and his public.

*

"The fruits of my travels this summer. I stood at the doors of railway carriages and looked around vaguely. That gave me the idea of doing some landscapes. There are twenty-one of them."
"What? Very vague things?"
"Perhaps."
"States of mind?" . . .
"States of eyes" replied Degas. "We do not use such pretentious language."
(Quoted in Kendall, "Degas and the Contingency of Vision: 180)

After the end of the impressionist exhibition, Degas had a one-man show in which he stated his ironic relationship to the "school" of impressionism (it had been ironic from the beginning). In 1892–93 he emerged one last time, to exhibit another series of related works, this time at Durand-Ruel's: a set of almost completely abstract landscapes done in monotype with oil colors, sometimes with pastel (figs. 112–15: *Forest in the Mountains,* Mrs. Bertram Smith Collection, New York; *Burgundy Landscape,* Orsay, Paris; *Esterel Village,* Bibliothèque Nationale, Paris; and *Landscape* [pl. 4], Metropolitan Museum of Art, New York).[44]

This was a typically contradictory move on the part of Degas—contradicting his own famous contempt for the art of landscape and for the notion of *plein air* painting and the instantaneous "impression." Both ultra-impressionistic and anti-impressionistic, even conceptual in a way ("I stood at the doors of railway carriages and looked around vaguely. That gave me the *idea* [my italics] . . ."), both "states of mind" (though Degas controverts that) and "states of eyes," the landscapes are "vague things," extremely sensuous images conceived entirely in blotted ink and color, utterly lacking in the rigors of drawing and gesture that had always characterized his work, even his messiest monotypes and his most frag-

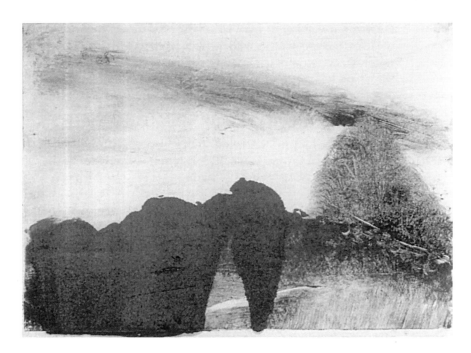

FIG. 112 Degas, *Forest in the Mountains (A Wooded Landscape)*, 1890–93

mented pastels. They look like *intimiste* versions of Monet's great late se-
ries, also shown at Durand-Ruel's during the same years: in Degas's own
words, "more Monet than my eyes can stand" (Kendall, "Degas and the
Contingency of Vision": 192). Indeed, they seem to give the strategy of
seriality over to Monet and to landscape art, and to remove it from the
sphere of gesture and physiognomic expression. They also seem to com-
pletely divorce the world of sensation from its physiognomic, positivist
ground, to divorce it absolutely from all semblances of human meaning,
indeed from the field of representation itself: landscape is the barest pre-
text for these clouds of color and spots of ink. The landscape monotypes
are Degas's most completely abstract works; as such, though Degas
wouldn't have foreseen this, they help to situate the advent of abstraction,
and its relationship to the recording of sensation, back in Monet's ephem-
eral, nonhuman world of sky, cloud, water, and unarticulated pieces of
land—in visual pleasure as detached from physical life and gestural work.

The landscape monotypes are utterly private fantasies, tiny in com-
parison to Monet's ever larger series, made out of the same veils of pea-
cock color that had constituted dancers' dresses, make-up and spotlight,
the fabrics of *coulisses* and *boudoir* alike: fantasies which rather perversely
make the world of "natural" sensation—Monet's world—over into that
of artifice. How typically contrary to Degas, to come out of hiding and go
public one last time, with the most private of his images, the most idio-
syncratic and self-negating.

Chapter 4

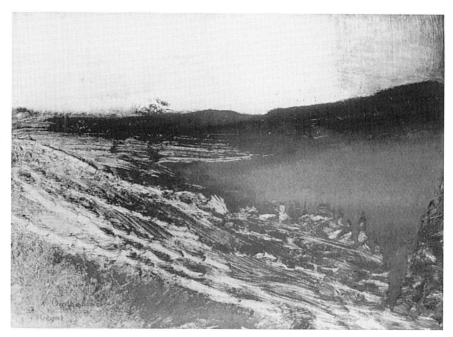

FIG. 113 Degas, *Burgundy Landscape,* 1890–92

FIG. 114 Degas, *Esterel Village,* 1890–92

FIG. 115 Degas, *Landscape,* 1890–93

Monet: Degas's old rival within the impressionist group, the impressionist painter *par excellence,* the one of the old group who stood most for the notion of painting that Degas claimed to despise, the one who had always been at the head of the group's opposing faction, about whom the most vivid symbolist language was produced, and since then the most concerted discussion of seriality, narcissism, and reflexivity.[45] I would like to end this chapter with this suggestion: whatever else the landscape monotypes might be, as an exhibited series, they must have been meant, at least in part, to be seen in ironic relationship to Monet's series,[46] defining the culmination of impressionist sensationalism as a world of utter formlessness and absolute introversion. Ultimately they define Degas's art as such as well, at least at its most extreme, when severed from the gestural, corporeal foundation so crucial to it, and so idiosyncratic. Degas's last gesture to his public, it was also his last concerted statement about his place in modern painting and aesthetics and about his relationship to the group with which he had begun. Without realism, without modern-life physiognomics or physiognomic sensation, this was what was left: formlessness, face paint, vaguely erotic sensation turned in on itself, absolutely disconnected from the world, an unmappable, unreadable landscape of the mind. These paintings are also the most extreme illustrations possible of Huysmans's inversion and introversion of naturalist aesthetics and his implosion of the fetish and the idol—for there are no better exemplars of Huysmans's *surdité* than these small, *informe,* abstractly erotic images,

which have, for once, the vague, insidiously oriental, pseudo-organic look of symbolist painting.

Perhaps it is also true that the landscape monotypes invert the inverting tendencies of the nudes, undermining not only representation but also its obverse, abstraction. For if parody can be associated with such lovely, iridescent images, then the landscape monotypes stand in parodic relationship to the basic tenets of abstraction as founded in realism and impressionism and expanded in the twentieth century, and as laid out by Clement Greenberg: the celebration of pure sensation, pure vision, pure painting, the utopian freedom from representation and its history.

FIG. 116 Degas, *After the Bath (Woman Drying Her Back)*, 1896

The Myth of Degas

From Vasari onward, accounts of the oeuvres of major artists have included anecdotes and stories about the artists' lives. And biography is a particularly important component of nineteenth- and twentieth-century art history, fiction, and criticism. As Zola said, "For me, . . . a work of art is . . . a personality, an individuality . . . it's a matter of being oneself, of showing one's naked heart, of energetically formulating an individuality . . . What I look for above all in a picture is a man and not a picture" (*"Pour moi, . . . une oeuvre d'art est . . . une personnalité, une individualité . . . il s'agit d'être soi, de montrer son coeur à nu, de formuler énergiquement une individualité . . . Ce que je cherche avant tout dans un tableau, c'est un homme et non pas un tableau"*—Zola, "Mon Salon," 1866: 61). Zola's treatment of Manet's art as symptomatic of his personality is prototypical of this approach in the nineteenth century. In the twentieth century, the best examples, of course, are the many accounts of Picasso's life and loves.[1] Most modern artists also participated actively in the mythification of their own lives by means of autobiography: Delacroix, with his *Journals,* concentrating as they do on events from his *éducation sentimentale,* and Van Gogh, with his letters detailing his amorous desires and frustrations, and the relationship between his art, his love life, and his "madness," are both exemplary. But Degas was different. Certainly his personality and personal history were mythified, and just as certainly did he participate in the process—but he did so through silence and enigma. And so did his would-be "biographers." Foremost among these was P. A. Lemoisne, whose four-volume work on Degas still constitutes the major monograph on the artist. These are Lemoisne's opening words about Degas's life and character:

Explain Degas: difficult, delicate task! . . .

His genius was so vast but so complex, so full of reticences, so voluntarily effaced behind the sobriety of his means, that those who broach this subject can only outline it partially or in a general way, put off by the difficulty of synchronizing so to speak, the man and his work.

This is because Degas does not reveal himself to the first comer—even in his works—he who pronounced, "painting is private life." In order to follow the evolution of the artist, it would be necessary to know the man, his way of thinking, his tastes, his dreams. And if he was a man difficult to know, walled up as he was in his insurmountable discretion, in a sort of timidity which rendered him caustic and

often severe when he felt that timidity menaced, this *was* indeed Degas. His profound horror of chatter, of any hint of speculation applied to art, his fierce reserve vis-à-vis that which he felt and thought, his voluntary retreat into his studio can hardly do other than complicate the task of the historian. First of all, because they suppress most of one's sources of information, but more importantly because they contribute to the creation of a legend around Degas which by its very essence was only true of a negligible part of him, but which, carefully cultivated by the artist himself, whom it amused to do so, sufficed to hide the true face of Degas for a long time.

Moreover, as soon as one attempts to know the man better, one immediately finds oneself in a vicious circle; audacious in spite of an insurmountable modesty, ardent in spite of a fierce reserve, decisive in spite of his eternal scruples, expansive in spite of an innate sobriety of expression—Degas was himself only in his works. The result is that one arrives at this conclusion: that in order to better understand Degas, one cannot judge him on the basis of character judgments, on the basis of his jokes and jibes, on the basis of witticisms transformed beyond recognition, any more than on rifled-through pictures and drawings, chosen at random, often classed without thought, but rather on the magnificent ensemble of his life and his entire production.

Expliquer Degas: tâche difficile et délicate! . . .

Son génie fût si vaste mais si complexe, si plein de réticences, si volontairement effacé derrière la sobriété des moyens, que ceux qui abordèrent ce sujet ne purent l'envisager que partiellement out dans les grandes lignes, déroutés par la difficulté de synchroniser, si l'on peut dire, l'homme et l'oeuvre.

C'est que Degas ne se livre pas au premier abord, même dans ses oeuvres, lui qui bougonnait "la peinture, c'est de la vie privée." Pour mieux suivre l'évolution de l'artiste il faudrait donc connaître l'homme, sa façon de penser, ses goûts, ses rêves. Or s'il fût un homme difficile à connaître, muré qu'il était dans une invincible discrétion, une sorte de timidité qui le rendait caustique et souvent dur lorsqu'il la croyait menacée, c'est bien Degas. Son horreur profonde du 'battage,' de toute idée de spéculation appliquée à l'art, sa reserve farouche quant à ce qu'il sentait et pensait, sa retraite voulue dans son atelier, ne font certes que compliquer la tâche de l'historien. D'abord parce qu'elles supprimer la plupart des sources d'information, mais surtout parce qu'elles contribuèrent à créer autour de Degas une légende qui, par son essence même, n'était vraie que pour une part infime, mais qui, soigneusement entretenue par l'artiste qu'elle amusait, suffit à cacher longtemps le vrai visage de Degas.

De plus, lorsque l'on tente de mieux connaître l'homme, on s'aperçoit vite que l'on tourne dans un cercle vicieux, Degas n'ayant été vraiment lui, audacieux malgré d'éternels scrupules, éblouissant malgré une sobriété innée d'expression, que dans ses oeuvres. Et l'on en arrive donc à ce résultat que, pour mieux comprendre Degas, il ne faut pas plus le juger sur des aperçus de caractère, des bribes de son esprit, des mots colportés et transformés, que sur des tableaux ou des dessins éparpillés, choisis au hasard, souvent classés au petit bonheur, mais bien sur l'ensemble magnifique de sa vie et de son entière production. (Lemoisne, *Degas et son oeuvre,* vol. 1: 1–2)

Peculiarly contradictory opening—for *the* definitive monograph on an artist—and one full of the contradictions in the artist's personality. Those contradictions are put to the service of an account characterized by occlusion and incapacity. Lemoisne used the contradictions in Degas's persona to deny the efficacy of a reading of milieu and manners (in other words, Duranty's—and Taine's—theory of readability can no more be applied to this artist's personality than to his works), and to rehearse Huysmans's mythification of the artist's privacy, reserve, and inaccessibility to the public. Saying that Degas was "himself only in his works," Lemoisne is negative about the connectedness of the oeuvre to the inaccessible persona of this artist, in effect denying the efficacy of biographical narrative right at the opening of his own biographical treatment of Degas.

In general, the picture of Degas bequeathed to us by friends and biographers is that of Degas the octogenarian. Benedict Nicholson provides us with a résumé of this picture in his editorial on Degas of June 1963. He begins "Degas as a Human Being" with a quote from Degas's friend Jacques-Emile Blanche: " *'Le bel obstiné au visage du vieil Homèr'* is an acceptable *idée reçue* about Degas in old age; 'King Lear' is another, also accurate" ("Degas as a Human Being" 239).[2] Nicholson ends his short piece thus (p. 241): "King Lear, in other words, blundering into a cluster of vultures." This article amounts to a collection of reports about Degas made by Blanche, Lemoisne, Paul Valéry, Daniel Halévy, Ambroise Vollard, Jeanne Fevre, and Paul Lafond, all of whom knew Degas more or less intimately. Their reminiscences are naturally colored by the remembrance closest at hand: Degas the old man. For example, the account written by Daniel Halévy, an important historian of the remnants of the *ancien régime* in the Third Republic and the son of Ludovic Halévy, one of Degas's very closest friends until the Dreyfus affair,[3] portrays Degas as an ancient—not surprisingly, since his are a youngster's memories of a mythic elder, a legendary old avuncular figure prominent in familial recollections. As Halévy says,

> I take this from notes I took myself between 1888 and 1897. Thus it is an adolescent of sixteen years that the reader has before him.
>
> An octogenarian has recently been silenced.
>
> *Je prends ici des notes relevées par moi-même entre 1888 et 1897. C'est donc un adolescent de seize ans que le lecteur a devant lui.*
>
> *Un octogenaire vient de se taire. (Degas parle: 26)*

Another biographer, Paul Jamot, begins his monograph on Degas with an image of the end of the painter's life:

> At the end of a long life devoted entirely to his art, Degas was famous, but his was a vague and mysterious fame. He could not complain about this obscurity. He did not complain: he hid his life from view, as he hid his work. His name was uttered with respect, with fear. His personality was hardly any more public than his painting. His phrases circulated through the ateliers of Paris. Most of

them were sarcastic. Some of them were unfair. A few seemed tremendously witty. But nothing dies faster than the fires of witty repartee. Posterity demands other qualifications. It interrogates the work of the artist; was it not this that Degas really wanted, secretly hoped for? He was almost blind in the last years of his life, and this infirmity, aggravating the ordinary effects of age, isolated him more than ever from his century. Perhaps his old Homer's eyes, which saw neither the works of nature nor those of man any longer, were filled with a vision of a Parnassus such as the old masters dreamed of, where the injustices of his day would be magnificently revenged.

> *Au déclin d'une longue vie que l'art avait occupée sans partage, Degas était célèbre, mais d'une célébrité mystérieuse et imprécise. Il ne pouvait se plaindre de cette pénombre. Il ne s'en plaignait pas: il a caché sa vie, il a presque caché son oeuvre. On prononçait son nom avec respect, avec crainte. Sa personne n'était guère plus publique que sa peinture. Des mots couraient les ateliers. La plupart sont mordants. Plusieurs sont injustes. Quelques-uns ont paru très spirituels. Mais rien ne se glace plus vite que les feux de l'humeur et de la repartie. La postérité demande d'autres titres. Elle interroge l'oeuvre; n'est-ce pas ce que voulut, espéra secrètement Degas? Devenu presque aveugle dans les dernières années de sa vie, cette infirmité, aggravant l'effet ordinaire de la vieillesse, l'isolait plus que jamais de son siècle. Ses yeux de vieil Homère, qui ne voyaient plus les ouvrages de la nature ni ceux des hommes, n'étaient-ils pas remplis par la vision d'un Parnasse, tel que l'ont rêvé les anciens peintres, où les injustices d'un jour reçoivent des réparations magnifiques? (Degas: 4)*

Jamot's first paragraph sets out the important factors of the end of Degas's life: his blindness, his isolation, his atavism, his idiosyncratic renown. The litany of the public's injustice, so dear to biographers of the avant-garde, runs through it, but the crucial figure of the opening of this account is, as in all of the others, that of old age. To a certain extent, the old-age, hindsight view is typical of monographs, and of biographical narratives, especially in the case of artists with large myths. Picasso is a good case in point. But Picasso's end-of-life story is very different from that of Degas: the randy old man, rich in offspring, whose libido was the material of his art, and whose every private peccadillo became the material of his public persona. Listen to this, for example:

> In a colorful farmhouse at Mougins on the Riviera, poetically named Notre-Dame-de-Vie . . . an old artist each day goes through the same motions. In over seventy-five years they have given birth to one of the most diversified and amazing, as well as controversial, bodies of work in the history of art.
>
> This man, soon to die at ninety-two, hardly shows age . . . These slight inconveniences aside, he is robust, active, and each day devotes long hours to his work . . . He is Pablo Picasso. (Cabanne, *Pablo Picasso, His Life and Times*: 7)

Degas, on the other hand, is described as a celibate, infirm old gentleman with plenty of background but no heirs; his myth is constituted out of his retreat from public life and his apparent lack of private life, his oeuvre is

marked by occlusion and blockage, and the loss of sensory connection. Where the master terms of Picasso's personal myth, *the* personal myth of modernism, are virility and fertile production, the master terms of Degas's myth, by contrast, are those of privacy and privation, blindness and barrenness. And the old-age story is special in Degas's case: its finality, its difficulty, and its obscurity are read back over an entire life. Certainly Halévy does this, calling Degas the "painter become blind as Beethoven is the musician become deaf" (*"peintre devenu aveugle comme Beethoven est le musicien devenu sourd"*—*Degas parle:* 10), and reading this "catastrophe" into Degas's entire oeuvre. In Degas's case, old age is not simply the place from which to begin a retrospective look at a life, it is a narrative beginning with ending writ in it through and through. Dead fires figure at its center. And if forgetting, as much as remembering, is what old age is about, then it is no wonder that it is the old Degas whose picture is painted: for the biography written of him is always one where the inaccessibility and illegibility of his biography loom large. His fame, to paraphrase Jamot, circulates through the ateliers, but it is fame in the form of obscurity, of unremembered personal presence, of an oeuvre detached from a life, of strange word fragments—Degas's *bons mots* take pride of place in all the accounts of the artist[4]— of oblivion, secrets, and dead old jokes: fame, in sum, in the form of enigma. In short, Degas's myth is constructed out of the failure of biography, of a positive, narratable view of the self, and of a linear, globalizing, authorial concept of the "oeuvre."

FIG. 117 Degas, *Dancer from the Corps de Ballet,* 1896

One writer on Degas was programmatic about the critque of biography. This was Paul Valéry, a poet and essayist whose writings span the period from the 1890s to the 1940s. Valéry, not unlike Degas in his personality and background,[5] was just as much an odd man out in the history of modern literature as Degas was in the history of late nineteenth-century art. He began as a symbolist disciple of Stéphane Mallarmé as well as of Huysmans, was a close friend of André Gide, became for a while a figurehead of dada and surrealism, and was referred to by Greenberg as one of the prime "abstract" poets of the twentieth century.[6] Yet Valéry was also a conservative, a modern classicist who was responsible for the resurrection of literary forms belonging to the French classical tradition: the aphorism, the fragment, and the dialogue.[7] As art historians have had a difficult time in finding a place for Degas, so literary historians have had difficulty in positioning Valéry, whose oeuvre was marked by determined intermittence and interruption, by obscurantism and intellectualism, and by a notorious period of deliberate silence. Thus Valéry's was a career, like Degas's, in which occlusion and self-negation figure at the center. At least, this is his reputation, consciously cultivated by him in texts such as *Soirée avec M. Teste* and *Introduction à la méthode de Léonard de Vinci*, both seminal statements of Valéry's literary and critical ethos, and both intimately connected to his writing on Degas. Finally, Valéry was one of the most important predecessors of structuralist and poststructuralist criticism.[8]

Degas was as much a figurehead for Valéry as he was for Duranty and Huysmans. He was the main subject of Valéry's most important piece of art criticism, *Degas Danse Dessin*,[9] right at the beginning of which the concept of the biography is refuted, as well as the discipline of history and the practice of positivist observation. "It is not a question of biography" (*"Il ne s'agit point de biographie"*—*Degas Danse Dessin:* 11), he states, and then later goes on to say:

> I had formed an idea of him that I had derived from a few of his works that I had seen and from a few of his sayings that had been spread around. I always find great interest in comparing a thing or a man with the idea that I had formed of him before I saw him. . . .
>
> From such comparisons we gain some measure of our capacity for imagining on the basis of incomplete facts. They also show us the complete vanity of biographies in particular, and history in general . . . To observe is, for the most part, to imagine that which one expects to see.
>
> . . . I had formed of Degas an idea of a personage reduced to the rigor of a drawing, a Spartan, a stoic, a Jansenist artist . . . I had written, only a little while earlier, the *Soirée avec M. Teste,* and this little essay-portrait of an imaginary figure, though constructed of remarks and relationships that were verifiable and as precise as possible, had been more or less influenced (as they say) by a certain Degas that I

had created for myself. The idea of various monsters of intelligence and of self-consciousness preoccupied me quite a bit in those days.

Je m'étais fait de lui une idée que j'avais formée de quelques-unes de ses oeuvres que j'avais vues et de quelques-uns de ses mots que l'on colportait. Je trouve toujours un grand intérêt à comparer une chose ou un homme avec l'idée que je m'en faisais avant que je le visse . . .

De telles comparaisons nous donnent une certaine mesure de notre faculté d'imaginer à partir de données incomplètes. Elles nous remontrent aussi toute la vanité des biographies, en particulier, et de l'histoire en général . . . Observer, c'est, pour la plus grande parte, imaginer ce que l'on s'attend a voir.

. . . Je m'étais fait de Degas l'idée d'un personnage reduit à la rigueur d'un dur dessin, un spartiate, un stoïcien, un janséniste artiste . . . J'avais écrit peu de temps auparavant la Soirée avec M. Teste, *et ce petit essai d'un portrait imaginaire, quoique fait de remarques et de relations vérifiables aussi précises que possible, n'est pas sans avoir été plus ou moins influencé (comme l'on dit) par un certain Degas que je me figurais. La conception de divers monstres d'intelligence et de conscience de soi-même me hantait assez souvent à cette époque. (*Degas Danse Dessin: 18–19)

In refuting the concept of biography, Valéry makes it clear that his is a recollected, half-fabricated image of the old man, whom he met only in 1893, toward the end of Degas's career, and whom he equates with the central character of his most famous piece of fiction, *Soirée avec M. Teste.*

There are a variety of ways in which Valéry identifies Degas with the fictional M. Teste, himself a deconstructed version of the novelistic protagonist. In *Soirée avec M. Teste,* M. Teste is described, much as Degas is in *Degas Danse Dessin,* as a figment of Valéry's imagination. The decription of Teste's "character" is as obscure and enigmatic as the monographic evocations of Degas's personality. The setting in which M. Teste is found delivering his strange, almost indecipherable quips and sallies, much like Degas's famed *bons mots,* are also those of Degas—the Opera, for example, which Valéry describes in a manner reminiscent of Degas's pictures:

I see him now, standing, together with the golden column of the Opera . . .

An immense young woman of copper separated us from a group murmuring on the other side of the glare. In the depths of the vapor shone a naked morcel of woman, as smooth as a pebble. Many separate fans agitated through this dark and light world, frothing up to the lights above. My gaze picked out a thousand little figures; it fell on a sad head, slid among some arms, through the throng . . .

Everyone was in his place, separated by little movements. I sensed the system of classification, the virtually theoretical simplicity of the assembly, the social order . . .

M. Teste murmured: "One is only beautiful, only extraordinary for others. They are devoured by the others!"

That last word emerged from the silence of the orchestra. Teste breathed in and out.

The Myth of Degas

. . . I regarded that skull which met the angles of the cornice, that right hand which shone from the gilding, and in the shadow of the purple, those great feet. From the distances in the auditorium, his eyes came to rest on me; his mouth said, "Discipline is not a bad thing . . . It's just a beginning . . ."

I did not know how to reply. He said with his low, quick voice, "They enjoy and they obey."

He stared for a long time at a young man facing us, then at a woman, then at a whole group in the top galleries . . . and then the whole crowd, the whole theater . . . ardent, fascinated by the scene on the stage that we could not see . . .

M. Teste said, "The absolute simplifies them."

We walked; phrases that were practically incoherent escaped from him. In spite of all my efforts, I could follow his words only with great difficulty.

Je le vois debout avec la colonne d'or de l'Opéra, ensemble . . .

Une immense fille de cuivre nous séparait d'un groupe murmurant au delà de l'éblouissement. Au fond de la vapeur, brillait un morceau nu de femme, doux comme un caillou. Beaucoup d'éventails indépendants vivaient sur le monde sombre et clair, écumant jusqu'aux feux du haut. Mon regard épelait mille petites figures, tombait sur une tête triste, sur des bras, sur les gens . . .

Chacun était à sa place, libre d'un petit mouvement. Je goûtais le système de classification, la simplicité presque théorique de l'assemblée, l'ordre social . . .

. . . M. Teste murmurait: "On n'est beau, on n'est extraordinaire que pour les autres! Ils sont mangés par les autres!"

Ce dernier mot sortit du silence que faisait l'orchestre. Teste respira.

. . . Je regardais ce crâne qui faisait connaissance avec les angles du chapiteau, cette main droite que se rafraîchissait aux dorures, et, dans l'ombre de pourpre, les grands pieds. Des lointains de la salle, ses yeux vinrent vers moi; sa bouche dit: "La discipline n'est pas mauvaise . . . C'est un petit commencement . . ."

Je ne savais répondre. Il dit de sa voix basse et vite, "Qu'ils jouissent et obéissent!"

Il fixa longuement un jeune homme placé en face de nous, puis une dame, puis tout un groupe dans les galeries supérieures . . . et puis tout le monde, tout le théâtre . . . ardent, fasciné par la scène que nous ne voyions pas . . .

M. Teste dit: "Le suprême les simplifie."

Nous marchions, et il lui échappait des phrases presque incohérentes. Malgré mes efforts, je ne suivais ses paroles qu'à grand peine. (M. Teste: 37ff., 40, 41) [10]

Teste is a version of Degas, and Degas, in *Degas Danse Dessin,* is a version of Teste—as Valéry himself asserts.

Valéry also identifies Degas with another "monstre d'intelligence" who occupies a central place in his criticism—Leonardo da Vinci:

Rumor had it that he [Degas] made studies of rocks in his room, by using a bunch of coal fragments taken from his stove as a model. He was supposed to have emptied the pail on a table and applied himself

to carefully drawing the site thus created by the random forms resulting from this act . . .

If this is true, this idea seems to me amazingly Vinci-esque.

On prétend qu'il a fait des études de rochers en chambre, en prenant pour modèles des tas de fragments de coke empruntés à son poêle. Il aurait renversé le seau sur une table et se serait appliqué à dessiner soigneusement le site ainsi créé par le hasard qu'avait provoqué son acte . . .

S'il est vrai, cette idée me semble assez vinciste. (Degas Danse Dessin: 69–70)

The equation of Degas and Leonardo is part of Valéry's refutation of the procedures and assumptions of biography, for the *Intoduction à la méthode de Léonard de Vinci* is as pointed a discussion of biography-as-fiction as *Degas Danse Dessin* is. Valéry's account of Leonardo, as of Degas, reads as a celebration of intentionality and of the authority of the ego. For example: "He retains, this *symbolic* [my italics] mind, a vast collection of forms . . . the power of recognizing in the expanse of the world an extraordinary number of distinct things, of arranging them in a thousand ways, is what he is made of. He is the master of faces, of anatomies, of machines . . . Perhaps the greatest self-possession distances the individual from all particularity—except that of being master and center of oneself" (*"Il garde, cet esprit symbolique, la plus vaste collection de formes . . . la force de reconnaître dans l'étendue du monde un nombre extraordinaire de choses distinctes et de les arranger de milles manières, le constituent. Il est le maître des visages, des anatomies, des machines . . . Peut-être la plus grande possession de soi-même éloigne-t-elle l'individu de toute particularité—autre que celle-là même d'être maître et centre de soi"—Introduction à la méthode de Léonard de Vinci: 34, 38*—marginal notes).[11] Even so Valéry undermines the very foundation on which the concept of the authorial self rests, the idea of a person, an "individuality" as a container of a mind, of a particular personal history as the source of intentional structures. In place of this, Valéry asserts an impersonal, disembodied "method," a self-creating and self-perpetuating intellectual system: "Among the multitude of minds, this one seemed like . . . a sort of *system complete* [my italics] unto itself" (*"Dans la multitude des esprits, celui-ci parait comme . . . une sorte de système complète en lui-même"—Introduction à la méthode de Léonard de Vinci: 38*). Valéry's obsession with "method" is written right into the title of his 1894 essay on Leonardo, as well as into the body of that text: "We think that he thought . . . It is the basis of the method that we will take up" (*"Nous pensons qu'il a pensé . . . Elle est la méthode qui va nous occuper et nous servir"—Introduction à la méthode de Léonard de Vinci: 9, 11*). Later, in the margins, Valéry states: "In reality, *man* and *Leonardo* were the names I gave to what then impressed me as being the power of the *mind*" (*"En réalité, j'ai nommé* homme *et* Léonard *ce qui m'apparaissait alors comme le pouvoir de l'esprit"—Introduction à la méthode de Léonard de Vinci: 11*).

As he does Leonardo, Valéry characterizes Degas as a *moi pur*[12] and a "monstre d'intelligence." He writes that Degas was "a personage reduced to a rigorous drawing, a spartan, a stoic, a Jansenist artist." Like Leonardo, Degas, according to Valéry, was a man of method and pure mentality. In *Degas Danse Dessin* the most extended account of this impersonal "method" is found in Valéry's discussion of the *informe*, following immediately on his description of Degas as a Leonardesque figure:

> I throw a handkerchief that I have crinkled on a table . . . It is then a matter of rendering intelligible the particular structure of an object that appears to have no determinable structure, where there is no given or no memory to direct one's labor as there is when one draws the image of a tree, a man, or an animal which is divided into well-known parts. It is in this case that the artist may exercise his intelligence, and where the eye must find, by its movement over that which it sees, the path of the pencil on the paper, as the blind man must accumulate, through touch, the elements of contact with a form, and acquire point by point the knowledge and the unity of an irregular solid.
>
> . . . thus the artist may, by the study of formless things, that's to say of things with singular form, try to discover his own singularity, the primitive and original state of coordination between his eye, his hand, objects, and his will.
>
> In the case of the great artist, his sensibility and his means are related in a particularly intimate and reciprocal manner, such that, in the state vulgarly known as inspiration, they arrive at a kind of union, an almost perfect exchange or correspondence between desire and that which satisfies it, between will and capacity, idea and act.
>
> *Je jette sur une table un mouchoir que j'ai froissé . . . Il s'agit donc de rendre intelligible une certaine structure d'un objet qui n'en a point de déterminée, et il n'y a point de cliché ou de souvenir qui permette de diriger le travail, comme on le fait quand on dessine une figure d'arbre, d'homme ou d'animal qui se divisent en portions bien connues. C'est ici que l'artiste peut exercer son intelligence et que l'oeil doit trouver, par ses mouvements sur ce qu'il voit, les chemins du crayon sur le papier, comme un aveugle doit, en la palpant, accumuler les éléments de contact d'une forme, et acquérir point par point la connaissance et l'unité d'une solide très irrégulier.*
>
> *. . . ainsi l'artiste peut, par l'étude de choses informes, c'est-à-dire de forme singulière, essayer de retrouver sa propre singularité et l'état primitif et originel de la coordination de son oeil, de sa main, des objets et de son vouloir.*
>
> *Chez le grand artiste, la sensibilité et les moyens sont dans une relation particulièrement intime et réciproque qui dans l'état vulgairement connu sous le nom d'inspiration, en arrive à une sorte de jouissance, échange ou correspondance presque parfaite entre le désir et ce qui le comble, le vouloir et le pouvoir, l'idée et l'acte.* (*Degas Danse Dessin:* 71–73)

Thus, according to Valéry, "Degas," like "Leonardo," is simply a name for a representational process, a set of intellectual and physical operations, and a series of mechanical relations and repetitions. Even his

"desire" and his "will" are described as relational structures, a set of contact points between body and world, rather than as the characteristic drives of a person.

Like "Degas," then, the "Dessin" in *Degas Danse Dessin* stands for Valéry's view of the self as impersonal method. So is the "Danse" in *Degas Danse Dessin* similar to the way that the Leonardesque observation of amorphous objects is described; in a number of very Bergsonian passages Dance is described phenomenologically, in terms of pure will and pure desire, as a pattern of space and time and of volitional movements caught up in a structure of self-dissipation and self-organization, as opposed to the involuntary, quotidianal movements that belong, instead, to an economy of self-preservation (*Degas Danse Dessin*: 22–30). (Dance also stands for Valéry's anti-interpretive stance—he is even critical of the procedures of art criticism, and he uses one of Degas's classicisizing *mots*, which figures Dance, to support his view: "[T]he Muses do not discuss among themselves. They work the entire day . . . they dance: *they do not speak*" (*"[L]es Muses ne discutent entre elles. Elles travaillent tout le jour . . . elles dansent:* elles ne parlent pas"—*Degas Danse Dessin*: 12). *Degas Danse Dessin*, then, is not a biography; in it, Degas the man is not a draw-er of dancers (following Mallarmé, whom Valéry quotes as saying, "[T]he dancer is not a woman who dances, for she is not a woman, and she does not dance"— *"[L]a danseuse n'est pas une femme qui danse, car elle n'est point une femme, et elle ne danse pas"* [*Degas Danse Dessin*: 28; Mallarmé, "Crayonné au théâtre": 192]).[13] Instead "Degas" *is* "Danse," *is* "Dessin."

Given his protodeconstructionist views of biography and the authorial self,[14] it comes as no surprise that Valéry is well known for his contempt for psychoanalysis.[15] "I am the least Freudian of men and . . . and I have my doubts about dreams"; "No, no! I do not at all care to find myself on the old paths of my life. It is not I who would research *le Temps perdu!* Even less would I approve of these absurd analyses which inculcate in people the most obscene rebuses which they had already composed at their mother's breast." (*"Je suis le moins Freudien des hommes et . . . il m'arrive de douter les rêves"*—letter to Mme. Pavel, 19 January 1935; *"Non, non! Je n'aime pas du tout me retrouver en esprit sur les voies anciennes de ma vie. Ce n'est pas moi qui rechercherais le Temps perdu! Encore moins approuverais-je ces absurdes analyses qui inculquent aux gens les rébus les plus obscènes, qu'ils auraient déjà composés dès le sein de leur mère"*—*Propos me concernant*, t.2, 1506; in Mauron, *Des métaphors obsédantes au mythe personnel*: 82). Nevertheless, his account of Degas as a Leonardesque figure suggests a Freudian exegesis—Valéry's evocation of Degas as a man of method and a "monster of intelligence" is strongly reminiscent of the definition of sublimation and the "investigative drive" in Freud's account of the art and life of Leonardo.[16] Freud equates the investigative drive with the sublimation, as opposed to the repression, of eros, and he defines sublimation as eros transformed into will, the obsession with observation and the desire to

know, which in turn are but disembodied and etherealized versions of the wish to find out about one's own body, one's own sexual self, and one's origins, hence also the wish to find out about the female body, the body of the mother.

It is in Valéry's Leonardesque account of Degas as a man of method that we find the closest corollary to Freud's concept of sublimation. According to Valéry, although he didn't use the words, Degas possessed the investigative drive to a high degree: libido transformed into the will to know, to order, to formulate and systematize; onanistic self-exploration converted into ceaseless observation of the surrounding world, indeed in Degas's case into mimicry of others. Even Valéry's depersonalization of the idea of the author and of the *logos* may be described in terms of sublimation—as a lifting up and out of the historical self into the ether of a detached system or method.

Valéry's sublimated account of Degas as a sublimated type should be connected to another element of the myth of Degas that has acquired "the status of a commonplace" (Broude, "Degas's Misogyny": 354)— his misogyny. For "misogyny," like "aristocracy," is another facet of the inaccessibility of Degas's personal history: the claims made about Degas's celibacy, his misogyny, and sometimes his latent homosexuality, have most to do with our lack of knowledge of his private life. Nicholson says it this way: "There may, therefore, be something in the theory that he was a repressed homosexual, who in youth perhaps—who will ever be able to tell us? but it is not very important that we should know—had closed down on his *éducation sentimentale* after some bitter experience, and had allowed passion to wither; but there is no positive evidence whatever for this" ("Degas as a Human Being": 239). An obscure trauma is attributed to Degas, so obscure that no one knows anything about it.[17] Misogyny means repression, withering, closing down—in that respect, it is part of the old-age myth. But more than that, it means no evidence and no access to any, nothing known and nothing told; in short, it means no narrative. Thus in the monographs on Degas, "misogyny" is another code word for a myth constructed out of the failure of biography. In Valéry's account, "misogyny" is attached to the sublimation of biography.

Degas Danse Dessin includes a series of passages on Degas's nudes— not on the series of 1886 specifically, but on Degas's attitude to the nude in general and on his place in the tradition of the genre:

> It is easy to see that for Titian, when he painted Venus in the pleni-
> tude of her perfection as goddess and as painted object . . . to paint
> was to caress, to join two kinds of sensuality in one sublime act,
> where the possession of oneself and of one's means, and the posses-
> sion of Beauty through all one's senses were joined.
>
> . . . M. Ingres [on the other hand] pursued grace to the point of
> monstrosity: never was there a spine supple and long enough, never
> a neck flexible or thighs slick enough, and bodily curves conducive

enough to the gaze which envelops and touches them much more
than it sees them . . .

. . . All his life [by contrast] Degas sought in the Nude, observed
from all sides, in an unbelievable quantity of poses, even in full action,
the unique system of lines that would formulate any given moment
of the body with the utmost precision and the utmost generality . . .
[H]e, essentially voluntary, never satisfied with that which came to
him at first try, his mind so terribly taken with the critical and so
nourished on the best of the great masters, never abandoned himself
to natural sensuality. I love such rigor. There are those beings who
have not the sensation of acting or of accomplishing anything if they
have done it *against themselves* [my italics]. That is perhaps the secret
of men who are truly virtuous.

On sent bien que pour Titien, quand il dispose une Vénus dans la plénitude de
sa perfection de déesse et de chose peinte . . . peindre fût caresser, joindre deux
voluptés dans un acte sublime, où la possession de soi-même et de ses moyens,
la possession de la Belle par tous les sens se fondent.

. . . M. Ingres poursuit la grâce jusqu'au monstre: jamais assez souple et
longe l'échine, ni le col assez flexible, et les cuisses assez lisses, et toutes les
courbes des corps assez conductrices du regard qui les enveloppe et les touche
plus qu'il ne les voit . . .

. . . Degas toute sa vie, cherche dans le Nu, observe sous toutes ses faces,
dans une quantité incroyable de poses, et jusqu'en pleine action, le système
unique de lignes qui formule tel moment d'un corps avec la plus grande préci-
sion, mais aussi la plus grande généralité possible . . . lui, essentiellement vol-
ontaire, jamais satisfait de ce qui vient au premier jet, l'esprit terriblement
aimé pour la critique et trop nourri des plus grands maîtres, ne s'abandonne
jamais à la volupté naturelle. J'aime cette rigueur. Il est des êtres qui n'ont pas
la sensation d'agir, d'avoir accompli quoi que ce soit s'ils ne l'ont fait contre
soi-même. C'est là peut-être le secret des hommes vraiment virtueux. (Degas
Danse Dessin: 77—79)

In these passages, Degas's response to the female body is contrasted to
the responses of two of the great painters of the female nude: Titian and
Ingres. *The* master of the tradition of the nude, Titian, as Valéry has him,
is the painter of the sensuality *par excellence:* the painter for whom the
painted body is as fleshy and present as a real body, for whom the paint-
erly touch is a sexual caress, for whom facture is eros itself. Ingres, by
contrast, is held to be the pornographer of the tradition: Ingres's is the
slick, perverse imagery that answers to the voyeuristic gaze, which is de-
fined as a kind of disembodied touch. In Valéry's terms, Titian's and
Ingres's nudes are two versions of the fetishized body, corresponding to
the traditions of *colore* and *disegno*—on the one hand, the representation
of the female body amounts to a fetishization of its materiality, its flesh;
on the other hand, to a fetishization of its form and shape, its design. In
the company of these two, Degas is again credited with "chastity," for his
representations intellectualize and thus set at a distance both the flesh

and the form of the female body. Instead of Titian's *volupté* or Ingres's manipulative voyeurism, Degas's position is that of sublimation, wherein bodily desire is replaced by bodiless will, the *vue voulue* (*Degas Danse Dessin:* 58), the libidinal drive is transformed into formulaic observation and the sensual into the intellectual and into resistance against itself. Degas suggests this himself, emphasizing the conflict between, rather than the identity of, eros and vision: "To make fire without sight, that must be love itself"[18] (*"Faire feu sans voir, voilà l'amour lui-même"*—*Lettres de Degas,* no. 41 of 9 September 1882; to Bartholomé, p. 69). Since this section on the nude is as much about drawing as is the passage on the *informe,* desire is also sublimated into *design,* a willful but unpossessive draughtsmanship that is nothing but itself—it does not claim to caress or manipulate the female body, but only to master its own system.

At the end of Valéry's account of Degas as a Leonardesque type, we find this statement, in which the artist's sublimated "dessin" begins to sound suspiciously like a kind of draughtsmanly impotence:

> A work was for Degas the result of an indefinite quantity of studies and then a series of operations. I really believe that he thought that a work could never be said to be finished . . . certain artists . . . work over, attack, correct, and imprison themselves. They cannot leave the game or get out of the circle of their gains and losses.
>
> *Une oeuvre était pour Degas la résultat d'une quantité indéfinie d'études, et puis, d'une série d'opérations. Je crois bien qu'il pensait qu'une oeuvre ne peut jamais être dite achevée . . . certains . . . s'acharnent, s'attaquent, corrigent et s'enchaînent, ils ne peuvent lâcher la partie, sortir du cercle de leurs gains et de leurs pertes.* (*Degas Danse Dessin:* 80–81)

This passage suggests that Degas's "method" is characterized by repetition, and by an *in*ability, an impotence, to get outside his own system. In another passage, Valéry also calls Degas an "abstract" artist, and thus links his "method" to abstraction:

> Sometimes he returned to experimental prints like these; he would add colors, mix pastel with charcoal: yellow skirts on one, violet on the other. But lines, acts, prose, are there beneath them, essential yet separable, usable in other combinations. Degas is of that family of abstract artists who distinguish between form, color, and matter.
>
> *Il revient parfois sur ces sortes d'épreuves; il y met des couleurs, mêle le pastel au fusain: les jupes sont jaunes sur l'une, violettes sur l'autre. Mais la ligne, les actes, la prose, sont là-dessous, éssentiels et séparables, utilisables dans d'autres combinaisons. Degas est de la famille des artistes abstraits qui distinguent la forme, de la couleur, ou de la matière.* (*Degas Danse Dessin:* 63)

Thus Valéry arrives at a theory of abstraction as sublimation, characterized by the conversion of fetishistic facture and graphics into a repetitive, never completed, self-referential process of drawing and material

facture, separated out from one another, but incapable of escaping the circular process to which they belong.

Abstraction, for Valéry, is also the final feature of his critique of biography, and his replacement of personal history with abstract structure, his substitution of *Danse* and *Dessin* for *Degas*. For three forms of sublimation are combined in *Degas Danse Dessin*. First, under the heading of biography, the narrative of Degas's personal history is replaced by a description of a set of structural relationships between mind, body, and world signified by the name "Degas"—structural analysis, of a kind, substitutes for biographical storytelling. Second, regarding Degas's persona, libidinal energy is converted into the investigative drive; in place of *volupté* is Degas's "Jansenism," his habit of formulaic observation—his relationship to his own system, in short, instead of desire, dance, and design. Third, under the rubric of representation, the fetish is "sublimely" replaced by a "virtuous" and "rigorous" abstraction. Here, Valéry describes an *abstract* system of representation, in which representation is identified with, rather than opposed to, abstraction, and in which abstraction is imprisoning, rather than libidinal and liberating.

Huysmans presented Degas as an antimodern figure, and the majority of his monographers confirmed this image of Degas as the atavistic artist. But Valéry gives the image special weight by portraying Degas as a Leonardesque figure, rather than as a representative of his age and his history. Valéry's image of Degas as a man of method also agrees with Huysmans's presentation of him as an ascetic type, and agrees as well with his against-the-grain appraisal of Degas's art, in that the abstraction of Degas's works for Valéry is arrived at against the grain of *himself,* against the grain of the artist's nature. A barren, blind old man with an unknown history and an inaccessible biography, a mythic figure whose reputation is construed entirely as enigma, a human life emptied into odd, assorted figures of speech: Valéry takes these elements of the myth of Degas as constituted by his biographers and monographers and deliberately transforms the artist into a piece of fiction that is deeply modernist in some ways, in its abstraction, its self-referentiality, its detachment from history, and deeply antimodernist in other ways, in that his Degas is the opposite of the free, romantically conceived, avant-garde modern artist: a figure who was not only retrogressive, but also repetitive, unoriginal, and impersonal. His work was also unlyrical—Valéry was known to have thought that the failing of Degas's art was that it did not "sing"; if it was not prose, it finally was not poetry either.[19] Degas was for the poet a figure of sublimation, *bound* to work against and outside of himself, against and outside his own libido, rather than *free* to realize and express it, or free to escape from tradition, convention, and representation. For traditional representation and self-referential abstraction are bound together in Degas's art, according to Valéry, bound together in a peculiarly ab-

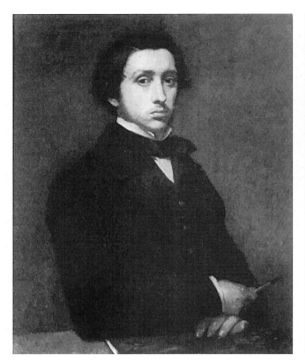

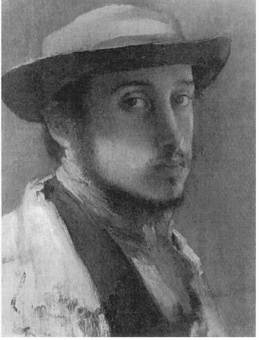

FIG. 118 Degas, *Self-Portrait with a Crayon-holder,* 1854–55

FIG. 119 Degas, *Self-Portrait,* 1857–58

stract notion of the self as an authoritatively anti-authorial structure of representation.

 *

Degas's own most explicit address to the problem of the self lies in a group of paintings and photographs which bracket his career. These are his self-portraits, a group of which he produced at the beginning of his career, and another group at the end of it. Degas did a series of painted, drawn, and printed self-portraits during the 1850s and 1860s, and then stopped painting self-portraits altogether. Then, in the 1890s, he did a series of photographic self-portraits.[20] Two clumps of self-portraits in different media separated by some thirty years, they open and close the artist's oeuvre, forming parentheses around his career as a painter and draughtsman. Separately, they present us with a serial image of the artist as a constricted, arrogant, and no doubt disagreeable quasi-adolescent, and then as an abstracted and isolated old man. These images will serve as a fitting close to a book devoted to readings of Degas's work and reputation, taking us back to the beginning and then forward to the ending. They also fit rather neatly with the principal components of the myth of the man: his retrograde status as aristocrat, his unavailability to biographical narrative, even his reputed misogyny. Moreover, they articulate the Valéryan structure of the impersonal self in terms specific to the pro-

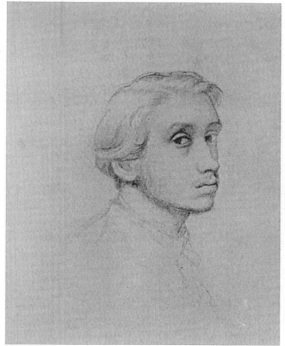

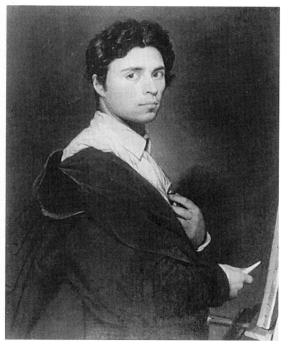

FIG. 120 Degas, *Self-Portrait*, 1857–58 FIG. 121 J. A. D. Ingres, *Self-Portrait at Twenty-four*, 1804

ducers of painted and photographic representation; indeed, in a way close to Valéry's, they equate selfhood with representation rather than with personality.

To begin with the painted self-portraits. The most fascinating of these, in my view, are the ones in the Musée d'Orsay and the Sterling and Francine Clark collection in Williamstown (figs. 118, 119). The earlier one, the Musée d'Orsay self-portrait, is based on at least two models: a self-portrait by Degas's teacher, Louis Lamothe, and the famous *Self-Portrait at Twenty-four* by Lamothe's master and Degas's favorite painter, J. A. D. Ingres (fig. 121). By referring to these precedents, Degas began his habit of tradition recuperation; he also began to define his artistic lineage and to work out the terms of his self-image as retrogressive, inaccessible aristocrat. At the same time, he began to explore some problems inherent to self-portraiture, such as the difficulty of at once posing and painting, of locating oneself simultaneously in the process and the product of image-making, of defining oneself as both the origin and the object of the image before one's eyes. Ingres had chosen to show himself as both painter and sitter. His self-portrait combines two costumes in one—his white shirt and elegant, sliding cloak is a piece of apparel with a double life, at once the semi-bohemian *déshabillé* of the studio and the dandified flourish of a carefully nonchalant "gentleman." Ingres's garb is both profes-

The Myth of Degas 227

sional and presentational—that of the man at work and of the man of leisure—and its sly combination of the modern and the retrospective (its reference to the look of a beautiful-young-man-of-the-Renaissance) is doubly made too. Ingres presents himself as an artist-courtier. Moreover, his self-portrait combines the outward, viewer-directed gaze and the sitter's pose with the painter's twist toward the canvas, chalk in hand. It combines two gestures, that of showing and presenting himself to us, indeed that of pointing to himself with that of representing. The two gestures are shown side by side in the artist's own body—in fact, they are compressed and almost crossed over one another, forming a kind of circle of showing, seeing and drawing. Finally, the self-portrait fuses the left and right orientations of these two gestures and functions of the self-portrait: the reversed orientation of the mirrored body and the parallel orientation of the body before the canvas.[21]

Degas's self-portrait in the Musée d'Orsay duplicates this doubling of painter and poser in a very restrained fashion. For the most part, it is the gentleman-sitter, all constrained, black-suited and buttoned-up in his Sunday best, who predominates: he is the Second Empire bourgeois-aristocrat, haughtily, sullenly unavailable to us. No pseudobohemian *déshabillé* here, and no references in Degas's clothing to his professional status or to the act of working at painting. Rather, he presents himself to us as the banker's son, withdrawn, uneasily cool, slightly uncomfortable about the mix of painterly vocation and would-be aristocratic status. Moreover, Degas's face and body are more frontally presented to us. Yet the remnants of Ingres's double gesture and twist away from frontality toward the canvas may be seen in Degas's slight turn and crossed-over hands—the composed, carefully at rest hands of a man being seen, yet at the same time passively, almost unnoticeably occupational: the one hand holds the *porte-fusain,* just as Ingres wields his chalk. There is none of the circle of seeing, showing, and depicting witnessed in Ingres's folding of the one gesture over the other, for Degas's one hand lies flat and the other points unobtrusively away, beyond the frame, to another picture and another self. (Ingres's painting has a bit of canvas represented within it, at its edge, almost serving as a kind of hinge between the world of the painter *out here,* and the world of the painter *in there*—it is not by accident that there is no such juncture represented in Degas's self-portrait.) And Degas's hands are almost botched; certainly they are much less *realized* than the rest of his presentable person, nowhere near as precise and particular as his attention to his own gaze and facial features. This self-portrait does declare its own double function of presenting both the portrayer and the portrayed, but it does so guardedly, in a quietly obstructionist way. The relationship here between man in front of the mirror and man in the mirror has many dimensions: a relationship between painting activity and social presence, it is also a relationship between subject and object, and between vision and body, even more particularly

between eye and hand. (The relationship between eye and hand is particularly important to Valéry's impersonal construct of the artistic "moi pur.") In this self-portrait the relationship between sitter and painter is envisioned as restricted and obstructed in all of its dimensions.

While Ingres's painting is both finely drawn and finely painted, Degas's painting is neither so evidently based in fine draughtsmanship, nor is it always meticulously painted. Its presentation of itself as a made object is ambivalent. In the hands, drawing flattens out into broad, "optical" painting, while most of the rest of the image, with the exception of the eyes and face, is dry, dark, and thin, with little demonstration of painterly bravura. Then there is a split between the eyes and the hands of the likeness: rather than Ingres's closed circle between eye and hand, Degas severs one from the other. The center of the image is the gaze, set in a face framed by a broken strip and a diamond of white, and divided off from the white-edged lightness of those barely articulated hands by the faded black of the painter's torso. The torso itself is strangely without body or shape—a blackish mass centered indeterminately within the rectangle of the canvas. The only highlights in the picture, besides the crisp white of the artist's starched and boiled shirt, are those on his lips, eyes, and fingernails, and they constitute a kind of subtle play between shadow and brilliance, and at the same time between hard and soft: the dimly high-lit hardness of the fingernails, the slightly shiny softness of the lips, the glistening, liquid-solid, hard/soft viscosity of the eyes—the obscurely differentiated softness of flesh, form, and face, as against the uniform hardness of a mirror surface, whose hard shine is recalled in each of those instances, whether hard or soft, of gleam-and-glisten. The elusive ability of the image to conjure up the body's differences in substance and solidity resides nowhere but in the play between shade and highlight, and so it is of an optical nature, as is its more durable capacity to remind us of the reflecting surface of the mirror. Indeed, the pleasure of this self-portrait lies precisely in that subtle oscillation between the opticality of the image surface itself and the optically suggested corporeal life of the artist's depicted body. That is, any *volupté* which this reserved image possesses lies neither in its corporeality nor in its facture, but in its specularity. After all, Degas's most sustained attention appears to have been given to those parts of his self-portrait which have to do with the gaze and not with the hands, with opticality and not with manu-facture: those aspects, in short, which look self- or light-produced. In a way, the Musée d'Orsay self-portrait aspires to a kind of authorship so immaterial and disembodied as to be a sort of authorlessness, and to an impersonal narcissism, what has been called elsewhere, "the narcissism of light."[22] In these little ways, it corresponds, not only to the biographical myth of Degas, but even more, in its own representational terms, to the impersonal, reflexive structure of authorial selfhood proposed by Valéry.

In later self-portraits, Degas "resolved" the division between hand-

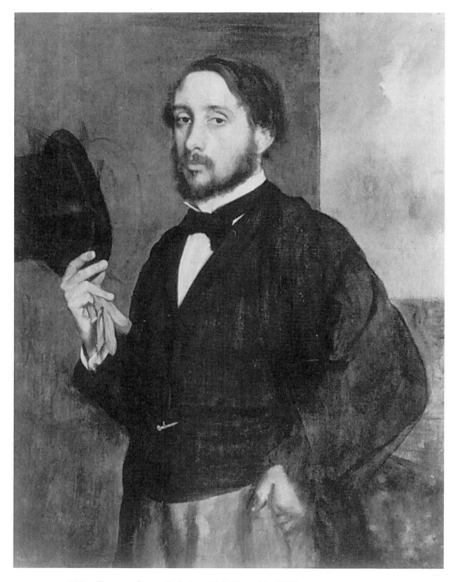

FIG. 122 Degas, *Degas Saluting (Self-Portrait), 1862*

making and specular surface, and between painter-subject and sitter-object, by further splitting them apart. In these images, he alternates between painter and gentleman, sometimes showing himself in painter's clothes—as in the Williamstown self-portrait and the roughly contemporaneous Rembrandt-like series of drawings and etchings which share the same composition—and sometimes in gentleman's garb, as in his last painted self-portrait, *Degas Saluting* (fig. 122). Moreover, much of his portrait work of the same years is organized around divided doubles, pic-

torial worlds caught between two gazes and two directions of viewing: out at us and away to the side.[23] It is as if the double function of Ingres's maker-made, seer-seen had been split apart and given over to two figures, sometimes almost with the character of Siamese twins caught between frontality and a three-quarter turn. This is seen in all of his family group portraits: the Morbillis, the Bellelli sisters, and most famously, the Bellelli family, with its mirror background, its world of opposing gazes and conflicting bodily vectors, and Mme Bellelli's pair of hands, which Degas was to isolate and paint over as a picture in its own right (figs. 57, 123, 54, 56). (It is not insignificant that the twinning, doubling, and splitting apart happens in the context of the family, which was being portrayed by Degas at the same time that he was involved in portraying himself—obviously he conceives division as a function of the family as well as of the self.)

The phenomenon of twin gazes is also to be found in a double portrait which includes a self-portrait—*Degas and Evariste de Valernes* (fig. 124). In other, single self-portraits, Degas simply isolated one or the other gaze, and with it, one or the other identifying garb. This is true of *Degas Saluting*, where he is all sitter-object, gazing out at us and greeting us, present not at all as the maker of the image, but exclusively as a social person of a certain manner, class, and disposition, who responds to being seen with a conventional social gesture. By contrast, in the lovely little Williamstown self-portrait (fig. 119) Degas presents himself to us in artist's smock and hat: now he is the painter where elsewhere he is the sitter, and he gives us no clue as to his other, gentlemanly identity.

In this painting of himself as painter, Degas's likeness is almost voluptuously painted, and very makerly indeed—here the looseness of the facture has a kind of confident, color-rich impasto that does not suggest a failure to realize, but rather the skillful deployment of a Corot-like sketch mode. But for all its signature, the bust-length likeness of the Williamstown self-portrait has no hands at all. It is cut above the body, the hands, and their movements. So again it is the gaze and the face of the painter to which we are asked to attend. And upon closer regard, that gaze is a peculiar one, slightly skewed and swiveled, as if it had been abnormally fixed upon. It is as if Degas hadn't been able to let go of his own eye in the painting of it, in the hopes that he might be able to see his eye as object of his gaze, and as the source of it, doubly and simultaneously; his eye as part of his face, reflected outwardly back at him, and at the same time his eye in the act of looking and thus reflecting, not his face, but his own mirror-directed regard. For in latching upon it, that eye has become peculiarly frontal, such that it is almost monocular, The Eye, rather than the two eyes of the human face as exterior, social aspect. (The other eye is seen in a three-quarter turn: it is the relationship between the two eyes and the effect of combining frontal and profile aspects in the other features of the face that make that one eye seem so odd. In a drawing that

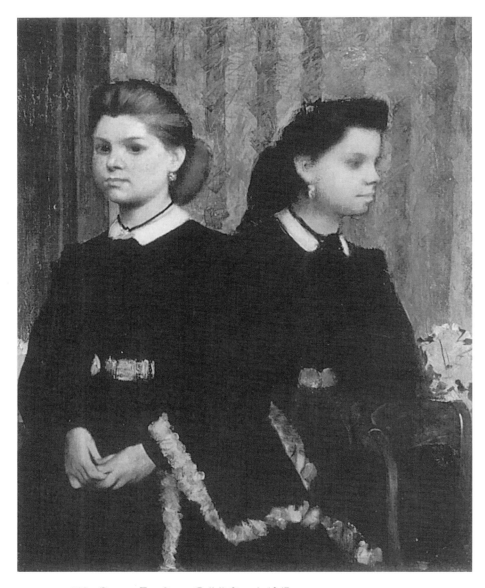

FIG. 123 Degas, *Two Sisters (Bellelli Sisters),* 1865

matches this self-portrait [fig. 120],[24] the Picasso-like combination of front and profile views is even more pronounced, and so is the monocular quality of its stare. And if either the drawing or the painting is reversed, as in a mirror, this slight peculiarity becomes a greater strangeness.) It is as if Ingres's bodily twist had been collapsed into a single gaze, the split between the eye and the hand, and between the painter-maker and sitter-object, condensed and concentrated into a single eye, so that what was once a conundrum involving both body and vision is now an exclusively

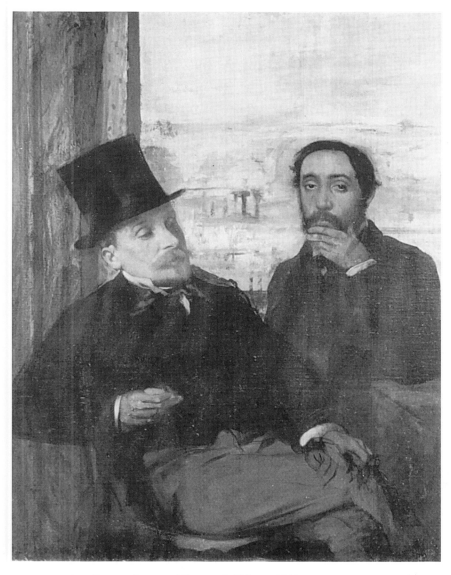

FIG. 124 Degas, *Degas and Evariste de Valernes*, 1864

ocular problem. And so it is now as if the site of the painter's craft is in the eye and not in the hand, as if his painter's clothes are now the sign of his job of looking, rather than his manual, material activity. Ultimately both the drawn-ness and paintedness of the picture are seen as the issue, not of the hand *and* the body, but of the eye by itself. Where the opticality of the earlier Musée d'Orsay self-portrait proposes a kind of authorlessness as the solution to the conundrum of the mirror, a few years later, in the Williamstown self-portrait, it is as if Degas had at-

The Myth of Degas 233

FIG. 125 Jan Vermeer, *Head of a Girl*, 1665

tempted to make authorship entirely ocular, assigning the eye the au-
thorial function, a bit like the single camera eye. And thus, besides
attempting to collapse the subject and object functions of the eye, the
Williamstown self-portrait also attempts to elide the fictions of author-
ship and authorlessness together in one visage and one gaze.

There is something about the Williamstown self-portrait that I have al-
ways found strangely reminiscent of Vermeer's *Head of a Girl* (fig. 125).
Perhaps it is the softness and flatness of Degas's face, the equal softness
of his lips, and the shine on his nose separating it so barely from his un-
articulated cheek, that make this male self-portrait with its sullen expres-
sion so eerily reminiscent of that little girl with the pearl. Or perhaps it is
its quality of soft light and dark, and its play with flesh-like tones—the
salmon-pink of the neck cloth setting off the skin of the face, slightly
curdling the warmth and translucence of flesh, and connecting it, this
time not to the cool, hard luminosity of a pearl, but to the brushy, lubri-
cated thickness of fish-colored oil pigment—the way, in other words, it
incessantly transforms flesh back to paint. Perhaps, finally, the resem-
blance between the two images is to be found in Degas's sideways glance,
which has a "feminine" cast to it: in its obliqueness, its appearance of
responsiveness, the illusion it creates of being at once called into exis-
tence by our gaze, a regard that is always already a responsive one, and
then calling back at us, creating us as viewers through its apparent re-
sponse to our vision. For it is this response which appears to conjure up

Chapter 5

the person and the act responsible for the image "in the first place," end-lessly transforming the object into the origin, and the originating force back into a responding one. Like Vermeer's girl,[25] Degas's self-portrait seems almost to offer us a model of illusionistic representation, and of the desiring, generative relationship between subject and object, painter, painting and viewer, which is reflective and reflexive, rather than linear or extensive—rather than offering us a straight line between the origin and the object of making, or between the possessor and the possessed, it catches us up in a circle of responses. As so it confounds the idea of origination involved in the concept of authorship.

Degas's painted self-portraits from the beginning of his career suggest three related disturbances within the traditional notion of the author, all of which have something to do with Valéry's modernist/antimodernist deconstruction and sublimation of the biographical mode. The first is suggested most by the Williamstown self-portrait—it is the de-gendering, and perhaps the re-gendering of authorial activity: if not the "feminization," at least the de-"masculinization" of the concepts of creation and generation involved in image-making. This we will consider shortly, when we turn to the last section of this chapter, and to Degas's late photographs. The second disturbance we have already been considering, and that is the imprisonment and depersonalization of the artist's self in the concentration on the abstract, reflexive structure of representation that the mirror proposes. The third is a kind of representational narcissism, one that replaces the possessive erotics and outwardly directed alienation of voyeurism with a kind of "mirror stage."[26] This is, again, an impersonal narcissism of a shadowy, obstructed sort which has more to do with a preoccupation with painting and mirroring than with a pleasure in one's own person.

In this regard, it is well to keep in mind that though the Williamstown self-portrait seeks an impossible union between subject and object, self and other, its poignancy resides precisely in the *impossibility* of that union—in that the sought-after union is only a constant reminder of the inevitable, duck-rabbit[27] splitting and switching between the two. The same may be said of the "mirror stage"—it depends on division and separation rather than on successful self-possession. For the "mirror stage" is a structure of the self which puts the doubling of representation on the same plane as unrealizable desire, self-consciousness, and alienation from the self. So do Degas's self-portraits, which equate the divisions of alienated narcissism, the Pascalian "moi haïssable" (Dunlop, *Degas:* 35; McMullen, *Degas:* 67, 120), with the representational divisions of the mirror, and with a mitotic model of image generation.

From the very beginning of Degas's career, let us now turn to the very end of it, and close the brackets. In many ways Degas's other, more famous series, particularly his late dancers, "reflect" the structure of the "mirror stage" more obviously than the self-portraits do: their insistence

FIG. 126 Degas, *Self-Portrait with Zöe Closier (Degas and His Servant)*, 1890–1900

upon fragmentation, doubling, and repetition, upon bodies divided and split off from themselves, upon the rehearsal of motor activity and its inextricable relationship to the occupation and definition of space, all of these are fundamental characteristics of the mirror stage. But Degas's late photographs represent that stage perhaps better than any of his other images do.[28] His photographs of dancers and bathers, for example, which exactly replicate the poses of some of his late pastels of the same, insist on a kind of literal replication: replication by means of the mirror, and by means of photographic negatives and positives (figs. 116, 117). And his photographic self-portraits, which represent his old-age self, almost exactly replicate the characteristics of his painted, youthful self-portraits. They emphasize the split between making and seeing and the absence of a "hand" in the same fashion as his painted self-portraits do—by the fading away and the failure of attention to his own hands and the focus on pairs of gazes (fig. 126): except that in the photographs the absence of the "hand" is a fact of the medium, rather than a painted fiction. Moreover,

even more than in his painted self-portraits, Degas's photographs of himself make paradoxes out of the notion of the "origin" or the authorship of the image. There Degas is, in *Self-Portrait with Zöe Closier*, in front of the apparatus, so he cannot also be behind it, directing its "vision"—or can he? Within the photograph he looks away from the camera, refusing to confront, and thus seeming to exclude his other, directorial self—he is *there*, but not *here*. As a source for his own image, he seems to be, not only elsewhere, but nowhere. Degas was known to have been an autocratic, extremely demanding director of photographic poses, but here his authority is evaded—that he commands his own pose is a fact that is unacknowledged. Where Degas's handmade self-portraits seemed to lean in the direction of light-sponsored auto-production, his truly photographic self-portraits seem to be dubious about the bodilessness of their medium, its separation of the eye from the manufacturing hand, its detachment of the process of generation from material signature, and its attachment of origination to mechanical automation and to optical responsiveness. Dubious they may be, but they are also assertive of their passiveness and bodilessness, their separation and detachment, their mechanicalness and their responsiveness.

Though Degas did not do darkroom work, in both his photographs of others and his photographs of himself he seemed to stress the photographic interplay between dark and light, sightedness and blindness—by his choice of dark rooms and difficult viewing conditions, another aspect of Degas's photographic sessions about which his friends protested. Always, Degas worked at forcing his light-drawn, photo-graphic figures to emerge with as much hindrance as possible from dark itself, as if attempting to bend his own vision to make it see into the world of deepest darkness and harness the domain of shadow to the authority of light and sight, and yet at the same time submitting himself to the condition of blindness and making his every act of visual will subservient to the essential impotence of that condition. By their attachment to darkness, all his photographs involve themselves in the circle of power and powerlessness, of authoritative intervention and blind reaction, which circumscribes the intentionality of photography more than it does that of any other medium.

Degas's photographic self-portraits locate the paradox of self-representation, principally the elision-cum-division of the active and passive positions of the mirror found in his painted self-portraits, in the defining conditions of the medium of photography. The self as a depersonalized structure of representation, the impersonal narcissism of mirroring, the de- and re-gendering of the generative process: these too are defined in photographic terms by the photographic self-portraits.

There is one late photograph, not properly speaking a self-portrait, which explicitly addresses the apparatus and activity of photography, a medium about which Paul Valéry had something to say.[29] This is also a

FIG. 127 Degas, *Portrait of Renoir and Mallarmé,* c. 1890

photograph which matches Valéry's "method," and even his "moi pur":
his substitution of a structural for a biographical self, of a *system* for
the *author,* a substitution which, in this photograph, is made specific to
photography. The photograph in question is a portrait of Renoir and
Mallarmé, a copy of which Valéry owned and described (fig. 127):[30]
"Near a large mirror we see Mallarmé leaning against the wall, and
Renoir seated on a sofa facing us. In the mirror, in the state of phantoms,

Degas and his apparatus, Mme and Mlle Mallarmé can be made out" (*Auprès d'un grand miroir, on y voit Mallarmé appuyé au mur, Renoir sur un divan assis de face. Dans le miroir, à l'état de fantômes, Degas et l'appareil, Mme et Mlle Mallarmé se devinent"*—*Degas Danse Dessin:* 64–65). Valéry also described the photograph's making: "This photograph was given to me by Degas, whose apparatus and phantom can be seen in the mirror. Mallarmé is standing near Renoir, who is seated on the sofa. Degas has inflicted on them a pose of fifteen minutes in the light of nine kerosene lamps . . . In the mirror can be seen the shadows of Mme Mallarmé and her daughter" (*"Cette photographie m'a été donnée par Degas, dont on voit l'appareil et le fantôme dans le miroir. Mallarmé est debout auprès de Renoir assis sur le divan. Degas leur a infligé une pose de quinze minutes à la lumière de neuf lampes à pétrole . . . dans le miroir on voit ici les ombres de Mme Mallarmé et de sa fille"*—Janis, "Degas's Photographic Theater": 480). In different order, both of these descriptions of the photograph lay out the following: Renoir and Mallarmé (the men) in front of the mirror, Degas and his apparatus in the mirror as phantoms, Mme and Mlle Mallarmé (the women) in the mirror with him as shadows, and finally, the image of time (fifteen long minutes of photographic posing), a barrage of light (nine kerosene lamps) counteracting conditions of dimness, and the directorial Degas inflicting his sitters' poses upon them and subjecting them to his difficult, painstaking vision.

So the photograph consists of a machine, a series of mirrors, and a little social theater made up of friends and their reflections. Though these, instead of the features of the artist, are its ingredients, it is nevertheless a kind of self-portrait. For the camera reflected within the mirror *is* Degas: he is present *only* as the photographer—the operator of the machine and the agent of the medium. This is one of the very simple ways in which his self is reduced to a structure of representation; other ways have to do with the constituent effects of the photographic medium which are announced in both the photograph itself and in Valéry's description of it. These effects include the following: the reflection, the ghostly trace— photography is as spectral as it is specular—the opticality of light and dark, as well as doubling and division.

Besides the apparatus and the mirror, the bright light and the long posing time, Valéry describes the contents of the photograph as a set of reflections, phantoms, and shadows. And the photograph itself presents its inhabitants as such—its juxtaposition of the reflections in the mirror with the figures of Renoir and Mallarmé, whose images by contrast are clearly delineated, helps to underline the spectral, blurred quality of the mechanical and human inhabitants of the mirror. Moreover, Degas's "fantôme" is in the part of the photograph with the greatest amount of light and the patch of deepest shadow at its heart—at the center of the image where the black and white tones of the medium are most polarized and thus most emphasized, and where the opticality which produces the

photograph is most pronounced. Finally, the effects of doubling and dividing are also announced at the photograph's center—not only is the photograph's tonal splitting most exaggerated there where everything is most caught up in the mirror's game of duplication, so is Degas himself represented as something split and duplicated, divided and repeated in the amorphous black shape of the camera and the vague black shape of his body next to it, his head obliterated in the glare.

Which brings us to another peculiarity—the elision of Degas, in this photograph, with the agency and effects of photography also has the result of identifying his figure and mechanism with the most amorphous, obliterative aspects of the medium. For Degas's formless phantom is visually tied, not only to shapelessness and to shadow, but also to the ephemeral, pre-formal phenomenon, light itself, which makes photographic vision possible, but which is fundamentally invisible, and which is even destructive to vision and its objects. *Renoir and Mallarmé* is perhaps the most light-filled of Degas's photographs, suffusing the space of the image (and of the mirror) with the action of light itself, locating Degas's reflection in the bright light which constitutes the image and then almost wipes it out. Right at the heart of the photograph, then, at the center of its articulated forms and its defined pair of masculine persons (Renoir and Mallarmé, who are present in the shapes of their biographical, historical selves), the phenomenon of photographic authorship is formally linked to a nonhuman, pre-intentional agency which cannot be visualized and which ultimately defeats vision. Meanwhile, Degas as an individual author is depicted as *informe,* obliterated, absent, always located outside of and next to himself: not a person, not even a form, but only an abstract, self-referential set of effects and relationships.

Doubling and division: these effects are simultaneous with those of amorphousness and obliteration. It might be that they have something to do with one another, that they are connected in the way that they qualify the impersonal narcissism of photography, at least as this photograph seems to have it. Let us look more closely, in this regard, at the effects of doubling and division which *Renoir and Mallarmé* associates with the medium. Doubleness is found through and through this photograph. For instance, as we have seen, Degas is coincident with both the mirror and the camera, which are coincident with one another, and he, Degas, is nowhere but in that coincidence. As a photograph of the phenomenon of mirroring, and simultaneously a mirror image of the act of photographing, *Renoir and Mallarmé* defines both his activity as a photographer-artist and his self as something circular, doubled over on itself: photographing, it seems to suggest, is the same as mirroring, and mirroring is the same as the self—and both are the same as doubling and division from within. The doubleness of this photograph adds up to a photographic narcissism strongly reminiscent of the mirror stage, but from which the person of

the artist is ousted. It is a narcissism symptomatic of nothing but the equation between specular system and photographic process.

The reflexive doubling and division of this photograph also suggest the process of reversal, the switching back and forth between subject and object positions found in the early, painted self-portraits. Valéry inadvertently genders this oscillatory process by gendering the space of the photograph, locating the society of men in front of the mirror and the world of women within it. According to him, the masculine space is out *here* and the feminine space is in *there*. Picture and mirror are divided into the realms of the different sexes, according each gender its traditional place: the domain of the subject is masculine, while that of the mirrored object is feminine. But it is also true that the reflections of the women show us what was *here,* in our subjective domain, and the photograph as a whole reflects what is *there,* in its reflective domain: Renoir and Mallarmé, the men. So it reverses the *here* and the *there,* the subject and object, even the masculine and the feminine, into infinity. But the real confusion comes with the positioning of Degas the photographer, who is again in both places, both inside and outside of his own photograph. Indeed, as Valéry indicates, if Degas is firmly located anywhere in *Renoir and Mallarmé,* he is placed in the world of women, the world of reflections, ghosts, and shadows—in short, in the mirror, the domain of the Other, and not in the domain of the "author." Thus, with its backwardly gendered positioning and its constant switching of places, *Renoir and Mallarmé* reverses Degas's location as "origin" ad infinitum into the site of the reflection, and defines his authorial function in terms of the vertiginous enigma of the mirror, the same enigma which has so often been associated, in *vanitas* imagery and the like, with the domain of the feminine. It is in this way that the impersonal, structural narcissim of the photograph also begins to turn over into a de- and re-gendered generative process.

It does so, first of all, precisely by the contrast reversals which characterize the viewing of this image. Neither union nor stasis is permitted to the gendered positions of subject and object, so neither the subjective fiction of possession nor the objective fixity of the fetish is permitted to *Renoir and Mallarmé.* Nor does it admit to a linear order between the two. Instead, it describes its own generative process as circular and mitotic, as passive and internal. In effect its very unauthorial model of authorship is de-"masculinized," and correspondingly "feminized."[31] For rather than emphasizing either term of the mirror's dividedness, *Renoir and Mallarmé* celebrates the *process* of division. And rather than a strict division *from* the world, it offers division from within—as is the case with Degas's dancer pastels and painted group portraits. Its model of representation, like its model of the self, is mitotic—like the self-dividing, self-replicating life of a cell. If this sounds like photography as nature, it is, a bit—but it is not the same as sounding once again photography's embeddedness in the

"real," or its status as a natural, unintentional object: Degas's presentation of the dominating apparatus, the commanded pose, and all that interior, artificial light is too insistent for that. But this photograph, like photography itself, does play with our cherished distinctions between the artificing procedures of human representation and nature's processes of self-generation, just as it plays with our distinctions between what is intentional and what is not, what is produced by will and what produces itself. Reflection begets reproduction—not naturally, but impersonally, mechanically, mitotically—and thus the generative play of the camera, as this image defines it, is more of an indeterminately "feminine" than of an authoritatively "masculine" kind.

For the apparatus itself is found in the mirror with the shadowy, ghostly shapes of the women. In the middle of the blinding glare of light in the mirror is a dark shape with a black hole within it—the camera, a black box with an eye, replacing the figure of Degas. Here, the camera is presented as a dark place, the absence of light at the heart of the whole confusing business of reflection, light, and sight—it is identified with that aspect of the photographic medium most intimately associated with powerlessness and unknowing—the dark, unseeing side of photography: photography, in other words, not as the *camera lucida,* but as the *camera obscura,* the dark room, the obscure place, the locus of emptiness and darkness, the receiving box. Insofar as Degas's self is identified with this "object," this mechanism of reproduction, he is defined as a no-thing, a lacuna in the world, an absence of substance, presence, and even of light, a kind of hold in the picture. The photograph's inclusion of masculine and feminine spaces, Degas's location of himself in the mirrored domain of the women, and Valéry's gendering of the image, allows us to put it more strongly: together the photographer and his camera are portrayed less as a phallic object and more as a feminine void, or *frauenzimmer.*[32] And if the play of the camera puts the ego and the id, as it were, of the artificing game (or the masculine and the feminine, as *Renoir and Mallarmé* has it) slap-up, face to face with one another, making one reverse into the other, then Degas's (masculine) presence as (feminine) absence in the photograph is like the moment of rupture between the two, which, like the click of the apparatus, generates the process of splitting. In these ways then, *Renoir and Mallarmé* qualifies both the mechanism and the process of the medium as vaguely, artificially "feminine." At the same time, it describes both authorship and selfhood in a way that is at once Valéryan and Benjaminian—as an abstract system of specularity and mechanical reproduction within which the aura of personhood, the authority of the author, the authenticity of the "origin" are all caught up and all obliterated.[33]

In this last section I have wanted to replicate, in my own writing, the way of the mirror—and the way of the photograph: their manner of

doubling, reversing, and splitting. I have also wanted to describe some of Degas's old-age work. Fittingly, his photographs mirror the mortuary tone of the monographs written about him, and *Renoir and Mallarmé* does so best, with its presentation of a set of graybeards, and its portrayal of Degas as an absence. Most of all, I have wanted to look at Degas's career-bracketing self-portraits, both the beginning and the ending series, in terms of Valéry's depersonalized structure of authorial selfhood. Again, *Renoir and Mallarmé* best illustrates Valéry's construct, because Valéry owned and described it; because it takes the Artist as its subject matter—indeed, different kinds of artists: the painter, the poet, and the photographer—and because it quite directly opposes artists presented as persons with names, families, and private lives (with biographies, in short) to the artist presented as a personal absence and a representational mechanism.

Degas's pseudophotographic attachment to repetitive, apparently self-generating series, and his particular obsession with feminine repetition and groups of female bodies mitotically replicating one another, had always been wondered at, and had always made him a kind of outsider to the bold, willful practices of later nineteenth-century modernist painting. However, in spite of his use of the medium, Degas had always tended to disparage photography for its instantaneity and its lack of art. Yet its fascination for him seems to have lain precisely in that which he disparaged. Though, with his predilection for difficult viewing conditions and long posing times, he worked against the instant vision of the medium, he also appears to have been drawn to its process of reflexivity and self-generation, and to have found within it a way of dissolving the fixed, authorial self of representation within the very process of repetition out of which representation is constituted. It is in this way that his pictorial strategies, in painting and in photography, may be said to match Valéry's critique and deconstruction of the authorial self, just as they match the strange, recalcitrant myth of the man. They match Valéry's substitution of the impersonal structure of selfhood (Leonardo's abstract "method") for the biographical treatment of the "author" as "person." While eminently modern in some ways, they are also strategies which help to explain why Degas was, in yet another way, an "odd man out"—not only within the group of artists to which he had belonged in the seventies and eighties, but also within the larger ideological construct of modernism. For they help to place the reputation of Degas outside the romantic obsession with the person of the modern artist. Degas was not free, but bound within a structure of representation; his persona was not predicated on a myth of authentic presence, but on personal disappearance; and he was not the virile possessor of the world and its women through his painting and his sexuality. Instead he hovered indeterminately within the very domain that he, as a "misogynist," was said to despise: that of femininity. Sublimated, structural, and antilibidinal, deconstructed and disappearing, Degas's self also made him an "odd man out" for mythic

modernism, whose preferred self is a free, a virile, an "authentic" *one,* not that different from the logocentric self promoted in the West since the Renaissance.[34] Logocentric *and* antilogocentric (in the way that Valéry's writing also is), Degas's fragmentary, mechanically reproductive self had always made him difficult to take for the Realist generation that historically produced him. For his was a self both more modern and more traditional than that of the nineteenth-century modernists.

Postscript

At the end of my opening remarks to this book, I suggested that this text was a complicated one which could be reduced to some simple aims. At the beginning of my closing comments, it seems desirable to say something further about that mixture of complication and simplicity, and about the interpretative shifts that have characterized this mélange of views about the work of Degas. For some of the book's complications reside in its eclectic collage of interpretative strategies. Neither tidy nor economical, neither linear nor global in its account, this text is also ideologically impure, doctrinally plural, and it is fickle in its application of theoretical discourse. But that, in my view, is all to the good.

Why? Because the effort to get verbally close to the imagery *and* still register the unavoidable distance of language from images just might require that multiplicity of approach, that combination of directness and indirectness, of repetition and variation. And because I fail to see the desirability of a marriage to a method. It only forces a false union between individual observations and an overarching rule, and an exaggerated, warping conformity of visual things to the rationalizing, organizing power of words. And because singularity, economy, methodological monogamy do not, any of them, suit the imagery in question or the man who made the images. Neither does a faith in any kind of critical closure. Plurality, then, is the password of this book.

Moreover, the interpretative shifts of this book are meant to follow the shifts of writers of Degas's time, and to be responsive to the different ways of reading and writing about pictures that these writers provide. In addition, my interpretive shifts are meant to answer to the kinds of different moves that I believe the different sets of Degas's images demand: A reading of social context and market practices where it seems most pertinent—in Degas's depictions of contemporary social and economic life. An address to the semiotics and linguistic structure of the image where that seems to be required—in the pictures in various genres which seem to have most to do with that, and which critics like Duranty seemed to treat that way most. An account of gender constructs, of fetishism, corporeality, and the corporeal materiality of the image, where those seem appropriate—in the 1886 nudes and related renderings of the female body, and in Huysmans's exaggeratedly misogynist description of them. And finally, a look at the construct of the author and the self where that

seems most relevant—in the biographies and monographs on Degas and in his own self-portraits. Very crudely speaking, it might be fair to say that the book has been subject to an oscillation between positivist and deconstructivist points of view—both in my own stance, and in the multiple accounts I give of Degas's double project of tradition-recuperation and -disintegration. Yet I am wedded to neither end of that arc of oscillation. I want an account that is both an empirical one *and* one that registers an awareness of the constructedness of its own empiricism. For neither positivism nor deconstructivism will do, all by itself—not for this artist and not for these images.

One of the other reasons for the plurality of this book on Degas lies in one of its dominant themes: Degas's strange position within and without the modernist tradition. But what exactly is this modernism to which Degas's work and reputation do and don't belong? Modernism can be theorized in two large ways: as a narrative which constructs a historical trajectory or as a construction of a set of defining cultural conditions which vary from era to era and from place to place. In other words, modernism can be construed diachronically or synchronically. One way of writing diachronically about the modernist trajectory is as a history of abstraction, abstraction *as opposed to* illusionistic representation. Another way is in terms of the history of the avant-garde. As for modernist conditions, their variations are a synchronic matter of social formation, economic structure, and psychic situation, and the historic avant-garde, with its rebellion against social and artistic conventions, against the ideology of its time, and against the institutions which underwrite and are supported by both, is a tactical response, with its own historical variations, to those varying conditions. Of course, the history and the conditions of modernism intersect one another, and, as the best writers on modernism have shown, even the formalist version of the canonical history of modernism is embedded in its social conditions.[1] Most important for our purposes is the fact that all these ways of writing about modernism are predicated on the principles of rupture and opposition: between past and present, conservative and radical, the traditional and the modern, to name the most basic pairs of binary terms. If it is true that only in writing is modernism a thing, only in writing that it is narrativized and structured as a single, global phenomenon, then modernism is nothing if not a myth of the great historical divide between the modern and that which came before it, nothing if not a story of ideological antagonism[2] between the inimical opposites of modernism and that which modernism is set against. It is nothing if not a romantic romance, or antiromance.

Degas's work—I would say "by contrast," but of course I can't—is different in its yes-and-no particularity, different, but not opposite. This is true of most challenging work, but the difference is that Degas made particularity his specialty—his strategy *and* his theme—and that his difference is not oppositional. For in spite of his negativity and his intran-

sigence, his work in not built on a mechanism of binary opposition between the modern and the not-modern. It is modern *and* traditional rather than one *or* the other. It is not abstract *as opposed to* representational, but the one inverted, disintegrated into, and built out of the other. Degas's devotion to drawing, printmaking, and photography, over and above the tradition of painterly illusionism, necessarily makes the relationship between abstraction and representation a more tangled one in his case—for his preferred media are more inescapably semiotic forms of representation than painting is, and less exclusively literal in their materiality.[3] So their self-referentiality is slightly different, necessarily including representation itself as one of their referents.

Certainly Degas's work answers to the modern conditions, social, economic, and psychic, of his time—but it does so in a deeply ambivalent way: neither subversive on the surface nor celebratory and positive, it does not work by *exposing* the dominant ideologies of the day, but only by altering their structures a little, slightly changing the terms of their equations, by making them fall apart a bit from within, rather than blowing them apart from without. Neither was Degas's persona at all avant-garde—politically he was conservative, artisically he was both conservative *and* radical and neither: he was avant/retro. His tactics were not advance-scout, guerrilla-warfare ones. If anything, they were more akin to those of espionage, and they were tactics which he was as wont to turn against his own as against the other side.

This is true on all levels: the socioeconomic, the linguistic, the sexual, the authorial. On all levels Degas's is a yes/no, is/isn't project; in all of its dimensions it is structurally implosive rather than iconographically explosive, combinatory *and* disintegrative rather than *either* positively positive *or* liberatingly negative. Degas was imprisoned rather than free; monkish, misogynist, *and* pseudofeminine, rather than womanizing masculinist; both authorial *and* anti-authorial; self-referring, self-returning, *and* self-negating. He cannot quite be excluded, but neither can he be included in the romance of modernism: his was neither a utopian nor a tragic scenario; he was not a romantic hero-protagonist; his story has no clear antagonistic plot and no bugle calls to accompany it. Repetitively plural rather than oppositionally singular, Degas was an unromantic figure of repetition and irresolution, of variation and permutation, of endless, impersonal, antipolemical praxis. And one of the lessons to be learned from this figure and his work is an unglamorous one. It has to do with an unromantic possibility, which is this: that *maybe* the more nuanced, less absolutist difference is the more difficult one, that the finer the permutation the more interesting the subversion, and the quieter and more internal the violence to a structure the greater the chance of some real loosening of it and of some kind of imprisoned escape from the Janus-figure shape that is formed by the binary pair of a system and its radical, inimical opposite.

Another characteristic of the art history of modernism, besides its romantic antagonism, and in spite of its love of individualist heroes, is its preoccupation with groups, movements, and "isms." A share of the special attraction of Degas's work, for me, lies precisely in its stubborn specificity, its conflictedness with itself, its resistance to manifestoes, to inclusion within a group, even to interpretation—in short, its not-quite-categorizable intransigence. I have said that I did not want to force Degas's images into the constricted space provided by the strict parameters of *a* verbal theory. It is a possibility that I have multiplied rather than eliminated that danger—I hope not. I hope I have still allowed this body of work its escape, still permitted it its particularity, and that its intractability remains a part of the interest and pleasure we take in it. One of my goals has been to try to explain Degas's odd-man-out status—I hope that in explaining it I have also protected it. I hope I have for the sake of the works and of our own *jouissance,* but I also hope so in the name of particularity itself, under the sign of a different kind of difference—difference established horizontally and plurally, not hierarchically or binarily—and in honor of simple, unheroic praxis.

Notes

PREFACE

1. Jean Prouvaire, "L'Exposition du boulevard des Capucines," *Le Rappel*, 1 floréal an 82—20 April 1874.

2. "Jacques," "Menus propos: Salon impressionniste," *L'Homme Libre*, 23 germinal an 85—12 April 1877.

3. Felix Fénéon, "Les Impressionnistes en 1886," *La Vogue*, 7 June 1886—republished in *L'Art moderne*, Paris, 1919.

4. Felix Fénéon, "Un Bottin des lettres et des arts" (1886), *Oeuvres*, Paris, 1948 (4th ed.): 199.

5. See Marshall McLuhan and Quentin Fiore, *The Medium is the Message*, New York, 1967: 123, 126, 128. See also Walter Benjamin, "The Work of Art in the Age of Mechanical Reproduction," *Illuminations* (Hannah Arendt, ed., Harry Zohn, trans.), New York, 1969: 217–51; and Clement Greenberg, "The Newer Laocoön," *Partisan Review*, July–August 1940: 296–310, reprinted in John O'Brian, ed., *Clement Greenberg: The Collected Essays and Criticism*, Chicago, 1986, vol. 1: *Perceptions and Judgements 1939–1944*: 23–38.

6. The reader will notice that I will rarely put quotation marks around "realism," in spite of the fact that I am wary of the assumption of transparency that usually goes with the word. It is a word that is very much part of nineteenth-century discourse, and I will use it as such. Some switching back and forth between the capitalized and uncapitalized versions of the word will also be noticed—I will use "Realism" only to refer to the painting and literature of the generation of 1848, and of the era preceding it; otherwise I shall use "realism."

7. *Le Rappel* was an anti-imperial journal founded by the friends of Victor Hugo in 1869. Its republican leanings are evident in its use of the revolutionary calendar—Jacques Lethève, *Impressionnistes et symbolistes devant la presse*, Paris, 1959: 293. The same was true of *L'Homme libre*.

8. Marc de Montifaud was a pseudonym for a female critic named Marie Amélie Chartreule—see Steven Zalman Levine, *Monet and His Critics* (Ph.D. thesis, Harvard, 1974), New York and London, 1976: 19, 466.

9. Marc de Montifaud, "Salon de 1874. Exposition du boulevard des Capucines," *L'Artiste*, 1 May 1874.

10. Paul Mantz, "L'Exposition des peintres impressionnistes," *Le Temps*, 22 April 1877.

11. Philippe Burty, "Exposition des impressionnistes," *La République française*, 5 April 1877.

12. Georges Rivière, *L'Impressionniste*, no. 1, 6 April 1877.

13. Montjoyeux (Jules Poignard), "Chroniques parisiennes—Les Indépendants," *Le Gaulois*, 18 April 1879.

14. Maurice Denis, "Définition de Neo-Traditionisme," *Art et Critique*, 23 and 30 August 1890, included in *Théories 1890–1910*, Paris, 1920 (4th ed.): 1–13, and in Herschell B. Chipp, *Theories of Modern Art: A Source Book by Artists and Critics*, Berkeley, 1968: 94.

15. Fouquier, "Les Impressionnistes," *Le Dix-Neuvième Siècle*, 3 April 1886.

16. In 1877, for example, Degas's pictures were isolated and hung all together in

a small gallery in the rear of the show. See John Rewald, *The History of Impressionism,* New York, 1973 (4th ed.): 312. See also Bertall, "Exposition de impressionnistes," *Paris-Journal,* 9 April 1877: "Celui-là [Degas] s'est réservé une petite chapelle, où il a élevé son autel à part."

17. Banville (Baron Schop), "La Semaine parisienne," *Le National,* 7 April 1876.

18. Anon., "Le Jour et la nuit," *Le Moniteur universel,* 8 April 1877. The same phrase was used by the critic for *La Petite Presse:* Anon., "Les Impressionnistes," *La Petite Presse,* 9 April 1877.

19. Baron Schop, "Choses et autres," *Le National,* 8 April 1877.

20. Paul Mantz, "Exposition des oeuvres des artistes indépendants," *Le Temps,* 14 April 1880. Quoted in The Fine Arts Museum of San Francisco, *The New Painting: Impressionism 1874–1886,* San Francisco, 1986: 324.

21. One other critic mentioned an ambiguously identified picture in the show of 1874: "De M. Degas nous avons vu un *Intérieur de coulisses* où une jeune danseuse, à l'ombre d'un portant, regarde les entrechats que font ses compagnes sur la scène éclairée par les feux de la rampe"—Léon de Lora, "Petites nouvelles artistiques—Exposition libre des peintres," *Le Gaulois,* 18 April 1874.

To get an idea of how difficult it is to decide which of Degas's pictures were actually shown (it is perhaps particularly difficult in Degas's case, given his tendency to send pictures in late, or to take or hold back altogether ones that he had listed in the catalogue), see, for example, *The New Painting,* p. 174, where it is suggested that the *Ballet Rehearsal On Stage* was shown in 1876, and not in 1874 after all (one critic, G. d'Olby, writing for *Le Pays,* mentioned a *grisaille* sketch of a dance foyer). See also Ronald Pickvance, "Degas's Dancers, 1872–1876," *Burlington Magazine,* 1963, vol. 105: 256–66. He shows that the principal dance picture (besides the Orsay *Ballet Rehearsal On Stage*) described by the critics in 1874 could not have been the Orsay *Dance Class,* but was rather the New York *Dance Foyer* (he cites Burty and Montifaud, both of whom mentioned a *little* picture); moreover, he indicates that the former could not have been completed until 1876. It is possible, according to his evidence, that the *Dance Class* was shown in 1877 (it was bought by Captain Henry Hill, as was the *Absinthe Drinker,* and was lent to an exhibition in Brighton in 1876—if the *Absinthe Drinker* was lent to the impressionist exhibition in 1876, so might the *Dance Class* have been in 1877. There was an *Dance Examination,* belonging to M. H. H., and also a *Dance Class* listed in that exhibition—it might be one of these, instead of, or as well as, the Corcoran *Dance School*). The *Dance Examination* (the companion to the Orsay *Dance Class,* which belonged to Faure, may have been shown both in 1874 (Pickvance has redated it to 1874) and in 1876: in both cases there is a *Dance Examination,* listed as belonging to Faure, included in the catalogues. See Lionello Venturi, *Les Archives de l'impressionnisme, lettres de Renoir, Monet, Pissarro, Sisley et autres, Mémoires de Paul Durand-Ruel, Documents,* Paris and New York, 1939: 255–71—in which the eight impressionist exhibition catalogues are published. See also George T. Shackleford, *Degas: The Dancers,* National Gallery of Art, Washington, D.C., 1984—for an account of Degas's working procedures, and also for a confirmation of Pickvance's estimation of the dating of Degas's dance-class canvases (with one exception [p. 53]). He sees the New York *Dance Examination* as having been executed later than the Orsay *Dance Class* (now redated to 1876). I am not convinced that "pentimenti" in the New York canvas and the lack thereof in the Paris picture are evidence that the latter is a later work—such judgments about the relationship between working picture and finished picture simply seem inappropriate to Degas's oeuvre, especially given its repetitions and variations. Moreover, the red shawl mentioned by Prouvaire in 1874 is to be found in this picture, and in the Corcoran *Dance School,* alone among those that may have been in the exhibition of 1874.

22. *The New Painting* (pp. 216–17) suggests only that the Metropolitan *Dancers at the Bar* might have been shown in 1877, along with the *Dance School.*

23. In 1880 Degas showed, among other things, two outstanding portraits—of Ed-

mond Duranty and Diego Martelli (only one is mentioned by the critics)—a *Dance Examination* that was not one of his most typical compositions, and *The Loge* (an isolated picture: he meant to show an old academic picture as well, the *Young Spartan Girls*).

24. Eugène Véron, "Cinquième exposition des indépendants," *L'Art,* t. 2, 1880: 94.

25. Anon., "Les Impressionnistes," *L'Artiste,* February 1880: 142.

26. Arthur Baignères, "Concours et expositions: Exposition de peinture par Mme Bracquemond, Caillebotte, Degas, etc.," *La Chronique des arts et de la curiosité,* 10 April 1880.

27. Philippe Burty, "Choses d'art: L'exposition des impressionnistes," *La République française,* 5 April 1880.

28. *Lettres de Degas,* Marcel Guérin, ed., Paris, 1945.

29. George Moore, *Impressions and Opinions,* London, 1913.

30. Of course, two of the principal criticisms of the impressionists were that they produced sketches, not finished pictures, and that their subjects were merely insignificant—whereas Degas's were insignificant *and* undefinable, repetitive, and obsessive. Until the 1880s, the other impressionists' paintings were more individualized—for example, Monet's *Boulevard des Capucines, The White Turkeys, Impression: Sunrise, Japonerie,* etc.—and they were so reviewed. The Parisian critics did not begin to talk about Monet's series as such until 1887. See Steven Z. Levine, *Monet and His Critics,* New York, 1976: 11–17.

31. The following is a litany of the critics' remarks about the question of Degas's skill with pencil and brush. In 1874: "J'ajoute qu'il dessine d'une façon précise, exacte, la couleur est un peu lourde, en général. . . . Excepté pourtant dans un petit tableau, *Aux courses en province,* oeuvre exquise de coloration, de dessin"—Ernest Chesneau, "A côté du Salon II. Le plein air: exposition du boulevard des Capucines," *Paris-Journal,* 7 May; "Mais quelle justesse dans le dessin et quelle jolie entente de la couleur"—Jules Castagnary, "Exposition du boulevard des Capucines—les impressionnistes," *Le Siècle,* 29 April. In 1876: "On voit que c'est un dessinateur défroqué"—Arthur Baignères, "Exposition de peinture par un groupe d'artistes, rue le Pélétier," *L'Echo universel,* 13 April; "M. Degas a toujours une palette singulière"—Baron Schop, *Le National.* In 1877: "Le dessin a parfois des défaillances, mais comme l'artiste est spirituel dans la note de couleur"—Roger Ballu, "L'exposition des peintres impressionnistes," *Chronique des arts et de la curiosité,* 14 April; "dans lesquelles (les danseuses, etc.) se rencontrent de véritables qualités de coloration et de sentiment juste du dessin et de la forme"—Bertall, *Paris-Journal;* "dessinateur prompt et instruit"—Burty, *La République française;* "Le tout est sobrement colorié. Peut-être le dessin est-il un peu lâche"—Baron Grimm, "Lettres anecdotiques du Baron Grimm. Les Impressionnistes," *Le Figaro,* 5 April; "Les mouvements sont justes et piquantes, et sa couleur est brillante . . . Mais ne demandez à M. Degas que des à-peu-près"—de Lora, *Le Gaulois;* "des dessins très réussis"—O'Squarr, "Les Impressionnistes," *Le Courrier de France,* 6 April; "Chaque oeuvre contient autant de talent littéraire et philosophique que d'art linéaire et de science de coloration"—Rivière, *L'Impressionniste;* "M. Degas a toujours une palette singulièrement distinguée"—Paul Sébillot, "Exposition des impressionnistes," *Le Bien public,* 6 April. Even Zola, who was sometimes critical of Degas's technique, wrote: "Degas est un dessinateur d'une précision admirable, et ses moindres figures prennent un relief saisissant"—Emile Zola, "Une exposition: Les peintres impressionnistes," *Le Sémaphore de Marseilles,* 19 April. In 1879, critics wrote: "Une hardiesse de ligne, une provocation de dessin . . . tout est correct, tout se tient, tout est en place"— Montjoyeux, *Le Gaulois;* "Le dessin en est d'une vérité et d'une justesse exquises"— Armand Silvestre, "Les Indépendants," *La Vie moderne,* 24 April; "M. Degas . . . est un savant dessinateur"—Anon., "Exposition des artistes indépendants—Ave. de l'Opéra," *Le Journal des arts,* 9 May; "M. Degas surtout dont le pinceau est fort habile"—Anon., "Chronique," *Le Temps,* 11 April. In 1881: "Quant au maître Degas, tempérament de peintre très puissant et dont le dessin est des plus savants . . . "—Comtesse Louise, "Lettres familières sur l'art: Salon de 1881," *La France nouvelle,* 1–2 May; "Mais que de jolies choses j'ai vues de cet homme de talent, que de dessins d'une coupe originale"—

Albert Wolff, "Courrier de Paris," *Le Figaro,* 10 April. In 1886, critics were still saying the same: "Il n'arrête chaque scène et chaque figure d'une ligne sûre, bien accentuée,"—Jules Désclozeaux, *L'Opinion,* 27 May; "Très habile exécutant"—Fouquier, *Le Dix-Neuvième Siècle;* "On sera forcé de s'inclincer devant la maestria de l'exécution"—Firmin Javel, "Les Impressionnistes," *L'Evénement,* 16 May; "Vision pénétrante, science de la forme, précision du dessin"—Roger Marx, "Les Impressionnistes," *Le Voltaire,* 17 May; "Tout cela est dessiné d'une façon superbe. Il y a des pieds et des mains qui sont des chefs d'oeuvre, et la souplesse de la ligne est telle que, cessant d'être un contour, elle devient une enveloppe"—Georges Auriol, "Huitième Exposition," *Le Chat noir,* 22 May.

32. Edmond and Jules de Goncourt, *Journal, Mémoires de la vie littéraire,* Monaco, 1903, vol. 10, 1871–75: 164—13 February 1874.

33. Emile Zola, "Lettres de Paris. Nouvelles littéraires et artistiques," *Le Messager de l'Europe,* June 1879: *Salons,* Paris, 1959 (F. W. J. Hemmings and Robert J. Niess, eds.): 225–30.

34. Zola developed a theme of virility in his *Salons,* particularly in "Mon Salon" of 1866, referring to Manet and the other "vigorous," flesh-and-blood, raw, strong painters who merited his approval, as opposed to *pompier* painters, whom he tended to describe as effeminate, eunuch, boudoir painters: Emile Zola, "Mon Salon," *L'Evénement,* 27 April 1866; and "Une nouvelle manière en peinture: Edouard Manet," *Revue du dix-neuvième siècle,* 1 January 1867, in *Salons:* 63, 64, 66, 69, 70, 72, 74, 76, 80.

35. Richard P. Brettell and Suzanne Folds McCullough, *Degas in the Art Institute of Chicago,* Chicago, 1984; Roy McMullen, *Degas, His Life and Work,* Boston, 1984; Sue Welsh Reed and Barbara Stern Shapiro, *Edgar Degas: The Painter as Printmaker,* Boston, 1984; George T. Shackleford, *Degas: The Dancers,* Washington D. C., 1984; Jacqueline and Maurice Guillaud, *Degas: Form and Space,* Paris, 1984; Eunice Lipton, *Looking into Degas,* Berkeley, 1986; Richard Kendall, *Degas by Himself: Drawings, Prints, Paintings, Writings,* London, 1987; Richard Thomson, *Degas: The Nudes,* London, 1988; and Galeries Nationales du Grand Palais, *Degas,* Paris, 1988.

Chapter 1

1. See *Lettres de Degas,* nos. 6–9 of 1874 and 1876—to Bracquemond and Burty, pp. 33–38. See also Louis Enault, "Mouvement artistique: l'exposition des intransigents dans le galerie Durand-Ruel," *Le Constitutionnel,* 10 April 1876: "M. Degas est peut-être le plus intransigeant de cette intransigeante compagnie"; Baignères, *L'Echo universel,* 1876: "En tête des hommes, nous plaçons M. Degas, le pontif, je crois, de la secte des intransigeants impressionnistes"; Schop, *Le National,* 1879: "le chef"; Anon., *Le Journal des arts,* 1897: this critic placed Degas and Caillebotte at the head of the group; Anon., *L'Artiste,* 1880, p. 142: "M. Degas, le maître"; Elie de Mont, "L'Exposition du boulevard des Capucines," *La Civilisation,* 21 April 1881: "M. Degas en tête"; Wolff, *Le Figaro,* 1881: "M. Degas, le chef de cette coalition . . . Il est le porte-drapeau des Indépendants, il en est le chef; on l'adule au café de la Nouvelle Athènes"; Anon., "Exposition des artistes indépendantes," *La Chronique des arts et de la curiosité,* 2 April 1881: "A la tête du premier groupe se place M. Degas"; and Anon., "Beaux arts: les indépendants," *La Petite République française,* 21 May 1886: "la tête de colonne." If not the "chef," Degas was one of the "étoiles": Anon., *La Petite République française,* 1879. That same year, Duranty called him "l'homme au contact de qui vingt autres peintres doivent leurs succès"—Edmond Duranty, "La quatrième exposition faite par un groupe d'artistes indépendantes," *Chronique des arts et de la curiosité,* 19 April 1879.

2. Marcel Guérin, ed., *[Edgard Germain Hilaire] Degas Letters,* Marguerite Kay, trans., Oxford, 1948.

3. Joris Karl Huysmans, *Certains,* Paris, 1889.

4. Works by Degas which were shown in the Salons include: *The Misfortunes of War*

(Salon of 1865), the *Bellelli Sisters* (*Deux Soeurs,* Salon of 1867), *Mlle Fiocre in the Ballet "La Source"* (Salon of 1868), *Mme Gaujelin* (Salon of 1869), *Mlle Gobillard* and *Mme Camus in Red* (Salon of 1870): P. A. Lemoisne, *Degas et son oeuvre,* Paris, 1946, vol. 2: 62, 64, 74, 82, 110, 132.

5. See Victor Chauvin, *Histoire des lycées de Paris suivie d'une appendice sur les principales institutions libres et d'une notice historique sur le concours général depuis son origine à nos jours,* Paris, 1866; Gustave Dupont-Ferrier, *Les Ecoles, lycées, collèges, bibliothèques, L'Enseignement public à Paris,* Paris, 1913; *La Vie quotidiènne d'un collège parisien pendant plus de 350 ans. Du Collège de Clermont au Lycée Louis le Grand,* Paris, 1921; Maurice Donnay, *Le Lycée Louis le Grand,* Paris, 1939.

6. Jean Sutherland Boggs—*Portraits by Degas,* Berkeley, 1962—includes biographical information on most of Degas's friends at the end of her book. See also Daniel Halévy, *Degas parle,* Geneva, 1960; and Georges Rivière, *M. Degas, bourgeois de Paris,* Paris, 1935.

7. In 1874 Degas wanted to call the group "La Capucine"—the name, "Société anonyme des artistes, peintres, sculpteurs, graveurs, etc.," that the others finally settled upon struck him as inflammatory; he thought it would designate the group as rejected, and hence revolutionary. It was for the same reason that at that time he wished to include Salon artists. See Giuseppe de Nittis, *Notes et souvenirs,* Paris, 1895: 237—cited by Rewald, *The History of Impressionism:* 392. In 1877 and 1879, he was firmly against the designation "impressionist"; in 1879 he suggested a compromise title: "groupe d'artistes indépendants, réalistes et impressionistes," thereby attempting to distinguish the independents and the realists of the group, namely himself and his clique, from the impressionists. The "independent" part of his title stuck—Degas, *Carnet 5,* Bibliothèque Nationale, Paris, cited in Rewald, *The History of Impressionism:* 390, 421. See also Stephen F. Eisenman, "The Intransigent Artist *or* How the Impressionists Got Their Name," *The New Painting:* 51–59.

8. See Denis Rouart, *Corréspondance de Berthe Morisot,* Paris, 1950: 92. Rouart cites a letter from Degas to Berthe Morisot in which the former was adamant about the question of Salon submissions. Rewald describes his turnabout—from his willingness, indeed his insistence on allowing conservative Salon artists into the group in 1874, to his intransigent refusal to admit Salon exhibitors in 1877. Rewald, *The History of Impressionism:* 313, 390. The most eloquent description of the Salon as the kind of open market that Degas claimed to hate is to be found in Zola's *Salons:* "Mon Salon" of 1866: 49ff., and "Une nouvelle manière en peinture," 1867: 102, in which he speaks of the Salons as a huge "boutique," as a giant kitchen or stew, as a series of competing republics, and as an immense machine.

9. See Jeanne Fevre, *Mon Oncle Degas,* Geneva, 1949: 1–19; and Roy McMullen, *Degas, His Life, Times and Work,* Boston, 1984: 7–8, who on the basis of documents discovered by Lemoisne and Rewald, establishes (and is the first to stress) that Degas's great-grandfather was a baker in Orléans; that the Degas signed themselves as such through the 1830s; and that in the 1860s a genealogist was hired to promote the family to the ranks of nobility, replete with obscure Languedoc origins, aristocratic particle, and coat of arms.

10. See the series of letters from Auguste Degas to his son when he was living with his relatives in Italy, cited by Lemoisne, *Degas et son oeuvre,* vol. 1: 29–32; and Ian Dunlop, *Degas,* London, 1979: 38–40.

11. One such friend was reportedly George Moore, who says of Degas: "[A] story is in circulation that he sacrificed the greater part of his income to save his brother, who had lost everything by imprudent speculation in American securities"—Moore, *Impressions and Opinions:* 226. See also Dunlop, *Degas:* 100–120; and John Rewald, "Degas and His Family in New Orleans," *Gazette des beaux-arts,* 88e année, sér. 6, t. 30: August 1946: pp. 105–26, reprinted in *Edgar Degas: His Family and Friends in New Orleans,* New Orleans, 1965. Later Degas would say obliquely, "C'est qu'au fond je n'ai pas beaucoup de coeur. Et ce que j'en avais n'a pas été augmenté par les chagrins de famille"—*Lettres de Degas,* no. 68, 19 December 1884—to Bartholomé, p. 99.

12. Degas made only two very brief mentions of the exhibition of 1876, though he still spoke as a partisan. His other extremely terse letters of that year are about money troubles. He mentioned the third impressionist show not at all, the fourth only obliquely in one letter, and the fifth angrily—otherwise he seemed taken up with the *Le Jour et la nuit* project. He did not mention the sixth, seventh, or eighth exhibitions either. See *Lettres de Degas,* no. 8 of 1876—to Burty, p. 37; no. 9 of 1876—to Bracquemond, p. 38; no. 16 of 1879—to Bracquemond, p. 44; no. 18 of 13 May 1879—to Bracquemond, p. 44; no. 24 of 1880—to Bracquemond, p. 51.

13. See Gustave Goetschy, "Indépendants et impressionnistes," *Le Voltaire,* 6 April 1880: "C'est un artiste qui produit lentement, à son gré et à son heure, sans souci des expositions et des catalogues. Faisons en notre deuil! Nous ne verrons ni sa *Danseuse,* ni ses *Jeunes Filles Spartiates,* ni d'autres oeuvres encore qu'il nous avait annoncées"; and the same critic in 1881: "De lui, on n'y voit encore qu'une peinture, un dessin et deux pastels, mais le catalogue nous promet sept tableaux et, de plus, cette fameuse statuette de cire que nous avons si ardemment et si vainement souhaité de contempler à l'exposition de l'an dernier. La vitrine qui doit la contenir est cependant en place et l'artiste m'a assuré qu'elle serait exposée demain"—Gustave Goetschy, "Exposition des artistes indépendants," *Le Voltaire,* 5 April 1881.

14. Zola's words, in 1880, reflect some of this. He says that only Degas benefited from the impressionist exhibitions; that he had never had any difficulty at the Salons (though people had passed unnoticingly by his works), and had wanted a kind of private chapel in which one could study his works apart from the crowd; that he had a circle of fervent admirers, and that his images stood out, for their delicacy, from the less fine work of the impressionists—Emile Zola, "Le Naturalisme au Salon," *Le Voltaire,* 18–22 June 1880.

15. A substantial part of Degas's correspondence was with Henri Rouart and his son, Alexis. Rouart, a wealthy engineer, collector, and amateur painter, was a friend of Degas's from the Lycée Louis le Grand. At Degas's instigation, he exhibited at all the impressionist shows except for the seventh one—from which Degas also abstained. He was the artist's closest friend. Other friends of Degas's who were *amateurs* and *amateur* artists and, because of Degas, exhibitors in the impressionist shows include Mary Cassatt and the engraver Vicomte Lepic (who was responsible for Degas's introduction to the monotype medium). The latter exhibited with the impressionists in 1874 and 1876, and only stopped exhibiting because of the rule about Salon submissions.

16. A good indication of the kind of publicity the impressionist shows were receiving and that Degas was complaining about is to be found in the remarks of a critic in 1879: "Tous les murs ont été recouverts hier de superbes affiches, où ce titre rayonne en lettres immenses."—Valtès, "Un Domino—echo de Paris," *Le Gaulois,* 10 April 1879.

17. The first mention of this project is found in letter 17 of 13 May 1879, *Lettres de Degas,* p. 44; then in letter 19, pp. 46–47, where Degas mentions Ernst May (whom he portrayed in the *Bourse*) as one of the project's financiers; then no. 21 of 1879–80, p. 48; no. 22, p. 49; no. 23, p. 50; no. 24 of 1880, p. 51 (all of the above to Bracquemond). In the last of these he also mentions the argument with Caillebotte. Other references occur in letter 25 to Pissarro, p. 52, about printing techniques; and in no. 26, also to Pissarro, p. 55—about advertising for the journal and the advice he had received from printing amateurs. In the following letters, friendship, craft, and connoisseurship mingle as activities, and are contrasted to the production of "articles," Degas's word for salable pictures in oil and pastel: letter 16 of 1879—to Bracquemond, p. 42; and no. 32 of 1882—to Alexis Rouart, p. 61: "articles à confectionner." See also Sue Welsh Reed and Barbara Stern Shapiro, eds., *Edgar Degas: The Painter as Printmaker,* Boston Museum of Fine Arts, 1984: on Degas's experimentation with and interest in new industrial techniques combining printmaking and photography (Douglas Druick and Peter Zegers, "Degas and the Printed Image, 1856–1914," pp. xvff.); and especially on the project *Le Jour et la nuit* (pp. xxxix–li), which is described as a magazine to reach the many, as a publication to be modeled on

other successful illustrated magazines, like *La Vie moderne,* and as one which would follow the example of the impressionists, who, partly at the instigation of Duranty, had contributed prints to the *Beaux Arts illustrés.* Caillebotte was to have helped finance and promote the project along with May, and Ludovic Halévy was to have written for it. The major problems with this view that the project was an extension, not an alternative, to the exhibitions, as some of these facts suggest, lie in these considerations: first of all, the title of the project was taken from the article in *Le Moniteur universel* of 8 April 1877 called "Le Jour et la nuit," which was hostile to the impressionists (though not to Degas); that Degas was squabbling with Caillebotte (and yet needed his financial support); that Degas refused to exhibit with a group of printmakers in London who invited him to do so in 1881; that he posed his printmaking activities against "earning a living"; that the project would fail precisely because of the success of other illustrated magazines, such as *L'Art et la mode;* finally, that if Degas were to have publicity, if he were to sell to a public at all, he would rather it were in this form, *rather* than in the form of exhibitions.

18. Many critics pointed out the group's lack of unity. For example: "MM. les Impressionnistes ne s'entendent guère entre eux"—Schop, *Le National,* 1877; "dix-huit peintres qui ne forment pas absolument une école"—Jules Robert, "La Journée: Echos et nouvelles," *Paris-Journal,* 7 April 1877; in 1881 Elie de Mont said the same—de Mont, *La Civilisation,* 1881.

19. Besides his own family and artist friends (and the many, many works which remained in his own studio until his death), the recipients and early buyers of Degas's pictures include the following: Marcel Guérin, the Rouarts, Georges Viau, Hector Brame, Jacques Fourchy, the Dihaus, Cte. Ivan Podgoursky, Manzi, Paul Valpinçon, Gobillard-Morisot, Hoschédé, the Faures, Puvis de Chavannes, Jeantaud, Charles Ephrussi, Tissot, Albert Hecht, Alphonse Cherfils, Isaac de Camondo, Comtesse de Béhague, Henri Lerolle, C. S. Gulbenkian, Mme. Jacques Doucet, Eugène Manet, Ernst May, Caillebotte, the Halévys, Jacques-Emile Blanche, Mary Cassatt, Maurice Exteens, Charles Haviland, Roger Marx, Ivan Stchoukine, Georges Charpentier, Théodore Duret, the municipality of Pau, British buyers (Sir William Burrell of Scotland and others), American buyers (the Havemeyers of Philadelphia—through Cassatt—Senator Clark of Washington, the Potter-Palmer family of Chicago, A. A. Pope of Farmington, Conn., Murray S. Danforth of Providence, R. I., E. F. Milliken of New York, etc.). Many of Degas's pictures were also sold through the galleries of Durand-Ruel and Ambroise Vollard. See Lemoisne, *Degas et son oeuvre,* vols. 2 and 3.

20. George Moore also records Degas's disdain for publicity and his refusal to exhibit: "There can be but little doubt that he desires not at all to be sold by picture-dealers for fabulous prices, but rather to have a quiet nook in a public gallery where the few would come to study. His one wish is to escape the attention of the crowd. To that end he has for many years consistently refused to exhibit in the Salon, now he declines altogether to show his pictures publicly."—Moore, *Impressions and Opinions:* 224. (This reads as almost a direct transcription of Huysmans's words.)

21. See *Degas Letters,* no. 6, 18 February 1873—to Tissot, pp. 29–32; Dunlop, *Degas:* 100; and Marilyn R. Brown, "Degas and 'A Cotton Office in New Orleans,'" *Burlington Magazine,* vol. 130, no. 1020, March 1988: 216–21.

22. Brown proves, on the basis of the Degas-Musson family archives in New Orleans, not only that Degas's father and Michel Musson had lost investments in Confederate funds, but that the firm—Musson, Lavaudais & Prestridge, Cotton Factors and Commission Merchants—was officially dissolved by 1 February 1873, at the time of Degas's painting of the picture: Ibid.: 217. See also E. J. Hobsbawm, *The Age of Capital 1848–75* (which uses the *Cotton Office* on its front cover), New York, 1979: 342; and S. B. Saul, *The Myth of the Great Depression 1873–1896,* London, 1969, for discussions of the depression.

23. Such as Philippe Burty, in *La République française* (1 April); Alfred de Lostalot, *La Chronique des arts et de la curiosité* (1 April), who said the picture "owed nothing to revolu-

tionary methods"; Silvestre, in *L'Opinion nationale* (2 April); Charles Bigot in *La Revue politique et littéraire* (8 April), who distinguished the *Cotton Office* favorably from Degas's dancers and laundresses; Louis Enault in *Le Constitutionnel* (10 April), who said the picture was "realism at its gloomiest and most unfortunate"; and G. d'Olby in *Le Pays* (10 April). These critics are mentioned in the Fine Arts Museums of San Francisco, *The New Painting*: 170–71. A few of the critics, however, did not even notice the picture, focusing instead on Degas's more usual subjects. Such was the response of Emile Porcheron, "Promenades d'un flâneur: les impressionnistes," *Le Soleil*, 4 April 1876.

24. Marius Chaumelin, "Actualités: L'Exposition des intransigeants," *Le Gazette (des étrangers)*, 8 April 1876. Chaumelin also preferred Caillebotte to the other impressionists, likening his work to Dutch painting and contrasting it favorably to the "realism" of Courbet and Manet. He also was the one critic to describe the *Cotton Office* extensively, enumerating the occupations of its cast of characters—see *The New Painting*: 171. Other critics mentioned in *The New Painting* (p. 171) who addressed this picture include Philippe Burty, "Fine Art: The Exhibition of the 'Intransigeants,'" *The Academy*, London, 15 April 1876, who likened it to Flemish painting; and Pierre Dax, "Chronique," *L'Artiste*, 1 May 1876, who said it summed up the office mentality of American civilization.

25. Another critic, while he did not directly refer to the *Cotton Office*, or even to Degas, did refer to Courbet and the *Burial at Ornans*, and treated the second impressionist show as a depoliticized realist "salon" fit for the Third Republic: "Depuis vingt ans que Courbet a donné cette note dissidente, elle s'est affirmée vigoureusement. Le réalisme, aujourd'hui, n'est plus une incarnation isolée, c'est un genre, une école . . . Telles sont les pensées que l'ouverture de l'Exposition des réalistes doit suggérer à tout esprit impartial . . . En République, il ne saurait y avoir des parias."—Emile Blavet, "Avant le Salon: L'Exposition des Réalistes," *Le Gaulois*, 31 March 1876.

26. Brown suggests that in fact Degas painted the picture this way to appeal to his hoped-for English buyers—Brown, "Degas and 'A Cotton Office in New Orleans'": 217.

27. See Rewald, *Edgar Degas and His Family and Friends in New Orleans*, pp. 13ff., on the Musson family—related to Degas by blood and by marriage (René Degas married Estelle Musson). Germain Musson, Degas's grandfather on his mother's side, was a merchant-adventurer; his son Michel was a very successful businessman who, from ruination in the earlier depression of 1837, rapidly acquired considerable wealth in the cotton business.

28. See Robert L. Herbert, *Impressionism: Art, Leisure and Parisian Society*, New Haven, 1988: 52–53, for another market reading of this image.

29. Quite the contrary—at the time it appeared that Degas's brothers were doing quite well, and he, for his part, showed pride in them in his letters: "Ils gagnent pas mal d'argent ici et sont dans une situation vraiment rare en leur age. —On les aime et les considère beaucoup et j'en suis tout fier"—*Lettres de Degas*, no. 2, 27 November 1872—to Fröhlich, p. 23.

30. See Meyer Schapiro, "The Nature of Abstract Painting," *Modern Art: Nineteenth and Twentieth Century Papers, Selected Papers*, New York, 1978: 185–211 (originally in *The Marxist Quarterly*, vol. 1, January 1937: 77–98), and "The Social Bases of Art," *Proceedings of the First Artists' Congress Against War and Fascism*, New York, 1936: 31–37—for discussions of the connection between the look of impressionist painting and the conditions of the capitalist marketplace.

31. A few years later, another critic would say the following: "Quant au maître Degas . . . il s'est simplement moqué de ses amis, de ses admirateurs, et de ses jeunes collègues"—Comtesse Louise, "Lettres familières sur l'art. Salon de 1881," *La France nouvelle*, 2 May 1881.

32. In 1865, Manet's *Olympia* had been linked to Baudelaire, though only by one critic. Mantz had also written on Manet's pictures in the 1865 Salon, though he had not made the connection to Baudelaire. See Timothy J. Clark, "Preliminaries to a Possible Treatment of 'Olympia' in 1865," *Screen*, Spring 1980: 18–41; and *The Painting of Modern Life: Paris in*

the Art of Manet and His Followers, New York, 1985: 79–146; and George Heard Hamilton, *Manet and His Critics,* New York, 1969: 64–65. Degas was sometimes likened directly to Manet: "le chef (Degas) . . . la queue de Manet"—Schop, *Le National,* 1876 (Schop also mentions Baudelaire in the same review); "Il passera certainement, comme le grand-prêtre Manet, à l'opportunisme et au Salon."—Bertall, *Paris-Journal,* 1877.

33. Louis Leroy, "L'Exposition des impressionnistes," *Charivari,* 25 April 1874.

34. Camille Delaville, "Chronique parisienne," *La Presse,* 2 April 1880.

35. Bertall, "Exposition des impressionnalistes—rue Lepéletier," *Le Soir,* 15 April 1876.

36. Georges Maillard, "Chronique—Les Impressionnistes," *Le Pays,* 9 April 1876.

37. See Clark, "Preliminaries to a Possible Treatment of 'Olympia' in 1865": 25–26; and "Olympia's Choice," *The Painting of Modern Life:* 92, 94, 96–97, for accounts of the Olympia as dislocated and dirty, as an *ébéniste* and a *charbonnière,* even as a "cadaverous" figure.

38. L. G., "Le Salon des 'impressionnistes,'" *La Presse,* 6 April 1877.

39. Bertall, "Exposition des indépendants," *L'Artiste,* June 1879.

40. Henry Fouquier, "Chronique," *Le Dix-Neuvième Siècle,* 27 April 1879.

41. Louis Leroy, "Beaux Arts," *Charivari,* 17 April 1879.

42. "Choses et autres," *La Vie parisienne,* 10 May 1879.

43. In 1874, one critic said the whole group was realist: "un groupe dont M. Manet est l'apôtre . . . une école nouvelle qu'il ne faut point confondre avec l'école réaliste dont Courbet était le chef"—Emile Cardon, "Avant le Salon," *La Presse,* 28 April 1874. Particularly in 1876 and 1881, the critics designated Degas—and the rest of the impressionist group—in realist terms. In 1876, Schop termed Degas's canvases realist—Schop, *Le National,* 1876; the critic for the *Gazette des étrangers* described Caillebotte, with whom Degas was most often linked, this way: "M. Caillebotte s'annonce comme un réaliste aussi cru, mais bien autrement spirituel que Courbet, aussi violent, mais bien autrement précis que Manet"—*Le Gazette des étrangers,* 1876; and Blavet called the whole group a realist group—Blavet, *Le Gaulois,* 1876. In 1881, Elie de Mont linked Degas's *Little Fourteen-Year-Old Dancer* to the school of naturalism—de Mont, *La Civilisation,* 1881; and Comtesse Louise linked the whole group to Realism, to Courbet and Manet: "tour à tour Réalistes, Intransigeants, Impressionnistes, sont Indépendants cette année. Courbet et Manet fûrent les grands maîtres de cette franc-maçonnerie"—Comtesse Louise, *La France nouvelle,* 1881.

44. Philippe Burty, "Exposition de la Société anonyme des artistes," *La République française,* 25 April 1874.

45. Charles Ephrussi, "Exposition des artistes indépendants," *Chronique des arts et de la curiosité,* 2 April 1881.

46. See Perrot, *Les dessus et les dessous de la bourgeoisie:* 259–300—"Le vêtement invisible." See also Valerie Steele, *Fashion and Eroticism: Ideals of Feminine Beauty from the Victorian Era to the Jazz Age,* Oxford, 1985: 192–210, and David Kunzle, *Fashion and Fetishism: A Social History of the Corset, Tight-Lacing and Other Forms of Body Sculpture in the West,* Totowa, N.Y., 1980. The emphasis on uncleanliness may be another indication that, as a whole, Degas's women were seen as improper, and indeed more than that: the nineteenth-century literature on prostitution was fairly clear on the resonances of uncleanliness (not to mention *too* much concern for cleaning the body): Alexandre Parent-Duchatelet, *La Prostitution à Paris au dix-neuvième siècle* (1836), Paris, 1982 (Alain Corbin, ed.): 103. See also Perrot, *Les dessus et les dessous de la bourgeoisie:* 228–32: "Les Ecarts à la norme: Propreté."

47. Millinery, dressmaking, laundering, as well as serving and performing in *bals,* cafés, and theaters, were all linked to prostitution: see Parent-Duchatelet, *La Prostitution à Paris au dix-neuvième siècle:* 99, 123–24; C. J. Lecour, *La Prostitution à Paris et à Londres 1789–1877,* Paris, 1882 (3d ed.; 1st, 1870): 198, 200: "Elles servent seulement d'intermédiaires entre les étrangers riches qui n'aiment pas les préambules et les courtisanes en rénom, soit qu'il s'agisse de célébrités de bals publics ou de la galanterie, soit qu'il faille

arriver auprès de ces femmes qui déshonorent l'art dramatique, et pour lesquelles la scène et la rampe remplacent le trottoir" (p. 197); "Le plus souvent, c'est sous le couvert d'une industrie spéciale: le commerce de la toilette, que les femmes se mettent en relation avec un nombreux personnel de jeunes filles ou de femmes" (p. 198); and "N'oublions pas, pour que le tableau soit complêt, certains blanchisseuses du quartier Latin" (p. 200); Charles Virmaître, *Paris impur,* Paris, 1900: 102, 108—"Le Coup de la Blanchisseuse qui ne blanchit rien" and "Le Coup de la Blanchisseuse est à la portée de toutes les femmes; elle le fait blanchir par une ouvrière, mais c'est elle qui le repasse, elle a le plus souvent la clientèle de voyageurs qui désirent être servir à la minute"; Octave Uzanne, *Parisiennes de ce temps en leurs divers milieux, états et conditions: études pour servir à l'histoire des femmes, de la société, de la galanterie française, des moeurs contemporaines et de l'égoisme masculin (Etudes de sociologie féminine),* Paris, 1910: 421. See also Susan Hollis Clayson, *Representations of Prostitution in Early Third Republic France,* Ann Arbor, 1984 (U.C.L.A. Ph.D.): 205ff., and Lipton, *Looking into Degas:* 116–86.

48. Such is the case in books like Albert Vizentini, *Derrière la toile (foyers, coulisses et comédies), petites physiologies des théâtres parisiens,* Paris, 1868; Adolphe Jullien, *L'Opéra secret au XVIIIe siècle,* Paris, 1880. (Jullien wrote a whole series of books on the *coulisses* of the Opera in the eighteenth century, including: *L'Opéra en 1788: documents inédits: extraits des archives de l'état,* Paris, 1875, and *La comédie et la galanterie au dix-huitième siècle,* Paris, 1879, the latter illustrated with *rocaille* page headings). Other works on the Opera are Gabrielle Randon, *Mystères des coulisses d'Opéra, révélations,* 1885, and *Scènes comiques à l'Opéra,* Paris, 1886; Gaston Capon & R. Yve Pléssis, *Les théâtres clandestins, Paris galant au XVIIIe siècle,* Paris, 1905, and *Fille d'Opéra, vendeuse d'amour, Histoire de Mlle. Deschamp (1730–64) raconté d'après les notes de police et des documents inédits,* Paris, 1906. See also Félicien Champsaur, *L'Amant des danseuses,* Paris, 1888, illustrated by Cheret and H. Gerbault.

49. Appropriately, Gaston Capon, for one, also specialized in rococo versions of the prostitutional literature such as: *Les petites maisons galantes de Paris au dix-huitième siècle: folies, maisons de plaisance et vide-bouteilles—d'après des documents inédits et des rapports de police* (preface by R. Yve Pléssis), Paris, 1902; and *Les maisons closes au dix-huitième siècle. Académies de filles et courtières d'amour, maisons clandestines: matrones, mères-abbesses, appareilleuses et proxénètes; rapports de police, documents secrets,* Paris, 1903. See also Edmond de Goncourt, *La femme au dix-huitième siècle,* Paris, 1887, and *La Guimard, d'après les régistres des menus-plaisirs de la Bibliothèque de l'Opéra,* Paris, 1893. It is evident that the rococo literature of the *coulisses* was very closely connected indeed to the literature on prostitution, sharing its voyeuristic stance, its soft-porn tone, its privileged point of view, and its pretensions to the physiognomic-scientific recording and cataloguing of the Parisian underworld. Just as the *coulisses* literature was a kind of mock-gallant inversion of the prostitutional literature, so the opposite was true as well—the latter was simply the underside of the former, replete with individual-by-individual accounts of famous courtesans and *madames* reminiscent of the accounts of particular dancers. The eighteenth-century prostitutional literature is marked by references to rococo painters, and deliberate contrasts between decorative, rococo loveliness and sordid realist "truth," reminiscent of Montifaud's language—see in particular the preface to Capon, *Les maisons closes:* pp. ii–v. For its part, the literature of the *coulisses* is full of titillating accounts of debauched *abonnés* and dancers seduced into becoming courtesans (Randon's *Scènes comiques* and her *Mystères* are both pseudofeminist narratives of the plight of the dancers, yet nevertheless coquettish and deliberately titillating—like the writing of her female counterpart in the field of art criticism, Montifaud); of the privilege of entrance into the *coulisses;* of the relationship between classes, replete with mention of *blanchisseuses* and the like (Randon, *Mystères:* 3). There are fictional anecdotes about dancers' love lives (Randon, *Mystères:* 17ff., 29ff., 40ff.); the listing of pet names for dancers, as for prostitutes (Vizentini, *Derrière la toile:* 25–26); and the contrast between the artifice of theatrical beauty and realist truth (Randon, *Mystères:* 24ff.; preface to Vizentini, *Derrière la toile:* iv–v). These narratives are full of the epithets used by other critics to

describe the dancers, including Terpsichore, "les petits anges du ballet," "vierges," etc. (Vizentini, *Derrière la toile:* 13, 23, 36). One writer ends thus: "Eh bien! lecteurs, êtes-vous contents? Connaissez-vous assez ces dames? Nous n'avons insisté sur leurs petits travers, que pour vous ménager d'agréables surprises. Allez-donc voir et admirer ces onze mille vierges, vous serez vaincu tout de suite et vous vous écrierez comme Emile Augier: 'Elles sont charmantes, charmantes, charmantes!'"—Vizentini, *Derrière la toile:* 36. Of particular interest is Félicien Champsaur's *L'Amant des danseuses* (1888), in part because its fictional hero (as Theodore Reff, in *Degas: The Artist's Mind,* New York, 1976: 19–45, has shown) is a translation of the figure of Degas. In this little book, more explicitly a piece of fictional *erotica* than the rest, Degas is transformed into one of the lascivious *abonnés* described by Randon, his preferred subject of Opera dancers and other demimondaines turned into an excuse for sexual dalliance, of which several detailed accounts are given. This is an account which also includes narratives, given by the dancers themselves, of their own lives.

50. Edouard Nöel and Edmond Stoullig, *Les Annales du théâtre et de la musique,* Paris, 1875; J. P. Moynet, *L'Envers du théâtre, machines et décorations,* Paris, 1873; Ivor Guest, *The Ballet of the Second Empire,* London, 1974. See also Lipton, *Looking into Degas:* 73–105; Mari Kalman Miller, "Exercises in and around Degas's Classrooms," *Burlington Magazine,* March 1988, vol. 130, no. 1020: 206; Linda D. Muehlig, *Degas and the Dance,* Northampton, Mass., 1979: 6; Shackleford, *Degas: The Dancers:* 22, 37ff.; and Herbert, *Impressionism:* 103–30. Though all of these accounts do describe the world of the *coulisses,* none of them place any particular emphasis on the *discourse* of the *coulisses,* or on its eighteenth-century resonances.

51. A good example of that is found in A. Coffignon, *Paris vivant. Les Coulisses de la mode,* Paris, 1888.

52. Edmond and Jules de Goncourt, *L'Art du dix-huitième siècle et autres textes sur l'art,* Paris, 1967. See Alfred Werner, *Degas Pastels,* New York, 1968: 14–16; Camille Mauclair, *Degas,* New York, 1941; and Virginia and Lee Adair, *Eighteenth-Century Pastel Portraitists,* London, 1971, for accounts of the connections established between the medium of pastel and eighteenth-century practice. See also Octave Uzanne, *Les Ornements de la femme,* Paris, 1882: 79, 176, for the perceived relationship between fan-making (in which Degas specialized) and the eighteenth century.

53. Degas had a collection of eighteenth-century works which emphasized the oeuvre of de la Tour, very important to the development of his pastel technique. This collection was sold at the time of the Degas family bankruptcy. See Fevre, *Mon Oncle Degas:* 69–70; and Reff, *Degas: The Artist's Mind:* 114ff., 127ff. Degas's collection, and his connection to eighteenth-century art, was part of his inheritance—his father had been closely associated with the major collectors of eighteenth-century art in Paris, such as LaCaze and Marcille. See Douglas Cooper, *Pastels by Degas,* New York, 1953; and Werner, *Degas Pastels:* 15. In addition, Degas's reliance upon Watteau as a source may be seen throughout his dance pictures of the seventies, and most particularly in his sketch sheets of the *Women on the Beach* (Lemoigne catalogue, vol. 2: 259–61): based quite clearly on Watteau's *feuilles d'études* of female heads. There is also a strong resemblance between the female head in the background of *Gilles* (now *Pierrot*) and the profiles and faces of dancers sandwiched between other dancers in the two *Dance Classes* of 1874 and 1876—to mention just a few of such connections. See also studies like the *Amazone* of 1865 (Lemoisne, *Degas et son oeuvre,* vol. 1: 40).

54. See *Lettres de Degas,* no. 34, p. 63, to Hecht: "Avez-vous le pouvoir de me faire donner par l'Opéra une entrée pour le jour de l'examen de danse, qui doit être Jeudi, à ce que l'on m'a dit? J'en ai tant fait de ces examens de danse, sans les avoir vus, que j'en suis en peu honteux"; also no. 35, p. 64 to Hecht; no. 38, p. 84, to J. E. Blanche (1882) about his Opera *abonnement;* no. 43, p. 70, to Heymann about dining with Boldini and some dancers; nos. 46 and 47, pp. 72–73, to Halévy (November 1883) about writing a letter of recommendation for a dancer to Vaucourbeil, director of the Opera; no. 58, p. 84, to

Geffroy about a *soirée* at the Opera with Raffaelli, Clemenceau et al.; no. 72, p. 98 to Mme. Halévy (1884); no. 81, p. 105, to Cavé; no. 82, p. 106, to Rouart (1885); no. 84, p. 107, to Bartholomé about an Opera supper; no. 87, p. 112, to Bertrand, then co-director of the Opera (5 January 1886).

55. Arthur Meyer, *Ce que mes yeux ont vu,* Paris, 1911: 181, 208; *Ce que je peux dire,* Paris, 1912. See Reff, *Degas: The Artist's Mind:* 182ff.

56. In the same letter Degas mentions the "rococo"—*Lettres de Degas:* 93. See also Jean-Paul Crespelle, *Degas et son monde,* Paris, 1972: 11–34, on Degas's *ancien régime* affectations.

57. Jean Nepveu Degas, *Huit Sonnets d'Edgar Degas,* Paris, 1946.

58. The Cardinal "illustrations" were undertaken as a serious project, to be printed by the engraver Dujardin—one heliogravure block exists in the Bibliothèque Nationale. However, most of them remained in Degas's studio, and apart from two of them, found in private collections in Paris, remained unseen and unpublished until 1938, when *La Famille Cardinal* (bringing together *Mme Cardinal, M. Cardinal,* and *Les Petites Cardinal*) was produced by Marcel Guérin, together with Auguste Blaizot et fils, with thirty-one of Degas's Cardinal monotypes appearing in it in facsimile. See Eugenia Parry Janis, *Degas Monotypes: Essay, Catalogue and Checklist,* Harvard, 1968: xiii–xxiii; Jean Adhémar and Françoise Cachin, *Degas: The Complete Etchings, Lithographs and Monotypes,* London, 1974: 87–88.

59. These are all taken from the first two Cardinal stories, *Mme Cardinal* (pp. 10–11, 14–15), and *M. Cardinal* (p. 32): Ludovic Halévy, *Madame et Monsieur Cardinal* (1871), Paris, 1900 (illustrated by Morin)—"Madame Cardinal" (May 1870), p. 1–28, and "Monsieur Cardinal" (November 1871), pp. 29–51.

60. Louis Emile Edmond Duranty, "Où est donc la vérité?" *Paris Journal,* 8 May 1870: "une petite plaisanterie que font au peintre ses amis, à cause de ses idées d'art."

61. This is in fact the thesis of Richard Sennet's *The Fall of Public Man: On the Social Psychology of Capitalism,* New York, 1978: that the defining characteristic of the modern era is its absolute separation of the public (the social) and the private (the sexual), and the degeneration of the public *into* the private.

CHAPTER 2

1. Oscar Reütersward's "An Unintentional Exegete of Impressionism: Some Observations on Edmond Duranty and His *La Nouvelle Peinture,*" *Konsthistorik Tidskrift* (Stockholm), vol. 4, 1949: 111–16, suggests that it was not meant as a catalogue at all, and that in fact Duranty was writing about an altogether different group of painters who were also showing in the Durand-Ruel galleries. As evidence for this he refers to a letter by Duranty written to Diego Martelli and to a copy of *La Nouvelle Peinture* with names of the artists to whom Duranty was referring written in the margins (p. 112). That this list of names does not include any of the *bona fide* impressionists is no argument against the pamphlet's being dedicated to Degas's group, however—it coincides with other histories of impressionism, such as that of Duret ("Salon de 1870," *L'Electeur libre,* May–June 1870, reprinted in *Critique d'avant-garde par Th. Duret,* Paris, 1885: 3–53), in its stress on academic painters, and in its mention of Jongkind, Boudin, Manet, and others—and it clearly singles out Degas's faction within the group: Bracquemond, de Nittis, Desboutin, Lepic, and Degas himself. Reütersward himself suggests that Degas's works was the basis for Duranty's argument (p. 114). See also Hollis Clayson, "A Failed Attempt," in *The New Painting:* 145–59.

2. Louis Emile Edmond Duranty, *La Nouvelle Peinture: A propos du groupe d'artistes qui exposent dans les galeries Durand-Ruel* (1876), Paris, 1946. Reprinted and translated in *The New Painting:* 37–47.

3. See Rewald, *The History of Impressionism:* 376–78; and Linda Nochlin, *Impressionism*

and Post-Impressionism, 1874–1904 (Sources and Documents in the History of Art Series), Engle-wood Cliffs, N.J., 1966: 3; and Venturi, Les Archives de l'impressionisme, vol. 1: 50. Rewald denies the allegation made by many of Degas's contemporaries, and by Rivière, in M. Degas, bourgeois de Paris (p. 81), that Degas had actually coauthored, or indeed entirely dictated, Duranty's essay. It is much more likely that, as Marcel Crouzet, in Un Méconnu de Réalisme: Duranty—Paris, 1964: 337—suggests, Duranty's ideas may have influenced Degas's conception of what he was about. See also Marianne Marcussen, "Duranty et les impressionnistes," Hafnia: Copenhagen Papers in the History of Art, vol. 5, 1978: 24–42; vol. 6, 1979: 27–49.

4. Duranty was reputed to be the illegitimate son of Emilie Lacoste and Louis-Edmond Anthoine. His mother's and father's people were Bonapartists, liberal financiers, and gov-ernment officials opposed to the Restoration regime. On his father's side, he appears to have been partly aristocratic. Duranty grew up to be remote and reserved, taciturn and protective about his beginnings and his private life, and combative about his place in the world. At his death, his friends remarked on how difficult he had been to know. In this, he was strikingly like Degas, although for rather different reasons. Ibid.: 10–26. Duranty was educated at the Ecole François Ier, a municipal school which, unlike the Lycée Louis le Grand, which Degas attended, was conducted on the basis of the educational theories deriving from the revolution. The sciences and modern European arts and letters were stressed there, as opposed to Latin and Greek; thus it became an important breeding ground for the school of realism. Duranty's friends at the Ecole François I were of mixed background. It was there, for example, that he met Jules Assézat, son of a typesetter, who was later to be an important realist cohort of Duranty's. Ibid.: 26–32.

5. In the only other article (after the beginning of the impressionist shows) in which he included remarks on Degas, Duranty was careful to downplay impressionism: "Pour en revenir aux indépendants, impressionnistes, réalistes ou autres sans étiquette," and to dis-tinguish Degas from those of the group who might be termed impressionists—Degas was one of the "autres sans étiquette," an "homme à part."—Duranty, La Chronique des arts et de la curiosité, 1879. Moreover, Duranty's only direct commentary on the impres-sionists is extremely cool: he doesn't like Renoir, he says Sisley's work is but a pale copy of Jongkind's, and Pissarro's pictures he finds good, but restricted—Edmond Duranty, "Les Irréguliers et les naïfs ou le clan des horreurs," Paris-Journal, 19 May 1870.

6. It is possible that Duranty might also be referring to one of Caillebotte's works with his reference to a man crossing a public square, as well as his mention of a person playing piano (Caillebotte's Young Man Playing Piano, 1876). See Clayson, "A Failed Attempt," in The New Painting: 148–49.

7. "Textuelle," like "littérale," means "literal" in English, as in a word-for-word quota-tion or translation—but, particularly in the context of the rest of Duranty's essay, I be-lieve its resonances for him are also textual, whereas for Fromentin it probably only meant "literal."

8. Eugène Fromentin, "Les Maîtres d'autrefois, IV: Ecole hollandaise-Ruysdael-Cuyp," La Revue des deux mondes, vol. 13, 15 February 1876.

9. Crouzet, Un Méconnu du Réalisme: 190–91, 372.

10. Ibid.: 43–48, 167–95.

11. Edmond Duranty, "La caricature et l'imagerie pendant la guerre de 1870–71, en Allemagne, en France, en Belgique, en Italie et en Angleterre," Gazette des beaux-arts, t. 5, 1 February and 1 April 1872: 155–72, 322–43; t. 6, 1 November 1872: 393–408. See Champfleury's series on caricature, for example: Histoire de la caricature moderne, Paris, 1865; Histoire de la caricature sous la République, l'Empire et la Restauration, Paris, 1874.

12. Duranty, "Daumier," Gazette des beaux-arts, 1 May and 1 June 1878, t. 27: 429–43, 528–44; Champfleury, "Notice biographique sur Honoré Daumier," in Exposition de pein-ture et dessins de H. Daumier. Galeries Durand-Ruel, Paris, 1878.

13. See Champfleury, "Une visite au Louvre," L'Artiste, 1 December 1844: 212.

14. Edmond Duranty, "Ceux qui seront les peintres," *Almanach parisien,* 1867: 13–18; "M. Manet et l'imagerie" *Paris-Journal,* 5 May 1870, and "Le Salon de 1872," *Paris-Journal,* 30 May 1872. Duranty's guarded enthusiasm vis-à-vis Manet and the impressionists resembles Zola's own mixture of admiration and disappointment.

15. Meyer Schapiro, in "Courbet and Popular Imagery, an Essay on Realism and Naiveté," *Journal of the Warburg and Courtauld Institutes,* vol. 4, 1941: 164–91 (reprinted in Schapiro, *Modern Art, Nineteenth and Twentieth Centuries:* 67–71), shows how Champfleury modified his "avant-garde" tone during the Second Empire, disassociated himself from the worker-peasant ethos that Courbet had adopted, and gradually erased the 1848 overtones from his Second Empire writings on caricature and popular imagery. And T. J. Clark, in *The Absolute Bourgeois: Artists and Politics in France 1848–1851,* London, 1973: 141–77, traces Baudelaire's gradual alienation from the cause of 1848. (I should add that when I claim that Duranty set out to detach the "new" realism from "ideology," and that he aimed to "depoliticize" it, I do *not* mean to imply that Duranty's move was not political or ideological: in fact, the depoliticizing, de-ideologizing aspect of *La Nouvelle Peinture* is precisely what makes it political, and what makes it conform to bourgeois or positivist ideology.)

16. Over and over again, in his articles of the late sixties and early seventies Duranty had cited Courbet as the example to follow: "Nous n'insisterons pas non plus, à leur propos, sur M. Courbet, le robuste initiateur de ces tentatives. M. Courbet parait avoir imprimé personellement tout le mouvement qu'il pouvait donner"—Duranty, "Ceux qui seront les peintres": 13ff.; see also Duranty, "M. Manet et l'imagerie" and "Où est donc la vérité?" *Paris-Journal,* 8 May 1870.

17. Denis Diderot, "Essai sur la peinture," in *Oeuvres complètes de Diderot,* Jules Assézat, ed., Paris, 1876.

18. The following were Diderot's words in the section of the "Essai sur la peinture" that Duranty cited: "Toujours le même pauvre diable, gagé pour venir trois fois la semaine se déshabiller et se faire mannequiner par un professeur, . . . J'aimerais autant qu'au sortir de là, pour compléter l'absurdité, on envoyât les élèves apprendre la grâce chez Marcel ou Dupré, ou tel autre maître à danser qu'on voudra . . . "—Diderot, "Essai sur la peinture": 464.

19. This complaint echoes those repeated by Duranty himself in the criticism that intervened between *Réalisme* and *La Nouvelle Peinture:* "Il faut arriver à l'imagerie transcendante, l'imagerie admirablement faite, admirablement dessinée, d'une puissance complète. Sauf M. Courbet, nos peintres actuels manquent de puissance"—Duranty, "M. Manet et l'imagerie"; "Cependant, les peintres dont nous venons d'indiquer [Fantin, Whistler, Manet, Legros, among others] petite succession historique, ne sont pas arrivés à la plénitude de leur talent, et il faut que de nombreux travaux leur apportent de plus décisifs résultats."—Duranty, "Ceux qui seront les peintres."

20. See Schapiro, "Courbet and Popular Imagery": 66; Mary Lane Charles, *The Growth of Diderot's Fame in France from 1784 to 1875,* Bryn Mawr, 1942: 76–78, 91–93, 96–97; Gita May, *Diderot et Baudelaire,* Paris, 1957: 1–16.

21. Crouzet, *Un Méconnu du Réalisme:* 347–51.

22. Duranty and Assézat were associated with a group of "libre-penseurs," including Henri Thulié, Louis Asséline, and André Lefevre (the latter two also worked on the *Oeuvres complètes*), who collaborated on the positivist, "libre-penseur" publications *La Libre Pensée, La Pensée nouvelle, L'Encyclopédie générale,* and the *Revue d'anthropologie,* and after the war, worked together on the *Bibliothèque des sciences contemporaines* editions. These men, including Thulié, were important members of the Société d'Anthropologie, instructors at the Ecole d'Anthropologie, and dignitaries of the Conseil Municipal. Thulié, for one, was also a freemason. (Besides his principal involvement in the study of madness, Thulié was concerned with questions of hygiene, public works, and education. He was also a confirmed anticlerical.) See Crouzet, *Un Méconnu du Réalisme:* 63, 272–73, 453–54,

952. The ideas of these men were close to those of historians like Quinet. They were preoccupied with pedagogy, history, and the sciences; with the history of science; and with the relationship between the natural and social sciences. They were ardent evolutionists, though theirs was a modified, humanized version of Darwinian theory.

23. Assézat saw himself as editor and publisher of the eighteenth century. In his biographical and critical notices to his three-volume collection of Restif de la Bretonne's works (*Restif de la Bretonne—Les Contemporaines, ou les aventures des plus jolies femmes de l'âge présent,* Paris, 1875–76), he showed that he considered that author to be a father of the nineteenth-century "science de l'homme"—vol. 2, p. xxxvi. He also connected his work on that eighteenth-century author with his earlier contribution to *Réalisme*—vol. 2, p. v. Asséline wrote *Diderot et le dix-neuvième siècle* (1865), and, with Lefevre, edited and published the *Chefs-d'oeuvres de Diderot* (1879–80), *Jacques le Fataliste* (1885), and *La Religieuse* (1886). It is clear that others saw their preoccupation with the eighteenth century as part and parcel of their "libre-penseur" philosophies and scientific interests, and that they themselves understood their collaboration on the *Revue encyclopédique* and the *Bibliothèque des sciences contemporaines,* for which Duranty was to have written a "history of art," as continuations of the eighteenth-century *Encyclopédie.* (Larousse's *Grand Dictionnaire universel du dix-neuvième siècle* was probably conceived in the same way.) Thulié, for his part, made it quite clear that he saw his own medical and scientific work as thoroughly in the spirit of the eighteenth century. (Crouzet, *Un Méconnu du Réalisme:* 75, 348–55.) In a more general way, Charles shows us the extent to which Diderot, both as encyclopedist and as novelist, was thought of as the parent of nineteenth-century positivism, social thought, and style (Charles, *The Growth of Diderot's Fame in France:* 96–101).

24. Crouzet, *Un Méconnu du Réalisme:* p. 340.

25. See Edgar Quinet, *L'Esprit nouveau,* in *Oeuvres complètes,* Paris, 1895 (5th ed.): 11–15, 36–42, 45–50, 97, 329ff., etc.

26. Fromentin's articles on Dutch and Flemish painting are a little different from those of Thoré-Bürger, Taine, and Blanc. His writing tends to be much more vividly descriptive of individual paintings, and much more devoted to evocations of the individuality and personal genius of particular painters—such as Rubens and Rembrandt. But his remarks on the Dutch school, as opposed to the Flemish one, does concentrate on the national character of the Dutch to a certain extent. Whereas he opens his account of Belgian art (where he focuses on the work of one individual, Rubens) with a discussion of the museum in Brussels, and of artistic tradition, by contrast, his opening remarks on the Dutch school have to do with Dutch culture and character, Dutch "egalitarianism," even the particular qualities of Dutch nature—its landscape. See Eugène Fromentin, *Les Maîtres d'autrefois,* in *Oeuvres complètes,* Paris, 1984: *Belgique I,* 571–81, and *Hollande I* and *II,* 649–66.

27. Duranty was aware of the works of Thoré-Bürger and Taine. He was personally acquainted with Thoré-Bürger, and in *La Nouvelle Peinture* explicitly echoed Thoré-Bürger's "Nouvelles tendances de l'art," written the same year as *Trésors d'art en Angleterre (Trésors d'art exposés à Manchester en 1857, et provenant des collections royales, des collections publiques et des collections particulières de la Grande Brétagne)* Paris, 1857—see Crouzet, *Un Méconnu du Réalisme:* 190–91; Théophile Thoré-Bürger, "Nouvelles tendances de l'art," in introduction to *Salons de Théophile Thoré,* Paris, 1868. He was, moreover, openly competitive vis-à-vis Taine's standing as a critic and historian (Crouzet, *Un Méconnu du Réalisme:* 467), and he must have been aware of Charles Blanc's extremely well-known works. His "Promenades au Louvre: Remarques sur le geste dans quelques tableaux," *Gazette des beaux-arts,* t. 15, 1 January 1877, clearly shows his engagement with the current discussion of Dutch seventeenth-century painting—there certainly, he followed in Fromentin's footsteps, analyzing the same group of pictures in the Louvre that Fromentin had described the year before. That he saw himself as a contributor to the discussion of Dutch and Flemish painting is clear in an article of two years later: Edmond Duranty, "Bibliographie de l'art et les

artistes hollandais, par Henry Havard," *Gazette des beaux-arts,* t. 20, 1 August 1879: 169–72. Furthermore, he wrote his "Promenades au Louvre" in the context of an encyclopedic discussion, of which the writings on Dutch art were a part, about the schools of art of the world, considered nation by nation. He wrote four more "Promenades," all about the Louvre's Egyptian collection: "Promenades au Louvre. Remarques à propos de l'art egyptien," *Gazette des beaux-arts,* t. 17, 1 March 1878: 221–33; t. 19, 1 March 1879: 209–24; t. 20, 1 August 1879: 135–45, and 1 October 1879: 132–36. At the same time, he was writing articles—also for the *Gazette des beaux-arts*—about various national schools of art represented at the Universal Exhibition and in other shows: "L'Exposition Universelle: Les écoles étrangères de peinture," *Gazette des beaux-arts,* t. 18, 1 July 1878: 50–62, and 1 August 1878: 147–68; "L'Extrème Orient. Revue d'ensemble des arts asiatiques à l'Exposition Universelle," *Gazette des beaux-arts,* t. 18, 1 December 1878: 101–148; "L'Exposition de la Royal Academy et de la Grosvenor Gallery à Londres," *Gazette des beaux-arts,* t. 20, 1 October 1879: 366–76; "Munich et l'exposition allemande," *Gazette des beaux-arts,* t. 20, 1 November 187–89: 454–61. In this respect, he obviously echoed Thoré-Bürger, Taine, and Blanc.

28. Thoré-Bürger's *Trésors d'art exposés à Manchester,* later known simply as *Trésors d'art en Angleterre,* was an overview not only of Dutch painting but of most of the national schools of Europe. In it, the Dutch and Italian schools are seen as the two principal, contrasting schools of Europe. See Frances Suzman Jowell, *Thoré-Bürger and the Art of the Past* (Harvard Ph.D., 1971), New York, 1977. Taine's *Philosophie de l'art dans les Pays Bas* of 1869 was a companion work and follow-up on, and in explicit contrast to, his *Philosophie de l'art en Italie* of 1866 (Hippolyte Taine, *Philosophie de l'art,* in *Miroir de l'art* series, Paris, 1964), while Fromentin's "Les Maîtres d'autrefois" of 1876 was, according to Gonse, originally intended to be part of a much larger history of world art (Louis Gonse, *Eugène Fromentin, peintre et écrivain,* Paris, 1881: 173–74). Similarly, Charles Blanc's *Ecole hollandais* was part of his larger *Histoire des peintres de toutes les écoles,* which was also published in 1876. In his introduction to it, written in 1860, he quite explicitly distinguished the Italian tradition from the northern one.

29. For a discussion of the depoliticization of Courbet's reputation, see Linda Nochlin, "The De-Politicization of Gustave Courbet: Transformation and Rehabilitation under the Third Republic," *October,* no. 22, Fall 1982.

30. This presents quite a striking contrast to Duranty's description of Manet's "fond gris sombre" and Manet's protest against bric-à-brac settings and the too detailed rendering of costumes and materials—Duranty, "M. Manet et l'imagerie." It also contrasts with Duranty's only extended description of an individual work by Degas, the latter's so-called "*Dame au clair-obscur social (Mme Camus),*" of which, in "Où est donc la vérité?" he says that he finds it lacking in "l'accord, auquel il tient d'ordinaire, entre le personnage et l'intérieur" and also lacking in "sa compréhension si particulier de la physionomie."

31. Theodore Zeldin, in *France 1848–1945: Intellect and Pride,* Oxford, 1980: 205–42, gives a good account of the stress on "verbalism" in French nineteenth- and twentieth-century culture, as inculcated in its citizens in the classroom.

32. A complete list of his novels, novelettes, short newspaper stories, and works of criticism is available at the end of Crouzet, *Un Méconnu du Réalisme:* 735–45.

33. Henri Thulié, "Du Roman: La Description," *Réalisme,* no. 4, 15 January 1857: 38; and "Du roman: L'Action," ibid., no. 5, 15 March 1857: 701.

34. Duranty echoed another criticism of Balzac's oeuvre that was very common: that Balzac's writing was overwrought, baroque, and exaggerated, and therefore more romantic than realist—Bernard Weinberg, *French Realism: The Critical Reaction, 1830–70,* London, 1937: 33–81.

35. Weinberg, *French Realism:* 73–81.

36. Henri Thulié was a medical man, a psychologist, sociologist, and anthropologist, and a "libre-penseur." In the 1850s he was part of Champfleury's circle, where he met

Duranty. (Crouzet, *Un Méconnu du Réalisme:* 62–63). He shared with Duranty an interest in mental disease and aberration, and in the social conditioning, physiological aspects, and bodily appearance of extreme psychological states. His foray into literary criticism was of very brief duration—it lasted only as long as the journal *Réalisme* (ibid.: 75)—but his involvement in Realism was clearly part and parcel of his lifelong professional commitment to the positivist linkages between medicine, psychology, and social science. This is evident in his works of the 1860s—*Etude sur le délire aigu sans lésions,* Paris, 1865, and *La Folie et la loi,* Paris, 1866, and in his "avant-propos" to his *La femme, essai de sociologie physiologique,* Paris, 1885. See also his history of the Paris School of Anthropology—Henri Thulié, *L'Ecole d'Anthropologie de Paris depuis sa fondation 1876–1906,* Paris, 1907. Duranty's "La liberté et la folie," in *Paris-Journal,* 21 February 1870, closely echoes Thulié's writings—indeed, he mentions "Dr. Thulié" several times, referring to the pro-institutional, pro-control attitude toward the mad evidenced in Thulié's *La Folie et la loi.* So Thulié's interest in Realism is very much in the tradition of the earlier nineteenth-century use of realist observation as a tool of physiognomic investigation and medical-psychological diagnosis.

37. Louis Emile Edmond Duranty, "Sur la physionomie," *La Revue libérale,* t. 2, 25 July 1867: 499–523.

38. There is this remark in one of Degas's notebooks from the late 1860s: "Make of the *tête d'expression* a study of modern feeling—it's like Lavater, but a more relative Lavater in a way. Study Delsarte's observations on those movements of the eye inspired by feeling—Its beauty must be nothing more than a specific physiognomy. . . . Make portraits of people in typical, familiar poses, being sure above all to give their faces the same kind of expression as their body. Thus if laughter typifies the individual—make her laugh!"—quoted in Kendall, *Degas by Himself:* 37. See also Dunlop, *Degas:* 63; Reff, *Degas: The Artist's Mind:* 216–19.

39. Although the heyday of physiognomic studies, "phrenology," and the "physiologies" was between the 1830s and 1850s, as Judith Wechsler points out in *A Human Comedy: Physiognomy and Caricature in Nineteenth-Century Paris,* Chicago, 1982: 32, treatises and essays continued to appear through the seventies, eighties, and nineties, as Graeme Tytler, in *Physiognomy in the European Novel: Faces and Fortunes,* Princeton, 1982: 116–18, demonstrates. Physionomy continued to be the subject of a variety of discourses, ranging from treatises for artists to books of mime, dancing, and comportment; pseudoscientific works of anthropology, sociology, criminology, psychology, and physiology; and popular typologies and parlor-game hermeneutics in the manner of Jean Gaspard Lavater, whose works were extremely well known and widely read in France throughout the century: *Essai sur la physionomie, destiné à faire connoitre l'homme et à le faire aimer,* Paris, 1781–1803 (this, or versions of this, were published throughout the first and second decades of the nineteenth century and in 1826, 1835, 1841, 1845, as well as in 1909. Lavater's work and Charles Le Brun's *Expression des passions de l'âme,* Paris, 1727, were still the standard physiognomic texts in the nineteenth century (Jurgis Baltrusaitis, "Physiognomie animale," *Aberrations: quatre essais sur la légende des formes,* Paris, 1957: 43; and Tytler, *Physiognomy in the European Novel:* 82–84). Duranty himself mentions Lavater as standing for the notion of physiognomy, in "Les Irréguliers et les naïfs ou le clan des horreurs." Other important texts were those of Descartes, Gall, and Darwin: René Descartes, *Les passions de l'âme,* Amsterdam, 1650; Franz Gall and G. Spurzheim, *Anatomie et physiologie du système nerveux en général, et du cerveau en particulier, avec des observations sur la possibilité de reconnoitre plusieurs dispositions intellectuelles et morales de l'homme et des animaux, par la configuration de leurs têtes,* Paris, 1810–1819; Charles Darwin, *L'Expression des émotions chez l'homme et les animaux* (Samuel Pozzi and René Benoit, trans.), Paris, 1874. These were the sources for later nineteenth-century writers on physiognomy, the most important of which was Dr. Pierre Gratiolet (*De la physionomie et des mouvements d'expression,* Paris, 1865, based on lectures given at the Sorbonne), who trained in the Academy of Medicine and worked in the

Museum of the Jardin des Plantes and then in the Faculté des Sciences de Paris (Gratiolet, pp. 389ff.), and whose works Duranty was aware of—Duranty, "Sur la physionomie": 508. Degas, who had read Lavater's work, also demonstrated an interest in the widely read works of the criminologist-anthropologists Bordier and Lombroso—Reff, *Degas: The Artist's Mind*: 220. See Arthur Bordier, *Etude anthropologique sur une série de crânes d'assassins,* Paris, 1881; *Pathologie comparée de l'homme et des êtres organisés,* Paris, 1889; Cesare Lombroso, *L'uomo bianco e l'uomo di colore: letture sull'origine e le varietá delle razze umane,* Padova, 1871; *L'Homme de génie,* Paris, 1889; *Le crime politique et les révolutions par rapport au droit, à l'anthropologie criminelle et à la science du gouvernement,* Paris, 1892; *L'Homme criminel, criminel, criminel né, épileptique, criminel fou, criminel d'occasion, criminel par passion* (trans. from 5th Ital. ed.—the first one was 1876), Paris, 1895; *La Femme criminelle et la prostituée,* Paris, 1896; *Etudes de sociologie, les anarchistes,* Paris, 1897.

40. Eugène Mouton's *La Physionomie comparée, traité de l'expression dans l'homme, dans la nature et dans l'art,* Paris, 1885, one of the most interesting and extensive of the late nineteenth-century texts on physiognomy, bears witness to this eclecticism. At the beginning (p. 4), he speaks of the "langage universel de la nature," and then he ends his treatise with a series of chapters on the physiognomics of the animal and vegetal kingdom, and even that of the inorganic world. He also refers to the notion of man as the microcosm of the world, and to the Renaissance theory of resemblances (p. 34), to physiognomics as a "grammar" and as an "anthropology" (p. 50). He speaks of laws of proportion, of Le Brun-like temperaments and laws of expression, and of "les influences de milieu," in a manner akin to Diderot, Darwin, Balzac, and the Realists. And he returns repeatedly to aberrational and marginal physiognomies, very much in line with the interests of Bordier and Lombroso. Thus, Mouton collapses together ideas deriving from completely different eras and pertaining to epistemologies widely at variance with one another—it is as if he had taken the epistemological structures of the sixteenth, seventeenth, eighteenth, and nineteenth centuries as described in Michel Foucault's *Les Mots et les choses* (Paris 1966) and blithely elided them. As Baltrusaitis shows, his text was typical of the physiognomic tradition in general and particularly of the nineteenth-century French obsession with it (Baltrusaitis, "Physiognomie animale": 42–43).

41. Louis Emile Edmond Duranty, "Notes sur l'art," *Réalisme,* no. 1, 10 July 1856.

42. The most often cited physiognomist of them all, Lavater, was certainly subjectivist in his method, and indeed he celebrated the subjectivity of the physiognomist, whom he termed an "artist"—Jean Gaspard Lavater, *Essai sur la physionomie destiné à faire connoitre l'homme et à le faire aimer,* La Haye, 1781.

43. Michael Fried, in *Absorption and Theatricality: Painting and Beholder in the Age of Diderot,* (Berkeley, 1980), sees these modes of criticism as the inventions of Diderot: see pp. 55, 589, 122–30. Indeed, in the nineteenth century Diderot's writings on art were widely adopted as models not only for realism writing but also for art criticism—by conservative and avant-garde critics alike. See Charles, *The Growth of Diderot's Fame in France:* 90–96. Charles Blanc, for example, paid homage to him in the *Grammaire des arts du dessin,* 5th ed., Paris, 1883 (1st ed., 1867), by structuring his book like the "Essai sur la peinture"—according to the categories of judgment. It would appear, however, that Duranty and other nineteenth-century critics looked to Diderot's writing as a model—*not* for a system of judgment categories, but for what it also provided: an anticategorical, unsystematic style of critical prose and critical attention. From mid-century on, when his art criticism became known, critics increasingly aped the Diderotian style: the breeziness, the playful dialogues and arguments, the mixed modes, the sarcasm, the epigrams, the contradictions, and the carelessnesses—Diderot's critical whimsy, in other words, rather than his theoretical structure. Diderot's was a language which sounded like casual talk; as such it became associated with wit, rapid judgment, and lack of structure—Frenchness, flair, and facility—with eighteenth-century *esprit,* in short, rather than with seventeenth-century rigor. Nineteenth-century critics appropriated this eighteenth-century critical

style and made it over into a rhetorical mode of their own, marked by flippancy and impudence—a rhetorical mode derived from critical, journalistic precedents rather than from careful theoretical models. In their hands, the chatty style of writing initiated by Diderot became a mode of inattention. Though Duranty was interested in processes of attention and acuity, he often seemed to adopt this style himself. In "Promenades au Louvre," he used a variety of critical modes: from dialogue with another critic to absorption within, eavesdropping upon, and direct questioning of images. The abrupt shifting from one mode to another characteristic of "Promenades" was itself a thoroughly Diderotian strategy. On a broader level, Duranty's lightly sarcastic tone, his casual, conversational style, his summary treatment of some issues and lengthy treatment of others, his sometimes contradictory didacticism—in short, his combining of theoretical aspirations with antitheoretical modes—is reminiscent of Diderot's style of criticism. In other words, he too used the *disorder,* rather than the order, of Diderot's critical style for his own purposes. (It is interesting, in this respect, that in one of his Salon reviews, "Réflexions d'un bourgeois sur le Salon de peinture"—*Gazette des beaux-arts,* t. 15, 1 June 1877, pp. 547–81; t. 16, 1 July 1877: 48–82, and 1 October 1877: 355–67—Duranty expressly addresses the issue of "disorganized" criticism, saying in his first installment [p. 581] that in judging the pictures at the Salon he had followed the path of his personal whim rather than respected the hierarchy of genres.)

44. Rivière, *M. Degas, bourgeois de Paris:* 97–98; Reff, *Degas: The Artist's Mind:* 202. Quentin Bell, *Degas: Le Viol: Charlton Lectures on Art* (Newcastle-upon-Tyne; 1965), cites Duranty's novel, but denies that it is the story represented. That the story, in its original serial form, "Les Combats de François d'Hésclieu," published in *L'Evénement illustré* between April and July of 1868, could have inspired the picture generally is possible because of its date (the picture has been redated several times) and because this newspaper was much read by Degas and his circle—see Hélène and Jean Adhémar, "Zola et la peinture," *Arts,* no. 389, 12–18 December 1952.

45. Reff, *Degas: The Artist's Mind:* 202ff.

46. Bell centers his whole argument around the question of exactly which of the above texts was illustrated in *The Interior,* finding that none of them exactly match the image. Finally, he places *The Interior* within a whole series of images by Degas which he terms "private fantasies" of "murder, torture and rape," and which he explains as deriving from Degas's familial relationships and his obsession with blindness, etc. It is, I think, a picture which solicits such interpretation—but into which the failure of such interpretation is also built.

47. Lemoisne, *Degas et son oeuvre,* vol. 1: 61–62; Lafond, *Degas,* vol. 2: 4; and Georges P. F. Grappe, *Edgar Degas,* Paris, 1908: 50, all assert that Degas called the picture *The Rape,* but Jeanniot and Henri Rouart said he called it simply *The Interior,* and "my genre painting," while Paul Poujaud angrily denies that the artist himself ever conceived of the image as *The Rape:* G. Jeanniot, "Souvenirs sur Degas," *Revue universelle,* no. 55, 1933: 29; *Lettres de Degas,* 11 July 1936 (letter written by Paul Poujaud): 255. See Reff, *Degas: The Artist's Mind:* 201–2: "My Genre Painting." Apparently the image was of such significance to Degas that he was at work restoring it in 1903–E. Rouart, "Degas," *Le Point,* vol. 2, no. 1, February 1937: 21.

48. See Bell, *Degas: Le Viol;* Camille Mauclair, *Degas,* Paris, 1937: 14; Reff, *Degas: The Artist's Mind:* 200ff.

49. Suggested to me in lectures on David's painting by Thomas Crow at Princeton University.

50. Ambiguous subject matter with sexual references is indicated by Fromentin, for example, in his description of Terborch's *Militaire et la jeune femme:* "ce gros homme en harnais queue, avec sa cuirasse, son pourpoint de buffle, sa grande épée, ses bottes à entonnoir, son futur posé par terre, sa grosse face enluminée, mal rasée, un peu suante, avec ses cheveux gras, ses petits yeux humides et sa large main, potélée et sensuelle, dans la-

quelle il offre des pièces d'or et dont le geste nous éclaire assez sur les sentiments du personnage et sur l'objet de sa viste"—*Les Maîtres d'autrefois* (*Oeuvres complètes*): 686 (this after he had earlier announced that Dutch painting in general was characterized by "l'absence totale de ce que nous appelons aujourd'hui *un suget*": 669).

51. Rouart, *Le Point*, 1937.

CHAPTER 3

1. Joris Karl Huysmans, *L'Art moderne,* Paris, 1883.

2. The catalogue for the 1876 show mentions six portraits, including a portrait of Manet and one of Mme Camus, along with the *Cotton Office;* the catalogue of the 1877 exhibition mentions two portraits, those of Henri Rouart and Degas's sister, Rose Adelaide Aurore de Gas (painted in 1867); the catalogue of 1879 mentions ten portraits, including those of Martelli, Duranty, Mme Dietz-Monnin, and Michel-Lévy, and the *Stock Exchange;* that of 1880—three portraits: the *Stock Exchange,* Martelli, Duranty; 1881— four portraits; and 1886—two portraits. See Venturi, *Les Archives de l'impressionisme,* vol. 2: 257, 259–60, 262, 264, 265–66, 269–70.

3. Martelli was one of Degas's Italian friends, a critic known for his defense of the Macchiaioli and of the impressionists. Director of the *Gazzettino degli arti e del disegno,* and art lecturer in Florence and Livorno, his theories on painting, like those of Duranty, were heavily based on the positivist writings of Taine, Proudhon, Thoré-Bürger (whose writing on the Universal Exposition he published in the *Gazzettino*), Zola, et al. Visiting Paris in 1862, 1869, 1870, and 1878, he became known to Degas through Zandomeneghi, and became involved in the group's discussions at the Nouvelle Athènes. See Alba del Soldato and Valeria Masini, "Diego Martelli ed i Macchiaioli," *Seconda Mostra, 1976, Diego Martelli,* Biblioteca Marucelliana di Firenze, December 1976–March 1977. See also: Diego Martelli, *I Macchiaioli* (1877), and *Gli Impressionisti* (Pisa 1880)—collected in *Scritti d'Arte di Diego Martelli* (Florence, 1952). See also B. Bacci, *Diego Martelli* (Florence, 1952), and Boggs, *Portraits by Degas:* 123. That Duranty and Martelli might have been associated in Degas's mind is suggested first by Duranty's preoccupation with Degas's portrait of Martelli, and then by a copy of *La Nouvelle Peinture* that Duranty dedicated to Martelli (clearly indicating that it was Degas, and not the impressionists, to whom Duranty referred in that text). See Crouzet, *Un Méconnu du Réalisme,* pp. 338–39; and Reütersward, "An Unintentional Exegete of Impressionism." Certainly Martelli would have been seen by Degas in a similar light: like Duranty, he was not first and foremost an impressionist critic, but one who was aligned with painters like Degas's friend Zandomeneghi, and hence with Degas's more conservative coterie. The portraits were to have been shown together in 1879, along with an unusually large group of portraits, those of Mme Dietz-Monnin, Halévy and Cavé, May and Bolâtre, and Michel-Lévy in his studio—Boggs, *Portraits by Degas:* 57, 59. They were also meant to be shown together the following year, but critics mention only the portrait of Duranty. (Both portraits seem to have been omitted the year before, or at least, though it seems unlikely, simply remained unnoticed—with the exception of one critic, who mentioned the portrait of *Duranty* briefly, though he didn't actually describe it; it is possible that he was only referring to the catalogue: Montjoyeux, *Le Gaulois,* 1879.)

4. See, for example, this passage from "Artémise Tirpenne," *Revue de France,* 15 September 1877, t. 15: 444: "Un *étincellement de toits rouges et d'éclats de zinc* revelant les rivières, des touffes de bois, *des lignes* de peupliers courant et s'entrecroisant, des clochers, des obélisques d'usines, des masses boisées *d'un bleu foncé* et vapoureux affermissant la solidité des coteaux qui fuyaient, *les barrières violettes* et transparentes des lointains, de longues trainées blanches et confuses . . . *une palpitation de couleurs.* [My italics]" Crouzet sees this intense focus on the palette and on color sensation as a particular feature of Duranty's

fiction and of his criticism—*Un Méconnu du Réalisme:* 635ff. It is also, however, an important part of naturalist description in general—see Emile Zola's *L'Oeuvre,* in *Les Rougon-Macquart, Histoire naturelle et sociale d'une famille sous le Second Empire,* Paris: 1966, vol. 4, for example: "Un éclair éblouissant lui coupa la parole; et ses yeux dilates parcoururent avec efarrement ce coin de ville inconnue; *l'apparition violâtre* d'une cité fantastique. La pluie avait cessé. De l'autre côté de la Seine, le quai des Ormes alignait ses petites maisons *grises,* bariolées en bas par les boiseries des boutiques, découpant en haut leurs toitures inégales; tandis que l'horizon élargi s'éclairait, à gauche, jusqu'aux ardoies *bleuies* de combles de l'Hotel de Ville, à droite jusqu'à la coupole plombée de St. Paul" (p. 12; my italics); "Par les jours de ciel clair, dès qu'ils débouchèrent du pont Louis-Philippe, toute la trouée des quais, immense, à l'infini, se déroulait. D'un bout à l'autre, le soleil oblique chauffait *d'une poussière d'or* les maisons de la rive droite; tandis que la rive gauche, les îles, les édifices, se découpaient en *une ligne noir,* sur la gloire enflammée du couchant. *Entre cette marge éclatante et cette marge sombre,* la Seine pailletée luisait, *coupée des barres minces* de ses ponts, de plus en plus fins, montrant chacun, au delà de son ombre, *un vif coup de lumière, une eau de satin bleu, blanchissant dans un reflet de miroir;* et, pendant que les découpures crépusculaires de gauche se terminaient par la silhouette des tours pointues du Palais de Justice, *charbonnées* durement sur le vide, *une courbe mole s'arrondissait* à droite dans la clarté, si allongée et si perdue, que le pavillon de Flore, tout là-bas, qui s'avançait comme une citadelle, à l'extrême pointe, semblait un château de rêve, *bleuâtre, léger et tremblant, au milieu des fumées roses de l'horizon*" (pp. 102–3; my italics).

5. Jean Boggs, who has written fairly eloquently of the psychological intricacies of the Bellelli portrait, cites some of its sources: Bronzino's *Girl with a Missal* and his *Portrait of Lucrezia Panciatichi,* both in the Uffizi (I would add Bronzino's *Eleanora di Toledo,* on view in the same museum); a drawing by Pontormo; Van Dyck's *Portrait of the Marchesa Brignole-Salé,* and his *Geronima Brignole-Salé and her Daughter;* Ingres's *Gatteaux Family* and *Forestier Family;* Courbet; Clouet; and Holbein; and daguerrotype portraiture—Boggs, *Portraits by Degas:* 11–16. To this array of sources, Theodore Reff has added Netherlandish group portraiture, such as Frans Floris's *Van Berchem Family,* as well as Clouet's portraits—for the small framed drawing in the background of the *The Bellelli Family,* which is a reworking of Degas's 1857 etching of *René-Hilaire de Gas*—Reff, *Degas: The Artist's Mind:* 96ff. It is hardly far-fetched, then, to see this as a quite deliberate summation and recuperation of the tradition of the full-finish, fully descriptive portrait.

6. See Carol Salus, "Degas's *Young Spartans Exercising,*" *Art Bulletin,* vol. 67, 1985: 501–6; Phoebe Pool, "The History-pictures of Edgar Degas and Their Background," *Apollo,* October 1964: 307ff.

7. Norman Bryson, *Word and Image: French Painting of the Ancien Régime,* Cambridge, 1981: 368.

8. The sources cited for the *Young Spartan Girls* include the Parthenon casts and other Greek reliefs in the Louvre, Delacroix's *Alexander and Bucephalus,* Ingres's *The Age of Gold* and his *Ambassadors of Agamemnon,* and Gérome's *King Candaulus.* See Pool, "The History-pictures of Edgar Degas": 309.

9. Neither Pierre Cabanne, "Les Malheurs de la ville d'Orléans," *Gazette des beaux-arts,* 104e année, sér. 6, t. 59, May–June 1962: 363ff., nor Pool, "The History-pictures of Edgar Degas," is able to determine the precise subject of this painting. Cabanne searches through the events in medieval history related to the town of Orléans, where Degas's grandfather was born, and can find no pretext for such an image. Quentin Bell relates it to New Orleans and Degas's familial connections there, implying, like others—such as Norma Broude, "Degas's Misogyny," *Art Bulletin,* vol. 59, March 1977: 96–107, and Hélène Adhemar, "Edgar Degas et la scène de guerre au Moyen Age," *Gazette des beaux-arts,* 109e année, sér. 6, t. 70: November 1967: 29–58—that it is an image of the aftermath of the American Civil War, and of the Franco-Prussian war as well. See Quentin Bell,

Degas: Le Viol. In any case, as if to increse these interpretative difficulties, Degas eradicated the props of the original *Misfortunes of War* in much the same way as he did in the *Young Spartan Girls.*

10. Degas's reliance upon David's imagery is witnessed directly in his copy of David's *Death of Joseph Bara* (Lemoisne, vol. 2, catalogue 8).

11. This is suggested in Thomas Crow's extended exploration of David's disruption of the compositional criteria and techniques of traditional narrative painting in "The Oath of the Horatii in 1785: Painting and Pre-revolutionary Radicalism in France," *Art History,* vol. 1, no. 4, December 1978—see especially pp. 457ff.

12. Daniel Halévy, preface to the catalogue of the *Exposition Degas—Galerie Georges Petit,* 1924: 9; Cabanne, "Degas et *Les Malheurs de la ville d'Orléans*": 963.

13. According to one critic, Gustave Goetschy, writing for *Le Voltaire* on 6 April 1880 ("Indépendants et impressionnistes"), it was not shown.

14. The following are Diderot's essay subtitles: 1. "Mes pensées bizarres sur le *dessin*"; 2. "Mes petites idées sur la *couleur*"; 3. "Examen du *clair-obscur*"; 4. "Ce que tout le monde sait sur *l'expression,* et quelque chose que tout le monde ne sait pas"; 5. "Paragraphe sur la *composition,* où j'espère que j'en parlerai"; etc.

15. Roger de Piles, *Cours de peinture par principe,* Paris, 1708. Thomas Puttfarken, in *Roger de Piles' Theory of Art,* New Haven and London, 1985: 57–79, stresses de Piles's order of judgment: *dessin* (p. 64); *couleur/coloris* (pp. 64–72); *clair-obscur* (pp. 72–75); *le tout ensemble* (757–59). It is clear that that order is derived, not only from painterly seeing and from that which is special to painting ("la différence de la peinture"—de Piles, p. 312), but from the way he thinks painters put paintings together: *drawing* and then *painting* (*shading* comes third in de Piles's discussion because it is that which holds drawing and painting together: "l'harmonie des couleurs"—de Piles, p. 19). De Piles himself makes this clear, saying: "Il me reste présentement à placer les parties de la Peinture dans un ordre naturel, qui confirme le Lecteur dans l'idée que je viens de tâcher d'établir dans son esprit"; "Après l'Invention et la Disposition, le Dessein et le Coloris suivis de toutes les parties qui en dépendent . . . tous deux travailleront de concert, à mettre la dernière main à l'ouvrage et à n'y laisser rien à désirer" (de Piles, pp. 20–23). Moreover, he declares himself to be addressing painters as well as other men of taste: "Cette idée générale frappe et attire tout le monde, les ignorans, les Amateurs de Peinture, les Connoisseurs, et les Peintres mêmes" (pp. 3–4).

16. De Piles had also used the term to refer to the unities of place and time: "Comme le Peintre ne peut représenter dans un même Tableau que ce qui se voit d'un *coup d'oeil* dans la Nature, il ne peut par conséquent nous y exposer ce qui s'est passé dans les tems différens"—De Piles, *Cours de peinture par principe:* 65.

17. In fig. 115 of Armand Cassagne's *Eléments de perspective,* 1881, sec. 81: 76: "L'Escalier tournant," where the spiral stair is used to illustrate a perspectival system encompassing 360 degrees in space: an infinite number of *Durchsehungen* organized around a kind of three-dimensional vanishing point. The "escalier tournant" seems to be the culmination of Cassagne's discussion of the "échelle de proportion" (p. 47) and the "échelle appliquée aux figures (pp. 48ff.); as well as of the "applications de l'échelle aux plans verticaux fuyant obliquement" (p. 49), the "application de l'échelle fuyante à des figures placées sur des plans inclinés" (pp. 56ff.), the "cercle" and the "cercle fuyant" (pp. 57ff.). It is, in other words, the culminating illustration of obliqueness and ellipsis. See also Erwin Panofsky, *Die Perspektive als "symbolische Form," Vortrage des Bibliotheke Warburg,* Nendeln/ *Liechtenstein,* London, Warburg Institute, vol. 4, 1924–25. (It is important to remember, however, that even at its inception, this system was a theory more than a practice—by the nineteenth century the waters of even the theory were considerably muddied.)

18. Our knowledge of Degas's reliance on Daumier's work in general is due in large part to Reff's *Degas: The Artist's Mind:* 70ff. Lemoisne, among others, establishes that

Degas's later collection contained an outstanding number of Daumier's (and Gavarni's) prints: Lemoisne, *Degas et son oeuvre*, vol. 1: 178.

19. Alexandre Pothey, "Expositions," *La Presse*, 31 March 1876.

20. Emile Bergerat, "Les Impressionnistes et leur exposition," *Le Journal officiel de la République française*, 17 April 1877.

21. Louis Besson, "Messieurs les Impressionnistes," *L'Evénement*, 12 April 1879.

22. That year another critic also saw Degas's works as caricatural: "M. Degas a une tendance à tomber dans le caricatural"—Anon., "L'exposition des oeuvres des artistes indépendantes," *Le Temps*, 14 April 1880. In 1881, writing about Degas's two *Criminal Physiognomy* images, Comtesse Louise made it quite clear that Degas's works were nothing but caricatures: "Quant au maître Degas . . . il s'est simplement moqué de ses amis, de ses admirateurs et de ses jeunes collègues, en exposant quelques caricatures, croquis pris à la cour d'assises."—Comtesse Louise, *La France nouvelle*, 1–2 May 1881. The same year Elie de Mont spoke of Degas's *Little Fourteen-Year-Old Dancer* in heavily caricatural terms, and described his pictures of *café-concert* singers as *charges:* "Votre rat d'Opéra tient du singe, de l'aztèque et de l'avorton. Plus petite, on serait tenté de la renfermer dans un bocal à l'esprit de vin. . . . Toutes les petites *charges* de chanteuses de café-concert qui figurent là aussi, sans figures au catalogue, mériteraient au plus les honneurs d'un album de croquis! Elles deviennent ridicules à force de prétension."—Elie de Mont, *La Civilisation*, 1881.

23. Anon., "Exposition des impressionnistes, 6 rue Le Pélétier," *La Petite République française*, 10 April 1877. Other critics compared Degas to Forain, and in this context described him as an artist of "wit"—such was the case of the critic (anonymous) for *La Petite République française* in 1879, and for Desclozeaux in *L'Opinion*, (1886).

24. The clearest discussion of the way caricature works is to be found in Ernst Gombrich's "The Cartoonist's Armory," in *Meditations on a Hobby Horse, and Other Essays in the Theory of Art*, Oxford, 1963: 127–42, in which he writes of caricature in terms of processes of "condensation and fusion" (p. 133), and in terms of the physiognomics of the artist's gesture as linked to, yet opposed to, the traditions of physiognomic expression engaged in allegorical and narrative painting. See also "On Physiognomic Expression" in the same collection of essays, pp. 45ff., as well as "Action and Expression in Western Art," and "The Mask and the Face," in *The Image and the Eye*, Oxford, 1982: 78ff., and "The Experiment of Caricature," in *Art and Illusion: A Study in the Psychology of Pictorial Representation*, Princeton, 1960: 331ff.

25. Chesneau, *Paris-Journal*, 1874, mentions *Aux courses en province (At the Racecourse);* in 1879, Silvestre cites the *Champ de courses* in *La Vie moderne*.

26. See Degas's sonnet "Pur Sang," describing a thoroughbred "tout nerveusement nu, dans sa robe de soie": Lemoisne, *Degas et son oeuvre*, vol. 1: 207; and Nepveu-Degas, *Huit Sonnets d'Edgar Degas:* 25.

27. See A. Gibert and P. de Massis, *Historique du Jockey Club français depuis sa fondation jusqu'en 1871 inclusivement*, Paris, 1893: 29ff.; Gontrand de Poncans, *De Temps de Papa*, Paris, 1905; Joseph-Antoine Roy, *Histoire du Jockey Club de Paris*, Paris, 1958; Gilles de Chandenay, *Physiologie du Jockey-Club*, Paris, 1958: these accounts of the notorious Jockey Club stress the connection of the racing world and the aristocratic horse set to the Opera, where the Jockey Club had its "loge infernale," its members making up a good portion of the *abonnés* at the Opera and of the men who had *coulisses* privileges.

28. *The Orchestra* is a group portrait of Degas's musician friends: Désiré Dihau as the bassoonist; Gouffé, the bassplayer; Pillet, the cellist; Gard, set designer for the Opera: the white-haired player glimpsed next to Pillet; Lancien as first violinist; Pagans seated next to the harp, etc. See Boggs, *Portraits by Degas:* 29ff.

29. See Clayson, *Representations of Prostitution in Early Third Republic France:* 187–89. Clayson reads Rivière's words "et pas seulement ça" as "a vernacular short-hand complaint about a client's niggardly payment" (p. 189), and identifies the *Women in Front of*

the *Café during the Evening* as prostitutes. Certainly another critic read them as such. "Ces créatures fardées, flétries, suant le vice, qui se racontent avec cynisme les faits et les gestes du jour"—Aléxandre Pothey, "Beaux Arts," *Le Petit Parisien,* 7 April 1877. I find it harder to read such a precise meaning into "and not only that."

30. See Eugenia Janis, "The Role of the Monotype in the Working Method of Degas," *Burlington Magazine,* vol. 109, pt. 1: January 1967: 20–27, and February 1967: 71–81; Janis, *Degas Monotypes, Essay, Catalogue and Checklist,* catalogue entry 1; and Jean Adhémar and Françoise Cachin, *Degas: The Complete Etchings, Lithographs and Monotypes,* London, 1974: 75–90.

31. Janis describes Degas's engagement in the monotype medium in terms of chiaroscuro (as a version of the tradition of chiaroscuro underpainting), but does not really address the issue of Degas's peculiar transformation of chiaroscuro as it is traditionally defined. Janis, "The Role of the Monotype": 22–27.

32. The later references to Daumier's influence on Degas's imagery should be seen as belonging to Daumier's critical renaissance after 1878: Duranty, for one, celebrated Daumier's work and its devotion to the depiction of "la physiognomie humaine" in his review "Daumier," *Gazette des beaux-arts,* 1878. See Michel Melot, "Daumier devant l'histoire de l'art: Jugement esthétique/jugement politique," *Histoire et critique des arts,* Paris, 1980: 159ff., on Daumier's critical reputation. Melot traces the aestheticization (and depoliticization) of Daumier's work. He sees the exhibition of Daumier's works at Durand-Ruel's in 1878 (one year before the death of Daumier) as a turning point in Daumier's reception. Even the medium of caricature itself seemed to be neutralized, by being subsumed into the category of art. There is a curious relationship between the following aestheticization of Daumier's work and the baffled reactions to Degas's technical qualities: "il n'en devra rien à la caricature, genre bâtard et conventionnel . . . s'il est grand, c'est pour la qualité extrinsèque de son dessin, par son don de coloriste, par sa force d'observation, par tout ce qui fait qu'un peintre est grand"—Emile Bergerat, in *Le Journal officiel,* 26 April 1878: 1 (cited by Melot, op. cit.: 166). Where Daumier became disassociated from caricature, Degas became reassociated with it, ambivalently—but the same language of technique is used.

33. Wechsler shows how deeply connected were the "Physiologies" of the earlier part of the century to a sense of the spaces of the modern city of Paris, and the ability to uncover and read them. She implies, however, that with Haussmannization the connection between physiognomics and urban space was severed—owing to the extreme controlling and artificing of urban space undertaken at that time (*A Human Comedy:* 39). On the contrary, I think, Haussmannization may be looked at as an extension of the physiognomic claims of the earlier period, one which was predicated on an increase both in apparent illegibility and in control which resulted in an increased desire to read the city itself, and its marginal spaces. Sennett, in *The Fall of Public Man:* 161ff., traces this dialectic of legibility and illegibility from Balzac through Darwin, in terms of public and private life, street clothing and underclothing, describing an intensification in the desire to hide from view which he ties closely to the growth and urbanization of cities like Paris and London. See Clark, *The Painting of Modern Life:* 205–39. See also Herbert, *Impressionism:* 1–32.

34. Reff points to the "illustrations" in pencil that Degas did of Edmond de Goncourt's *La Fille Elise,* 1876, and relates the brothel monotypes to Huysmans's *Marthe, histoire d'une fille,* 1876,—and more generally to the works of the Goncourts, Zola, and de Maupassant—*Degas: The Artist's Mind:* 172ff. Dunlop links them, accurately I think, to Baudelaire's writing about prostitutes in *The Painter of Modern Life*—*Degas:* 146. The brothel monotypes were used to illustrate the 1935 (Vollard) edition of de Maupassant's *La Maison Tellier,* 1880, but apart from the presence of the madam, they seem to bear little resemblance to de Maupassant's story about provincial prostitutes.

35. Hollis Clayson, in "Avant-Garde and *Pompier* Images of Nineteenth-Century

French Prostitution: The Matter of Modernism, Modernity and Social Ideology," *Modernism and Modernity, The Vancouver Conference Papers*, Nova Scotia, 1981: 43ff., argues that the brothels depicted in Degas's monotypes are of a very special type, catering to a select upper-class clientele with specialized sexual tastes. The evidence given in support of this—taken from sources like Parent-Duchatelet's widely read and many times published *De la prostitution dans la ville de Paris* of 1836—centers on the costume, décor, gestures, and poses of the prostitutes. I would question this only because said indications within the monotypes are so crude, smudged, and elliptical, and because it seems to me just as likely that Degas is drawing upon the discourse on prostitution described by Clayson, *Representations of Prostitution* (similar to other physiognomic and literary discourses with which he was familiar) as he is on actual frequentation and inside knowledge of a specific type of brothel, and that hence he is eliding received notions about different classes of brothel together into a repertoire of generalized bordello imagery closely related to his more general repertoire of female types and poses. See also Charles R. Bernheimer, "Degas's Brothels: Voyeurism and Ideology," *Representations,* vol. 20, Fall 1987: 158–86, for a more overtly Freudian reading of the monotypes than I myself have chosen to give them. See as well his *Figures of Ill Repute: Representing Prostitution in Nineteenth-Century France,* Cambridge, Mass., 1989.

36. One of these was apparently shown in the 1881 impressionist show: *In the Salon of a Brothel* (see *The New Painting:* 363).

37. See Alain Corbin, "Commercial Sexuality in Nineteenth-Century France: A System of Images and Regulations," *Representations,* vol. 14, Spring 1986: 211–12: on putrid bodies, degeneration, and *ordure* as a function of the prostitutional literature.

38. See Greenberg, "Towards a Newer Laocoön," *Partisan Review:* 305: "The arts, then, have been hunted back to their mediums, and there have been isolated, concentrated and defined." This is part of a discussion of the advent of abstraction which locates the latter in a move away from literary, or nonpictorial, meaning, and toward music or pure sensation; toward the purity of the medium of painting itself, with purity characterized in terms of brushwork, line, and color, the flat plane and the "square shape of the canvas" (p. 307). See also his "Avant-Garde and Kitsch" (1939), "Abstract, Representational and so forth" (1954), and, especially, "On the Role of Nature in Abstract Art" (1949), all in *Art and Culture, Critical Essays,* Boston, 1961: 3–21, 133–38, 171–74: for his famous discussions of "art for art's sake," "the imitation of the processes of art" (p. 6), the denial of subject matter, and the assertion of the flat picture plane. The latter essay in particular is valuable for our purposes, because of its emphasis on the relationship between art and nature and on the "impressionist readjustment" (p. 172), and because of its stress on a continuous line traced from Courbet and Cézanne, and thence to the cubists (and Kandinsky). In "The Later Monet," in *Art and Culture* (p. 81), Greenberg mentions Degas as one of the *un*orthodox impressionists who he says came into favor when the "orthodox" ones like Monet fell out, in the face of criticisms of the "amorphousness" of their painting. This concern for the critical fate of the various movements in the modernist canon is shared by others—see Schapiro, "Nature of Abstract Art" (1937), in *Modern Art:* 185–211, for a similar discussion. One of the things that is interesting about these discussions, however, is that they make clear that at whatever point in the fluctuations of taste for modern art we find ourselves, it is still desirable to ascertain who is orthodox and who is not, and that the criteria for the modernist trajectory are fixed.

CHAPTER 4

1. Julius Meier-Graefe, *Degas* (trans. J. Hobroyd-Reece), New York, 1923. For Meier-Graefe's connection to the symbolist generation, as well as to the "primitivism" of this period, referring by and large to the French and European "primitives"—artists before

Raphael—see Meier-Graefe's *Modern Art: Being a Contribution to a New System of Aesthetics* (Florence Simmonds and George W. Chrystal, trans.), London, 1908. See also Richard Shiff, *Cézanne and the End of Impressionism: A Study of the Theory, Technique and Critical Evaluation of Modern Art,* Chicago, 1984: 155, 276, 278, on Meier-Graefe, Meier-Graefe's *Entwicklungsgeschichte,* and Roger Fry.

2. Alfred Paulet, "Les Impressionnistes," *Paris,* 5 June 1886.

3. Neither Fénéon nor Huysmans, nor any of the other critics, mentioned all of these— nor do their descriptions always match up. (Fénéon, for example, mentioned an outdoor bathers' scene that none of the others indicated, except George Moore: possibly this was either the much earlier *Women Combing Their Hair* (L.376), or the *Little Peasant Girls Bathing in the Sea* (L.377), both of approximately 1876—the latter was shown in the exhibitions of 1876 and 1877—or one of the outdoors *Bathers* series that Lemoisne dates to 1890–95 (L.1070–83): Fénéon, "Les Impressionnistes en 1886." It is more than possible that Degas, as usual, did not submit all the pictures he promised, so the exhibition catalogue may not necessarily correspond exactly to what was shown. I am operating partly on the basis of my interpretation of the critics' remarks and partly on the basis of Lemoisne's reconstruction of what was in the show—which is not by any means always on the mark. *The New Painting,* pp. 421–73, mentions the Farmington *Tub,* the *The Baker's Wife,* and, one I haven't mentioned, the Washington National Gallery's *Girl Drying Herself.*

4. Fénéon remarked on the fact that Degas's presence in the show was conditional on the presence of his coterie of painters: "Mais suivant ces us, c'est sous condition que M. Edgar Degas daigne exposer. Aussi, faut-il revoir la bande trop fidèle des comparses"—"Les Impressionnistes en 1886."

5. Degas probably began making sculpture in the 1870s. His first known work was the *Little Fourteen-Year-Old Dancer,* which he began making in 1878—but his most intensive sculpture-making periods seem to have been in the 1880s and after 1900: Charles W. Millard, *The Sculpture of Degas,* Princeton, 1976: 721. His sculptural interests correspond roughly to the narrowing of his pictorial interest and the inflation of picture size and figure scale in his oeuvre (beginning in the eighties), as well as to his increasing blindness. Degas's eye trouble began during the Franco-Prussian war—after that, he had various bouts with intense eye trouble, the most severe of which seem to have been around the time of his visit to New Orleans and his painting of the *Cotton Office* in 1873. He had another bout in the mid 1880s, and then increasing trouble throught the nineties, until he became all but blind during the last years of his life. His letters of those years are full of his obsession with his eyes and his eye trouble (along with his other attacks of illness and simple old age): See *Lettres de Degas,* no. 2 of 27 November 1872—to Fröhlich, p. 23; no. 39 of July 1882—to J. E. Blanche, p. 67; no. 54 of 21 August 1884—to Lerolle, p. 80; no. 91 of 1886—to Henri Rouart, p. 119; no. 124 of 24 August 1890—to Bartholomé, p. 155; nos. 158 and 159 of 1891—to Bartholomé, pp. 188–89; nos. 173, 174 of 1893—to de Valernes, pp. 194–95; no. 198 of 28 July 1896—to Alexis Rouart, p. 211; no. 224 of 8 January 1899—to Hortense Valpinçon, p. 228; no. 242 of 17 January 1907—to Jean Rouart, p. 240; and no. 245 of 21 August 1908—to Aléxis Rouart, p. 243. See also *Degas Letters,* no. 3 of 19 November 1872; no. 8 of 1873; no. 14 of 1874—to Tissot, pp. 18, 34, 41; no. 40A of 26 October 1880—to Henri Rouart, p. 63; no. 49 of 5 August 1882—to Bartholomé, p. 70; no. 78 of 1884—to Henri Rouart, p. 96; no. 209 of 11 August 1897— to Ludovic Halévy, p. 201; no. 231 of 1898—probably to Marquis de Guerrero (husband of Lucie de Gas), pp. 207–8. See also Richard Kendall, "Degas and the Contingency of Vision," *Burlington Magazine,* vol. 130, no. 1020, March 1988: 180–97; Roger Marx, *L'Image,* October 1897: 321–27; A. B. Louchbein, "Degas's Double Vision," *Art News,* March 1947: 26–29, 61–62; R. Trevor-Roper, *The World Through Blunted Sight,* London 1970: 32–34; George Heard Hamilton, "The Dying of the Light: The Late Work of Degas, Monet and Cézanne," in J. Rewald and F. Weitzenhoffer, eds., *Aspects of Monet,* New York, 1984: 218–41.

6. That voyeurism is the theme of these pictures is suggested by Degas himself in his linking of them to the story of Susannah and the Elders: "Il y a deux siècles que j'aurais peint des Suzanne au bain et je ne peins que des femmes au tub" (Fevre, *Mon Oncle Degas:* 52); and in the following statement, made to Moore: "C'est comme si vous regardiez à travers le trou de la serrure" (Moore, *Impressionis and Opinions:* 232; Lemoisne, *Degas et son oeuvre,* vol. 1: 118). See my "Edgar Degas and the Representation of the Female Body," in Susan Suleiman, ed., *The Female Body in Western Culture: Contemporary Perspectives,* Cambridge, 1985.

7. Degas had apparently shown a *modiste* in an earlier exhibition—in 1876, Emile Porcheron of *Le Soleil* referred to an "atelier des modistes," indicating as he did so the clandestine profession associated with the theme—this he did by ironic denial: "les modistes, qui sont évidemment trop laides pour ne pas être vertueuses."

8. Degas had also shown a few nudes in earlier shows: the *Little Peasant Girls Bathing in the Sea* in 1877, a *Toilette* in 1879, and the monotype *In the Salon of a Brothel* in 1881—see *The New Painting:* 176, 322, 363.

9. Fénéon, who had headed the *Revue indépendante* when it was a naturalist journal, also wrote for it after it changed direction (as did Huysmans). Fénéon served as well as the critic for *La Vogue,* another of the symbolist magazines—his article on the impressionists in 1886 appeared in this journal. His interest in the newcomers of 1886—the neo-impressionists—his elucidation of their color science, and his synthetist argument about them, are all well known. It is important, however, to remember that Fénéon's original orientation was naturalist—Elizabeth Puckett Martin, *Symbolist Criticism of Painting: France 1880–1895,* Bryn Mawr, 1952: 97.

10. J. M. Michel, "Exposition des impressionnistes," *La Petite Gazette de Paris,* 1886. In general, the critics tended to see the nudes as continuations of Degas's physiognomic concerns: "M. Degas a le don de l'observation, nul ne le conteste; il voit et rend à merveille; quand il a campé un bonhomme, on peut être assuré que *ça y est.* Ses baigneuses ne sont point pour diminuer la bonne opinion qu'on a de lui."—Anon., *La Petite République française,* 1886. This critic continues, however, by demanding to know of what interest the gestures of the nudes are to him or to anyone else. (The phenomenological emphasis of his evocation of the there-ness of Degas's figures is also striking.) In addition, most of the critics cited in *The New Painting,* pp. 452–54, emphasized the themes of realism, realist physiognomics, and the inversion of classicism: Maurice Hermel, "L'Exposition de peinture de la rue Laffitte," *La France libre,* 27 May 1886; Octave Mirbeau (whose themes are rather close to those of Huysmans), "Exposition de peinture (1, rue Laffitte," *La France,* 21 May 1886; Firmin Javel, "Les Impressionnistes," *L'Evènement,* 16 May 1886; Henri Fevre, "L'Exposition des impressionnistes," *La Revue de demain,* May–June 1886; Jules Christophe, *Le Journal des artistes,* 13 June 1886; Jean Ajalbert, "Le Salon des impressionnistes," *La Revue moderne,* 20 June 1886 (Marseille); and Paul Adam, "Peintres impressionnistes," *La Revue contemporaine, littéraire, politique et philosophe,* April 1886.

11. See Blanche, *De David à Degas:* 282–308. Degas probably met many of the writers and artists of the new generation at Blanche's "dimanches."

12. *Certains* was a collection of earlier articles taken from *La Revue indépendante, L'Evolution sociale,* and *La Cravâche,* as well as previously unpublished essays, of which the review of Degas's 1886 series of nudes was one. See Philippe Jolivet, "Certains de J.-K. Huysmans," *Orbris Litterarum,* vol. 22, nos. 1–4, 1967: 88ff.; and George A. Cevasco, "J.-K. Huysmans and the Impressionists," *Journal of Aesthetics and Art Criticism,* vol. 17, no. 2, December 1958: 201ff.

13. See: *Oeuvres complètes de J.-K. Huysmans,* vol. 2: *Marthe, Histoire d'une fille; Emile Zola et l'Assommoir* (2nd ed., 1928): "avant-propos," pp. 7–9; "Notes," pp. 141–48, 193–97. See also Robert Baldick, *The Life and Times of J. K. Huysmans,* Oxford, 1955: 35–38. Prior to *Marthe,* Huysmans had written *Le Drageoir aux épices,* which was published in Paris in 1874. This was not a novel, but a collection of short vignettes, which mixed critical essays

on Dutch and Flemish artists, such as Rubens, Adrien Brauwer, Jordaens, and Cornelius Bega, with descriptive pieces on Parisian quarters and ambiguous prose fragments very similar to Baudelaire's *Paris Spleen*. It was the *Drageoir aux épices* that led to Huysmans's involvement with Zola and his writing, but it was not until *Marthe, histoire d'une fille* was published by Jean Gay in Belgium—prior to Goncourt's *La Fille Elisa*—that Huysmans was actually introduced to Zola, through Henri Céard, and began to attend the Thursday evening soirees at Zola's house, with Paul Aléxis, Léon Hénnique, Guy de Maupassant, et al.

14. Huysmans's other naturalist novels and short stories included *Les Soeurs Vatard* (1879)—about two book-stitchers; *Sac au Dos* (1880)—about the Franco-Prussian war: *En ménage* (1881)—about a failed novelist; and *A vau l'eau* (1882)—about a small-time government *fonctionnaire;* as well as another collection of *Paris-Spleen*-like vignettes, the *Croquis parisiens* of 1880, whose short subjects were much more naturalist than those of the *Drageoir aux épices* had been (collections of modern-life scenes, métiers, types and urban quarters). Of these semi-autobiographical works (Huysmans, son of a Dutch engraver-lithographer and a Parisian schoolmistress and stepson of a bookbinder, supported himself by means of a minor career in the Sûreté Générale), *En ménage* and *A vau l'eau,* with their studies, as much psychological as objectively descriptive, of the depressed, unhappy lives and affairs of the antiheroes André Jayant and Jean Folantin, were the most Baudelairean. See Charles Maignon, *L'Univers artistique de J. K. Huysmans,* Paris, 1977: 1–22, for the influence of Baudelaire on Huysmans's *Drageoir aux épices,* and on his critical writing.

15. Huysmans began as a full-fledged critic in 1879, when he went to work for the newspaper, *Le Voltaire,* that was serializing Zola's *Nana.* He wrote the first installment of his Salon of 1879 review for this newspaper (17 May 1879), before being thrown out for being too controversial. After that, Huysmans worked for Arthur Meyer's conservative journal, *Le Gaulois,* for a while, and for the newspaper to which the naturalist group had switched its support, *La Réforme*—for which Huysmans wrote his next Salon review (1880). It was then that, somewhat after the manner of Duranty and *Réalisme,* Huysmans conceived the idea of a completely naturalist journal, to be called *La Comédie humaine*—which he was to head, and to which Zola and the Medan group, as well as Edmond de Goncourt and others, were to contribute. This project was never realized. Baldick, *The Life and Times of J. K. Huysmans:* 46–57, 70ff. As for his reviews of the impressionist shows, it would seem that they did not appear in print until 1883—in *L'Art moderne* (see Lethève, *Impressionnistes et symbolistes devant la presse:* 112; Baldick, *The Life and Times of J. K. Huysmans:* 52). Huysmans also wrote for the symbolist magazine *La Vogue,* though he was less attached to such forums of symbolist theory than others were. His publication history, for one thing, was a difficult one—like many of his reviews, his essay on Degas was not published until 1889, in the series of his own essays called *Certains,* rather than in an arts and literature review.

16. Huysmans also published his "L'Exposition des indépendants en 1881" in *L'Art moderne:* 225–27. In it, he wrote at length about Degas's *Little Fourteen-Year-Old Dancer,* about her "terrible réalité," just as critics like Ephrussi did—yet his discussion of the sculpture was novel, more like his later criticism in *Certains* in that it focused on the *medium* of sculpture and its history, relating the "realism" of Degas's dancers to that of the wood sculptures of the Flemish primitives.—*L'Art moderne:* 262ff.

17. Baudelaire is named explicitly four times in *Certains*—in Huysmans's article on Moreau (p. 21), where he is listed as one of the "beings of exception" so dear to Huysmans—and so contrary to the Tainean notion of the influence of the milieu; in his essay on Forain (p. 46), where Baudelaire's essay on Guys, the "painter of modern life," is cited as the precursor of his own writing on Forain; and twice is his discussion of Rops (pp. 111, 116), where Baudelaire, along with Barbéy d'Aurévilly, is credited with the first exploration of satanism and the occult.

18. Sâr Péladan, *Réfutation esthétique du Taine,* Paris, *Mercure de France,* 1906—cited in

Robert Pincus-Witten, *Occult Symbolism in France: Josephin Péladan and the Salons de la Rose-Croix* (University of Chicago Ph.D., 1968), New York, 1976: 55. Like Huysmans, Sâr Péladan had earlier been engaged in the very type of encyclopedic art historical writing that he would refute in his discussion of Taine—with this important difference: that he focused on the primitives, on pre-Renaissance schools of painting: Sâr Péladan, *Introduction a l'histoire des peintres de toutes les écoles, depuis les origines jusqu'à la Renaissance,* Paris, 1884. The following are the ingredients (very similar to those of *Certains*) of Péladan's *Réfutation esthétique de Taine:* Taine's theory is held responsible for the modern school of painting as represented by Manet and Caillebotte (the impressionists are ignored—p. 8); great art is the production of exceptional individuals and not of their milieus—it reflects their personalities, not their social contexts, and it is most often in opposition to the tenor of the times in which it was made (as, for example, the "sweet, pure, mystical" art of Giotto and Benozzo Gozzoli, held to be the reverse of the murderous age in which they lived—there is, according to Péladan, no art to correspond to the works of Burckhardt and Machiavelli—pp. 21–22); the great artist is a dissident, and in times of decadence, a retrograde (p. 42); the "libre-penseurs" (Duranty's group), Quinet, Zola, and Charles Blanc are all refuted, as well as Taine (pp. 70–71, 88–89, 95); in contrast to Taine's theory, visual art is held to be anti-textual, indeed to be preliterary—to come *before* literature (p. 37); the primitives are resurrected in place of the Renaissance and the Dutch seventeenth century (pp. 18, 23, 52, 95–96); indeed, "primitivism" is the basis of the best art—Péladan's argument is explicitly anti-evolutionary (p. 96); finally, eros (decoration for the purposes of erotic attraction), not history, is the basis for art—here Péladan arrives at a universalizing, formalist account of art, citing the female nude as the prime example of his notion of *volupté* as the foundation of all art (pp. 10–11, 34–37).

Huysmans's ideas were important to Sâr Péladan—notably the praise of the authors of the Roman decadence in *A Rebours* (1884), Paris, 1978: 84ff., which Péladan took up in his series on *La Décadence latine* in 1886—and Huysmans's discussion of Moreau in *Certains* (pp. 17ff.), which Péladan also took up in the *Réfutation esthétique du Taine.* The current of influence flowed the other way as well. Péladan's *Le Vice suprême* of 1886—with its preface by Barbéy d'Aurévilly, its citing of Baudelaire's writing on Guys, and its frontispiece by Rops—and his "Les Maîtres contemporains, Félicien Rops, première étude," in *La Jeune Belgique,* Brussels, 1885 (reprinted in *La Plume,* June 1896), were both echoed in Huysmans's discussion of Rops in *Certains* (pp. 77ff.).

As for the discussion of Taine, it is clear that by the 1880s Taine began to be equated with Zola, Zola's method, and naturalism, and to stand for the positivist thinking again which all the symbolists were arguing: his theories were addressed and refuted by Bourget, Brunetière, Henne, as well as by Laforgue, Aurier, Bergson, Wyzewa, and Barrès. See Martin, *Symbolist Criticism of Painting:* 8, 66, 80–81, 150–51; Leo Weinstein, *Hippolyte Taine,* New York, 1972: 147; Victor Giraud, *Taine,* Paris, 1902. See also Shiff, *Cézanne and the End of Impressionism:* 39–49, on Taine and the symbolists.

19. That *A Rebours* was Huysmans's turning-point novel needs no proving—Huysmans himself stated it in his later preface (of 1903) to the book. In spite of the fact that it was originally conceived of as a continuation of *A vau l'eau* and that Des Esseintes was simply another variation on the depressed, in-retreat figure of Folantin, Huysmans said: "Ce qui est, en tout cas, certain, c'est qu'*A Rebours* rompait avec les précédents, avec *Les Soeurs Vatard, En menage, A vau l'eau,* c'est qu'il m'engageait dans une voie dont je ne soupçonnais même pas l'issue"—"Preface écrite vingt ans après le roman," in *A Rebours:* 55. See Baldick, *The Life and Times of J. K. Huysmans:* 78–91; Fernande Zayed, *Huysmans, peintre de son époque,* Paris, 1973: 383–420.

20. In his preface of 1903 (p. 55), Huysmans himself records Zola's dissatisfaction with *A Rebours,* and his own break with Zola's brand of naturalism. Significantly, he now cites Flaubert's *L'Education sentimentale* as the proper bible of the "naturalism" that he favored: one devoted to the psychology and interior life of its creatures. Moreover, Huysmans's

later preface to *A Rebours* is quite explicitly a refutation of his earlier article on Zola and *L'Assommoir*.

21. In *Là-Bas*, Huysmans's first extended exploration of satanism in a novel, the author opens with a conversation between the two main characters, Des Hermiès and Durtal, about the failings of naturalism and positivism, in which Zola and *L'Assommoir* are explicitly and severely addressed. It is clear throughout the rest of the novel that the negation of naturalism is the necessary premise for its exploration of the occult—J. K. Huysmans, *Là-Bas*, Paris, 1891: 16.

22. Huysmans's *A Rebours* is frequently credited as the starting point of symbolism. Martin, for one, stresses his importance to the symbolist movement (*Symbolist Criticism of Painting:* 29ff.), as does Philippe Jullian, *Dreamers of Decadence: Symbolist Painters of the 1890s*, London, 1971: 28ff.; Edward Lucie-Smith, *Symbolist Art*, London, 1972: 51ff.; and Robert Goldwater, *Symbolism*, New York, 1979: 113–15.

23. See Emilien Carassus, *Le Snobisme et les lettres françaises de Paul Bourget à Marcel Proust 1884–1914*, Paris, 1966: 49ff.; Arno J. Meyer, *The Persistence of the Old Regime: Europe to the Great War*, New York, 1981: 10–29. Huysmans is famous for his conversion to Catholicism at the urging of Abbé Mugnier in May of 1891: see Baldick, *The Life and Times of J. K. Huysmans:* 137–53, 184.

24. The increasingly diverse essays of the latter part of *Certains* include: "Des prix," suggesting a new museum of contemporary art across from the Luxembourg, one which would reunite the works of the artists touched on by Huysmans—Moreau, Degas, Whistler, Forain, Cézanne, Rafaelli, Redon, Rops, to mention a few (pp. 12–16); "Jan Luyken" (pp. 126–33); "Le Monstre," an essay on monstrosity and deformity in art (pp. 138–54); "La Musée des Arts décoratifs et l'Architecture cuite" (pp. 157–65); "Le Fer" (pp. 169–81)—in which Huysmans derides the Eiffel Tower and the new iron architecture of the engineers; "Millet" (pp. 185–96); "Goya et Turner" (pp. 199–215); "La Salle des Etats au Louvre," on Delacroix and Ingres (pp. 205–15); and "Bianchi" (pp. 219–228).

25. In the article entitled "La Musée des Arts décoratifs et l'Architecture cuite," devoted to the disparagement of the eclectic architecture of the Second Empire and the Third Empire, Huysmans recommends that the ruins of the Louvre (the Conseil d'Etat and the Cour des Comptes) left over from the Commune as a great, Piranesi-esque structure be left as it was, and then advises the burning of the Bourse, the Madeleine, the Opera, and so on—in order to scatter similar ruins through the rest of Paris. According to Huysmans, in the last paragraph of that essay, it was only by the violence of fire and destruction that true artistry was to be achieved in the nineteenth century—Ibid.: 165.

26. See Baldick, *The Life and Times of J. K. Huysmans:* 123–24; Maignon, *L'Univers artistique de J. K. Huysmans:* 123–79; and Kurt Martin, *Grünewalds Kreuzigungsbilder in der Beschreibung von Joris-Karl Huysmans*, Mainz, 1966. (Grünewald had been mentioned first by Burckhardt in 1847, and then once more by another writer, Woltmann, in 1872, but Huysmans was the first to write a full, appreciative account of his painting—see Martin, *Symbolist Criticism of Painting*, p. 25, who claims, unlike Baldick, that Huysmans did not see Grünewald's work until 1894.) Huysmans's other discussions of the primitives are scattered througout his novels, most prominently in *Là-Bas*, as well as in *La Cathédrale* and *De tout*, Paris, 1901, his article on Leonardo's contemporary Bianchi, in *Certains*, pp. 219ff., and his preface to the Abbé Broussolle's *La Jeunesse du Pérugin et les origines de l'école ombrienne*, Paris, 1900: i–viii; *Trois Primitifs*, 1903; *Trois Eglises et trois primitifs*, 1908.

27. The primitives were the subject of numerous writings and exhibitions in the first few years of the twentieth century. Some of these were: Henri Bouchot, *Exposition des primitifs français au palais du Louvre et à la Bibliothèque Nationale*, Paris, 1904; Louis Dimier, *Les Primitifs français*, Paris, 1911; E. Durand-Gréville, *L'Exposition des primitifs flamands à Bruges*, Paris, 1902; Paul Durrieu, *La peinture à l'exposition des primitifs français*, Paris, 1904; Henri Hymans, *L'Exposition des primitifs flamands à Bruges*, Paris, 1902; Georges

Lafenestre, *L'Exposition des primitifs français,* Paris, 1904; Georges Lafenestre, *Les Primitifs à Bruges et à Paris,* Paris, 1904; P. A. Lemoisne, *Notes sur l'exposition des primitifs français,* Paris, 1905; F. de Mély, *Primitifs français et Renaissance italienne,* Paris, 1905. Other "symbolists" besides Huysmans who began writing about Grünewald and the northern primitives included the Belgians Emile Verhaeren, "Le Peintre Mathias Grünewald d'Aschaffenburg," *La Société nouvelle, Revue internationale:* 2, 10e année, December 1894 (Brussels): 661–79; and "La Peinture flamande," *La Revue encyclopédique,* 1897; and Maeterlinck, "Le Mysticisme flamand," *La Revue encyclopédique,* 1897. Péladan, for one, had written about the primitives earlier, in 1884—in *Introduction a l'histoire des peintres de toutes les écoles.* See André Waltz, *Bibliographie des ouvrages et articles concernant Martin Schongauer, Mathias Grünewald et les peintres de l'ancienne école allemande à Colmar,* Colmar, 1903, compiled a year before Huysmans's *Trois Primitifs,* for a complete history of the writing on Grünewald prior to Huysmans—most of which credits Grünewald's paintings to Schongauer. Verhaeren credits Huysmans with the turn of attention to Grünewald ("Le Peintre Mathias Grünewald d'Aschaffenburg": 663). Verhaeren's account of the *Crucifixion,* based in his case on an 1886 trip to Germany, is striking for its stress on the exceptional character of the work (p. 663) and on the recessive personality of the artist, "Nous voici donc face à face avec un artiste silencieux et humble, qui travaille avec génie, dans son coin, sans que la gloire s'en emut" (p. 665); and for its positivist, physiognomic tone—Grünewald's work, according to Verhaeren, reflected its time and its society, was an expression of Germannes (p. 667), and was a popular art like that of Rembrandt and the Dutch (pp. 67–79).That Degas knew the writer of these articles is evident from his photograph of Verhaeren in the George Eastman House collection, reproduced in Eugenia Parry Janis, "Edgar Degas's Photographic Theater," in Guillaud, *Degas, Form and Space:* 480.

28. That Des Esseintes is first and foremost an *amateur* of all manner of artifice and aesthetic sensation, and that that is largely what *A Rebours* is about, is obvious right from the beginning of the book, which opens with Des Esseintes's descriptions of the interior decoration of his house at Fontenay—descriptions full of sensory "correspondances" and remarks about "spleen" and Baudelaire, whose critical sensibility Des Esseintes obviously takes as his model.

29. The phrase "la promiscuité dans l'admiration" derives directly from *A Rebours.* See Huysmans, *A Rebours:* 143—"Cette promiscuité dans l'admiration était d'ailleurs l'un des plus grands chagrins de sa [Des Esseintes's] vie."

30. Huysmans, *Certains,* p. 13: "Heureusement que ce profitable état de dilettante a un revers; fatalement, dans ces excès de pusillanimité, dans ces débauches de prudence, la langue se débilite, coule, revient au style morne et plombé des Instituts, se liquéfie dans la verbe humide de M. Renan; car l'on n'a pas de talent si l'on n'aime pas avec passion ou si l'on ne hait de même; l'enthousiasme et le mépris sont indispensables pour créer une oeuvre; le talent est aux sincères et aux rageurs, non aux indifférents et aux lâches."

31. The view of Degas as a misogynist (or the argument against that view) is almost always based on Huysmans's treatment of the nudes. See Halévy, *Degas parle:* 16; Lafond, *Degas,* vol. 2: pp. 51–57 (who mentions Huysmans, Fénéon, and Moore); Jamot, *Degas:* 103–7; and Lemoisne, *Degas et son oeuvre,* vol. 1: 118–21 (he mentions Moore, and implicitly argues against Huysmans). Eugénie de Keyser, *Degas: Réalité et métaphore,* Louvain-la-Neuve, 1981: 69–82 ("La chambre close"), doesn't mention Huysmans; nevertheless, she seconds his view of the nudes as erotically indifferent, chaste images of the "object du désir" (p. 82). See also Lipton, *Looking into Degas:* 182–86; Thomson, *Degas: The Nudes:* 162; and Edward Snow, "Painterly Inhibitions," in *A Study of Vermeer,* Berkeley, 1979: 25, 147–48.

32. For accounts of the nudes which, though they use some similar material, make claims that are rather different from mine, see Martha Ward, "The Rhetoric of Independence and Innovation," *The New Painting:* 421–42; Lipton, *Looking into Degas:* 151–86; Thomson, *Degas: The Nudes;* and Snow, "Painterly Inhibitions": 25–34.

33. Maurice Merleau-Ponty, *La Phénoménologie de la perception,* Paris (Gallimard): 1945.

34. The criminologist Lombroso, for one, defined asymmetry and disequilibrium as the central characteristics, not only of the criminal physiognomy, but also of the criminal's—particularly the *female* criminal's—abnormal "champ visuel": Lombroso, *L'Homme criminel:* 254; Lombroso, *La femme criminelle et la prostituée:* 380ff. See also J. M. Charcot and Paul Richer, *Les Difformes et les malades dans l'art,* Paris, 1889; Paul Richer, *Etudes cliniques sur la grande hystérie ou hystéro-épilepsie,* Paris, 1885; *Les démoniaques dans l'art,* Paris, 1887 (also Paul Richer, *Physiologie artistique de l'homme en mouvement,* Paris, 1895, for an account of the "normal" body); and Georges Didi-Huberman, *Invention de l'hystérie: Charcot et l'iconographie photographique de la Salpétrière,* Paris, 1982.

35. The passage from *Là-Bas* cited earlier is rewritten by Huysmans himself in his book on Grünewald and other primitives (such as Botticelli, the Master of Flémalle, Rogier van der Weyden, etc.): *Trois Primitifs,* pp. 10–12. It is remarkable, not only for its description of the coloration of putrid flesh, but also for its attention to the twisted pose of the body and its reading of Grünewald's Christ in terms of the physiognomics of aberration, in this case of illness (tetanus) and death: "Au dessus de ce cadavre en éruption, la tête apparaissait, tous les traits renversés pleuraient, tandis que la bouche descellée, riait avec sa mâchoire contractée par des secousses tétaniques, atroces."—Huysmans, *Là-Bas:* 11. See J. M. Charcot, *Les Syphilitiques dans l'art (Nouvelle iconographie de la Salpétrière, clinique des maladies du système nerveux),* Paris, 1888, t. 1: 257–60; and Dr. P. Richer, *L'art et la médicine,* Paris, 1901: 307–11, 496–97, for references to the Colmar and Cassel works. Verhaeren's writing on Grünewald (which includes a citation of the passage by Huysmans quoted above) also treats the artist's work in terms of the physiognomics of aberration and illness, as the expression of extreme states of mind and body—"Le Peintre Mathias Grünewald d'Aschaffenburg," especially pp. 669, 674. See Roger L. Williams, *The Horror of Life,* Chicago, 1980, in particular pp. 47–51, 107–9 (on syphilis), and 195ff. (on hysteria), for a history of the fascination with disease of various kinds in nineteenth-century literature. See also Corbin, "Commercial Sexuality in Nineteenth-Century France": 212.

36. See Mikhail Bakhtin, "The Grotesque Image of the Body and Its Sources," in *Rabelais and His World* (Hélène Iswolsky, trans.), Bloomington, 1984: pp. 303ff. The category of the "grotesque" applies rather neatly to Degas's imagery of the nude, most obviously to his monotypes, but also to the 1886 series of pastels—by no means a popular imagery of the body, as Bakhtin defines the "grotesque," Degas's is nevertheless an imagery which upends bodily canons.

37. See Gustave Kahn, *Félicien Rops et son oeuvre,* Paris, 1906; Camille Lemonnier, *Félicien Rops, l'homme et l'artiste,* Paris, 1908; Jean Paul Dubray, *Félicien Rops,* Paris, 1928; Maurice Exteens, *L'Oeuvre gravé et lithographié de Félicien Rops,* Paris, 1928; Jean-Pierre Babût de Marès, *Felicien Rops,* Ostende, 1971; Musée des Arts Décoratifs, *Félicien Rops,* Paris, 1985; J. F. Bory, *Félicien Rops, L'oeuvre graphique complète,* Paris, 1977. Rops, a Belgian printmaker, began as Huysmans did, with an engagement in realism and realist satire, and by illustrating the scenes and people, particularly the women, of modern life. His satanism, which attracted Huysmans, was allied to an engagement in explicitly pornographic illustration for the publisher of erotica Poulet-Malassis, and for others as well: *Album du diable; L'Art priapique; Les Bas-fonds de la société; Les Cythères parisiennes; Pornocrates (la dame au cochon); La Prostitution et la folie dominant le monde; La Pudeur de Sodome; Sataniques; Tentation de St. Antoine; La Vengeance d'une femme;* etc. Particularly for works like *L'Attrapàde* and *Le Gandin ivre,* he drew from popular and avant-garde modern-life scenes.

38. Besides *A Rebours,* this literary tradition includes Honoré Balzac, *Le Chef d'oeuvre inconnu* (1831); Edmond and Jules de Goncourt, *Manette Salomon* (1867); and Emile Zola, *L'Oeuvre* (1886).

39. For an account of Huysmans's written misogyny, see Charles Bernheimer, "Huysmans: Writing Against (Female) Nature," in Suleiman, *The Female Body in Western Culture:* 373–86.

40. Fetishism is defined by the worship of an "idol"—an object whose value is derived from its status as a sign for something outside, beyond, and different from itself, something which it *isn't:* that is, its value is representational, not literal. This holds true for religious, commodity, and sexual fetishes as well as for illusionistic paintings. For discussions of the sexual fetish, see Sigmund Freud, "Fetishism," in *Collected Papers* (1927) (James Strachey, ed.), New York, 1959, vol. 5: 198–204. As applied to imagery, see Christian Metz, "Photography and Fetish," *October,* Fall 1985: 81–90; and Laura Mulvey, "Visual Pleasure and Narrative Cinema," *Screen,* vol. 6, no. 3, Autumn 1975. And for the commodity fetish, see Karl Marx, "Commodities and Money: The Fetishism of Commodities and the Secret Thereof," *Capital,* in Robert C. Tucker, *The Marx-Engels Reader,* New York, 1978: 319–21.

41. See Zola, "Une Nouvelle Manière en peinture," 1867, in *Salons:* 91—"Toute la personnalité de l'artiste consiste dans la manière dont son oeil est organisé: il voit blond, et il voit par masses." (In his "Mon Salon" of 1866, Zola also described the Salon as a huge stew and as a kitchen with too many overcooked dishes, art as a human "secretion," Manet as a painter who offers good, healthy, raw meat in his kitchen, rather than sickening sweets—pp. 49, 62; and in "Une Nouvelle Manière en peinture" of the next year, he also spoke of Manet as a painter who painted with his flesh and blood in order to produce flesh-and-blood human creations—pp. 83, 88. Zola's well-known physiological account of the world extends to painting, to the body as well as to the eye of the artist [and the viewer]; I can't help thinking that Huysmans's against-the-grain physiology is specifically against the grain of Zola's physiological positivism as well.)

42. I am indebted to Jacqueline Lichtenstein for her observations, during a seminar which we taught together in 1988, about Huysmans's coloristic vocabulary in *Certains* and *A Rebours*—this is material, to which I have by no means given full justice, which she is presently preparing.

43. On this subject, see Jacqueline Lichtenstein, *La Couleur eloquent: Rhetoric et peinture á l'age classique,* Paris, 1989. Examples of the equation of color, amorphousness, and femininity abound in nineteenth-century novels on art and artists, as in Balzac's *Le Chef d'oeuvre inconnu* (in *Le Chef d'oeuvre inconnu/Massimilla Doni,* Paris, 1981: 67–69), in which the seventeenth-century painter Frenhofer's canvas, when submitted to the gaze of others, is discovered to have no woman on it at all (though Frenhofer believes she is there in the flesh), but only an apocalyptic conflagration of colored pigment from which only a bodily fragment, a foot fetish, emerges. Much the same happens to the coloristic painter Claude in Zola's *L'Oeuvre.* In all cases, these evocations of color as feminine amorphousness find a modern corollary in Luce Irigaray's defense of the *informe* as a feminine principle to be set within and against fetishistic, phallocentric discourse: Luce Irigaray, *This Sex Which Is Not One* (Catherine Porter, trans.), Ithaca, 1985.

44. See Janis, *Degas: A Critical Study of the Monotypes:* xxvi–xxvii, figs. 69ff. Also Fevre, *Mon Oncle Degas,* p. 102, cites a letter from Degas of December 1892: "J'ai fait chez Durand-Ruel une petite exposition de vingt-six paysages imaginaires qui m'a été plutôt favorables." See also H. G. Lay, "Degas in 1872: The Landscape Monotypes at Durand-Ruel," *The Print-Collector's Newsletter,* vol. 14, no. 5, November–December 1978: 142–47; and Kendall, "Degas and the Contingency of Vision."

45. See Michel Butor, "Monet, or the World Turned Upside-Down," *The Avant-Garde, Art News Annual,* vol. 34 (T. B. Hess and John Ashbery, eds.), 1968: 20–33; Steven Z. Levine, "Monet's Series: Repetition, Obsession," *October,* vol. 37, Summer 1986: 65–75, and "Seascapes of the Sublime: Vernet, Monet and the Oceanic Feeling," *New Literary History,* no. 16, Winter 1985: 377–400, as well as "Monet, Fantasy and Freud," *Psychoanalytic Perspectives on Art,* vol. 1, 1985: 29–35, "Monet, Lumière and Cinematic Time," *Journal of Aesthetics and Art Criticism,* 1978.

46. See Werner, *Degas Pastels,* p. 62, on the reactions of Pissarro, Paul Valéry, and others to Degas's exhibition of 1892–93, and their sense that the landscape monotypes

were indeed deflating, oneupsmanship parodies of Monet's work, as well as of post-impressionist imagery and of landscape painting in general.

CHAPTER 5

1. See, for example, Fernande Olivier, *Picasso and His Friends,* London, 1964; Pierre Cabanne, *Pablo Picasso, His Life and Times* (Harold J. Salemson, trans.), New York, 1977; Mary M. Gedo, *Picasso, Art as Autobiography,* Chicago, 1980; Arianna Stassinopoulos-Huffington, *Picasso, Creator and Destroyer,* New York, 1988; Eunice Lipton, *Picasso Criticism 1901–1939: The Making of an Artist-Hero,* New York, 1976; Roland Penrose, *Picasso: His Life and Work,* Berkeley, 1981; Patrick O'Brian, *Pablo Ruiz Picasso: A Biography,* New York, 1976; etc. The focus on biography in the case of Picasso has been properly criticized in Rosalind Krauss, "In the Name of Picasso," *The Originality of the Avant-Garde and Other Modernist Myths,* Cambridge, Mass., 1985: 23–40.

2. Benedict Nicholson, "Degas as a Human Being," *Burlington Magazine,* vol. 105, pt. 1, June 1963.

3. See Linda Nochlin, "Degas and the Dreyfus Affair: Portrait of the Artist as an Anti-Semite," in *The Dreyfus Affair: Art, Truth and Justice,* Jewish Museum, 1987, for a discussion of the artist's antisemitism. I have not addressed this because, while it is just as complicated a story as Degas's misogyny (it is true that Degas was vituperatively anti-Jewish, especially during and after the Dreyfus affair, but it is also true that some of his closest friends were Jews), it has even less to do with his imagery—with the possible exception of the *Stock-Exchange* (and the images related to it), whose dark, slovenly depiction of moneylenders might certainly be inflected with antisemitic racism.

4. See, for example, Kendall, *Degas by Himself;* Lemoisne, *Degas et son oeuvre,* vol. 1: 141–57; McMullen, *Degas, His Life, His Times, His Work:* 30–47, 151–69, 381–420, etc.; Jean-Marie Lhote, *Les Mots de Degas,* Paris, 1967.

5. Of Corsican and Italian extraction, Valéry was born in the Mediterranean town of Sète, educated in Montpellier, and destined for a law career. The resemblance to Degas does not end there: though happily married—to Berthe Morisot's niece, Jeannie Gobillard—Valéry's *éducation sentimentale* was troubled, marked by obscure traumas, infatuations, and affairs. See Charles G. Whiting, *Paul Valéry,* London, 1978: 3, 11; Agnes E. Mackay, *The Universal Self: A Study of Paul Valéry,* Toronto, 1961: 245; Raoul Pelmont, *Paul Valéry et les beaux-arts,* Cambridge, 1949: 10ff., 30.

6. See A. James Arnold, *Paul Valéry and His Critics: A Bibliography of French Language Criticism 1890–1927,* Charlottesville, 1972: 20, 49; Paul Souchon, "Critique des poètes, M. Paul Valéry," *Le Geste,* 12 and 19 December 1897; Daniel Halévy, "De Mallarmé à Paul Valéry," *La Revue universelle,* 1 May 1920. See also André Fontainas, *De Stéphane Mallarmé à Paul Valéry, notes d'un témoin 1904–1922,* Paris, 1928; Valéry's own *Ecrits divers sur Mallarmé,* Paris, 1949; André Gide, *Paul Valéry,* Paris, 1947; Valéry's *Le Souvenir de J. K. Huysmans,* Paris, 1927; Greenberg, "Towards a Newer Laocoön": 307; and "Avant-Garde and Kitsch," *Art and Culture:* 7. See also Jorge Luis Borges, "Valéry as Symbol," *Labyrinths,* New York, 1964: 198; T. S. Eliot, "Introduction," *The Art of Poetry VII: Collected Works of Paul Valéry,* New York, 1958: vii–xxiv.

7. See Georges Karaiskakis and François Chapon, *Bibliographie des oeuvres de Paul Valéry publiées de 1889 à 1965,* Paris, 1976; and Jeannine Parisies-Plottel, *Les Dialogues de Paul Valéry,* Paris, 1960. Eventually he was elected to that austere, conservative institution of French literary classicism, the Académie Française—see his own *Discours de réception à l'Académie Française,* Paris, 1927. In 1937, a year after writing *Degas Danse Dessin,* Valéry was elected to the Chair of Poetics at the Collège de France.

8. See Jacques Derrida, "qual quelle, les sources de Valéry," *Marges de la philosophie,* Paris, 1972: 325–63; Paul Bucher, *La Situation de Paul Valéry. Critique,* Paris, 1976; and

Genette, *Figures: Essais,* Paris, 1966: 264—"Les recherches modernes sur les figures de transformation à l'oeuvre dans le mythe, le conte populaire, les formes générales du récit, sont évidemment dans le droit fil du programme Valéryen. Cette grande histoire anonyme de la Litterature . . . ," and *Figures II: essais,* Paris, 1969: 13.

9. Paul Valéry, *Degas Danse Dessin* (1936), Paris, 1949.

10. Paul Valéry, *M. Teste* (1926), Paris, 1927.

11. Paul Valéry, *Introduction à la méthode de Léonard de Vinci,* 1894, Paris, 1957.

12. This is a term used by Jean Bucher, *La Situation de Paul Valéry. Critique,* Paris, 1976: 38ff., and by Whiting, *Paul Valéry:* 11, referring to a phrase in Valéry's *Note et digression* of 1919.

13. Stéphane Mallarmé, "Crayonné au théâtre," *Igitur/Divagations/Un coup de dés,* Paris (Gallimard), 1976.

14. See Roland Barthes, "The Death of the Author," *Image/Music/Text* (Stephen Heath, trans.), New York, 1977, pp. 142–48: "Valéry, encumbered by a psychology of the Ego, considerably diluted Mallarmé's theory but, his taste for classicism leading him to turn to the lessons of rhetoric, he never stopped calling into question and deriding the Author; he stressed the linguistic nature of his activity, and throughout his prose he militated in favour of the essentially verbal condition of literature, in the face of which all recourse to the writer's interiority seemed to him pure superstition" (pp. 143–44). See also Michel Foucault, "What Is an Author," in *Language, Counter-Memory, Practice: Selected Essays and Interviews* (Donald F. Bouchard, ed., and Sherry Simon, trans.), Ithaca, 1977: 113–38.

15. This denial has, however, been the basis of extended and repeated attempts to psychoanalyze Valéry's psyche and oeuvre. See particularly Charles Mauron, *Des Métaphores obsédantes au mythe personnel: Introduction à la psychocritique,* Paris, 1960. See also Bucher, *La Situation de Paul Valéry:* pp. 38ff.; Derrida, "qual quelle"; and Gilberte Aigrisse, *Psychanalyse de Paul Valéry,* Paris, 1964.

16. Sigmund Freud, "Leonardo da Vinci and a Memory of His Childhood" (1910), *The Standard Edition of the Complete Psychological Works of Sigmund Freud,* vol. 11: *Five Lectures on Psychoanalysis, Leonardo da Vinci and Other Works* (James Strachey, ed. and trans.), London, 1957: 631–37.

17. McMullen, *Degas* (p. 269), recounts a mysterious sexual incident early in Degas's life (1856) that seems to lie at the bottom of his reputed celibacy. It may be this, a reference to an obscure entry in a notebook in which Degas remarks on a sexual encounter with a girl and on his feelings of shame, to which Nicholson refers.

18. The themes of sight and love continue to alternate with one another throughout his letters: "Il faut continuer à tous regarder"—*Lettres de Degas,* no. 91, p. 119; "En aimant la nature nous ne pouvons jamais savoir si elle nous le rend"—no. 99, p. 125; "J'ai vu de bien belles choses, à travers de ma colère, et ce qui me console un peu, c'est qu'à travers de la colère, je ne cesse de regarder"—no. 127, p. 158; "Des passions je n'en ai pas"—no. 170, p. 192. Moreover, the stress on artifice and the refusal of spontaneity are repeated throughout Degas's letters and *mots;* one of the best examples of these links picture-making to strategic force rather than to pleasure, indeed links it to the perpetration of a crime: "Un tableau est une chose qui exige autant de rouerie, de malice et de vice que la perpétration d'un crime"—Lemoisne, *Degas et son oeuvre,* vol. 1: 119.

19. Pelmont, in *Paul Valéry et les beaux-arts* (pp. 32, 106), states that Valéry did not group Degas (or Leonardo) together with those artists who had achieved "poet-painter" status in his eyes.

20. See Boggs, *Portraits by Degas:* 8–9; Lemoisne, *Degas et son oeuvre,* vol. 1: 14, 19–20. See also Kendall, "The Contingency of Vision": 182–85, for a discussion of the self-portraits which attends to some of the same features of Degas's self-images as I do, but which accounts for them simply as symptoms of Degas's eye problems. See my "Reflec-

tions on the Mirror: Painting, Photography and the Self-Portraits of Edgar Degas," *Representations,* vol. 22, Spring 1988—some of this material is taken almost wholesale from that essay, and some of it is a permutation of it.

21. This might seem reminiscent of the argument Fried makes about Courbet's self-portraits and other works. It is, in fact, rather different, as I hope to show. See Michael Fried, "The Beholder in Courbet: His Early Self-Portraits," *Glyph,* vol. 4, 1978: 85–123; and also, "The Structure of Beholding in Courbet's Metaphysics: A Reading of 'The Quarry,'" in *Reconstructing Individuality and the Self in Western Thought* (Thomas C. Heller, Morton Sosna, David E. Wellberg, eds.), Stanford, 1986: 76–139.

22. Rosalind Krauss, "Impressionism: The Narcissism of Light," *Partisan Review,* vol. 43, no. 1 (1976): 102–12.

23. See Boggs, *Portraits by Degas:* 5–21.

24. See *Degas Letters:* 33.

25. See Snow, *A Study of Vermeer,* pp. 3–21, for a lyrical, perceptive, and entirely relevant account of this image.

26. Jacques Lacan, "The Mirror Stage as Formative of the Function of I as Revealed in Psychoanalytic Experience," in *Ecrits* (Alan Sheridan, trans.), New York, 1977: 1–8. (I should point out here that the "stage" in "mirror stage" is ambiguous—it can mean either "phase" or "theater," and is usually taken to mean the former. Since the French word is "stade," I take it to mean the latter, and have used it in that theatrical, spatial way throughout this chapter.)

27. Gombrich, *Art and Illusion:* 5.

28. For discussions of Degas's photographic work, see Janis, "Edgar Degas's Photographic Theater"; Douglas Crimp, "Positive/Negative: A Note on Degas's Photographs," *October,* vol. 5, Summer 1978: 89–100; and Antoine Terrasse, *Degas et la photographie,* Paris, 1983. For the relationship between Degas's other work and photography, see Krauss, "The Narcissism of Light," and Kirk Varnedoe, "The Ideology of Time: Degas and Photography," *Art in America,* vol. 68, no. 6, Summer 1980: 96–101.

29. See Paul Valéry, "The Centenary of Photography," in Alan Trachtenberg, *Classic Essays in Photography,* New Haven, 1980: 191–98; and "De la ressemblance et de l'art," *Ecrits sur l'art: textes de Paul Valéry,* compiled and edited by Jean-Clarence Lambert, Paris (Gallimard), 1962: 224–29 (here Valéry writes of the portrait tradition and the self—with a brief mention of photography, p. 225).

30. See Crimp, "Positive/Negative"; Janis, "Edgar Degas's Photographic Theater": 451–86; Wayne Roosa, "Degas' Photographic Portrait of Renoir and Mallarmé: An Interpretation," *Rutgers Art Review,* vol. 14, January 1982.

31. The models of "masculinized" and "feminized" creation that I am using here are loosely informed by Irigaray's and others' feminist critique of Freudian and Lacanian phallocentrism.

32. See Sigmund Freud, *The Interpretation of Dreams* (James Strachey, trans.), New York, 1965: 248, 387.

33. Benjamin, "The Work of Art in the Age of Mechanical Reproduction."

34. See Jacques Derrida, *Of Grammatology* (Gayarti Chakravorty Spivak, trans.), Baltimore, 1976; and *Writing and Difference* (Alan Bass, trans.), Chicago, 1978, for discussions of logocentrism: the Western, Judeo-Christian habit of looking to origins and sources, intentions and *authors* to discover meaning, instead of privileging the constantly shifting, plural play of interpretation of many different readers.

POSTSCRIPT

1. This is even true of Greenberg, who ties modernist formalism to a materialist view of the world: *Clement Greenberg: The Collected Essays and Criticism,* vol. 2: *Arrogant Purpose 1945–1949*—"Review of an Exhibition of Claude Monet" (*The Nation,* 5 May 1945: 20);

"Review of an Exhibition of the School of French Painters" (*The Nation,* 29 June 1945: 88); "Review of an Exhibition of Gustave Courbet" (*The Nation,* 8 January 1949: 276); and "Our Period Style" (*Partisan Review,* November 1949: 322–26).

2. See Renato Poggioli, *The Theory of the Avant-Garde* (Gerald Fitzgerald, trans.), Cambridge, 1981: 30ff., who defines avant-gardism as a stance predicated on an attitude of antagonism.

3. See William Ivins, *Prints and Visual Communication,* Cambridge, 1953; Estelle Jussim, *Visual Communication and the Graphic Arts: Photographic Technologies in the Nineteenth Century,* New York, 1974; and Roland Barthes, "The Rhetoric of the Image," *Image/Music/Text* (Stephen Heath, trans.), New York, 1977, for discussions of the inherently semiotic status of the graphic media of drawing, printmaking, and photography. See also Greenberg, "Collage," *Art and Culture:* 70–83, for a discussion which distinguishes representation from illusionism: from this distinction it is possible to derive a connection between representation and graphic media on the one hand (the drawing, print media, and newsprint that one finds in cubist collage and *papier collé*) and between illusionism and oil-painting on the other hand ("analytic" cubism). This is a distinction which could be applied to Degas, with his allegiance to drawing, as opposed to Courbet, Manet, and the impressionists, with their allegiance to painting. It is even possible that different trajectories, indeed different modernisms, ought to be established for the draughtsmanly and painterly traditions of the nineteenth and twentieth centuries.

Illustration Sources

15 Degas, *Laundress (A Woman Ironing)*, 1874. Oil on canvas, 57 × 39 cms. H. O. Havemeyer Collection, Bequest of Mrs. H. O. Havemeyer, 1929, Metropolitan Museum of Art, New York.

16 Degas, *At the Seaside*, 1876. Oil on canvas, 46 × 81 cms. Reproduced by courtesy of the Trustees, The National Gallery, London.

17 Degas, *Little Fourteen-Year-Old Dancer*, 1881. Bronze. Photograph from the Musées Nationaux. Musée d'Orsay, Paris.

18 Degas, *Miss Lala at the Cirque Fernando*, 1879. Oil on canvas, 117 × 77 cms. Reproduced by courtesy of the Trustees of The National Gallery, London.

19 Degas, *Dance School (The Rehearsal)*, 1879. Oil on canvas, 47 × 61 cms. Copyright The Frick Collection, New York.

20 Degas, *Dance School*, 1876. Distemper on canvas, 43 × 57 cms. Shelburne Museum, Shelburne, Vermont.

21 Degas, *Singer with the Glove*, 1878. Distemper and pastel on canvas, 52.8 × 41.1 cms. Courtesy of The Harvard University Art Museums. Bequest—Collection of Maurice Wertheim, Class of 1906, Fogg Art Museum, Cambridge.

22 Degas, *Dancer's Loge*, 1879. Pastel, 60 × 43 cms. Oskar Reinhart Collection, "Am Römerholz," Winterthur, Switzerland.

23 Degas, *Dance Examination (The Dance Class)*, 1874. Oil on canvas, 82.6 × 76.2 cms. Bequest of Mrs. Harry Payne Bingham, 1986 (1987.47.1), Metropolitan Museum of Art, New York.

24 Degas, *Dance Class*, 1874. Oil on canvas, 85 × 75 cms. Photograph from the Musées Nationaux. Musée d'Orsay, Paris.

25 Degas, *The Star*, 1878. Pastel, 58 × 42 cms. Photograph from the Musées Nationaux. Musée d'Orsay, Paris.

26 Degas, *Women in Front of the Cafe during the Evening*, 1877. Pastel on monotype, 41 × 60 cms. Photograph from the Musées Nationaux. Musée d'Orsay, Paris.

27 Degas, *Prima Ballerina (The Star: Dancer on Point)*, 1878. Gouache and pastel on paper, 57 × 76 cms. Norton Simon Foundation, Pasadena, Calif.

28 A. Marcelin, *La Vie Parisienne*, 3 January 1874. Phot. Bibliothèque Nationale, Paris.

29 Degas, *The Ballet (Danseuse au Bouquet)*, 1878. Pastel, 40 × 50 cms. Gift of Mrs. Murray S. Danforth, Museum of Art, Rhode Island School of Design, Providence, Rhode Island.

30 Degas, *Woman with the Opera Glass*, 1869–72. Oil on canvas, 31 × 19 cms. The Burrell Collection, Glasgow Museums and Art Galleries, Glasgow.

31 Jean Béraud, *Backstage at the Opera*, 1889. Oil on canvas. Photograph from Musées de la Ville de Paris © by SPADEM 1989. Musée Carnavalet, Paris.

32 Edmond Morin, frontispiece to Ludovic Halévy's *M. Cardinal*, 1871. In author's possession.

33 Henri Maigrot, alias Henriot, frontispiece to Ludovic Halévy's *Les Petites Cardinal*, 1880. Phot. Bibliothèque Nationale, Paris.

34 Degas, *Pauline and Virginie Conversing with Admirers*, 1880–83. Illustrations to *La Familie Cardinal*. Monotype, 21.5 × 16 cms. Courtesy of The Harvard University Art Museums. Bequest of Meta and Paul J. Sachs, Fogg Art Museum, Cambridge, Mass.

35 Degas, *Talking to Admirers*, 1880–83. Monotype. Whereabouts unknown.

36 Degas, *Ludovic Halévy Finds Mme Cardinal in the Dressing Room*, 1880–83. Monotype, second impression, 21 × 16 cms. Whereabouts unknown.

37 Degas, *Conversation*, 1880–83. Monotype, 25.6 × 17.9 cms. Gift of the Print Club of Cleveland in honor of Henry Sales Francis, 67.167, Cleveland Museum of Art, Cleveland, Ohio.

38 Degas, *Ludovic Halévy Meeting Mme Cardinal Backstage*, 1880–83. Monotype, 27.3 × 30.7 cms. Whereabouts unknown.

39 Degas, *Mme. Cardinal Scolding an Admirer*, 1880–83. Monotype, 21.5 × 16 cms. Whereabouts unknown.

40 Gabriel Metsu, *A Soldier and a Young Woman*, 1660s. Oil on panel, 61 × 46 cms. Photograph from the Musées Nationaux. Louvre, Paris.

67 Degas, *Dance Rehearsal*, 1874. Oil on canvas, 53.4 × 83.8 cms. The Burrell Collection, Glasgow Museums and Art Galleries, Glasgow.

68 Armand Cassagne, *Eléments de Perspective*, 1881. Fig. 115: "L'escalier tournant." Phot. Bibliothèque Nationale, Paris.

69 Degas, *Two Dancers on Stage*, 1877. Oil on canvas, 62 × 46 cms. Courtauld Collection, Courtauld Institute Galleries, London.

70 Degas, *Laundresses Carrying Laundry*, 1876–78. *Peinture à l'essence* on paper, mounted on canvas, 46 × 61 cms. Private collection, courtesy of Christie's, London.

71 Degas, *The Café-concert at the Ambassadeurs*, 1876–77. Pastel on monotype, 37 × 27 cms. Musée des Beaux-Arts, Lyon.

72 Degas, *At the Racecourse (Carriage at the Races)*, 1870–73. Oil on canvas, 36.5 × 55.9 cms. 1931 Purchase Fund, courtesy, Museum of Fine Arts, Boston.

73 Degas, *In Front of the Stalls*, 1869–72. *Peinture à l'essence* on canvas, 46 × 61 cms. Photograph from the Musées Nationaux. Musée d'Orsay, Paris.

74 Degas, *Laundress (Die Büglerin)*, 1869. Oil on canvas, 92.5 × 74 cms. Neue Pinakothek, Munich.

75 Honoré Daumier, *The Laundress*, 1863. Oil on wood, 48.9 × 33 cms. Bequest of Lizzie P. Bliss, 1931 (47.122), Metropolitan Museum of Art, New York.

76 Honoré Daumier, *The Orchestra during the Performance of a Tragedy*, 1852. Lithograph. Rogers Fund, 1922 (22.61.304), Metropolitan Museum of Art, New York.

77 Honoré Daumier, *At the Champs-Elysées*, 1852. Lithograph. Phot. Bibliothèque Nationale, Paris.

78 Degas, *The Dance Lesson*, 1877–78. Pastel on paper, 64.6 × 56.3 cms. H. O. Havemeyer Collection, 1971 (1971.185), Metropolitan Museum of Art, New York.

79 Degas, *Ballet Rehearsal*, 1875. Pastel and gouache, 55.2 × 68 cms. Acquired through the Kenneth A. and Helen F. Spencer Foundation Acquisition Fund (F73-30), Nelson-Atkins Museum of Art, Kansas City, Missouri.

80 Degas, *Ballet Master*, 1874–75. Monotype, 62 × 85 cms. Rosenwald Collection, National Gallery of Art, Washington, D.C.

81 Degas, *Café-concert (Cabaret)*, 1876–77. Pastel over monotype, 23.5 × 45 cms. William A. Clark Collection, in the collection of The Corcoran Gallery of Art, Washington, D.C.

82 Honoré Daumier, *Mother of the Singer*, 1856. Lithograph. Gift of Edwinde T. Bechtel, 1952 (52.633.1 [17]), Metropolitan Museum of Art, New York.

83 Degas, *The Serious Client*, 1879. Monotype, 21 × 16 cms. Photograph courtesy of the Lefevre Gallery, London. National Gallery of Canada, Ottawa.

84 Degas, *In the Salon*, 1879. Monotype, 15.9 × 21.6 cms. Photograph from the Musées Nationaux. Musée Picasso, Paris.

85 Degas, *Waiting*, 1879. Monotype, 21 × 15.9 cms. Photograph from the Musées Nationaux. Musée Picasso, Paris.

86 Degas, *In the Salon of a Brothel*, 1879. Monotype, 21.2 × 16 cms. Gift of the Mortimer C. Leventritt Fund and the Committee for Art at Stanford (73.23), Stanford University Museum of Art, Stanford, Calif.

87 Degas, *At the Milliner's*, 1882. Pastel on paper, 76.9 × 87.1 cms. H. O. Havemeyer Collection, Bequest of Mrs. H. O. Havemeyer, 1929 (29.100.38), Metropolitan Museum of Art, New York.

88 Degas, *The Baker's Wife (The Morning Bath)*, 1886. Pastel on paper, 67 × 52 cms. Photograph courtesy of the Metropolitan Museum. Henry and Rose Pearlman Foundation; on loan to The Art Museum, Princeton, New Jersey.

89 Degas, *The Tub*, 1886. Pastel on cardboard, 60 × 83 cms. Photograph from the Musées Nationaux. Musée d'Orsay, Paris.

90 Degas, *Woman in the Tub*, 1885. Pastel, 68 × 68 cms. Tate Gallery, London.

91 Degas, *Woman in the Tub*, 1884. Pastel, 53.5 × 64 cms. The Burrell Collection, Glasgow Museums and Art Galleries, Glasgow.

92 Degas, *Woman in the Tub (Woman Bathing in a Shallow Tub)*, 1885. Pastel on

41 Gabriel Metsu, *The Music Lesson, (Lesson at the Virginal)*, 1660s. Oil on panel, 32 × 24.5 cms. Photograph from the Musées Nationaux. Louvre, Paris.

42 Gabriel Metsu, *Vegetable Market in Amsterdam*, 1661–62. Oil on canvas, 97 × 83 cms. Photograph from the Musées Nationaux. Louvre, Paris.

43 Degas, *The Interior*, 1868. Oil on canvas, 81 × 116 cms. The Henry P. McIlhenny Collection in memory of Frances P. McIlhenny, Philadelphia Museum of Art, Philadelphia, Penn.

44 J. L. David, *Oath of the Horatii*, 1785. Oil on canvas, 300 × 425 cms. Photograph from the Musées Nationaux. Louvre, Paris.

45 J. L. David, *Lictors Returning the Bodies of His Sons to Brutus*, 1789. Oil on canvas, 325 × 425 cms. Photograph from the Musées Nationaux. Louvre, Paris.

46 Degas, *Duranty*, 1879. Tempera, watercolor, and pastel on linen, 101 × 100.4 cms. The Burrell Collection, Glasgow Museums and Art Galleries, Glasgow.

47 Degas, *Diego Martelli*, 1879. Oil on canvas, 110 × 100 cms. National Gallery of Scotland, Edinburgh.

48 Edouard Manet, *Emile Zola*, 1868. Oil on canvas, 146 × 114 cms. Photograph from the Musées Nationaux. Musée d'Orsay, Paris.

49 Degas, *The Print-Collector*, 1866. Oil on canvas, 53 × 40 cms. H. O. Havemeyer Collection, Bequest of Mrs. H. O. Havemeyer, 1929 (29.100.44), Metropolitan Museum of Art, New York.

50 Degas, *James Tissot in the Artist's Studio*, 1868. Oil on canvas, 151.4 × 112.1 cms. Rogers Fund, 1939 (39.161), Metropolitan Museum of Art, New York.

51 Edouard Manet, *Théodore Duret*, 1868. Oil on canvas, 43 × 35 cms. Photograph from Musées de la Ville de Paris by SPADEM 1989. Musée du Petit Palais, Paris.

52 Degas, *Carlo Pellegrini*, 1876–77. Watercolor, oil and pastel, 63.7 × 34.2 cms. Tate Gallery, London.

53 Degas, *Portrait after a Costume Ball (Portrait of Mme Dietz-Monnin)*, 1877–79. Gouache, charcoal, pastel, metallic paint, and oil on canvas, 85.5 × 75 cms. © 1988 The Art Institute of Chicago. All rights reserved.

54 *The Bellelli Family*, 1860–62. Oil on canvas, 200 × 253 cms. Photograph from the Musées Nationaux. Musée d'Orsay, Paris.

55 Agnolo Bronzino, *Eleanora di Toledo*, 1545. Oil on panel, 115 × 96 cms. Foto A.F.S. B.A.S. Florence, n. 128565. Uffizi Galleries (inv. 1830, n. 748), Florence.

56 Degas, *Study of Hands*, 1868. Oil on canvas, 38 × 46 cms. Photograph from the Musées Nationaux, Musée d'Orsay, Paris.

57 Degas, *Edmondo and Therese Morbilli*, 1865–66. Oil on canvas, 117.1 × 89.9 cms. Chester Dale Collection, National Gallery of Art, Washington.

58 Degas, *Young Spartan Girls Practicing for Battle*, 1859–60. Oil on canvas, 109 × 155 cms. Reproduced by courtesy of the Trustees, The National Gallery, London.

59 Degas, copy after Poussin: *Rape of the Sabines*, 1861–63. Oil on canvas, 150.6 × 208.9 cms. Norton Simon Foundation, Pasadena, Calif.

60 Degas, copy after Delacroix: *Mirabeau Protesting to Dreux-Brézé*, 1860. Pencil. Phot. Bibliothèque Nationale, Paris.

61 Degas, *The Daughter of Jephtha*, 1859–60. Oil on canvas, 195.5 × 298.5 cms. Purchased 1933, Smith College Museum of Art, Northampton, Mass.

62 Degas, *Misfortunes of War (Scène de guerre au Moyen Age)*, 1865. *Peinture à l'essence* on paper, pasted on canvas, 83 × 115 cms. Photograph from the Musées Nationaux. Musée d'Orsay, Paris.

63 *Young Spartan Girls Provoking Some Boys*, 1860. Oil on canvas, 140 × 97.8 cms. Charles H. and Mary F. S. Worcester Collection (1961.334). © 1989 The Art Institute of Chicago. All rights reserved.

64 Degas, *Mlle Fiocre in the Ballet "La Source,"* 1866–68. Oil on canvas, 130.8 × 145.2 cms. Gift of James H. Post, John T. Underwood, and A. Augustus Healy, courtesy of the Brooklyn Museum, Brooklyn.

65 Degas, *The Ballet of "Robert le Diable,"* 1876. Oil on canvas, 75 × 81 cms. Victoria and Albert Museum, London.

66 Degas, *The Orchestra of the Opera*, 1868–69. Oil on canvas, 53 × 45 cms. Photograph from the Musées Nationaux. Musée d'Orsay, Paris.

paper, 82 × 56 cms. H. O. Havemeyer Collection, Bequest of Mrs. H. O. Havemeyer, 1929 (29.100.41), Metropolitan Museum of Art, New York.

93 *The Toilette (A Woman Having Her Hair Combed)*, 1885. Pastel on paper, 74 × 60.6 cms. H. O. Havemeyer Collection, Bequest of Mrs. H. O. Havemeyer, 1929 (29.100.35), Metropolitan Museum of Art, New York.

94 Degas, *After the Bath (Woman Drying Her Foot)*, 1886. Pastel, 50.6 × 54.4 cms. H. O. Havemeyer, Bequest of Mrs. H. O. Havemeyer, 1929 (29.100.36), Metropolitan Museum of Art, New York.

95 Degas, *Woman in a Bath Sponging Her Leg*, 1883. Pastel, 19 × 41 cms. Photograph from the Musées Nationaux. Musée d'Orsay, Paris.

96 Degas, *After the Bath*, 1886. Pastel on cardboard, 54 × 52 cms. Photograph from the Musées Nationaux. Musée d'Orsay, Paris.

97 Degas, *The Tub*, 1886. Pastel, 70 × 70 cms. Hill-Stead Museum, Farmington, Conn. 06032

98 Degas, *Rose Adelaide Aurore de Gas, Duchesse Morbilli*, 1867. Oil on canvas, 27 × 22 cms. Photograph from the Musées Nationaux. Musée d'Orsay, Paris.

99 Matthias Grünewald, *Crucifixion (Tauberbischofsheim)*, 1523–24. Altarpiece, 192 × 152 cms. Kunsthalle, Karlsruhe.

100 Illustration from Richer, *Etudes cliniques sur la grande hystérie ou hystéro-epilepsie*, 1885. Phot. Bibliothèque Nationale, Paris.

101 Gustave Moreau, *Salomé Dancing before Herod*, 1876. Oil on canvas, 143.5 × 104.3 cms. Armand Hammer Collection, Los Angeles.

102 Félicien Rops, *Les Sataniques: L'idole*, 1882. Musée Félicien Rops, Namur, Belgium.

103 Degas, *After the Bath*, 1885. Pastel on paper, 64 × 51 cms. Norton Simon Foundation (F.75.2.D), Pasadena, Calif.

104 Degas, *After the Bath (Woman Drying Herself)*, 1890. Pastel on paper, 68 × 59 cms. Courtauld Collection, Courtauld Institute of Art, London.

105 Degas, *After the Bath*, 1882–92. Pastel, 104 × 99 cms. Reproduced by courtesy of the Trustees, The National Gallery, London.

106 Degas, *After the Bath*, 1898. Pastel on cardboard, 62 × 65 cms. Photograph from the Musées Nationaux. Musée d'Orsay, Paris.

107 Degas, *The Dancers*, 1899. Pastel on paper, 62.2 × 64.8 cms. Gift of Edward Drummond Libbey (28.198), Toledo Museum of Art, Toledo, Ohio.

108 Degas, *Woman in Her Bath*, 1880–85. Monotype, 20 × 42.9 cms. Whereabouts unknown.

109 Degas, *The Bidet*, 1878–80. Monotype, 16.3 × 12 cms. Whereabouts unknown.

110 Degas, *Sleep*, 1883–85. Monotype, 27.6 × 37.8 cms. British Museum, London.

111 Degas, *Admiration*, 1877–80. Monotype, 21.5 × 16.1 cms. Photo Soc. Amis Bibliothèque d'Art et d'Archéologie (Fondation Jacques Doucet), Paris.

112 Degas, *Forest in the Mountains (A Wooded Landscape)*, 1890–93. Monotype in colored inks, 29.9 × 40.3 cms. Collection of Mrs. Bertram Smith, New York.

113 Degas, *Burgundy Landscape*, 1890–92. Monotype in colored inks, 29.9 × 40.3 cms. Photograph from the Musées Nationaux. Musée d'Orsay, Paris.

114 Degas, *Esterel Village*, 1890–92. Monotype in colored inks, 30 × 42.5 cms. Phot. Bibliothèque Nationale, Paris.

115 Degas, *Landscape*, 1890–93. Monotype in colored inks with pastel, 25.6 × 34.2 cms. Mr. and Mrs. Richard J. Bernhard Gift, 1972, Metropolitan Museum of Art, New York.

116 Degas, *After the Bath (Woman Drying Her Back)*, 1896. Photograph, 17 × 12 cms. The J. Paul Getty Museum, Malibu, Calif.

117 Degas, *Dancer from the Corps de Ballet*, 1896. Photograph. Phot. Bibliothèque Nationale, Paris.

118 Degas, *Self-Portrait with a Crayon-holder*, 1854–55. Oil on canvas, 81 × 64 cms. Photograph from the Musées Nationaux. Musée d'Orsay, Paris.

119 Degas, *Self-Portrait*, 1857–58. Oil on paper, pasted on canvas, 26 × 19 cms. Sterling and Francine Clark Art Institute, Williamstown, Mass.

120 Degas, *Self-Portrait,* 1857–58. Pencil. Whereabouts unknown.
121 J. A. D. Ingres, *Self-Portrait at Twenty-four,* 1804. Oil on canvas, 79.4 × 66.6 cms. Photograph by Giraudon. Musée Condé, Chantilly.
122 Degas, *Degas Saluting (Self-Portrait),* 1862. Oil on canvas, 92 × 69 cms. Calouste Gulbenkian Foundation, Lisbon.
123 Degas, *Two Sisters (Bellelli Sisters),* 1865. Oil on canvas, 92.9 × 73 cms. Mr. and Mrs. George Gard de Sylvia Collection, Los Angeles County Museum of Art, Los Angeles.
124 Degas, *Degas and Evariste de Valernes,* 1864. Oil on canvas, 117 × 90 cms. Photograph from the Musées Nationaux. Musée d'Orsay, Paris.
125 Jan Vermeer, *Head of a Girl,* 1665. Oil on canvas, 46 × 41 cms. Mauritshuis, The Hague.
126 Degas, *Self-Portrait with Zöe Closier (Degas and His Servant),* 1890–1900. Photograph. Phot. Bibliothèque Nationale, Paris.
127 Degas, *Portrait of Renoir and Mallarmé,* c. 1890. Photograph, 17.9 × 13 cms. Gift of Mrs. Henry T. Curtiss, 1965 (65.500.1), Metropolitan Museum of Art, New York.

Index

Updated Photographic Credit Lines for Illustrations, 2003 Edition

Plate 4. No. 1972.626. Photo © 1979 The Metropolitan Museum of Art.

Figs. 2, 4, 7–9, 12, 14, 17, 24–26, 40–42, 44–45, 48, 54, 56, 62, 66, 73, 84–85, 89, 95–96, 98, 106, 113, 118, 124. © Réunion des Musées Nationaux/Art Resource, New York.

Fig. 10. Photo: Rick Stafford. Image © President and Fellows of Harvard College.

Fig. 21. Photo: Photographic Services. Image © President and Fellows of Harvard College.

Fig. 31. © Photothèque des Musées de la Ville de Paris. Negative: Ladet.

Fig. 34. Photo: Photographic Services. Image © President and Fellows of Harvard College.

Fig. 51. Photo: 1997 PPA 0364 © PMVP. Cliché: Pierrain.

Figs. 52, 90. © Tate, London, 2003.

Fig. 53. The Joseph Winterbotham Collection, 1954.325, The Art Institute of Chicago.

Fig. 57. Image © 2003 Board of Trustees, National Gallery of Art, Washington, D.C.

Fig. 59. Gift of Mr. Norton Simon, 1983.

Fig. 65. © V & A Images.

Figs. 69, 104. Witt Library, Courtauld Institute of Art, London.

Fig. 70. © Christie's Images, Inc., 1988.

Fig. 71. Photo © Studio Basset.

Fig. 72. © 2003 Museum of Fine Arts, Boston.

Fig. 74. Bayerische Staatsgemäldesammlungen Neue Pinakothek, Munich.

Fig. 79. Photo: E. G. Schempf.

Fig. 80. Image © 2003 Board of Trustees, National Gallery of Art, Washington, D.C.

Fig. 86. Iris and B. Gerald Cantor Center for Visual Arts at Stanford University; Mortimer C. Leventritt Fund and Committee for Art Acquisitions Fund.

Fig. 102. Musée Provincial Félicien Rops, Namur.

Fig. 110. © The British Museum.

Fig. 115. No. 1972.626. Photo © 1972 The Metropolitan Museum of Art.

Fig. 116. J. Paul Getty Museum, Los Angeles.

Fig. 121. Musée Condé, Chantilly. © Giraudon/Art Resource, New York.

Fig. 125. Royal Cabinet of Paintings Mauritshuis, The Hague.

DATE DUE

FEB 2 8 2004		
April 8th 2004		
OCT 1 1 2004		
GAYLORD		PRINTED IN U.S.A